⇢AN IMPERIAL COLLECTION⇠

Women Artists from the State Hermitage Museum

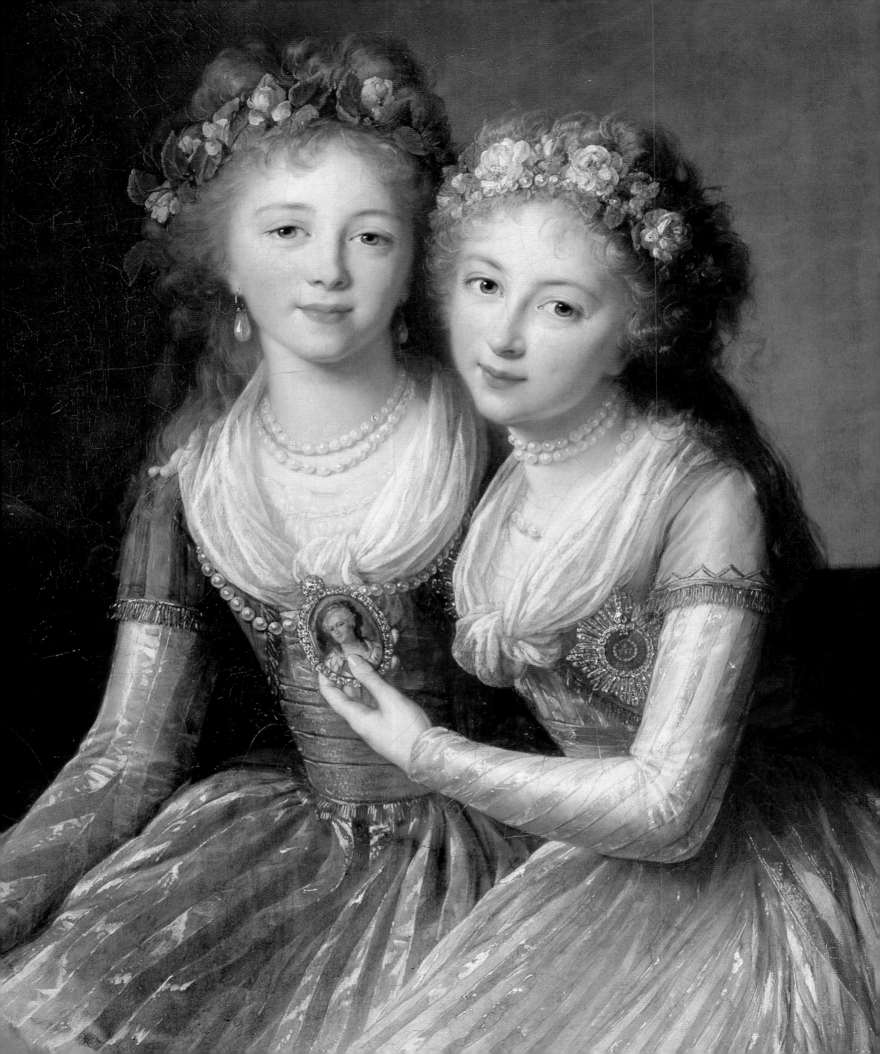

⤝AN IMPERIAL COLLECTION⤞

Women Artists from the State Hermitage Museum

Edited by Jordana POMEROY, Rosalind P. BLAKESLEY,
Vladimir Yu. MATVEYEV, and Elizaveta P. RENNE

National Museum of Women in the Arts
in association with
MERRELL

First published 2003 by
Merrell Publishers Limited
42 Southwark Street
London SE1 1UN

in association with the

National Museum of Women in the Arts
1250 New York Avenue, NW
Washington, D.C. 20005-3970

Published on the occasion of the exhibition
An Imperial Collection: Women Artists from the State Hermitage Museum

EXHIBITION ITINERARY

National Museum of Women in the Arts, Washington, D.C.
 14 February – 18 June 2003

Frye Art Museum, Seattle, Washington
 26 July – 30 November 2003

A catalogue record for this book is available from the Library of Congress

British Library Cataloguing-in-Publication Data:
An imperial collection: women artists from the State Hermitage Museum
1.Ermitazh 2.Painting, European – Influence 3.Women painters – Europe 4.Painting – Russia (Federation) – Saint Petersburg 5.Russia – Civilization – European influences 6.Russia – History
I.Pomeroy, Jordana II.Blakesley, Rosalind P. (Rosalind Polly) III.National Museum of Women in the Arts
759.7'44731

ISBN 1 85894 198 9 (hardcover edition)
ISBN 1 85894 199 7 (softcover edition)

Jacket/cover, front: Marie Louise Elisabeth Vigée-Lebrun, *Self-portrait*, 1800, detail (see p. 189)
Jacket/cover, back: Carolina Friederika Friedrich, *Fruit and Flowers*, 1788 (see p. 107)
Frontispiece: Marie Louise Elisabeth Vigée-Lebrun, *The Daughters of Paul I, Grand Duchesses Alexandra Pavlovna and Elena Pavlovna*, 1796, detail (see p. 185)
Pages 100–101: Angelica Kauffman, *Portrait of Lady-in-Waiting Anna Protasova with her Nieces*, 1788, detail (see p. 131)

Edited by Jordana Pomeroy, Rosalind P. Blakesley, Vladimir Yu. Matveyev, and Elizaveta P. Renne
Translated from Russian by Catherine Phillips

Produced by Merrell Publishers
Designed by Matt Hervey
Copy-edited by Kirsty Seymour-Ure
Index by Laura Hicks
Printed and bound in Italy

NOTES ON THE TEXT

This book follows the Library of Congress system of transliteration. The only exception concerns the transliteration of personal names, which omit the use of a prime to signify a soft sign, and at the end of which -y is used to express -й, -ий, and -ый. Russian rulers are referred to by their Anglicized names (thus Catherine, Nicholas, and Paul, rather than Ekaterina, Nikolai, and Pavel). Certain standard transliterations of Russian names are also followed, for example Alexander, Alexandra, and Yusupov. If an alternative system of transliteration is used in a reference, that variation is retained.

St. Petersburg was renamed Petrograd in 1914, Leningrad in 1924, and then St. Petersburg again in 1991. The name used in references is that current at the time in question, *i.e.* St. Petersburg 1703–1914
 Petrograd 1914–24
 Leningrad 1924–91
 St. Petersburg 1991–

AUTHORS OF ENTRIES

A.B. Alexander A. Babin, Curator of Nineteenth-Century Painting
E.D. Ekaterina V. Deriabina, Curator of French Eighteenth-Century Painting
I.E. Irina G. Etoeva, Curator of Nineteenth-Century Sculpture
A.K.-G. Asia S. Kantor-Gukovskaia, Curator of European Nineteenth–Twentieth-Century Drawings and Pastels
M.G. Maria P. Garlova, Curator of German Fifteenth–Eighteenth-Century Painting
T.K. Tatiana K. Kustodieva, Curator of Italian Renaissance Painting
N.N. Nikolai N. Nikulin, Curator of Early Netherlandish Painting
E.R. Elizaveta P. Renne, Curator of British and Scandinavian Painting

Contents

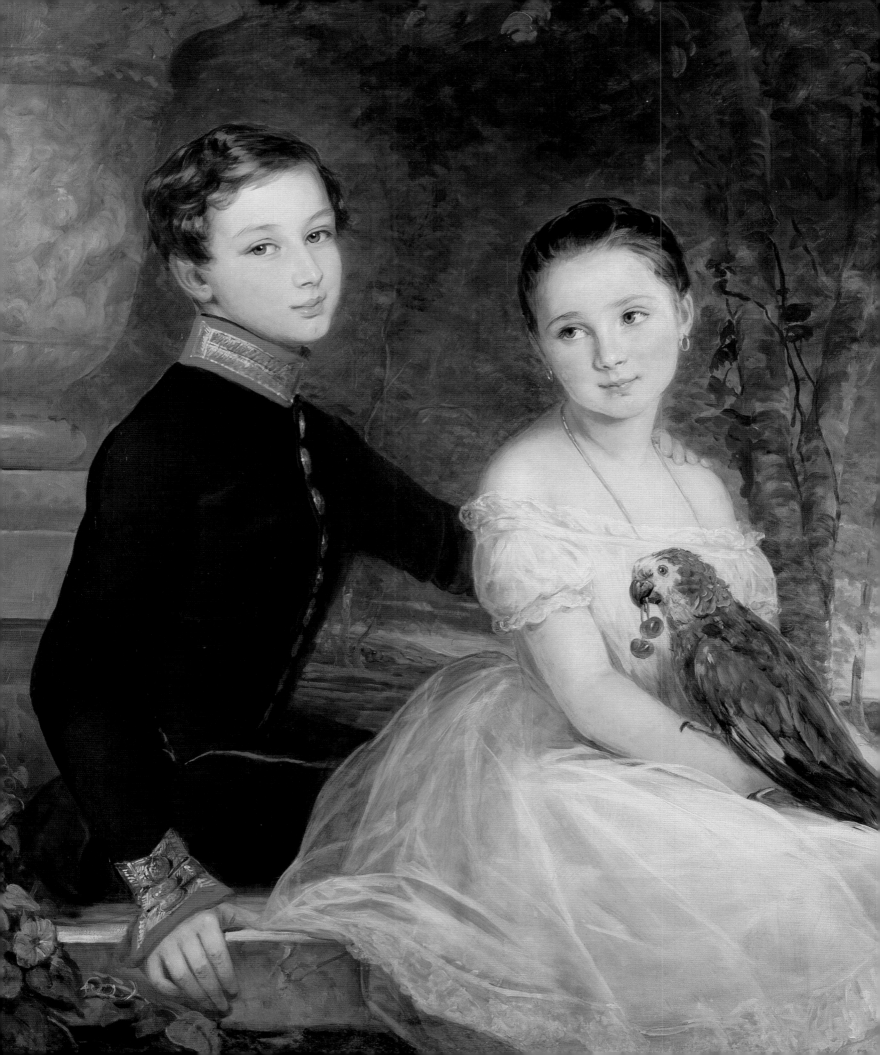

Foreword

THE TERCENTENARY OF THE FOUNDATION OF ST. PETERSBURG in 1703 has inspired tributes throughout that city and in the United States as well. While St. Petersburg has immersed itself in renovations of numerous historic sites, across the Atlantic we honor the city that shaped the vision of some of the foremost artists, writers, composers, and art patrons in the history of Western civilization. With its origins in swampland, on a river that was often frozen for five months of the year, St. Petersburg was an unlikely place to situate Russia's new capital. But Peter the Great was undeterred by the practical logistics of building on the River Neva's swamps and their proximity to Russia's greatest enemy, Sweden. Instead he envisioned a new city that would represent Russia's future. The Russian leader understood that to modernize his country, he had to make it accessible to the West, forge alliances with past enemies, and take advantage of modern technology.

Peter's vision for his new capital included an ambitious building scheme. This involved commissioning French, Italian, and Swiss architects and engineers to design luxurious government buildings, private residences, and gardens that could stand on marshland, withstand the harshness of an Arctic winter, and also be the envy of all Europe. By the time of Peter's death, in 1725, St. Petersburg was a thriving city complete with a fortress, churches, imperial palaces, government buildings, a hospital, and a community of merchants, artisans, and traders. Many members of the aristocracy had also built new residences there, hiring artists and craftspeople to furnish their elegant estates. Visitors to the Russian capital in the early eighteenth century recorded their awestruck impressions of a city that not only seemed to have arisen overnight, but also proclaimed the country's glory and strength with its gilt-clad Rococo and Baroque buildings.

The artistry of Bartolommeo Francesco Rastrelli, a Parisian-educated architect, is particularly visible in the building of the city. Rastrelli, who established his reputation as an architect to the royal and noble families of St. Petersburg, was given the

Christina Robertson,
Children with a Parrot, 1850,
detail (see p. 163)

commission in 1754 to rebuild and redecorate the Winter Palace. His masterpiece was completed in 1817, 46 years after his death. W. Bruce Lincoln evokes the beauty and monumentality of Rastrelli's work when he writes: "On the Winter Palace's Neva river side its stunning grand façade can be appreciated only from the opposite bank, nearly a fifth of a mile away. Here, as in Russia itself, space has its own meaning. Not since the days of Imperial Rome has any state expressed so grand a vision on such a monumental scale."[1] In this one palace Rastrelli captured the image of the new Russia.

When Catherine the Great seized the Russian throne from her estranged husband Peter III, a grandson of Peter the Great, she immediately made the Winter Palace Russia's center of power. It was here that Catherine held political court, signing laws, issuing treaties, and declaring war. It was also here that Catherine displayed the results of her insatiable hunger to collect and commission art. Purchasing large collections of art, Catherine put her country on a cultural par with Italy and France, a phenomenon that the current director of the State Hermitage Museum, Dr. Mikhail Borisovich Piotrovski, eloquently addresses in the opening essay. The empress's patronage of Marie-Anne Collot, in particular, forms the central focus of the essay by Irina Georgievna Etoeva, the Hermitage curator of nineteenth-century sculpture. Elizaveta Pavlovna Renne, the Hermitage curator of British and Scandinavian painting, examines the career of Christina Robertson, another foreign woman artist who was well received at the court of Nicholas I.

The Hermitage officially became a public museum in 1922, after the First World War. By then it included collections from Russia's royal and noble families, as well as those of industrial magnates. These collections often featured outstanding works by women artists, many of which appear in this book. To contextualize these developments, Professor Lindsey Hughes, Professor of Slavonic Studies at the University of London, looks at Russian women as artistic patrons and subjects up to the eighteenth century. Dr. Rosalind P. Blakesley, lecturer in Art History at the University of Cambridge, then traces the impact of Western European women artists working in Russia from the time of Catherine the Great, and the gradual appearance in the nineteenth century of Russian women artists.

It is our good fortune that Kathleen Elizabeth Springhorn, who serves on the Board of Directors of the American Friends of the Hermitage Museum as well as on our National Advisory Board, connected these two cultural institutions in a meaningful way. Because of her paired interest in women artists and the State Hermitage Museum, she sought to bring to Washington, D.C. works of art that have never before

left St. Petersburg. Following a lecture by Dr. Piotrovski at the National Museum of Women in the Arts, Board chair Wilhelmina Cole Holladay, Wallace Holladay, and chief curator Susan Fisher Sterling, visited St. Petersburg to formalize the partnership.

We are grateful to Dr. Piotrovski and his staff, especially deputy director Dr. Vladimir Yurievich Matveyev, who have been most generous in extending every courtesy both to our museum and to the Frye Art Museum. Elizaveta Pavlovna Renne deserves special acknowledgment not only for her intriguing essay but also for the many tasks that she graciously undertook. We thank Hermitage curators Alexander Alekseevich Babin, Ekaterina Vadimovna Deriabina, Irina Georgievna Etoeva, Maria Pavlovna Garlova, Asia Solomonovna Kantor-Gukovskaia, Tatiana Kirillovna Kustodieva, Nikolai Nikolaevich Nikulin, and Elizaveta Pavlovna Renne for their insightful and thorough contributions to this book, which will add immeasurably to the historiography on women artists. Catherine Phillips's translating prowess and dedication beyond the call of duty ensured the success of this publication.

We would like to express our heartfelt appreciation to Dr. Rosalind Blakesley and to Dr. Jordana Pomeroy, Curator of Painting and Sculpture before 1900 at the National Museum of Women in the Arts, for their collaborative editing of this fine book, and to Dr. Pomeroy for her dedication and commitment in bringing this enlightening exhibition to fruition. We owe the ease with which we were able to bridge two cultures and countries nearly half a world apart to the efforts of Dr. Alexander Shedrinsky, whose fluency in the ways of Russian and American museums contributed profoundly to the overall achievement of this ambitious project. To him we are extremely grateful. We would also like to thank the Board of Trustees and executive director, Richard V. West, of the Frye Art Museum in Seattle, Washington, for bringing this exhibition to a West Coast audience, and doing so in the most accommodating and efficacious manner possible.

This book, the exhibition, and the ancillary educational program would not have been possible without crucial support from John F. Mars and Adrienne B. Mars, Patti Cadby Birch, the Samuel Freeman Charitable Trust, the Trust for Mutual Understanding, and the Samuel H. Kress Foundation. Finally, Merrell Publishers deserves acknowledgment for the particularly elegant production of this book.

Dr. Judy L. Larson
Director, National Museum of Women in the Arts

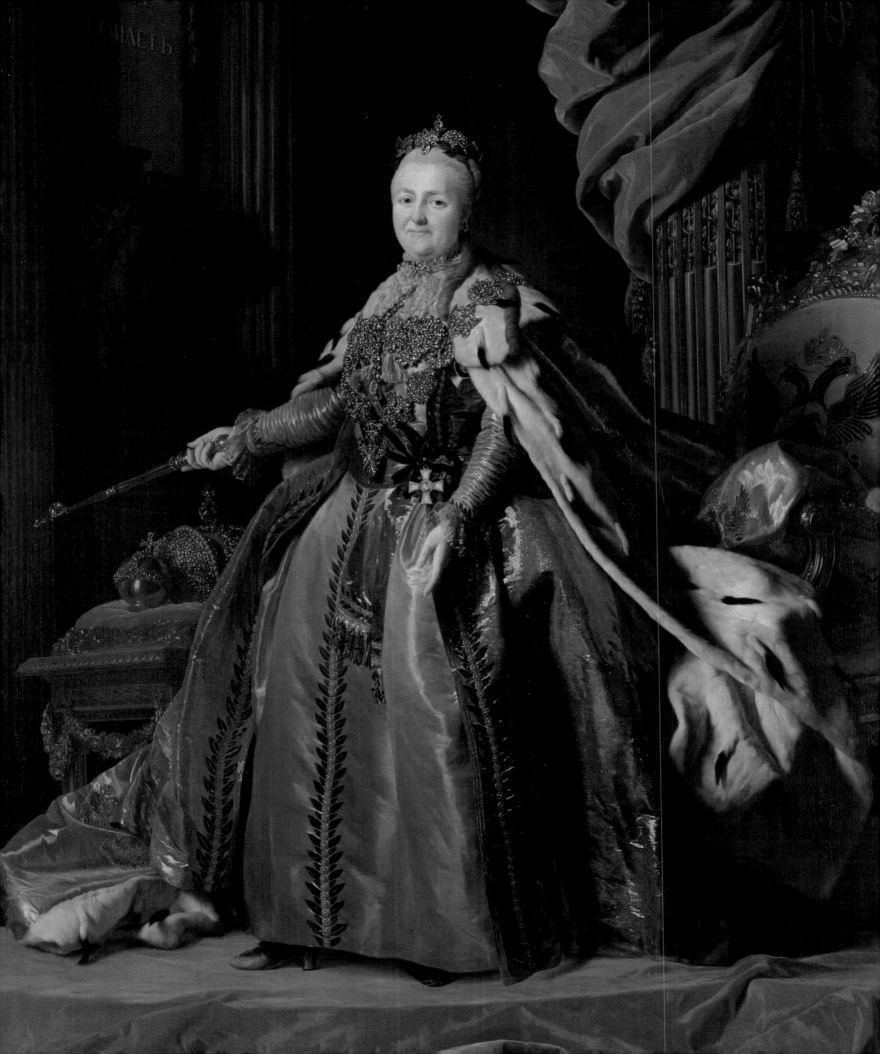

The Tsarina

MIKHAIL B. PIOTROVSKI

N St. Petersburg, the Russian Tsarina Catherine (ruled 1762–96) erected a celebrated monument to Peter the Great and wrote upon it: "To Peter the First—Catherine the Second." A proud if perhaps pretentious inscription, it clearly placed Catherine alongside the great and revered reformer, founder of St. Petersburg, vanquisher of the Swedes, the man who opened up a window in Russia through which Catherine could see Europe.

But Catherine was right to set her own value so high. This woman on the Russian throne was able to do things of which Peter could but dream. Peter had succeeded in carving out the foundation for a new Russia, and in creating all that was needed to ensure its future strength. He forcibly introduced European habits to the land, and encouraged European branches of learning. He dressed his army in European uniforms and began to learn how to conquer. He built new ships and towns. The tsar's activities were impetuous and energetic, shaking Russia through and through. But their vibrations were hardly felt in the rest of the world. Peter's military victories still seemed to be a matter of chance; the new city he had founded did not yet look like an imperial capital, and its factories had barely begun to produce their metal.

But when Catherine arrived on the throne some thirty-seven years after Peter's death, everyone was made to comprehend the great extent of Russia's wealth and the might of its mining industries. Russian armies set all of Europe quaking, thanks to Catherine's decisive advances toward the Black and Mediterranean seas, the conquering of the Crimea, and Russian victories over the Turks. St. Petersburg amazed people with its luxury and grandeur. Moreover, the city gained a reputation for its excellent libraries and marvelous collections of art. Russia became a great power, a power that was feared and respected. It was for this purpose that Peter had introduced his reforms, it was this that he had been seeking to achieve; Catherine understood and realized his dream.

Alexander Roslin, *Portrait of Catherine II*, 1776–77, detail (fig. 11)

At court and among the people she was known by the simple Russian word *matushka*, meaning "dear mother," and those who referred to her in this way had every reason to do so. A German with not a single drop of Russian blood, who spoke Russian with an accent, she was nevertheless one of the most Russian of all rulers, in both mood and approach, since the time of Peter himself. It was not that she sought to make the ladies of the court wear variations on the traditional Russian pointed *kokoshnik* headdress—although she herself did so. Rather, she learned Russian, and respected and gave strong support to everything native to her adopted country. Her whole policy was openly and emphatically aimed at furthering the interests of Russia. Her new motherland helped this provincial princess to gain the upper hand over her numerous arrogant German relatives, among them the Prussian king, Frederick the Great. Frederick was a celebrated and successful military commander, yet it was during his reign that the troops of Elizabeth—Peter the Great's daughter, and the person who was responsible for educating Catherine in Russia—first entered Berlin. And a little later, when Frederick, ruined by the cost of his wars, could not pay for a collection put together specially for him by a Berlin merchant and agent, Johann Gotzkowski, Catherine made a big show of purchasing it. Thus she laid the foundation of her art collection, one that would considerably surpass Frederick's own. It was this collection that marked the beginning of the Hermitage, the pride of Catherine herself, and the pride of Russia.

The tsarina was intent on using all possible means to increase Russia's might. She tended and nurtured her army, sending it on difficult and complicated campaigns—from which it returned victorious. It was Catherine of Russia who put an end to Turkish dominion over the Black and Mediterranean seas. Europe trembled beneath the thunder of Russian cannons, and Russian goods flowed freely on to European markets. European merchants scrambled in their haste to set up business in Russia, and even German peasants put their faith in Catherine, and uprooted themselves to move permanently to live and flourish in the rich Russian lands.

Catherine's Russia was luxuriant and magnificent (fig. 1). She traveled extensively across her boundless territories, ordering a rich dinner service for the administrative center of each province so that she should not have to carry her own with her wherever she went. She was generous in her gifts of land, peasant-serfs, and precious stones and metals to those who knew how to serve her or please her.

Many frivolous and scabrous anecdotes are told of Catherine's love life, and many of them are probably true. But we must bear in mind that this was the eighteenth

Fig. 1 Konstantin Ukhtomsky, *The Raphael Loggia*, 1860, watercolor, 16½ × 9⅞ in. (41.9 × 25.1 cm), State Hermitage Museum, St. Petersburg

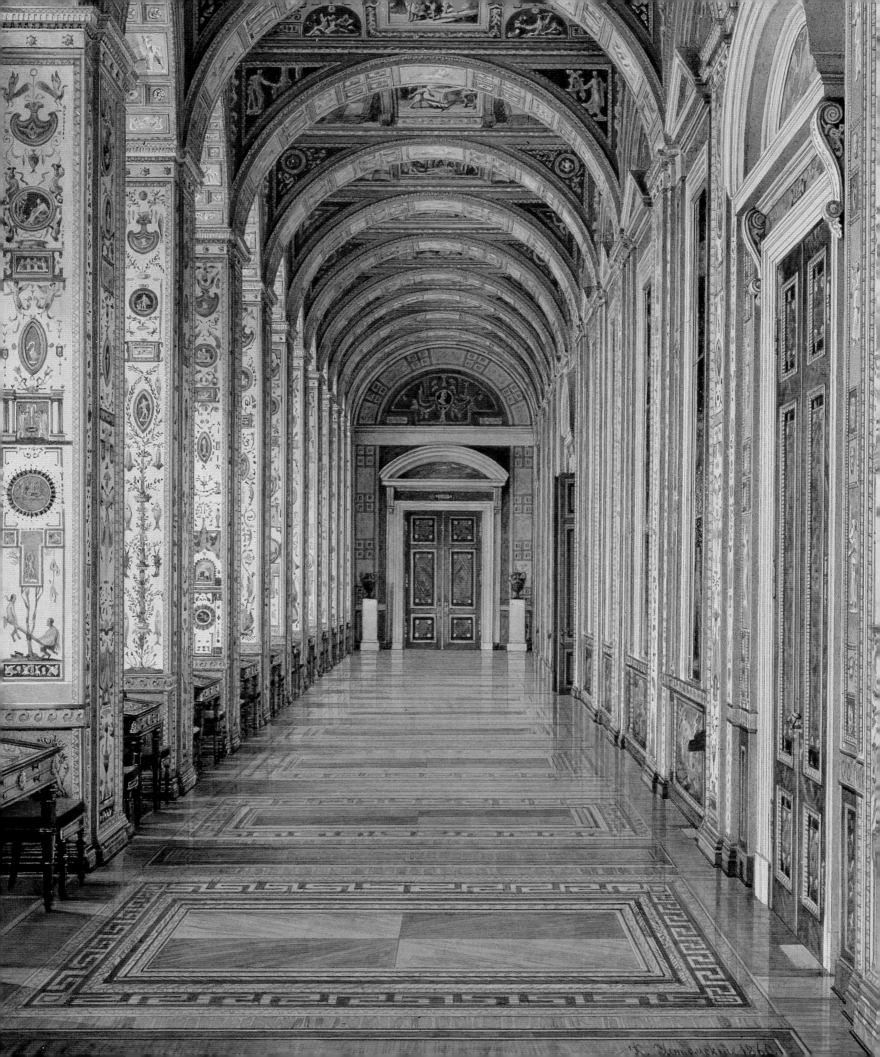

century, a century of great sexual freedom, although that freedom was essentially for men. Catherine allowed herself openly to take and then change lovers, just as Europe's male rulers kept and changed their numerous mistresses. Through such open behavior she helped to emphasize that she, a woman, was the equal of men. At the same time, her choice of lover was always made with an eye to her greater political interest. The Orlov brothers, Grigory Potemkin—these were the men who were responsible for Russia's military glory, they were the true organizers of her powerful state.

The tsarina knew how to select aides, how to teach them to anticipate her aims and carry out her will in all spheres of life. Her collecting of works of art is a superb example of this. It is clear that Catherine had neither the knowledge nor the strength personally to amass the artistic treasures that went to make up her Hermitage. Her vast financial resources, and even her aptly chosen method—to buy *en masse* Europe's best and most celebrated collections—were not enough. Catherine was helped by three categories of faithful aides. She had her Russian diplomats, such as Dmitry Golitsyn, who knew the realities of Russian life and understood what the tsarina might like. She also had the best minds of Europe working on her behalf—the "intelligentsia," including people such as Denis Diderot, who sought out genuine masterpieces and who bided their time for the right moment to make a purchase. Lastly, there were such art-market professionals as François Tronchin of Geneva. Catherine set up competent teams of loyal servants everywhere, and was victorious in every case.

In order to cultivate the tastes of her close circle of faithful courtiers, she established her "Hermitage," a place where people could enjoy themselves in relaxed surroundings, forgetting formality but never losing sight of politics and court intrigue. Great affairs and individual fates were decided over a game of cards and during readings of poetry. The paintings Catherine bought were delivered to her Hermitage pavilion, standing at the end of the Hanging Garden, attached to the Winter Palace (fig. 2). From that time onward, the Hermitage came to be called a museum.

The tsarina understood that, in eighteenth-century Europe, the possession of a good collection was hardly less important than the possession of a good army. And she added to her armies of paintings and sculptures. Her purchases caused a political furor in Europe. The best art collection in France, the Crozat collection, was purchased and carried off to the North, while in England people still lament Catherine's flamboyant purchase of the collection of Sir Robert Walpole, the country's first prime minister. From Dresden she acquired the collection of Count Brühl. Each

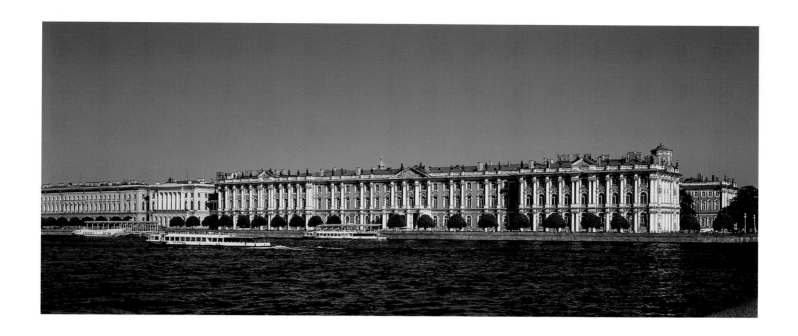

Fig. 2 Modern view of the State Hermitage Museum, St. Petersburg. Catherine the Great's Hermitage pavilion is to the left of Rastrelli's Winter Palace

purchase caused a scandal in its native country, but each attested to the financial and political might of Russia and its tsarina.

Critics unfairly said, and continue to say, that Catherine had no artistic taste, nor even any love of art. Although she did not choose the paintings and sculptures herself, her emissaries knew the tsarina's tastes. If they occasionally made a mistake, Catherine immediately sent back the objects. We know that she had a consuming passion for engraved gems, which she was perpetually collecting, studying, and admiring; it caused her great sadness to move that collection from her private apartments to the Hermitage, where it would be more accessible to others. She loved to linger over prints. In sum, she found in art a source of relaxation and inspiration.

The Hermitage was a place of rest, but it was much, much more—it was a multi-layered theatrical performance as well. The theater was another of the tsarina's passions, one of her means of ruling her world. Beside the palace, the great architect Giacomo Quarenghi (1744–1817) built the beautiful Hermitage Theater, and there was also a theater in the Winter Palace itself. Plays of all kinds were put on, including didactic and moralizing works written by the tsarina herself. She wrote the libretto for the first Russian historical opera. She also wrote plays that lampooned her crowned rivals. It was all quite serious, yet at the same time formed part of the court entertainment. She held evenings of entertainment known as her "Great Hermitages," which combined theatrical productions, dinner, walks through the rooms filled with paintings, and dancing.

Open and hidden theatricality blended in such a way that it was not always clear where the truth ended and the game began. Indeed, the whole of court life was built along such lines, and theatricalized politics often served as experiments for the real thing. The famous story of the "Potemkin villages" is a prime example. In this celebrated episode Grigory Potemkin, Catherine's advisor and the man who annexed the Crimea to the Russian Empire, supposedly had façades of pretty villages erected like theatrical sets along the riverbanks as Catherine sailed down to the Crimea, in an attempt to make her believe that her land was inhabited exclusively by jolly peasants who lived in picturesque comfort, and to hide from her the true state of rural life. Even today the phrase "Potemkin village" means a false façade or a cover-up. It has been proved that the episode never actually happened; and yet there really were grandiose designs, for the Crimea among other places, in which the end result was presented, or "predicted," in the form of theatrical models or stage scenery as part of a deliberate theatricality.

Catherine's greatest "theater" of all sometimes seems to be her renowned correspondence with Voltaire, Diderot, and the other *Encyclopédistes*. They were attracted first by the young princess, and then by the tsarina, who was so admiring of them, and they dreamed of her putting their ideas into practise. She wanted their support to help increase her international fame, and that of Russia. At the same time she did everything she could to dissuade Voltaire from traveling to Russia, and she was, as usual, quite right: Voltaire's visit to her rival/hero Frederick did nothing to improve relations between the philosopher and the royal soldier. Diderot, for his part, made the journey to Russia and was disenchanted.

Catherine too became disenchanted. There can be little doubt that she was initially driven by a genuine wish to improve the political system in Russia, and it seemed as though she had found the recipe. She worked intensively on documents intended to introduce "philosophical" order to Russia, and set up a straightforward yet flexible system of ruling her vast empire. But she did this not according to the formulae of the *Encyclopédistes*, but on the basis of Peter the Great's autocratic logic. In practise, she often saw that the schemes born of dreamers in other lands did not work in Russia. And a little later she saw with horror how they worked in France. So the tsarina remained a Russian tsarina, for whom an ordered and rational system of government was necessary in order to rein in those subjects who were inclined to rise up and cause disturbances. In order to keep the lower classes in even greater check, she allowed some freedom to her highest subjects, to

her grandees. Thus autocracy as a principle of rule was preserved by her and proved in practise.

The whole of Russia knew that Catherine had led the conspiracy that overthrew her husband. The whole of Russia suspected that he was killed at her command. The whole of Russia told—and still tells—frivolous stories about her private life. Yet despite it all, the whole of Russia admired, and continues to admire, Catherine as a great ruler, as a woman who conducted herself as the equal of men, as a ruler who so firmly and consistently advanced the interests of the land she had adopted as her own.

We admire her particularly for creating so unusual a museum, a museum that is not famous simply for the fabulous collections that she assembled. The museum has become a monument to the woman herself and it cannot be separated from her extraordinary personality. She stares down at us from portraits, and everywhere we find objects linked to Catherine. Her dresses are displayed in cases, as is the famous Cameo Service—for which she long neglected to pay, but eventually did so at a critical moment, thereby saving the Sèvres Manufactory from bankruptcy. She loved coffee, and took snuff. She liked military uniforms and the uniform dresses that emphasized her role as autocrat and commander of all the armed forces.

Catherine gathered together and left to us many magnificent objects, each of which is like some fragment of her great personality, a personality in which there were so many marked and outstanding features—good and bad—that they would have sufficed for a whole generation. In a century dominated by the accomplishments of men, Catherine the Great stands as one of the greatest European leaders of her time.

Women and the Arts at the Russian Court from the Sixteenth to the Eighteenth Century

LINDSEY HUGHES

ATHERINE II WAS ONE OF THE GREATEST PATRONS OF THE ARTS, female or male, that Russia has ever known. She extended the imperial collections of fine and applied art, commissioned portraits and sculptures, and sponsored publishing, music, theater, and, not least, the Imperial Academy of Arts, which she placed under her personal patronage in 1764. Catherine's reign saw an unprecedented program of city planning throughout the empire, the building of magnificent Neo-classical palaces, and the laying-out of parks. Numerous painters, sculptors, and engravers captured her likeness, making her the first woman in Russian history whose features were recognizable at home and abroad. But Catherine was not the first woman to sponsor the arts in Russia or to be portrayed by artists. To set her cultural program and achievements in a wider historical context it is necessary to explore the less familiar topic of Russian women as subjects and patrons of the arts before the 1760s, going back to the reforms of the Westernizing emperor Peter the Great in the early eighteenth century, and, beyond him, to the national roots of female imagery and patronage in the Orthodox religious culture of earlier times.

Russian art before the eighteenth century does not fit comfortably into the stylistic categories, periods, and genres that historians conventionally apply to Western Europe, not least in respect of representations of women. Female images pervaded the art of Muscovy, as foreigners called Russia from the fifteenth to the seventeenth century.[1] From Kremlin cathedral to village church, such Byzantine saints as Barbara and Paraskeva, and such native ones as Princess Olga of Kiev and Evdokia of Polotsk, gazed out from icons and frescoes. Images abound of Moscow's divine protector, the Virgin Mary, or the Mother of God as she is known in the Eastern Orthodox tradition, who appears in icons alone, and with the Infant Jesus or the resurrected Christ, and in scenes from her life, from Nativity to Dormition. Folk art had

Sofonisba Anguissola,
Portrait of a Woman, detail
(see p. 103)

its eye goddesses, bird women, and female earth deities, woven or embroidered on fabrics or carved in wood; and folk songs and tales featured female warriors, princesses, and witches, as well as the more humble "beauteous maids."[2] But naturalistic likenesses of living women and men were a late arrival in a country that, partly as a result of being ruled by the Mongols from the thirteenth to the fifteenth century, was hardly touched by the Renaissance, either in the arts or in learning. The exceptions were the cathedrals and other buildings in the Moscow Kremlin designed for Tsar Ivan III in the 1470s–90s by Italian architects, but even they observed Orthodox conventions, confining Renaissance details to the exterior decoration. The figurative arts remained resistant even to decorative influences. No Russian Raphaels or Rembrandts recorded the faces of their contemporaries or their wives and mistresses, no Holbeins or Van Dycks immortalized prominent men and women. Even icon painters had little freedom to customize their work by choosing hairstyles or clothing to reflect contemporary tastes, for it was believed that iconic images derived from the living prototypes—Christ, Mary, and the saints—and that these true images must never be changed. For example, St. Luke was believed to have captured Mary's likeness by painting her from life. Sculpture in the round, chiseled in stone or cast in metal, was alien to the Muscovite tradition on religious grounds, so there were no such monuments to kings, or stone tomb effigies of queens. An authentic portrait does not exist even of the notorious Ivan the Terrible (reigned 1533–84), although foreigners left some invented depictions of him.

Additional taboos restricted the portrayal of women. We have no idea what Ivan's seven wives looked like, although his first wife, Anastasia Romanova, whose reputation for piety and good works made her a role model for later royal women, would have been a logical candidate for a portrait. During negotiations in the 1640s for a match between a Danish prince and one of the daughters of Tsar Mikhail (reigned 1613–45), the tsar refused to send a portrait of his daughter on the grounds that such depictions were "unseemly."[3] The marriage did not take place and for the rest of the century the tsars made no further attempts to find husbands for their daughters or sisters, a policy that historians have explained by the absence of Orthodox suitors of sufficiently high status, the tsars' reluctance to complicate palace politics with the inconvenient ambitions of sons-in-law and their kinsmen, and their desire to emphasize the exclusivity of royal women, who were strictly segregated from men. Foreign travelers have left sketches of long-bearded boyars (as leading nobles were called), priests, and guards, even of the tsars in receptions and processions, but because

women were barred from such occasions they were rarely seen. Exceptions include drawings of a procession of the women of the tsar's court in the album of the Austrian diplomat Baron Augustin Mayerberg, who visited Russia in the 1660s.[4]

Historians have generally concluded that the virtual absence of living women in Russian art before the eighteenth century reflected their "facelessness" in real life.[5] They portray Muscovite women's lives in terms of limitations, using the vocabulary of imprisonment. Foreign visitors to Muscovy in the sixteenth and seventeenth centuries referred to the existence in upper-class households of separate women's apartments, known as the *terem*, where rules of seclusion were strictly observed. "You keep your women locked up like slaves and make them work all day long," wrote Baron Mayerberg indignantly. "No man is allowed to look them in the face and you marry off your daughters without even showing them their fiancés from a distance."[6] Women even attended church heavily veiled and screened off from the male congregation. As Princess Daria Golitsyna, born into a leading boyar family in 1668, complained, in her youth she was "a recluse raised within four walls," only occasionally leaving her home.[7] No masques or balls took place at court and if royal mistresses existed, they were hidden away, not kept openly as they were in certain Western royal households. Women wore layered and loose-fitting garments reminiscent of caftans, which revealed only the face and hands, and married women always covered their hair. The celebration of female beauty on canvas in provocative poses with glimpses of flesh, as perfected, for example, by Peter Lely and Godfrey Kneller in seventeenth-century England, was unthinkable. Muscovite élite society was segregated and prudish.

We should be cautious, however, about relying too heavily on the reports of foreign male visitors, who had few direct contacts with Russian women, or on the few Russian memoirs surviving from the early eighteenth century, which often deliberately denigrated the "old-fashioned" lifestyle of a few decades earlier. Some historians now question the restrictive nature of the *terem* and put forward more positive views of women's authority and independence.[8] Even revisionists, however, agree that royal and noble women in Muscovy had a different relationship with the arts from their counterparts in much of Western Europe. Muscovy was pre-modern and largely pre-literate, with urban dwellers accounting for no more than 4% of the population. Until the second half of the seventeenth century there were no schools whatsoever. Travel abroad required the permission of the tsar, or of the patriarch. Russian women could not be actresses or playwrights, a sphere open to a few women in

Restoration England, for example, because there were no theaters, apart from a short-lived experiment at court in 1672–76, and scarcely any secular publishing. Women pursuing independent careers in the arts and humanities were a rarity in the West, too, but in Muscovy there was little conception of "the arts" outside a religious context. There the figurative arts served the Church as essential elements of a religious world view, dedicated to depicting eternity through "sacred landscapes," and offering only rare glimpses of everyday reality. Conformity to set models was valued more highly than the artist's inventiveness or original powers of observation.

Within this world, women still had a role to play as subjects and patrons. The tsars' wives (tsaritsy) and daughters (tsarevny) actively supported the Orthodox faith, both at home and abroad, by commissioning and donating gifts—icons, frescoes, icon screens, crosses and other liturgical objects, service books, vestments, altar cloths, and tapestries—to churches and convents. For example, in 1522 Solomonia Saburova, wife of Tsar Vasily III, donated a religious tapestry to the important Trinity Monastery to the north of Moscow in the hope of gaining the intercession of its founder, St. Sergius, in conceiving a long-awaited heir. (The gesture was in vain. A year later the tsar divorced her.) In 1555 Tsaritsa Anastasia sent a liturgical curtain that featured a host of saints, including her own patron, St. Anastasia, to the Hilander Monastery on Mount Athos from her embroidery workshop.[9] The tsaritsy and tsarevny were buried in the wealthy convent of the Annunciation in the Kremlin, which received many such donations. Royal women, and some noblewomen, also presided over their own textile workshops. In certain cases they stitched or designed the donations themselves, although work was more often done by female employees, who specialized in embroidery, appliqué, spinning gold and silver thread, and sewing with pearls.[10]

Devotional paintings frequently depicted royal women in poses of reverence and supplication to heaven. Simon Ushakov's icon *Planting the Tree of the Muscovite Realm* (1668), for example, features images of Tsar Alexis (reigned 1645–76), his first wife Maria, and their two sons beneath a large icon of the Mother of God, to whom they proffer scrolls bearing sacred texts. Although the images of Maria and Alexis are stereotypical, underlining their status rather than their actual features, they are remarkable for having been produced during the subjects' lifetime. This is also the first image of a living tsar and his wife to be signed by the artist.[11] In Ivan Saltanov's icon *The Veneration of the Cross* (1677–78), Emperor Constantine the Great (c. 280–337), Tsar Alexis, and Patriarch Nikon on one side, and St. Helena

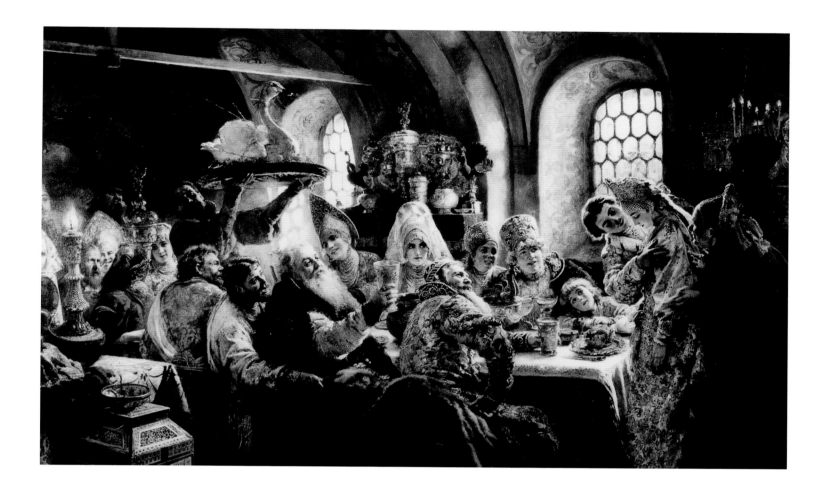

Fig. 3 Konstantin Makovsky, *A Boyar Wedding Feast*, 1883, oil on canvas, 93 × 154 in. (236 × 391.2 cm), Hillwood Museum and Gardens, Washington, D.C.

(Constantine's mother) and Tsaritsa Maria on the other, honor the Cross, all clad in richly embroidered and gem-encrusted robes. Tsarevna Tatiana, Alexis's sister, may have commissioned the icon to commemorate his death in 1676.[12] The iconography of such works stressed the existence of a female sphere in which women, like their historical counterparts in the Byzantine Empire, played a vital role in ensuring the prosperity of the realm through prayers and such pious acts as the collection of holy relics. It was believed that their relationship with the Mother of God gave them special powers as intercessors.

Despite the emphasis on prayer and devotion in contemporary writings and imagery, the women of the court were not condemned to suffer a nun-like existence in spartan surroundings. On the contrary, they lived in richly decorated apartments and were enthusiastic consumers of textiles, silver and gold objects, enamelware, and jewelry, both home-produced and imported from abroad. In the royal residence in the Kremlin, the Golden Palace of the Tsaritsy provided a sumptuous setting for the reception of visiting clergy and for celebrating name days, royal births, and weddings.

The main hall was decorated with frescoes depicting scenes from the lives of saintly ruling women such as Helena, Olga of Kiev, Theodora of Byzantium, and Dinara of Georgia, all of whom acted independently and sometimes heroically in defense of Orthodox Christianity.[13] The choice of subjects reflected the strong belief that this life was only a faint reflection of the other world and that the links between the two were direct and palpable, as well as the notion that Muscovy was the successor to earlier recipients of God's grace—Israel, Byzantium, Kievan Russia—through both the male and the female lines. Icons of the women's name-day saints hung in the palace chapels and in their private apartments as a constant reminder of their role models and patrons in heaven. Sadly, only laconic official records survive of women's activities inside the Kremlin apartments, and we know even less about the lives and residences of noblewomen. In the nineteenth century, when there was an upsurge of interest in Muscovite, or "Old Russian," art and architecture somewhat akin to the Gothic revival in the West, artists tried to fill the gaps in the historical narrative with imaginative reconstructions, such as Konstantin Makovsky's *A Boyar Wedding Feast* (1883; fig. 3), and Andrei Riabushkin's *Seventeenth-Century Russian Women in Church* (1899) and *A Wedding Procession in Seventeenth-Century Muscovy* (1901; both in the State Tretiakov Gallery, Moscow), which dwell not on seclusion but on bright colors and sumptuous fabrics.

The colorful designs of Muscovite arts, crafts, and textiles drew on both indigenous and Eastern traditions, especially from the Ottoman Empire, but in the seventeenth century influences also infiltrated from the West, partly through the activities of a few Dutch and German craftsmen who worked in the royal Armory and other workshops, and pioneered such innovations as painting in oil on canvas.[14] In 1652 a suburb of Moscow, the so-called German Quarter, was set aside for Western European military and technical specialists and merchants, who built Western-style houses and churches. Illustrated books, prints, and maps were imported from abroad, and the tsars received gifts from the diplomats who visited in ever greater numbers as Russia was drawn further into international politics. Wars with Poland in the 1650s to 1660s, and the annexation of Ukraine, brought artists to Russia from territories where Polish Catholic culture predominated. They introduced Baroque elements into architecture and design, as well as the Polish *parsuna* portrait, in which the subjects were portrayed in stiff formal poses, often with coats of arms to emphasize their status. A few Russian boyars, including Artamon Matveev, Tsar Alexis's foreign minister in the early 1670s, began to assemble picture galleries and to adopt Polish

fashions. The Orthodox Church reacted violently to what were deemed "Latin" and "Lutheran" deviations in religious art, especially "worldly" features, but could find no theological grounds for rejecting secular art as such. Ironically, leading clergymen were among the first to have their portraits painted.

By the 1680s, if not earlier, such influences had penetrated even the *terem*, where they received further encouragement from Russia's first woman ruler, Tsarevna Sophia Alekseevna (1657–1704). Sophia came to power in the minorities of her physically and mentally handicapped younger brother Ivan V (1666–1696) and her half-brother Peter I (1672–1725), who became co-rulers in 1682 after the bitter dynastic struggle that followed the death of their childless brother Tsar Fedor (reigned 1676–82).[15] Her seven-year regency saw Russia enter the Holy League against the Turks, in alliance with Poland, in 1686, the fostering of trade relations with Sweden, The Netherlands, and Prussia, and the widening of diplomatic contacts with a number of other countries. Russia's first institution of higher education, the Moscow Academy, was also founded during Sophia's regency, in 1687. The chief minister, Prince Vasily Golitsyn, had a particular influence over the tsarevna. Golitsyn extended a warm welcome to foreign visitors and was one of the few Russians to know Latin, which he learned from private tutors. His mansion in Moscow was stuffed with furniture, books, mirrors, pictures, and clocks from Western Europe, which marked him out as one of the most cultured and Westernized men of his era.[16]

With Golitsyn at her side, Sophia came out of seclusion to play an active role in the ceremonial aspects of government, and probably in decision-making too. She was also a patron of the arts. A poet wrote the following in verses dedicated to one of her portraits: "Marble bears witness to her munificence. Churches glorify the generous hand of their creator."[17] Her program of building churches was inspired by her assiduous cultivation of several wonder-working icons of the Mother of God, which she honored by embellishing their surroundings and attending processions of the cross on their feast days. Churches and icons in convents were traditional objects of female sponsorship, but Sophia commissioned hers in the fashionable new "Moscow Baroque" style, which was a hybrid of traditional Russian designs and Western decorative details based on the Classical orders.[18] Her most complete architectural ensemble survives in the sixteenth-century Novodevichy Convent, where Sophia built the churches of the Transfiguration and the Dormition, the refectory, bell-tower, upper perimeter walls and towers, and a new Baroque iconostasis for the old cathedral of the Icon of Our Lady of Smolensk. Bells in the tower are inscribed with

the name of "the Great Sovereign Lady, Great Princess and Tsarevna Sophia of all Great, Little and White Russia, since she has been the builder of this holy house for many years and now with ever greater zeal sees to its embellishment."[19] Such leading artists as Ivan Bezmin, Karp Zolotarev, and Fedor Zubov painted icons for her new churches, working in the new semi-naturalistic style of the 1680s, which used perspective, and light and shade, to produce three-dimensional effects that were new for Russian art, and sometimes even borrowed elements from Catholic iconography. Sophia commissioned many secular objects, too, such as a silver, niello covered-cup (1685) with a running flower pattern inscribed with her name, and plates similarly engraved.[20] One of her five sisters, Ekaterina, who adopted Polish fashions, sponsored her own projects in the Moscow Baroque style, notably the cathedral of the Convent of Our Lady of the Don, which follows a Ukrainian design, while their aunt Tatiana funded the completion of the Resurrection Monastery at New Jerusalem, not far from Moscow, which was consecrated in 1685.

In 1684–85 Sophia and her sisters decorated their new apartments in the Kremlin, commissioning paintings on religious themes for the walls and pillars, and refurbishing several chapels at considerable cost. The frescoes in Sophia's rooms focussed on scenes from Christ's Passion, a subject that emphasized her devout nature. Apostles, evangelists, and prophets occupied other spaces, along with images of the patron saints of Sophia and her sisters. Even small surfaces were decorated with cherubim and seraphim. The frescoes also incorporated more contemporary motifs: for example, one of the ceilings featured the signs of the zodiac, and the German painter Peter Engels executed a series of "perspective" scenes that may have been secular in content. Even religious subject-matter was painted in bright colors, with lashings of gold leaf, and decorative additions of flowers, fruit, and scrolls. Some rooms contained family portraits, executed in the *parsuna* style. The tentative expansion of secular subject-matter was reflected in the Armory, where, in 1683, as part of a general re-organization, a separate workshop for non-religious painting was created, although, sadly, almost none of the banners, charts, and "historical" and "perspective" scenes produced there have survived.

One of the most remarkable aspects of Sophia's regency was the propagation of the tsarevna's own image by painters, engravers, and poets. Some of them worked in a traditional religious idiom, referring to Sophia as a pious tsarevna after the image of such forceful biblical women as Judith, Deborah, and Susanna. Icons of Sophia the Divine Wisdom and St. Sophia the Martyr proliferated. Sometimes there are

Fig. 4 Abraham Blooteling, *Portrait of Tsarevna Sophia Alekseevna*, 19th-century copy of *c.* 1689 engraving, 12 × 9 in. (30.5 × 22.8 cm), collection of the author

allusions to Sophia in allegorical prints embellished with a characteristic Baroque mix of Christian and Classical imagery. The Ukrainian artist Ivan Shchirsky's print of 1683 depicts two tsars in full regalia hovering above a canopy that contains a double-headed eagle, the symbol of the ruling house of Muscovy. Christ floats between them and above him is a winged maiden, the Divine Wisdom (Sophia), who was understood to influence and protect the two tsars in the heavenly sphere, just as their sister did on earth.[21]

Sophia was the first living Russian woman to be depicted alone on canvas, outside a devotional context. Several anonymous oil paintings survive of her wearing a crown and holding an orb and a scepter, with the portrait set in an oval medallion that rests on the breast of a double-headed eagle. The bird's outstretched wings bear emblems of virginity, justice, mildness, piety, graciousness, and steadfastness, and above its head stands a lighted candle denoting wisdom. Prints by the Ukrainian printmaker Leonty Tarasevich, and the Dutch printmaker Abraham Blooteling, use a similar image of the tsarevna. Blooteling's work (fig. 4), in which the portrait is surrounded by seven virtues in the form of female figures identified by Latin inscriptions, was intended for dissemination to European courts. The message was clear: Sophia was a ruler in her own right, with a legitimate claim to the symbols of authority hitherto reserved for males. The emphasis was upon the regent's "throne-worthiness" as a

woman of royal blood and talent, not on her beauty or ability to be married, which were deemed irrelevant.[22] Western observers saw things differently. Some ungallant writers even commented on Sophia's ugliness, most memorably the French traveler Foy de la Neuville, who described her as "of a monstrous size, with a head as big as a bushel, a hairy face and growths on her legs, and at least forty years old."[23] Neuville almost certainly never saw Sophia and was no doubt relying on the gossip of his male informants. The implication was that a woman "with a mind more masculine than feminine" was forced to dabble in politics in order to compensate for a lack of personal charm.

Whatever her motives, which are not illuminated by any private writings, Sophia's rule was doomed to end with Peter's coming of age. Military failure in two campaigns that Prince Golitsyn led against the Crimean Tartars in 1687–89 hastened the inevitable. In 1689 Peter's supporters, who were anxious to forestall any plans that Sophia may have had to be crowned and extend her rule, forced a confrontation and accused her of acting too independently, of "bypassing" the tsars. The victim of clan politics rather than misogyny, she was duly banished to the Novodevichy Convent, to which she continued to donate treasures until her death, in 1704. These included a shrine containing relics of St. John Chrysostom, icon lamps, and a silver cross for the cathedral chapel of the Holy Martyr Sophia.[24]

Sophia's departure still left a sizeable contingent of women in the Kremlin's royal residence—her five sisters and two aunts, Tsar Fedor's widow Tsaritsa Martha, Tsar Ivan's wife Tsaritsa Praskovia and her daughters, and Peter's mother Natalia, his sister Natalia and his new bride, Evdokia, whom he married in 1689. None of these women wielded much political power and artists rarely portrayed them. A few *parsuna* portraits survive from the 1690s, showing that the old style persisted, although one such work, usually identified as Tsaritsa Martha, shows the tsaritsa holding a fan and a small lapdog, suggesting a shift away from the emphasis on piety to more worldly concerns. Until her death, in 1694, the dowager Tsaritsa Natalia was the senior woman in the palace. The only surviving portraits show her as a widow, her hair hidden and her face framed by a severe black headdress (fig. 5). In 1692 she placed an order with the painting workshop in the Armory for eleven large pictures for one of Tsar Peter's residences. Despite the fact that these were framed paintings on canvas rather than traditional icons on boards, the inclusion among the subjects of patron saints of members of the royal family—Alexis, Peter, Alexander Nevsky, and the martyrs Natalia and Evdokia—indicate that devotional considerations still

Fig. 5 Unknown artist, *Portrait of Natalia Kirillovna*, late 17th century, oil on canvas, 32 11/16 × 27 15/16 in. (83 × 71 cm), State Hermitage Museum, St. Petersburg

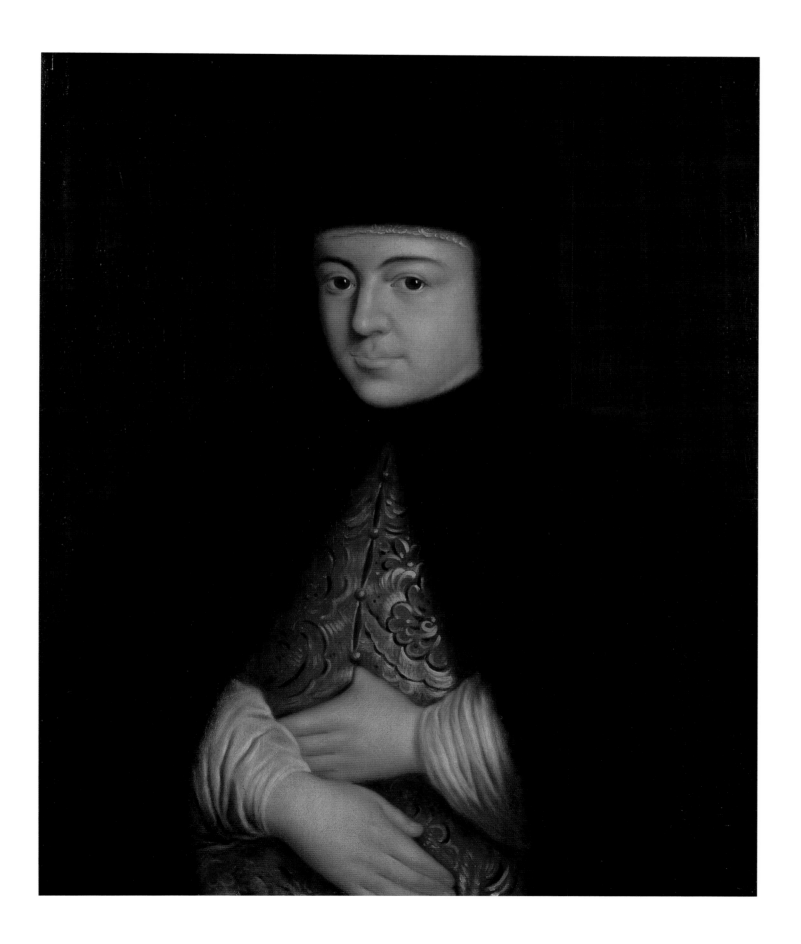

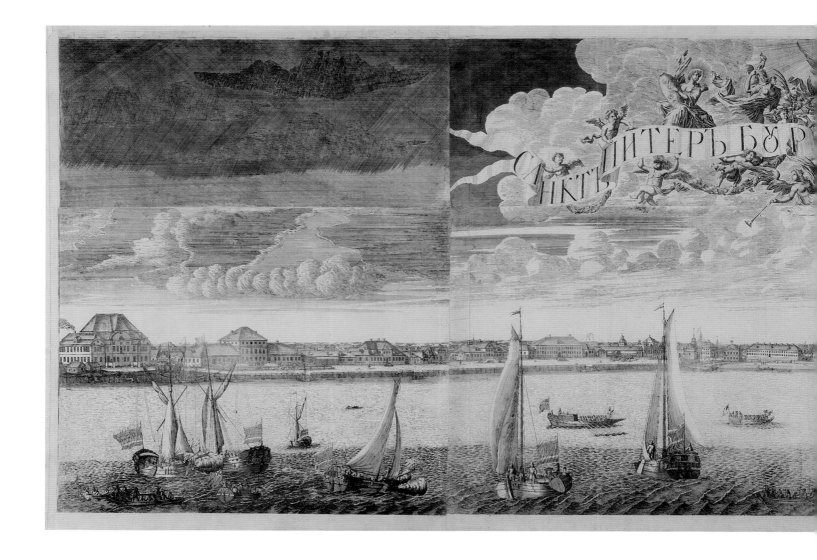

predominated. At the same time, there is evidence of the emergence of a distinct secular culture more reflective of the young Peter the Great's personal tastes, for example an order for twenty-three battle paintings "after the German model" in frames of German design, and pictures on canvas depicting "troops going by sea."[25] Palace records show that the women of the court often attended Peter's firework displays and celebrations, featuring gun salutes and parades of his new guards regiments clad in Western uniforms. In the 1690s Peter also founded the navy, thereby introducing more new motifs and subject-matter. Peter's tastes were shaped by visits to the Moscow German Quarter, and in 1697–98 to the West itself. His itinerary included the Baltic States, Prussia, The Netherlands, England, Austria, and Poland, where among other things he encountered Western women at social gatherings and in private.[26] Sir Godfrey Kneller's portrait of Peter, painted in England in 1698 and now

Fig. 6 Alexei Zubov,
Panorama of St. Petersburg,
1716, engraving,
29¾ × 92⁵⁄₁₆ in.
(75.6 × 234.5 cm), State
Hermitage Museum,
St. Petersburg

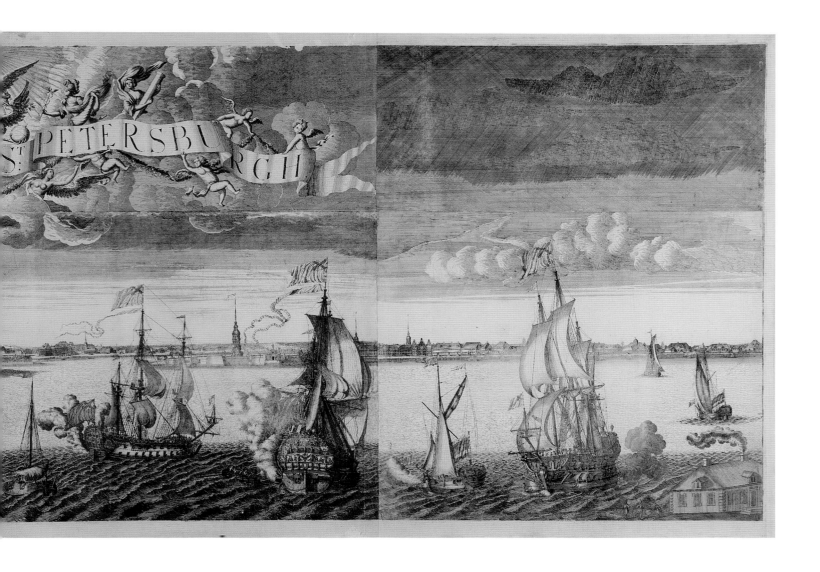

in Kensington Palace, London, was a landmark in the imagery of Russian rulers, depicting the young tsar not as some exotic Eastern potentate but as a regular Western ruler in armor and ermine, with a warship in the background.

Peter's travels paved the way for new attitudes and a new role for Russian women in court life, and in the arts. In general, the last three decades of his reign were a watershed in Russian history. People have argued about whether Peter changed Russia for the better or for the worse, but few have denied that he made a difference. This applies also to his role in sponsoring and promoting the arts through such activities as collecting paintings, prints, sculptures, and curiosities, hiring foreign artists and craftsmen, sending Russian artists to study abroad, and publishing architectural books. The linchpin of Peter's cultural reforms was the city of St. Petersburg, which he founded on the Gulf of Finland in 1703 and regarded as his capital from about

1712. St. Petersburg provided a Western setting for experiments not only in architecture and town planning, which were carried out almost exclusively by foreigners, but also for reforming the manners and appearance of his subjects. As part of his "westernizing" program, which was underpinned both by the requirements of a twenty-one-year war against Sweden, and by the personal conviction that Russia must catch up with its European neighbors, Peter forced élite women to discard their traditional robes in favor of Western dress; to go bareheaded, regardless of their marital status; to socialize in male company; to learn new skills such as dancing and polite conversation; and to move to St. Petersburg and live in new-style apartments.[27] Peter either contracted or negotiated foreign marriages for his daughters and nieces, ending the policy of enforced spinsterhood that had prevailed for much of the seventeenth century. Indeed, his campaign proved so successful that the German Friedrich Bergholz, who visited Russia in 1721–25 as attendant to the Duke of Holstein, pronounced: "The Russian woman, until recently coarse and uneducated, has changed for the better to such a degree that now she concedes little to German or French ladies in subtlety of manners and good breeding and in some respects is even superior to them."[28]

Artists were now commissioned to depict not only royal women, but also, for the first time, ladies of the court. Some of the most innovative studies celebrate sexuality and marriageability, such as a double portrait from 1717 of Peter's daughters Elizabeth and Anna by his French court artist Louis Caravaque (died 1754), portraying the girls as scantily clad nymphs carrying baskets of flowers.[29] Caravaque was one of several foreign artists whom Peter hired, who with a few Russians, notably Ivan Nikitin and the miniaturist Grigory Musikiisky, catered to the court's artistic needs. Their portraits of the ladies of the court, such as Daria Menshikova, the wife of Peter's favorite Alexander Menshikov, and her daughters, or Anastasia Naryshkina, wife of one of Peter's relatives, depict them as thoroughly modern women, with the latest hairstyles and fashions. Occasionally, however, traditional features linger. For example, Maria Stroganova, wife of an ennobled merchant, was painted wearing a high-necked brocade robe and an elaborate hair-covering, although she has sleeves that expose her forearms, and carries a fan.

Images of women counterbalanced the motifs of military might and masculinity prevalent in other areas of Petrine culture.[30] The "feminization" of Russian art brought not just a sharp increase in commissions for portraits of women, but also the widespread appearance in art of allegorical and mythological female figures, hitherto virtually unknown in Russia. In the gardens of Peter's Summer Palace the avenues

were lined with marble sculptures, most of them goddesses and female mythological figures representing subjects such as Glory, Nemesis, Wisdom, Truth, Sincerity, Navigation, and Architecture, by Italian artists including Pietro Baratta, Giovanni Bonazzi, Antonio Tarsia, and Guiseppe Toretti.[31] The figures' semi-nudity must have shocked early Russian visitors unaccustomed to "unseemly" Classical conventions. The studies of Sensuality, Satyr with Bacchante, and the Rape of the Sabine Women must have seemed particularly suggestive. But Peter evidently envisaged his sculpture park as a teaching aid for training unsophisticated Russian courtiers to appreciate the Classical idiom. On summer evenings he held concerts and dances among the sculptures in the gardens, where guests were sometimes treated to raw vodka served up by guardsmen from buckets. No one was allowed to leave until the tsar gave permission—the new manners were not accompanied by any diminution of the ruler's autocratic power.

Peter's predilection for mythological subject-matter also translated into commissions for paintings, prints, and work in plaster. *The Triumph of Minerva* mural in his study at the Summer Palace is possibly the first example in Russia of secular painting on an allegorical theme.[32] In 1718–22 in the Monplaisir pavilion at the Peterhof estate, a French artist included sculpted alabaster female figures representing the Four Seasons in his decorative scheme. Possibly the first allegorical work by a Russian artist was Andrei Matveev's *Allegory of Painting* (1725; State Russian Museum, St. Petersburg), which shows a woman naked from the waist up painting on a canvas, watched over by Minerva. Matveev studied in The Netherlands, returning to Russia to continue his career in 1729, and was one of several Russian artists working in the new idiom.

One of the chief exponents of the new art was the Swiss artist Georg Gsell (Gzell, Xsell; 1673–1740), who arrived in St. Petersburg in 1717 and worked there for the rest of his life.[33] The evidence for Gsell's career remains fragmentary, for much of his documented work has disappeared and no portraits bear his signature, but he was an important influence in Russia, and also served as curator of Peter's collection of mainly Dutch and Flemish paintings. On ceilings in the Summer Palace, in 1719, Gsell painted *The Triumph of Russia*, which depicts three women representing Rulership, Religion, and Plenty, surrounded by putti. He also catered to the court's tastes for the exotic and bizarre with such works as a portrait of Peter the Great's giant Nicholas Bourgeois, drawings of the internal organs of a deceased lion from the imperial zoo, and two non-extant paintings of a bearded peasant woman, one of

them in the nude.[34] Peter himself was an avid collector of so-called "freaks" and "monsters," having started his Chamber of Curiosities with purchases made in The Netherlands in 1697.[35] He had a particular liking for dwarfs, both male and female, who did domestic chores and participated in court entertainments.

Almost certainly the first foreign woman artist to work in Russia was Gsell's Dutch wife Dorothea (1678–1743), who from 1723 to 1743 worked on the displays for the Chamber of Curiosities exhibits, and who was the only woman on the payroll of the art section of the Academy of Sciences, founded in 1725. At the Academy, she produced nature studies and taught "the art of painting in water colors, drawing all manner of beasts and birds, various botanical specimens, and also landscapes and maps in oils."[36] Dorothea probably also produced the painted panels with flower subjects in the green drawing-room of the Summer Palace. Her mother Maria Sybilla Merian (1647–1717) was a celebrated entomologist and illustrator in Amsterdam, whose house Peter visited just after she died. He bought two volumes comprising 254 of her watercolor illustrations of plants, and later acquired an album of her insect drawings from his Scottish physician, Dr. Robert Erskine.[37] Another woman artist who worked in Russia during Peter's reign was the German miniaturist and musician Elisabeth Blesendorf, who was employed in the household of Alexander Menshikov, but we know little about her activities.[38] There may have been others, but the work of foreign artists, men as well as women, in early eighteenth-century Russia has only recently become the subject of detailed scholarly investigation.

The activities of these few foreign women artists found no equivalents among their Russian contemporaries. Peter established a number of military, medical, and technical schools to prepare boys for state service, but his reforms did not stretch to education for women. He is said to have devised a scheme for sending selected young noblewomen abroad to study, but their parents fiercely opposed it on the grounds that their daughters' virtue would be endangered.[39] He also failed to implement proposals submitted in 1713–14 by the state servitor Fedor Saltykov for the establishment of girls' schools to teach reading, writing, arithmetic, French, German, painting, needlework, and dancing. Another of Saltykov's unrealized projects proposed that female orphans should receive lessons in drawing, painting, sewing, weaving, carpetmaking, and other crafts, so that they could go out and earn their living and contribute to the "general good." The subjects listed for women painters—perspective drawing, flowers, landscapes, and portraits—omitted the grander genre of history painting, and naval, military, and "tragic" subjects deemed appropriate for male orphans.[40]

Even if Russian women painters were non-existent, women could still make their contribution as patrons. A leader in this respect was Peter's unmarried sister Tsarevna Natalia Alekseevna (1673–1716), who ran her own private theater, first in Moscow and then, from 1711, in St. Petersburg. Evidence of her tastes and attitudes may be found in the inventories of her mansion in St. Petersburg drawn up after her death. Many of the entries suggest a modern woman with Western tastes. Her home boasted thirty-one mirrors, in which she might have admired herself wearing items from her extensive wardrobe of Western outfits in all the colors of the rainbow, and accessories such as corsets and French-style *fontanges* (elaborate headdresses of ribbons and lace), which had not featured in the wardrobes of her seventeenth-century predecessors. The inventory also itemized costumes for her theater (tights and cloaks with spangles, Turkish and Persian costumes, angels' dresses, a jester's outfit), props, and the scripts of plays, some of them copied in Natalia's own hand. At the same time there is evidence that Natalia, although evidently better educated than many of her contemporaries, continued to observe older conventions and to cultivate elements of the image of the "pious tsarevna." She owned sixty-one pictures on secular themes, including royal portraits, but she also had nineteen icons, among which images of the Mother of God figured prominently.[41] Of the 110 books listed, religious subject-matter—lives of saints, prayer books, sermons, and edifying works—predominated.[42] We know from other sources that most of the repertoire of her theater was religious in content; for example, the lives of the saints provided material for such dramas as the *Play about the Holy Martyr Evdokia* and the *Comedy of the Prophet Daniel*.[43]

Two portraits of Natalia, attributed to Ivan Nikitin, are among the best-known female images of the Petrine era. Her hairstyle is up-to-the minute, her ample bosom is displayed in the cleavage-revealing fashion of the era, and her gaze is direct, leading to a thoroughly Westernized image, which a British observer might identify as "Queen Anne" style (one portrait is in the State Tretiakov Gallery in Moscow, while the second, of a younger-looking Natalia, is in the State Russian Museum in St. Petersburg). However, an allegorical memorial portrait, painted by an anonymous artist in 1717 and now in the State Russian Museum, suggests the essential duality of her existence, poised between Russia and the West, the religious and the secular. The central image depicts her in Western dress and royal ermine, elaborately coiffed, but the accompanying religious texts and smaller, icon-like medallions suggest that Natalia has conquered death by piety in life.[44]

Peter's sister-in-law Tsaritsa Praskovia (1664–1723) also sponsored a private theater, in which her daughter Ekaterina, young gentlewomen, and servants took part.[45] In 1702 Praskovia invited the Dutch artist Cornelius de Bruyn to paint two sets of portraits of her three daughters, which would have been an inconceivable breach of female seclusion during Tsar Alexis's time.[46] The daughters, two of whom were destined to marry foreign husbands, had foreign tutors. But the same Praskovia was devoted to a group of widows, orphans, "fools in Christ," and cripples, whom she fed and housed in her Moscow residence after the manner of Muscovite tsaritsy.

If even the reforming tsar's sister and sister-in-law did not completely cast off the old manners, it is no surprise that women outside the capital clung more tenaciously to their old habits. Frederick Christian Weber, a diplomat from Hanover, conceded that, by the end of his stay in Russia, in 1716, a foreigner entering a social gathering would "hardly believe he is in Russia, but rather, as long as he enters into no Discourse, think himself in the midst of London or Paris." Even so, he found that Russian women could not quite conquer "their in-born Bashfulness and Awkwardness." In Moscow he noted that "Russian Wives and Daughters are extremely retired, and never go abroad, unless it be to Church, or to see their nearest Relations. Ladies of Quality are dressed after the German Fashion, which indeed they prefer to their old antick Dress; but as to their Courtesies, still the old Custom prevails of bowing with the Head to the Ground."[47] Peter may have changed the appearance of royal and aristocratic women, but it would take decades to change attitudes.

The most remarkable new woman of the Petrine era was an outsider. Peter met his second wife Catherine (formerly Martha Skavronskaia) in Livonia, in about 1703, while campaigning against the Swedes, and married her in 1712, after she had already borne him five children. In order to counter the objections of traditionalists to his marrying a foreign commoner, Peter made every effort to enhance Catherine's status. In 1714 he established the all-female Order of St. Catherine, which had the motto "For Love and the Fatherland," to reward his wife for displaying bravery "more male than female" during the battle of Pruth against the Turks in 1711. Although Peter favored an informal style of court, he provided Catherine with a formal establishment, employing court officials with German-sounding titles. In 1717 the eminent French artist Jean-Marc Nattier (1685–1766) went to The Hague to paint Catherine's portrait as a companion piece to a study of Peter painted in Paris the same year. Nattier's portrait (fig. 7), now in the Hermitage, makes Catherine look

Fig. 7 Jean-Marc Nattier, *Portrait of Catherine I*, 1717, oil on canvas, 56⅛ × 43⁵⁄₁₆ in. (142.5 × 110 cm), State Hermitage Museum, St. Petersburg

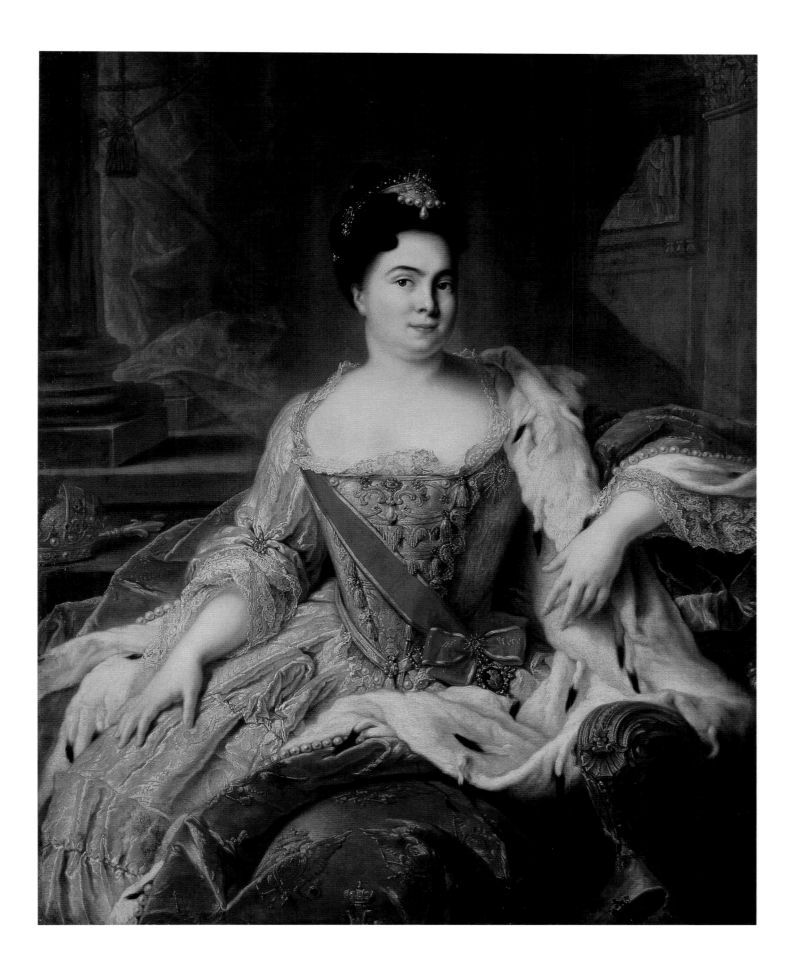

thoroughly regal after the Western European manner. Wearing a fashionably low-cut, jewel-studded gown in a gold-spun fabric with fine lace trimmings, an extravagant stole of royal ermine, an elegant hair decoration, and the red ribbon of the Order of St. Catherine, she is set against velvet draperies dotted with crowns and double-headed eagles, with a crown and scepter on a ledge behind. In 1724 Peter crowned her as his consort in a lavish ceremony in the Moscow Kremlin, perhaps in the hope of finally silencing those who muttered about her common origins. As Friedrich Bergholz commented: "One could not help but marvel at Divine Providence which has raised the empress from the lowly station in which she was born and which she previously occupied to the pinnacle of human honors."[48]

Even greater honors were to follow. In 1722, following a tragic clash with his eldest son by his first marriage, Peter issued a new law of succession that required the reigning monarch to nominate his successor with regard to "worthiness" rather than seniority. Peter died, in 1725, without naming an heir, but it suited a powerful clique at court to surmise that Catherine would have been his choice. With the accession of the first empress, publicists become adept at devising female scenarios of power and elaborating appropriate imagery in praise of female rule.[49] Catherine's supporters argued that she was Peter's "creation," the embodiment of her husband's spirit, "mother of all Russians," just as he had been their father. The clergy further exploited the image of Catherine's patron saint, the holy martyr St. Catherine of Alexandria, whose icons were placed in prominent locations, sometimes with features modeled on Catherine's own.[50] The new empress ordered the completion of the iconostasis in St. Petersburg's cathedral of Saints Peter and Paul, where her husband was buried, and commissioned icons, many with female subjects. She sponsored secular art, too, often with self-allusions, such as in the coronation portraits and ceiling paintings in the Summer Palace on the theme of *The Triumph of Catherine*. Her most important act was to confirm the charter for Peter's Academy of Sciences, which also provided training in the arts. But her reign was too short for her to develop her independent tastes.

Following Catherine's death, in 1727, and the premature death of Emperor Peter II (1715–1730), another woman ascended the imperial throne, Peter the Great's niece Anna Ioannovna (1696–1740). Anna had already run her own Western-style court in the Baltic duchy of Courland, having been widowed at the age of seventeen just months after her marriage to the Duke of Courland in 1710.[51] On her accession to the Russian throne, a group of men from prominent families tried to impose a set of conditions on Anna to reduce the power of the monarchy, but she rejected them,

vowing to rule for the common good. During her reign Russia continued to widen its cultural contacts. As one foreign observer remarked, Anna loved magnificence in her court and household, and encouraged luxury and outward display until they "rivalled that of the court of France."[52] Elegant examples of silver- and glassware survive, bearing the empress's cipher and image. But if some writers regarded hers as the first Russian court with any claim to refinement, others found the sumptuousness both vulgar and bizarre. For example, Anna relegated several nobles to the role of jester, most memorably Prince Mikhail Alekseevich Golitsyn, who had to pretend to be a chicken, and sit on eggs in a large basket. In 1740 she had him marry a Kalmyk woman, whom Russians regarded as hideously ugly and an unsuitable bride for an aristocrat. At Anna's command, the newly wedded pair were transported on an elephant, with attendants in carriages drawn by camels, goats, and pigs, to an ice palace built on the frozen River Neva, where they had to lie naked on an ice bed, wearing ice night-caps and slippers.

The best-known image of Anna is the rather threatening, bulky mass of Carlo Rastrelli's bronze statue, cast in 1739 and now in the State Russian Museum. To eighteenth-century viewers its very weightiness, the opulence of the jewel-studded robes, and the symbols of imperial power in the regalia conveyed an image of powerful rule. The black servant holding a globe symbolized the loyalty that all Anna's subjects owed to her, and indicated the extent of her empire, of which St. Petersburg remained the architectural showpiece. Anna's program for extending and embellishing the architectural setting of her capital included the completion of the building of the Chamber of Curiosities and the cathedral of Saints Peter and Paul, and sponsoring the early works of the architect Bartolommeo Francesco Rastrelli (1700–1771). She also developed the court orchestra, which comprised primarily Italian and French musicians, and brought Italian opera and ballet troupes to Russia, thus laying the foundations for greater achievements in the nineteenth and early twentieth centuries.

The arts continued to flourish under Peter the Great's daughter Elizabeth (reigned 1741–61; fig. 8), who was famed for court entertainments in which her own attractive person took center stage. As a contemporary observed: "I confess sincerely that I was amazed by the splendour of the court of our empress. The palace seemed to me the habitation of a being higher than mortal."[53] The success of Elizabeth's presentations depended on her graceful and majestic bearing. She loved dancing and dressing up, and she owned thousands of costly outfits, most worn only once, her rules on court dress and accessories ensuring that her own costumes and

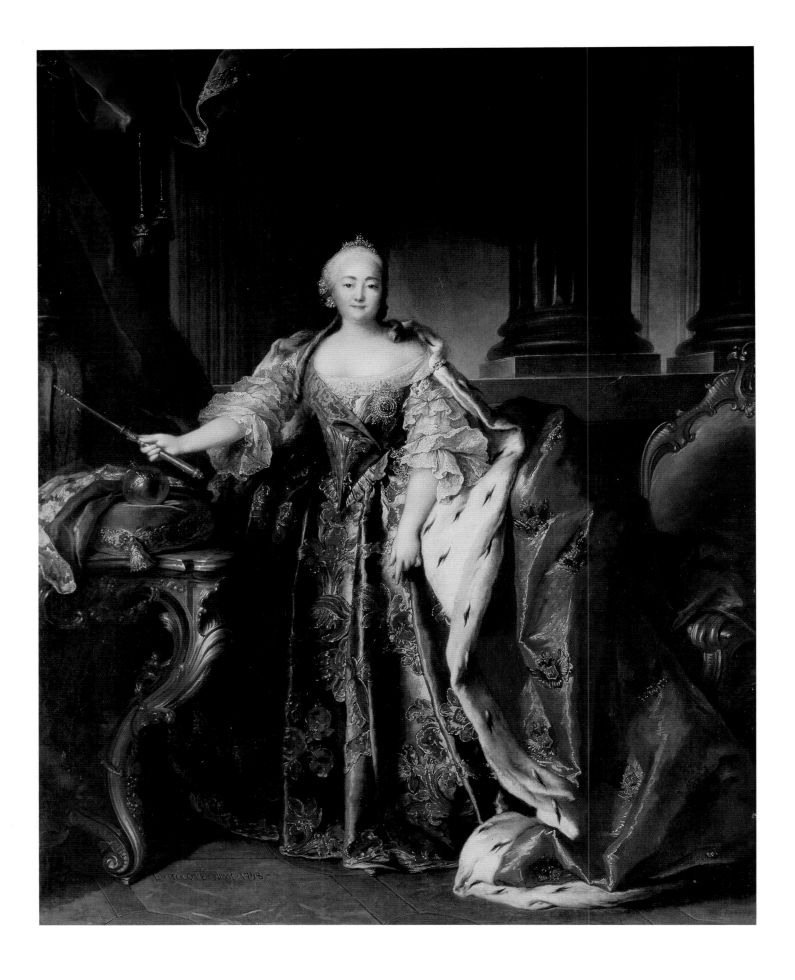

hairstyle were not duplicated. All eyes had to be on the empress. In particular, she loved the transvestite masquerade, at which women appeared dressed as men, and men as women.

One of the settings for such pageants was Rastrelli's Catherine Palace at Tsarskoe Selo outside St. Petersburg, built in the 1740s–50s and named in honor of the empress's mother, Catherine I. The palace is an amazing confection of vast length, its white-stone and gilded ornamentation and ornate plasterwork setting off its turquoise-blue walls. Inside, Elizabeth's guests were ushered into a seemingly endless enfilade of rooms, all decorated in gilt with white walls and painted ceilings, crammed with paintings, rare furniture, and porcelain, and glittering with chandeliers reflected in mirrors. Elizabeth also commissioned the Winter Palace (figs. 9, 10),

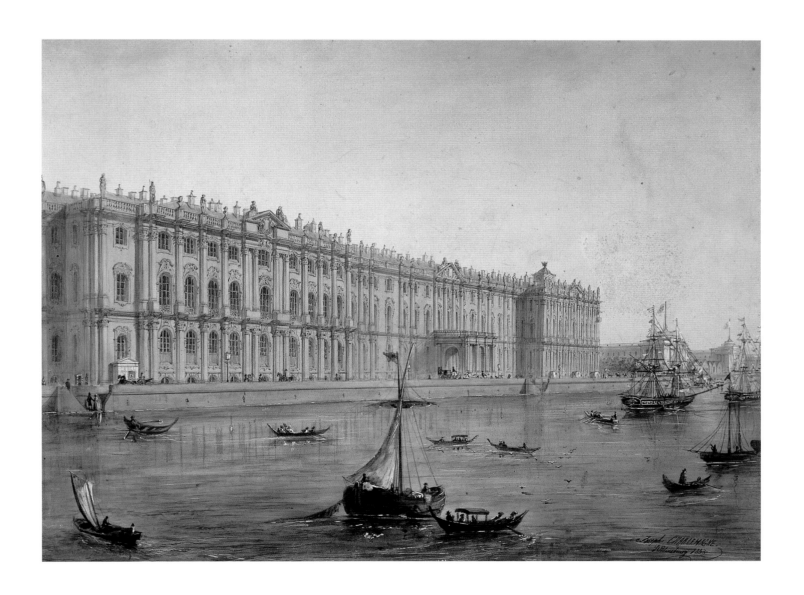

which, as Rastrelli himself declared, was created "for the glory of Russia," right in the heart of St. Petersburg, where it could be seen from many angles and provided a constant reminder of the wealth and power of the imperial family. Elizabeth envisaged another of Rastrelli's creations, the blue-and-white Smolny Convent, as a retreat for her old age. The splendid, five-domed cathedral was based on the traditional Orthodox models that Elizabeth, for all her Western ways, still favored in her church building.

Portraits and decorative panels were required in bulk for these and other imperial residences, and, in the absence of sufficient numbers of native artists, the practise of employing foreign court painters continued in the reigns of Peter's successors. Under Elizabeth these foreign artists included the Germans Georg Christoph and Johann Friedrich Grooth (the latter acting as an agent to buy paintings abroad), and, from Italy, Giuseppe Valeriani, Stefano Torelli, and, most notably, Pietro Rotari (1707–1762), who specialized in head-and-shoulder portraits of women in coy poses. The walls of the picture gallery (*Le Cabinet des Muses et des Graces*) in the Grand Palace at Peterhof are lined with 368 of his life studies of young girls. The French artists Louis Tocqué and Louis-Jean-François Lagrenée also worked in Elizabeth's favored Rococo style. From the 1730s foreigners were joined by a new generation of Russian artists, such as Ivan Vishniakov (1699–1761) and Alexei Antropov (1716–1795), who had been trained in Western techniques either abroad or under foreign tutors at home, but it took time for the full repertoire of Western subject-matter to be assimilated. In particular, history painting, regarded as the most prestigious of genres in Western academies, did not develop in Russia until the second half of the eighteenth century, and group portraits and landscapes remained a rarity. Peter the Great's efforts to promote home-grown sculpture failed almost entirely, and sculpture continued to be imported. In fact, the genre that took root most rapidly and firmly was the female portrait, which included studies not only of the empresses themselves, but also of less prominent women, for example Vishniakov's painting of Sarah Fermor, the young daughter of an army officer (State Russian Museum). Fermor displays all the attributes of the new, Westernized Russian, including a sumptuous dress and fashionable hairstyle, while a Classical column to the side hints at a family estate designed in the Western manner, but she is posed stiffly and awkwardly. This naïve feel finally disappears in the work of slightly later artists such as Fedor Rokotov (1735–1808), who created a gallery of delicate and enigmatic female portraits.

Fig. 10 Konstantin Ukhtomsky, *The Jordan Staircase*, watercolor, 17⅜ × 12⅝ in. (44.2 × 31.3 cm), State Hermitage Museum, St. Petersburg

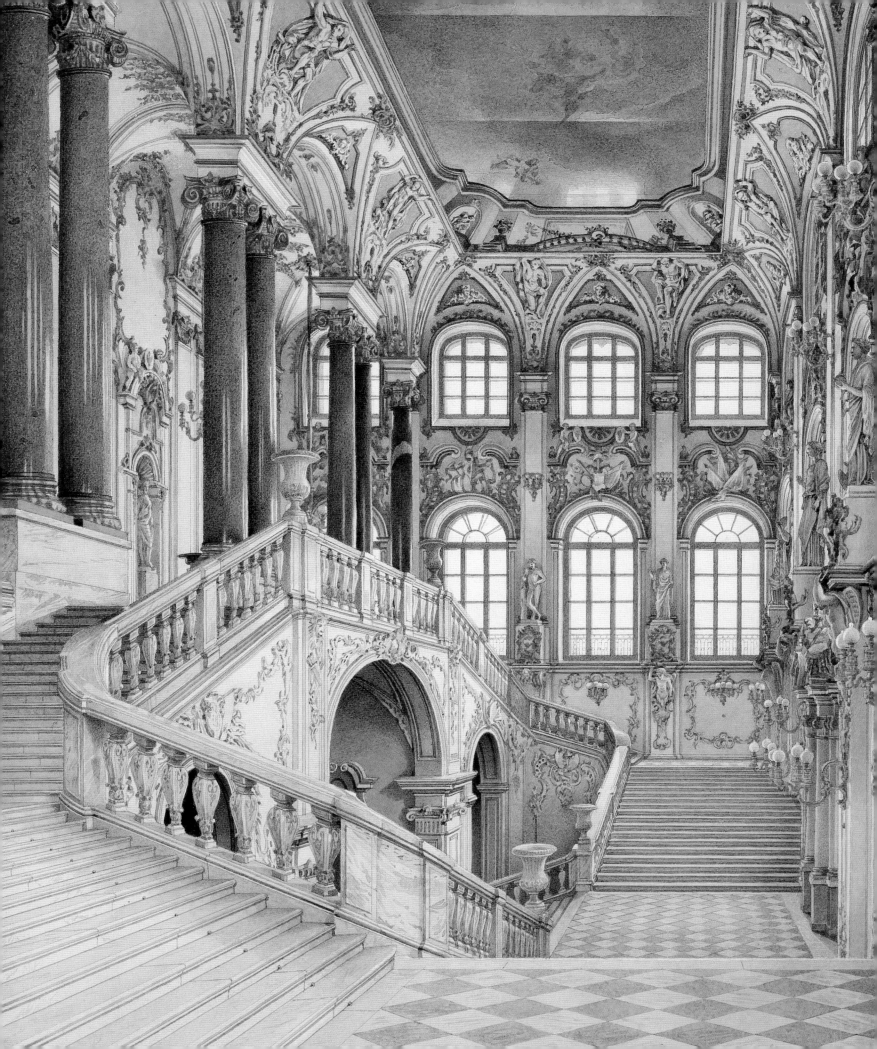

In 1757 Elizabeth founded the Imperial Academy of Arts in St. Petersburg, which provided training and a career path for Russian artists and architects, with the aims of bringing yet more "glory" to the empire and inculcating virtue in those who viewed the works of art. The first teachers were all foreigners and the programs were based on French models, involving not only tuition in painting, architecture, and sculpture based on drawing from casts, prints, Old Masters, and life, but also the indispensable study of Classical mythology and history, and of foreign languages. The best students finished their training abroad, some fifty-eight studying in Paris in the period 1760–90 alone. The first, Anton Losenko, returned to become a full professor of painting and Russia's first skilled practitioner of history painting.[54] The Academy drew its students from the "middling" classes, admitting even peasants occasionally, but not women.

Certain writers disapproved of the new culture that blossomed under Elizabeth, when some nobles preferred speaking French to Russian. The conservative thinker Prince Mikhail Shcherbatov (1733–1790), for example, complained in his discourse on the "corruption of morals" that women could spend 10,000 rubles or more on their outfits in order to participate in Elizabeth's entertainments, which he contrasted with the "seemly manners" of the Muscovite *terem*:

It was pleasant for the female sex, who had hitherto been almost slaves in their own homes, to enjoy all the pleasures of society, to adorn themselves with clothes and fineries, which enhanced the no small pleasure of being able to see in advance those with whom they were to be joined for life. The passion of love, hitherto almost unknown in an age of crude customs, began to over-whelm sensitive hearts, a change that first made itself felt through the action of the senses ... Women, previously unaware of their beauty, began to realise its power; they began to try to enhance it with suitable clothes, and used far more luxuries in their adornments than their ancestors. Oh, how the desire to be pleasing acts upon women's senses![55]

To be fair, Shcherbatov admitted that men, too, in their desire to be attractive to women, strove after self-adornment and luxury. Looking back on the same period, the historian Nikolai Karamzin wrote in 1810 that "Russian women ceased to blush at the indiscreet glances of men, and European freedom supplanted Asiatic con-straint."[56] Aristocratic women followed the latest Paris fashions both in gowns and coiffure, and in the art of flirtation.

Fig. 11 Alexander Roslin, *Portrait of Catherine II*, 1776–77, oil on canvas, 106 ¹¹⁄₁₆ × 74 ⅝ in. (271 × 189.5 cm), State Hermitage Museum, St. Petersburg

These trends culminated in the reign of Catherine II (1729–1796), who came to power in 1762 in a *coup d'état* that overthrew her unpopular husband Peter III after he had reigned for just six months. Shortly afterward Peter was killed, probably murdered with Catherine's connivance, if not on her express orders. The German-born Catherine, who had been brought to Russia to marry her husband in 1745, underpinned her worthiness to rule her adopted country by declaring herself to be Peter the Great's "spiritual daughter" and stating her intention to consolidate his reforms. There are many visual reminders of Catherine's acknowledged debt to Peter. In the Swede Alexander Roslin's grand portrait of her (fig. 11), she points at a bust of Peter, which is adorned with the inscription "She completes what has been begun." A similar message is conveyed in a miniature portrait, now in the Hermitage, in which Catherine holds the text of her *Instruction* to the Legislative Commission that she summoned in 1767 to discuss the recodification of the Russian laws. A marble bust of Peter stands on her desk.[57] Privately, however, Catherine deplored the "coarseness" and lack of good taste that characterized the Petrine era, with its heavy drinking and love of freak shows. To the extent that it was possible in a country in which peasants comprised 90% of the population, she was determined to extend civilization beyond St. Petersburg. Poets and artists liked to present Catherine as the Classical goddess Minerva, to underline her fostering of the Enlightenment through the arts and learning, based on the Classical models that had been part of Western European élite culture for centuries but were only now taking root in Russia.

Catherine rejected the stylistic excesses of the Elizabethan era, preferring the simpler, economical lines and muted colors of Neo-classicism, which she believed, as did other rulers of the Enlightenment, epitomized the virtues of Antiquity. She propagated the style in the new premises of the Academies of Arts and Sciences, the Hermitage Theater, the Cameron Gallery at Tsarskoe Selo, the Tauride Palace, and other elegant buildings. In out-of-town residences Classical temples were constructed in English-style parks and Palladian bridges were built over streams. The art collections of her predecessors pale into insignificance beside Catherine's, whose tally of acquisitions includes approximately 4000 Old Masters, 10,000 engraved gems, 10,000 drawings, 16,000 coins and medals, and countless snuffboxes, watches, instruments, pieces of furniture, and objects of porcelain. Among these purchases were 225 paintings offered by the agent Johann Gotzkowski after Frederick the Great could not afford to buy them; the collection of Sir Robert Walpole, which his heirs were forced to sell; the Pierre Crozat collection, which included eight Rembrandts,

six Van Dycks, three Rubens, and one Raphael; and the 944-piece Green Frog Service ordered from Josiah Wedgwood in 1773–74, which featured scenes of English stately homes, castles, and parks.[58]

Images of Catherine herself are many and varied, from the slender, newly married grand duchess depicted by Georg Christoph Grooth in 1745, to the stately woman wearing the uniform of the Semenovsky guards, astride her steed Brilliant, on the day that she snatched the throne in 1762, as the Danish artist Vigilius Eriksen envisaged her. The homely impression that the serf artist Mikhail Shibanov created of Catherine in traveling costume during a tour of the Crimea in 1787, or Vladimir Borovikovsky's study of her as a matronly figure walking her dog in the gardens at Tsarskoe Selo in 1794, contrast sharply with Roslin's resplendent portrait of the empress in imperial regalia, or Dmitry Levitsky's evocation of her sacrificing her youth in the service of Russia on the altar in the Temple of Justice.[59] She was also frequently sculpted in marble, for example by Fedor Shubin as well as by Marie-Anne Collot (the only female sculptor to work in Russia in the eighteenth century).

The empress did not steal all the limelight. By the 1760s the wives and daughters of leading state officials and military commanders routinely had their portraits painted, generally alone, rather than with their husbands and children. The empress herself commissioned one of the most evocative series of female portraits from the Ukrainian Dmitry Levitsky (1735–1822): seven studies, now in the State Russian Museum, of pupils at Russia's first girls' school, the Smolny Institute for Gentlewomen, which Catherine founded in 1764 (fig. 13). The girls are portrayed dancing, playing the harp, acting, sitting next to a piece of scientific equipment, but not painting or drawing. Levitsky, eighteenth-century Russia's most successful artist, painted many other memorable portraits of Russian women, as did the younger Vladimir Borovikovsky (1757–1825), whose dark-eyed beauties in flimsy empire-line gowns and relaxed Grecian hairstyles reflect the Russian élite's adherence to international fashion trends.

Catherine was determined that the Russian nobility should contribute fully to all areas of civic life. In 1762 her husband had freed the nobles from compulsory state service, a decree that Catherine confirmed in 1785 in her Charter to the Nobility, which gave guarantees in such areas as property rights and freedom to travel abroad. These acts inspired the flowering of country-estate culture, in which women played a significant role. Based on evidence of the ability to sign one's name in the notarial records, 41% of noblewomen were literate in 1750–55, rising to 67% in 1775–80 and

Fig. 12 Rembrandt, *Flora*, 1634, oil on canvas, 49³⁄₁₆ × 39¾ in. (125 × 101 cm), State Hermitage Museum, St. Petersburg. This painting was one of the many purchases made by Catherine the Great, entering the Hermitage collection between 1770 and 1774.

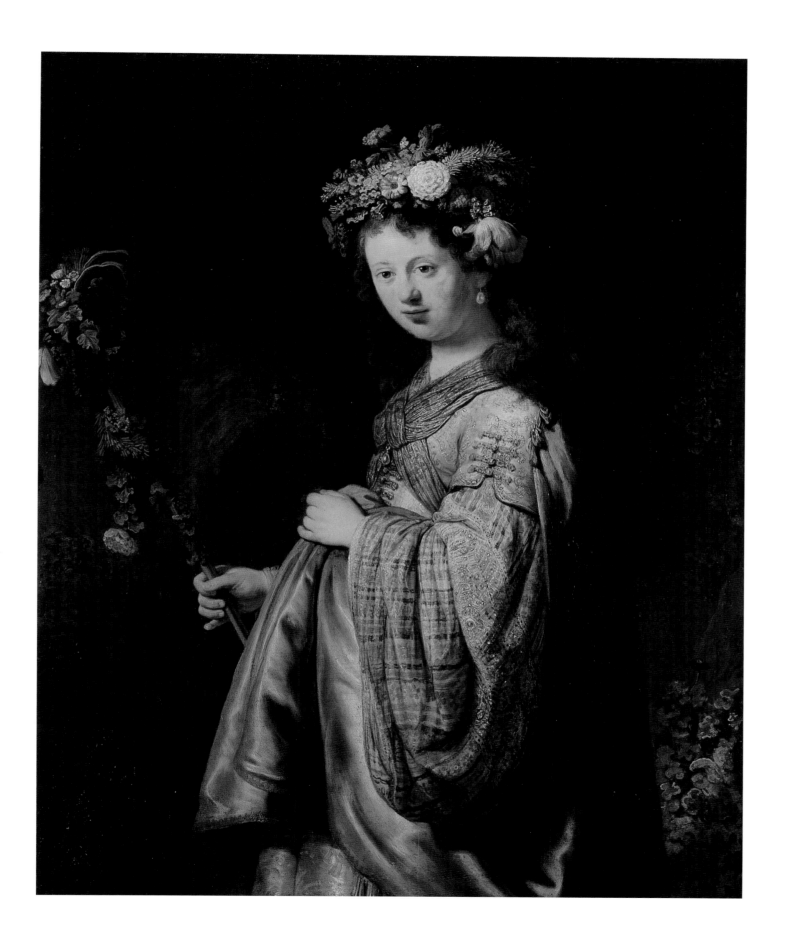

92% in 1805–10.[60] Women began to participate in literary circles and salons, acting as muses and sometimes even publishing their own work, especially poetry and translations.[61] Historians speak of the "feminization" of Russian literature in the last decades of the eighteenth century, as many poets and novelists wrote with women readers in mind, dealing in the language of love and tenderness. Even so, such refinements were still for the few. Most women who wrote did so for domestic circles, just as women venturing into the figurative arts tended to confine their efforts to water-colors and drawing—as far as we know, for no systematic study has been made of art by women in Catherine's reign. Women sometimes refer in letters to drawing and painting; for example, the remarkable Princess Ekaterina Vorontsova-Dashkova, who served as director of the Academy of Sciences and president of the Russian Academy (founded in 1783 for the study of literature and language), painted landscapes after she was exiled to a rural estate following Catherine's death. In her memoirs, she mentions giving the empress a picture by Angelica Kauffman.[62] Ironically, only women lower down the social scale could make a career in the arts, such as the famous serf actress and singer Praskovia Kovaleva (1768–1803), whose owner Count N.P. Sheremetev eventually married her. She was the subject of a famous painting by a fellow serf on the Sheremetev estate, the artist Nikolai Argunov. In general, however, the lives of peasants and the urban poor, both men and women, were reflected only faintly in art. Not until the nineteenth century did genre painting, the depiction of scenes from everyday life, win favor with the picture-buying public.[63]

By the 1790s the lives of Russian royal and aristocratic women differed radically from those of the secluded and pious tsarevny and boiaryni a century or so before. Women had ruled Russia for most of the eighteenth century, and Russians had become accustomed not only to portraits of their rulers on canvas, paper, coins, and medals, but also to allegorical and mythological images of women, and to portraits of their own wives and daughters. No women appeared in public at Tsar Alexis's court in the 1650s–70s, but from Peter the Great's time court life could not function without them. Even so, one should not exaggerate the discontinuities. In 1762 Catherine II justified her elevation to the throne with the rhetoric that her murdered husband Peter III, who had been raised in Germany, was contemptuous of Russia and that "Our Orthodox Church is being menaced by the adoption of foreign rites and all the respected traditions of our fatherland are being trampled underfoot."[64] In contrast to Peter III, Catherine swore to uphold Orthodox Christianity, for she and her advisors knew that they had to appeal to pious instincts as well as to political sensibilities. For

many Russians the ruler's devoutness was still regarded as an essential safeguard of the realm against misfortune. As a result, the German-born Catherine, who had sanctioned the murder of her husband and invited gossip by taking lovers, had to work hard to cultivate the image of the "pious tsaritsa." These efforts were reflected in less publicized aspects of her patronage of the arts. In 1764, for example, the painter Alexei Antropov reminded the empress that for her coronation he had painted an icon of the Nativity of Christ, two shrouds with Christ's image, and two portraits of the empress.[65] Catherine, who had converted to Orthodoxy as a young bride, was meticulous about attending services, observing church festivals, and visiting shrines. In the 1770s she restored three ancient cathedrals in the Moscow Kremlin, ordering the head of the church to ensure that their wall painting "be renovated with the same skill as the ancient ones, without any change," and warning that "the painters sent to do this work of icon painting and frescoes must not be secular, but religious people, and your Holiness should make sure that they carry out their work with the decorum appropriate to God's holy churches."[66] Virtually every important Russian artist working in the capital during the eighteenth century painted icons as well as secular works, and some began their careers as icon painters, including Vladimir Borovikovsky and Dmitry Levitsky, who was the son of a priest. In the countryside, meanwhile, religious art and folk art continued to be in high demand and the images of saints, female and male, continued to gaze out from the icons that adorned all public and private buildings. Thus, during the reign of Catherine II, older traditions rooted in religious culture coexisted with secular trends imported from the West.

After Catherine's death, in 1796, her son Paul restored the right of succession to the eldest son through the male line. There were to be no more women rulers in Russia. Empress consorts sponsored the arts, for example, Paul's wife Maria Fedorovna, who had a passion for interior decorating and gardens, but none of them had purchasing power on the scale of Catherine and her predecessors. But precedents had been set, and, in the course of the nineteenth century, artists such as Elena Polenova were to play an important role in the development of Russian art, along with sponsors of arts and crafts such as Elizaveta Mamontova at Abramtsevo and Princess Maria Tenisheva at Talashkino. In the early twentieth century, a group of women artists—the so-called "Amazons" of the avant-garde—would emerge to play an equal role alongside their male colleagues, but that is another story.

A Century of Women Painters, Sculptors, and Patrons from the Time of Catherine the Great

ROSALIND P. BLAKESLEY

THE REIGN OF CATHERINE THE GREAT, herself an exceptional patron and supporter of the arts, marked a turning point for women with artistic ambitions in Russia. If women had previously contributed to the visual arts primarily as patrons, with any artistic production of their own largely confined to the domestic sphere, from the late 1760s onward certain women began to achieve renown as fine artists. Initially, it was a few foreign women who succeeded in carving out careers as professional artists in Russia, winning prestigious commissions from the most lavish of court and aristocratic patrons. At the same time, some of these patrons were buying or commissioning works from women artists living in Italy and France. By the start of the nineteenth century, Russian as well as Western European women artists were figuring in records, as their work began to receive official recognition from the Imperial Academy of Arts. At first, attention focussed on the amateur work of primarily élite women, but by the middle of the century a number of women from a wider range of social groups were working as professional artists. From the magnificence of the imperial palaces to the long, dusty corridors of the Academy, their work made an increasingly prominent mark on Russian cultural life.

One of the first women to make a career in fine art in Russia was the French sculptor Marie-Anne Collot (1748–1821), who accompanied her mentor Etienne-Maurice Falconet to St. Petersburg in 1766, when the Empress Catherine commissioned him to create a monument to Peter the Great. In the Russian capital, the young Frenchwoman sculpted busts of Catherine, her son Paul, and various prominent figures on the St. Petersburg social scene, including Catherine's lover Grigory Orlov. She also played a key part in Falconet's commission, the equestrian statue of Peter I, as after Catherine had rejected three of Falconet's suggestions for Peter's head, Collot executed a model that the empress accepted.[1] Falconet felt that Collot's talents

were not sufficiently appreciated in St. Petersburg, complaining to Catherine on several occasions that his protégée was being underpaid.[2] But in 1767 she was made a member of the Imperial Academy of Arts, the first known woman artist to receive this rank in Russia, and when she left Russia in 1778 she was granted a life pension of 10,000 *livres* by Catherine the Great.[3] Her portrait busts were also later used as models for students in the Academy to copy, suggesting that the official establishment held them in particularly high esteem.[4]

Other women artists followed Collot to St. Petersburg, the most famous of whom was Marie Louise Elisabeth Vigée-Lebrun, who lived in Russia from 1795 to 1801. Vigée-Lebrun had already carried out a number of portrait commissions for Russian clients in Paris, and had no trouble in attracting generous and discerning patrons in her new, northern home. The most important of these was Count Alexander Stroganov, a statesman, a Freemason, and an exceedingly wealthy patron of the arts. Vigée-Lebrun and Stroganov had met in Paris, where the Russian count had lived from 1771 to 1778, and she became particularly friendly with his son Paul and daughter-in-law Sophia, who regularly invited the French artist to their dacha outside St. Petersburg. She portrayed many of the Stroganov family, including Alexander himself, his cousin Grigory, and Grigory's wife and child, who sat for the artist soon after her arrival in St. Petersburg in 1795. This virtuoso work (right, above) displays the delicate brushwork and informal intimacy much admired among the upper echelons of society in Russia at the time. These characteristics had been particularly fashionable since Dmitry Levitsky had painted his famous series of girls studying in the 1770s at the Smolny Institute, the establishment founded by Catherine the Great that provided for the education of young noblewomen (fig. 13).[5] Thus Vigée-Lebrun found her style in tune with the aesthetic sensibilities of many connoisseurs of modern painting in St. Petersburg, and painted more than forty-eight portraits while she was there.[6]

In 1800 Alexander Stroganov was elected president of the Imperial Academy of Arts. Soon after his appointment he made Vigée-Lebrun an honorary free associate (*Pochetnyi vol'nyi obshchnik*) of the Academy, marking one of the earliest occasions on which this distinction had been awarded to a woman.[7] She responded by painting a self-portrait and presenting it to the Academy, where it hung until the twentieth century in the famous collection of portraits in the Academy's Council Chamber (right, below). A challenging painting to read, this could be a beguiling image of a woman flirting gently with the overwhelmingly male membership of the Academy.

Marie Louise Elisabeth Vigée-Lebrun, *Baroness Anna Stroganova with her Son*, c. 1795–1801 (see p. 183)

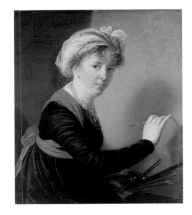

Marie Louise Elisabeth Vigée-Lebrun, *Self-portrait*, 1800 (see p. 189)

OPPOSITE Fig. 13 Dmitry Levitsky, *Portrait of Ekaterina Ivanovna Nelidova, later Maid of Honor of the Bed-Chamber*, 1773, oil on canvas, 64⁹⁄₁₆ × 41¾ in. (164 × 106 cm), State Russian Museum, St. Petersburg

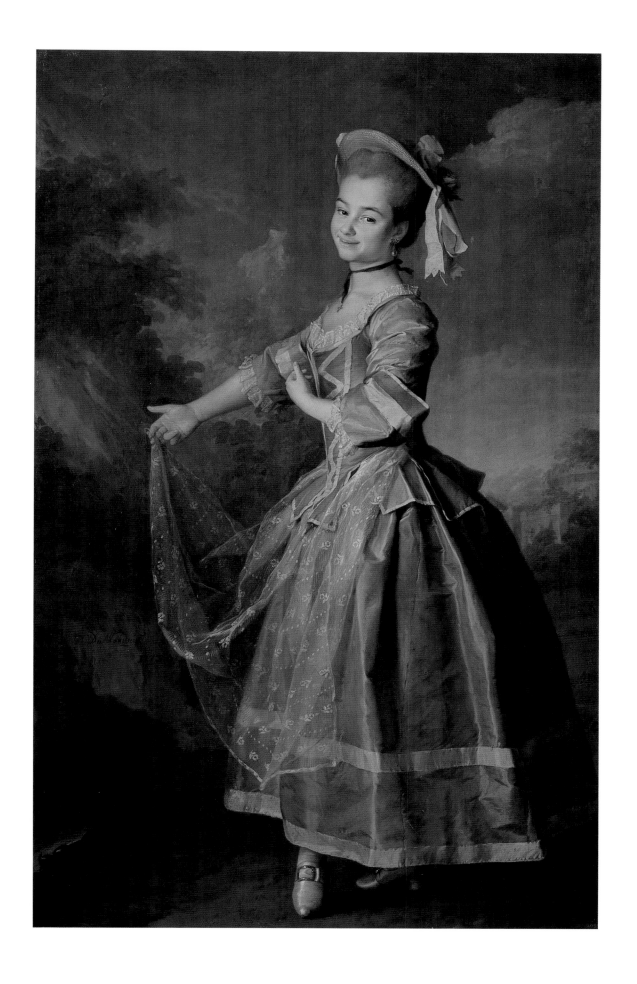

But it could also be a more confrontational statement, perhaps as part of Vigée-Lebrun's construction of a new self-image inspired by her success in Russia. There are three features to take into account in considering this second reading. The artist has placed considerable emphasis on her distinctive sense of dress, which challenged existing notions of taste: in her *Memoirs* she mentioned her habit of lacing a scarf under the arms, as is the case here,[8] and her ankle-length skirts were shorter and more figure-hugging than was the norm in Russia at the time.[9] Vigée-Lebrun has also depicted herself portraying a member of the imperial family, Empress Maria Fedorovna, which was for many a clear index of success. Finally, she has taken pains in her signature to indicate both place and date, as it reads: "*Vigée Le Brun à Pétersbourg 1800.*" The image can therefore be seen as a propaganda picture, in which Vigée-Lebrun is inscribing herself into history and celebrating the success that her distinctive style, both personal and professional, enjoyed in Russia.

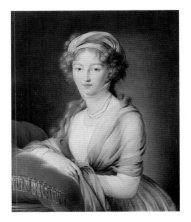

Marie Louise Elisabeth Vigée-Lebrun, *Grand Duchess Elizaveta Alekseevna*, 1798 (see p. 191)

Vigée-Lebrun carried out many commissions for members of the imperial family while she was in St. Petersburg. In 1798, for example, Grand Duchess Elizaveta Alekseevna commissioned a portrait of herself as a present for her mother (right; this is the first of two versions of the painting, the second of which was given away). Moreover, the artist retained a strong attachment to St. Petersburg and its patrons long after she had left Russia. In 1814 she presented Alexander I with her painting *The Genius of Emperor Alexander I* (see p. 197). When she died, she also left the Imperial Academy of Arts 100 francs with which to strike a medal to be awarded for the best painting of a "*tête d'expression*" each year. The medal, she stipulated in her will, was to have on one side an image of a palette with brushes illuminated by the sun's rays, and on the other the words "*Souvenir reconnaissant de M-me Le Brun.*" The gift was gratefully accepted by the Academy and the medal was awarded for many years, with a record of 1914 noting that 1709 rubles 32 kopecks of the original capital still remained.[10]

There are no records of Russian women working as professional artists at the same time as Collot and Vigée-Lebrun, but a member of the European nobility who married into the Russian imperial family was making a significant impact as an amateur artist. Born Princess Sophia Dorothea of Württemberg and christened Maria Fedorovna on her admission to the Russian Orthodox church, she had what might be seen as an unenviable fate. Chosen by Catherine the Great as a second wife for her son Paul (who still grieved for his recently deceased first wife),[11] Maria Fedorovna found herself married to a man whose loathing for his mother, coupled with his

frustration at having to wait so long to accede to the Russian throne, made him irritable, despotic, and eventually, justifiably, paranoid (he was murdered in his bedroom in 1801). Yet Maria Fedorovna loved her husband, and her adopted country, and created a distinct role for herself, not only as the wife of one emperor and mother of two more, but also as a painter, sculptor, and engraver of considerable talent, and as a discerning and committed patron of the arts.

Maria Fedorovna's tastes as a patron underwent a period of intense development from September 1781 to November 1782 when, at the bidding of Catherine the Great, she and her husband carried out a prolonged visit to Western Europe as part of Catherine's aim of cementing relations with the Austrian court.[12] They were ordered by the empress to travel incognito, as the comte and comtesse du Nord, to underline the unofficial nature of the trip; but this pretense was as transparent as that of Peter the Great, who nearly a century earlier had also traveled to Europe under a false name. Met by royals and dignitaries wherever they went, Paul and his wife found themselves the center of a hectic social and diplomatic program that included meeting the pope in Rome and attending a series of receptions hosted by European royals and aristocrats. Despite the demands of these social engagements, the imperial couple made time to visit museums, studios, and archaeological sites, and to meet many fashionable writers and artists. Given strict instructions by Catherine "not to spare money, but to make this journey through Europe as splendid as it was interesting,"[13] they also bought or commissioned paintings, sculpture, furniture, and applied art to decorate both their palace on Kamennyi Island in St. Petersburg (then under renovation) and their new summer palace at Pavlovsk outside the city, which was being built while they were away.

In Naples, the royal couple visited Herculaneum and Pompeii, and Maria Fedorovna ordered a plaster cast of the *Drunken Satyr* in the local museum. When this was damaged in a fire at Pavlovsk in 1803, she approached the Queen of Naples with a request for a second copy to be made, demonstrating the level of her attachment to specific works of art. Traveling on to Rome, the grand duchess visited the studio of Pompeo Batoni, both with her husband and alone, and became a munificent patron of the Neo-classical artist and his circle. Her purchases included originals and copies by Batoni, a miniature by his daughter Benedetta, and fifteen drawings by his son. As well as meeting Batoni, Maria Fedorovna fostered close links with the German artist Philipp Hackert, who accompanied the imperial couple to Tivoli and Frascati, and was commissioned to paint several views of Naples and its

surroundings.[14] The Russian couple also visited the studio of Angelica Kauffman in Venice and commissioned two paintings, *Eleanor Poisoned* (1781) and *Eleanor Cured* (1782; both in Pavlovsk Palace Museum). The paintings tell the story of the wife of Prince Edward of England saving her husband's life by sucking the poison from a wound, and were highly significant for Kauffman, as she won new patrons on the strength of such a prestigious commission. Maria Fedorovna, for her part, made several copies of Kauffman's work in the 1790s. These included small medallions after Kauffman's compositions, which the grand duchess used for decorative effect on a firescreen and a desk at Pavlovsk.[15]

Paul and Maria Fedorovna's journey culminated with a month in Paris, during which banquets and festivities were held in their honor at the court of Versailles. They were presented with Gobelin tapestries and a famous Sèvres dressing set by Louis XVI,[16] and ordered more than two hundred pieces of furniture, as well as further items from the Gobelin and porcelain manufactories. There is little documentation regarding the studios that they visited, but these are likely to have included those of Claude Joseph Vernet and Hubert Robert, from whom the imperial couple purchased several works.[17] No attempt was made to disguise their expenditures; on the contrary, their purchases were put on display on two floors of the Russian embassy in Paris, with each item carefully labeled with its price. The public could therefore appreciate the enormous sums that the royal couple had spent, including 300,000 *livres* on porcelain alone. Their acquisitions not only influenced the development of the decorative schemes at Pavlovsk (where, for example, rooms were modified to accommodate the Gobelin tapestries from Louis XVI), but also played a key role in bringing to Russia the latest in European fashion and design. Only twenty-three when she returned from her travels, Maria Fedorovna was already one of the most significant taste-makers of her day.

The grand duchess's experiences as the "comtesse du Nord" marked the beginning of a lifetime devoted to the development of Pavlovsk. "I assure you," she wrote to Karl Küchelbecker, the director of works there, "that Italy has not only not made me disenchanted with Pavlovsk—on the contrary, it has made me love it more."[18] While she was abroad, she carried out an extensive correspondence with those in Russia involved with the palace's construction and design. The palace's first architect, Charles Cameron, wrote regularly to the imperial couple, asking them to purchase antique marbles, sculpture, and busts for him to use at Pavlovsk, and often directed his requests specifically to the grand duchess. Nor was Maria Fedorovna a

passive patron who simply controlled the purse-strings. She frequently sent Cameron and Küchelbecker specific instructions, and requested the plans and dimensions of particular rooms for which she was purchasing furnishings or works of art.[19] Her continuing engagement as a patron at Pavlovsk is evident in her later relationship with the Russian architect Andrei Voronikhin, who was employed after fire caused extensive damage to the palace in 1803. Maria Fedorovna, by then the dowager empress, rejected Voronikhin's original designs for male herms in the Italian Hall in favor of female caryatids.[20] Perhaps she found their softer countenance more in keeping with the informal elegance that had become characteristic of her country home. She was also open to new ideas and aesthetic trends, accepting Voronikhin's introduction of bronze Egyptian figures and signs of the zodiac in place of the original statues of the months in the vestibule. Voronikhin was the first Russian architect to appropriate Egyptian motifs in his work. He was also the first to incorporate plate-glass windows and French doors, notably in the Lantern Study. Here, the understated Neo-classical elegance of the coffered ceiling and Ionic columns, and the subtle integration of decoration and furnishings, singles Maria Fedorovna out as a patron of the cutting edge of interior design.

But Maria Fedorovna was not content merely with patronizing the artistic activities of others. Like many women in royal or noble society at the time, she could paint and draw, on paper, glass, and porcelain, and she copied works by Raphael and other Old Masters, as well as those by Kauffman.[21] More unusually, Maria Fedorovna was an accomplished sculptor and engraver, fashioning medals, cameos, engravings, and other works in amber, ivory, onyx, and agate. She even owned her own lathe. The grand duchess studied with the German medalist and engraver Karl Leberecht (left), who in 1794 was made a professor at the Imperial Academy of Arts in St. Petersburg; but as her secretary and librarian Franz Lafermière noted, Maria Fedorovna was not slavishly dependent on her eminent teacher's advice. According to Lafermière, she would listen to Leberecht's views while she was first modeling her works in wax, but when it came to carving the actual stone, "her teacher would not dare to interfere, and his entire responsibility consisted only in handing her the necessary tools."[22] The grand duchess evidently had confidence in her technical abilities, as well as her aesthetic taste.

One of Maria Fedorovna's more elaborate projects involved a writing table (fig. 14) which, as she described in a lengthy letter to her mother in 1795, "is supported by twelve columns of ivory which I turned on a lathe." She continued to

Angelica Kauffman, *Portrait of Karl Leberecht* (?), 1785 (see p. 129)

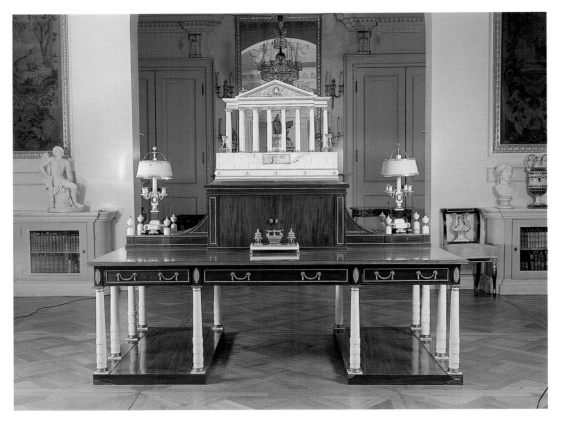

describe in detail her work on the miniature ivory temple on top of the table:

> On the pediment of the temple is a cameo of the Grand Duke mounted in clear glass on which I painted a trophy in grisaille. On the other side is the Grand Duke's monogram. … in the middle of the temple is an eight-sided altar made of amber and ivory; on the central one my monogram in a medallion painted on glass and mounted in amber; on the other, medallions of my seven children … I painted all the children's monograms in roses and myrtle; mine is in small blue flowers. … The writing set is of amber in antique form, the penknife, the paperknife, the pencil and seal handle are all in amber and made by me; I even engraved the monogram of the Grand Duke in steel for the cachet.[23]

The skills Maria Fedorovna had mastered under Leberecht clearly brought her great personal satisfaction and pride. She frequently gave her work to her husband or to her mother-in-law, Catherine the Great. In 1781, for example, Maria Fedorovna presented Catherine with a cameo that bore the empress's profile in the guise of Minerva (fig. 15), inspired by a medal struck at the time of Catherine's coronation in

1762.[24] In 1790 the grand duchess also gave Catherine one of several versions of her drawing of the profiles of her children, an image that Maria Fedorovna considered her best work (fig. 16). Catherine penned an effusive letter of thanks, writing: "I cannot express to you, my dear daughter, the pleasure which the charming and touching drawing of your six charming children has brought me." The image was engraved and carved on several occasions, as a cameo, in plaster, and in marble, and Catherine sent an engraving of it to her friend, the *Encyclopédiste* Friedrich Melchior, Baron von Grimm, in France.[25] A later version of the drawing, now including eight children, appears in a famous portrait of Maria Fedorovna that the German artist Johann Baptist Lampi the Elder (1751–1830) painted in 1795 (fig. 17).[26] Maria Fedorovna is depicted holding a pen, clearly indicating her authorship of the drawing, while on her chest hangs her cameo of Catherine as Minerva. Behind her looms a Classical temple, referring to the extraordinary patronage she bestowed on some of the greatest Neo-classical architects to work in Russia, while the large urn on the right recalls both the unrivaled collection of Classical antiquities that she and her husband amassed, and her enthusiasm for landscape design. To the left, behind a book denoting the grand duchess's learning, stands a bust of Paul, who gazes at his

wife with a mixture of love and pride. This is a parade portrait with a difference, defining Maria Fedorovna not only as a loyal subject, loving mother, and beloved wife, but also as an inspired patron and an accomplished practitioner in an impressive range of the visual arts.

The grand duchess received official recognition for her art in 1820, when she was made a member of the Berlin Academy of Arts. It is unlikely, though, that she viewed her artistic activities as a challenge to the traditional woman's role of wife and mother. On the contrary, she had been brought up in the strict patriarchal environment of a German Protestant family, which, coupled with observation of her parents' long and successful marriage, had instilled in her the belief that a woman's mission was to support her husband and educate her children.[27] Accordingly, she remained loyal to, and supportive of, the unfaithful and increasingly irascible Paul, urged her sons to recognize the importance of fidelity and marital love, and, after Paul's death, became an advocate of conservative values when her son, Alexander I, showed signs of adopting a more liberal stance.[28] Her patronage at Pavlovsk can be seen as part of the woman's duty of looking after home and estate, and her charitable work of establishing foster homes, schools, and women's training institutions also followed traditional gender divides, which placed women in a caring, nurturing role.[29] When Maria Fedorovna took over the direction of the Smolny Institute after Catherine's death in 1796, she was particularly scrupulous about a woman's proper place. While Catherine had been concerned not only with creating conscientious wives and mothers but also with encouraging intellectual thought, Maria Fedorovna believed that a woman's education should serve simply to improve her capabilities in the domestic sphere. In 1804, for example, she encouraged Smolny graduates "as daughters, to be obedient and respectful; as wives, to be faithful, virtuous, tender, modest, diligent and useful … to be conscientious about the order, comfort and well-being of [their] household, and as mothers to try to combine warmth towards [their] children with sensible concern about their future well-being."[30] Her art therefore should be viewed as part of the pastimes that were acceptable, even encouraged, in aristocratic and royal circles, rather than as any demonstration of independence from the traditional role of women.

While Collot, Vigée-Lebrun, and Maria Fedorovna were making their respective marks as artists in St. Petersburg in the last three decades of the eighteenth century, a few European women artists who had never set foot in Russia also attracted the attention of Russian patrons. In 1773 the Russian court commissioned a series of

Fig. 17 Johann Baptist Lampi the Elder, *Portrait of Grand Duchess Maria Fedorovna*, 1795, oil on canvas, 101⁹⁄₁₆ × 68⅛ in. (258 × 173 cm), Pavlovsk Palace Museum, St. Petersburg

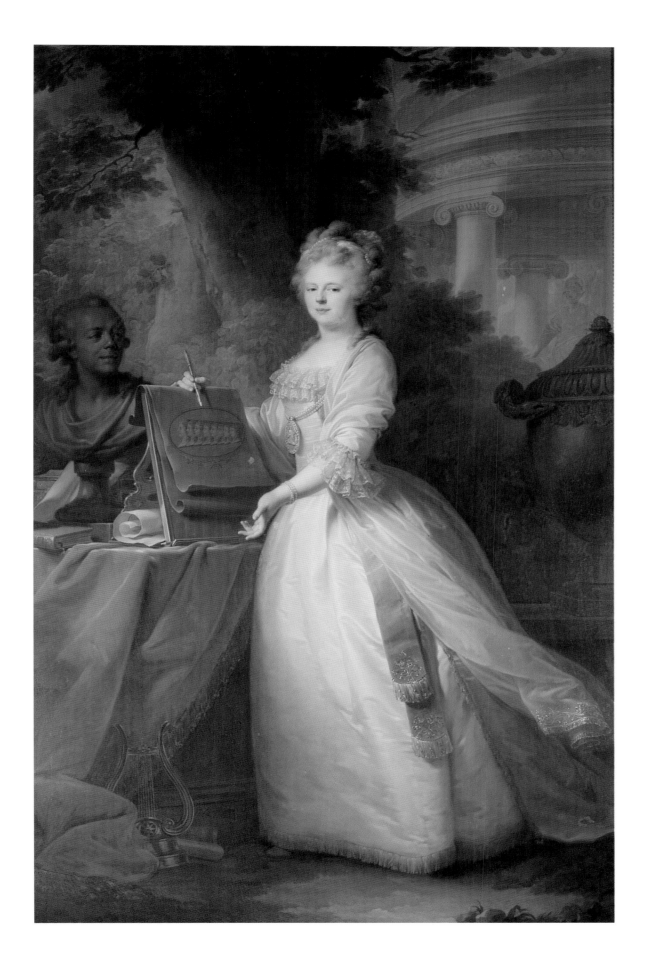

portraits of members of the Prussian royal family from Anna Dorothea Therbusch-Lisiewska (see pp. 173, 175). This was no incidental commission: Catherine the Great's key agent in the development of her painting collection, Prince Dmitry Golitsyn, had specifically conveyed the request to Therbusch-Lisiewska when he met her in Paris. Angelica Kauffman also enjoyed great popularity among Russian patrons, particularly after Paul and Maria Fedorovna visited her studio and bought her work. In the 1780s she received commissions from Catherine the Great, and from several members of the Russian nobility visiting Rome.[31] Most importantly, Prince Nikolai Yusupov, who had accompanied Paul and Maria Fedorovna through Europe, and was himself a patron of great distinction, began to buy Kauffman's work. The *Memorandum of Paintings* that the artist kept lists seven commissions for Yusupov from August 1784 to the end of 1785 alone.[32] In 1788 Yusupov commissioned another painting, *Portrait of Lady-in-Waiting Anna Protasova with her Nieces* (see p. 131). Kauffman noted in her *Memorandum* that Yusupov went to the trouble of sending six half-length portraits to Rome for her to use as likenesses for this work. The Englishman James Walker (1758?–after 1823), the chief engraver at the Russian court, also engraved the painting.[33] Both Yusupov's pains to secure Kauffman's services, and the decision to have the painting engraved by Walker, demonstrate the high esteem in which Kauffman and her work were held in Russia at the time. Yusupov also owned Kauffman's *Self-portrait* (see p. 127) and *Venus Persuading Helen to Accept the Love of Paris* (see p. 135), Marie Françoise Constance Mayer-Lamartinière's *Innocence Prefers Love to Wealth* (see p. 143), and Marguérite Gérard's *First Steps* (see p. 111). The last of these suggests that Yusupov, a man of exquisite taste and arguably the most important private Russian patron of his generation, was sensitive to the female visualization of domestic themes such as childcare and nurture, and the complex relationship between a mother and her child.

All of the women mentioned so far were of Western European origin, and, with the exception of Maria Fedorovna, were accomplished professional artists by the time they worked in Russia or for Russian patrons. None of them sought an artistic education in Russia, apart from the grand duchess, who, as wife of the heir to the throne, was able to request private tuition from a professor at the Academy of Arts. The question arises: what opportunities were available for Russian women to train as artists at the time? As was true throughout Europe, the Academy of Arts did not admit women students, and, although the few existing women's educational establishments usually included drawing classes, there was rarely any provision for more

advanced training in the arts.[34] Catherine's original charter for the Academy of Arts stipulated that there were to be four women teachers for the junior or "children's" class, who earned the same as their male colleagues in the two more senior classes—namely a salary of 200 rubles plus an additional 120 rubles for their subsistence.[35] But from 1802 onward, the revised statutes of the Academy no longer specified any women teachers, who it seems were by then all male. This elimination of designated women teachers is consonant with the efforts of Emperor Paul (reigned 1796–1801) to remove women from the public sphere (a policy with which Maria Fedorovna agreed).[36]

From the late eighteenth century, however, women were able to send their works to the Academy for assessment, and would occasionally be recognized with an official title, a medal, or the right to teach. In 1800 a woman by the surname of Nigri was "appointed" (*naznachennaia*), that is given the right to teach, on the basis of her successful drawing of the head of a man.[37] There is no evidence that this development was a direct result of the impact that foreign women artists had made in St. Petersburg, but it is worth noting that the Academy's move to recognize Russian women artists came at a time when Vigée-Lebrun's reputation in Russia was at its height (it was in 1800, the year of Nigri's appointment, that Vigée-Lebrun was made an honorary free associate of the Academy of Arts).

Some of the earliest women to feature in Academy records were related to men of importance in the artistic establishment. Thus, in 1774, Elizaveta and Sophia, the daughters of the Academy professor Nicholas Gillet, were given the right to teach on the basis of, respectively, a portrait and a still life.[38] In 1807 Ekaterina Leberecht, the daughter of Karl Leberecht, the Academy professor with whom Maria Fedorovna studied, was also recognized for her miniature painting. But others succeeded without any personal contacts. The first woman known to have won an Academy medal, for example, was Marfa Dovgaleva, the daughter of a retired chief forestry commissioner (*Oberforstmeister*), who, on 1 September 1812, was awarded a second-class silver medal for her work as an engraver. The medal was given in recognition of "the good successes of this young lady, and of her respect for the Academy itself."[39] In 1815 Dovgaleva won a further award, this time a first-class silver medal, in recognition of her "new successes."[40] Royal women also presented their work to the Academy. In 1796 four of Paul and Maria Fedorovna's daughters submitted examples of their painting, drawing, and sculpture, including Princess Alexandra's wax bas-relief head of Minerva after an antique original, and her

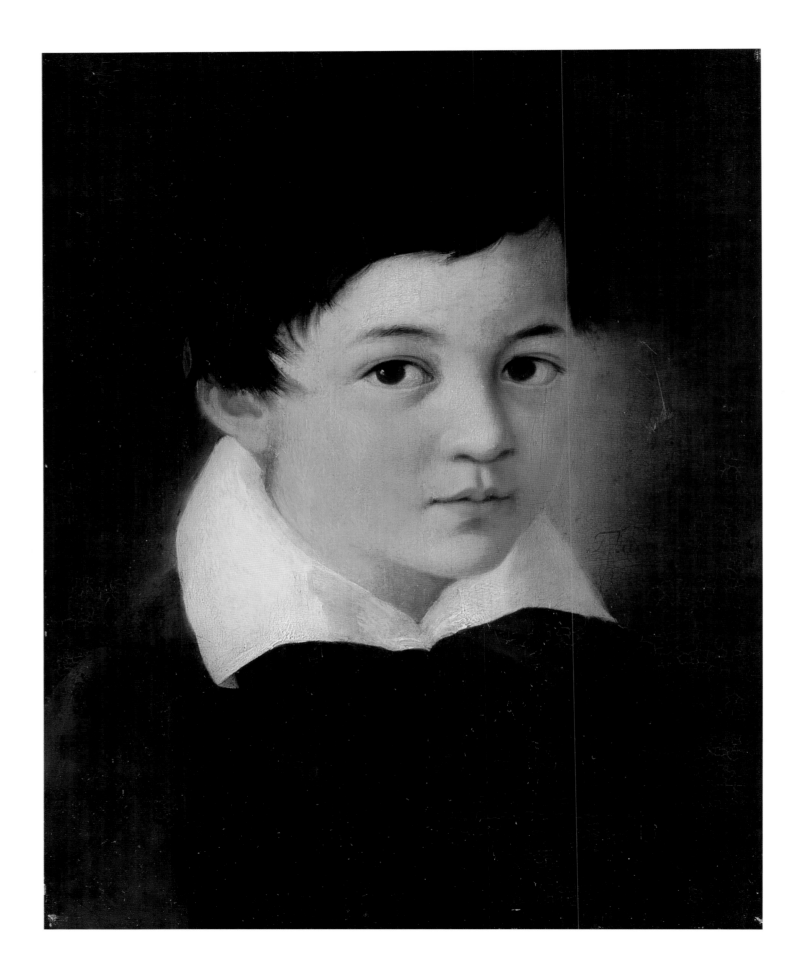

younger sister Elena's wax profile of Peter the Great; the two princesses, who were portrayed by Vigée-Lebrun the same year (see p. 185), were only twelve and eleven years old at the time.[41] In 1815 Maria Fedorovna visited the Academy with her daughter Anna Pavlovna, and presented a gold medal she had made that was dedicated to her son, Emperor Alexander I. A year later, Anna Pavlovna herself presented a life-size drawing after Raphael's *Holy Family*. The Academy, in response, made Anna an honorary lover of the arts (*Pochetnyi Liubitel'*), "in recognition as much of its feelings of gratitude as of its rightful respect for the work itself."[42] Maria Fedorovna, herself such a keen patron and artist, had not neglected her children's artistic education; in fact, she had hired as their tutor Orest Kiprensky, one of the greatest portrait painters of his day.

In the 1820s the number of women to win academic recognition, while still very small, began to increase. In 1820, for example, both Maria Durnova and Marie Gomion (see pp. 112–13) were "appointed" teachers after presenting, respectively, two and seven portraits. Durnova, the daughter of a history painter, may have submitted her *Portrait of a Boy* now in the State Russian Museum, which is signed and dated 1820 (fig. 18). This sensitive portrait shows the influence of such artists as Kiprensky, who were developing a more Romantic approach to portraiture in Russia at the time. In 1821, both Durnova and Gomion asked the Academy to set them a program to follow in order to compete for the title of Academician, as was normal practise at the time. They were each requested to paint a life-size portrait in oils of a well-known figure, so that the quality of the likeness could be easily assessed.[43] Unfortunately, there is no further mention of either woman in the Academy's records, which means that they were unsuccessful in their submissions for the title of Academician. In the 1830s, however, there are more signs of women artists achieving academic success. In 1834 A.M. Bakunina won a first-class silver medal for her *Portrait of Count V.V. Musin-Pushkin-Brius*, and the following year she traveled to Italy as a scholar of the Imperial Society for the Encouragement of the Arts, becoming the first Russian woman artist to receive a grant to study abroad.[44] The history and landscape painter Alexander Ivanov, himself sponsored by the Society for the Encouragement of the Arts, was indignant at this, writing to his father: "They have given Bakunina about as much as they gave me for a whole three years, which is a complete waste of money. They have dozens of minor pensioners, not one of whom will be of the slightest significance."[45] Ivanov's vitriol was to a certain extent justified, as we know practically nothing of Bakunina's further career; but he evidently

Fig. 18 Maria Durnova, *Portrait of a Boy*, 1820, oil on panel, 15⅜ × 12 in. (39 × 30.5 cm), State Russian Museum, St. Petersburg

disapproved of women artists *per se*, attacking the work of one of his peers as comparable to "women's painting, that is timid and weak."[46] There is no evidence that his was a representative view, but Ivanov's comments reveal the opposition that women faced from at least some of their contemporaries.

By this time, women artists seem to have been coming from a wider range of social backgrounds. The material on women artists in late eighteenth- and early nineteenth-century Russia, sparse as it is, suggests that almost all of them were either expatriates, relatives of male artists, or members of the aristocratic or the imperial élite; but by the 1830s, Academy records begin to feature women who were not exceptionally privileged or well connected. In 1839, for example, Maria Kurt, the wife of a merchant of the third guild in St. Petersburg, was made a Non-class Artist.[47] (The Academy awarded various titles at the time, the main categories of which were Professor, Academician, Class Artist, and Non-class Artist, in descending order of seniority.) It is important not to overstate this case, as there is little documentation available, but what evidence there is suggests a certain, albeit limited, democratization of female artistic endeavor. Maria Kurt seems to have owed her achievement to her driving ambition rather than to any social privilege, writing in her letter of application to the Academy: "having studied painting for ages, all my aspirations are focussed on attracting the attention of the public and, sooner or later, counting myself among the profession of Russian artists."[48] Sadly she found no lasting success, as twenty-six years later, at the age of seventy-five, she was writing to the Academy to ask for financial help.[49] The stories of Durnova, Gomion, Bakunina, and Kurt all suggest that even those women recognized by the Academy found it difficult, if not impossible, to make a career as a professional artist at the time.

While these women were aspiring to recognition as fine artists in the 1830s, another Russian woman was attempting to make a very different contribution to the development of the arts. She was Princess Zinaida Volkonskaia (1789–1862), a celebrated society figure, who in her youth had been a maid of honor to the Dowager Empress Maria Fedorovna, and the mistress and confidante of Alexander I. As a young woman she had sparkled in the most vibrant salons, including that of Alexander Stroganov, where on one occasion she had composed a poem, "*Vers au Président de L'Académie Strogonovienne*," celebrating Stroganov's portrait by Vigée-Lebrun.[50] Volkonskaia herself then became one of Russia's greatest *salonnières*, establishing salons in Moscow and, later, Rome, where she entertained a host of intellectual and artistic luminaries, including the writers Alexander Pushkin, Walter

Scott, and Nikolai Gogol, and the composers Mikhail Glinka and Gioacchino Rossini.[51] In Rome, her elegant villa became a focal point for young Russian artists working abroad as pensioners of the Academy of Arts.[52] The painters Karl Briullov and Fedor Bruni both stayed as houseguests in the 1820s. When Volkonskaia and Briullov met again in 1850, it was "with such an explosion of joy, such a reunion of common interests, that all present felt they were set apart, that they were merely chance, outside witnesses of another life."[53] Her close friendship with many pre-eminent artists is evident in a watercolor by Briullov, in which Volkonskaia, the Danish sculptor Bertel Thorvaldsen, Bruni, and Briullov himself watch an amateur dramatic performance in the Gagarin residence in Rome.

While she was living abroad, Volkonskaia was receptive to cultural and museo-logical developments in Western Europe, including the foundation of public art museums in Italy, France, England, and Germany, and she became acutely aware of the lack of any comparable institution in Moscow. She therefore drew up a proposal to establish a Museum of Fine Arts attached to Moscow University, which she published in the Russian journal *Telescope* in 1831. The museum would include casts and copies of works from Antiquity, the Middle Ages, and the Renaissance, models of famous architectural monuments, genuine Classical artifacts, and notable modern works. These would be arranged chronologically, so that the viewer could follow the development of the arts from Classical Antiquity to the present day. Significantly, the princess paid homage to "the immortal Winckelmann," and noted where certain sculptures featured in his texts, demonstrating her close familiarity with one of the most influential writers on Classical art. The entrance to the Egyptian section was even going to be flanked by a bust of Johann Joachim Winckelmann, "as the first interpreter of art."[54] The museum would open to artists every day, and to the general public twice a week. The princess planned to use her connections with some of the leading artists in Rome to have the copies and casts made, adding that her contacts would enable her to buy these at the preferential rates usually offered only to artists. She also proposed launching a subscription in Moscow and St. Petersburg to raise funds for the museum, and hoped, rather pointedly, that if Moscow University was unable to devote a specific building to the museum, then perhaps some local dignitary might.[55] In a separate letter she even named which dignitaries she had in mind, revealing the extent of her uninhibited canvassing on behalf of the museum.[56]

Volkonskaia sent her proposal to various influential acquaintances of hers in Moscow and St. Petersburg,[57] and found her greatest supporter in Mikhail Pogodin,

a young professor of history at Moscow University who would later make a name for himself as the editor of the prominent journal *The Muscovite*. Pogodin was exceedingly enthusiastic, not least because he sensed an advantageous opening for himself. In a letter of 10 April 1830 he suggested that the princess employ him to liaise with artists in Italy, advise on packing and transport, and help set up the exhibit in Moscow, adding that this would cost 3000 rubles for six months.[58] But Volkonskaia's project was not met with unanimous enthusiasm in Russia, with her husband, among others, voicing doubts as to its feasibility.[59] His scepticism was well founded, as the Council of Moscow University rejected Volkonskaia's plan for lack of funds. Russia had to wait another thirty years for a state art museum: the first one, the Rumiantsev Museum, opened in Moscow on 12 May 1862.[60] Volkonskaia's role was to raise awareness of the need for public art collections to assist in the education of artists and in the elevation of public taste. Nearly seventy years later, the importance of her contribution was recognized by the founder of the most direct descendant of her proposal, the Pushkin Museum of Fine Arts.[61]

By the middle of the nineteenth century, there were more opportunities for women to train as artists in Russia. A growing number were attending the Academy as a "free attendant" or auditor (*vol'noprikhodiashchyi*). These students had no right to the Academy's stipends, and could not take part in the official competitions that were held each year, but they were able to win medals and awards. Some of the new art schools in the provinces also admitted female students. These women were often related to those running the schools: Alexandra Venetsianova, for example, studied at the school that her father, the famous painter of peasants Alexei Venetsianov, had established on his estate in Tver Province in the 1820s. Ekaterina Demidova and Elizaveta Nadezhina also both studied at their father Afanasy Nadezhin's art school in Kozlov.[62] But the landowner Sophia Bekhteeva attended Nadezhin's school as well, and is no known relation of the male artist.[63] Bekhteeva's status as landowner may have put her in a position to support the school financially, which might have given her access to classes. On the other hand, her attendance at the school could suggest that at least some of the provincial art schools admitted women artists who had no family connections, but were assessed on their talent and/or application alone.

The most important development in women's artistic education in St. Petersburg was the special section for women auditors that was set up in the art school organized by the Society for the Encouragement of the Arts. We have a valuable record of this

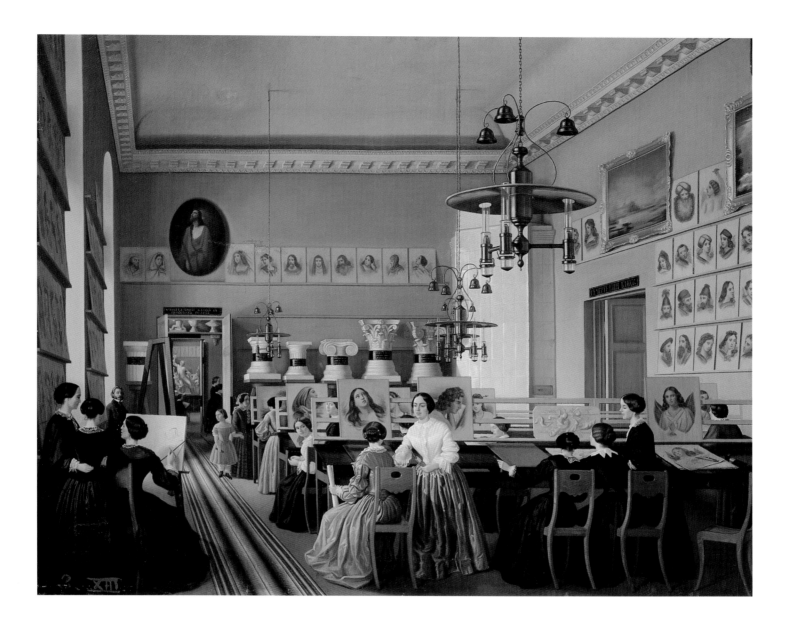

Fig. 19 Ekaterina Khilkova, *The Interior of the Women's Section of the St. Petersburg Drawing School for Auditors*, 1855, oil on canvas, 28¾ × 35⅛ in. (73 × 89 cm), State Russian Museum, St. Petersburg

part of the school in Ekaterina Khilkova's painting *The Interior of the Women's Section of the St. Petersburg Drawing School for Auditors* (1855; fig. 19). In the painting, a number of well-dressed women sit at carefully ordered desks, working on life-size drawings of heads. There are examples of their work pinned to the walls, along with a few oil paintings, while a copy of the Laocöon glimpsed through the open door gives an idea of the sort of Classical models they were encouraged to follow. Notably, the teachers are women, and there is one who appears to be visiting the class with a young girl; perhaps this is a young potential recruit, or evidence that the school recognized and accommodated some of the childcare responsibilities that many of their students may have faced. The painting speaks eloquently of the discipline and

application with which these women were studying their art. Khilkova submitted it to the Academy and was rewarded with a second-class silver medal in 1855.[64]

Khilkova was not unusual in receiving a silver medal, as women were gaining greater recognition at the Academy by this time. In 1850 the Academy Council noted that certain changes that it had asked the painter Elizaveta Klevetskaia to make to her work for the cathedral of St. Andrew had been completed, suggesting that women were winning public commissions that had been mediated by the Academy.[65] In 1851 Nadezhda Kreiter, the daughter of a collegiate councilor, was given the title of Artist of Perspective Painting for her copy of Karl Briullov's painting *The Fountain of Bakhchisarai*, and for an interior scene.[66] In 1852 Iulia Baltius, Maria Tsando, Marie Sordet, and Emilia Shtein also received the title of Artist.[67] Some of these women were clearly making a career in the arts. Shtein, for example, noted in her letter of application to the Academy that she had been a painter for many years, "as much to exist as out of her love for the art," and concluded that the title of Artist would provide both encouragement and better means to survive.[68] In 1852 the Academy also gave the title of Artist of History Painting to the twenty-one-year-old Elizaveta Lazareva-Stanishcheva, marking the first occasion on which a Russian woman was recognized for her work in the top category of the academic hierarchy of genres.[69] Lazareva-Stanishcheva's father had first sent examples of her work to the Academy in 1847, writing that his daughter had an evident aptitude for history painting but little opportunity to perfect her art, as he was a general-major stationed in Warsaw and could not afford to send her abroad. He therefore asked the Academy to sponsor her to study in Italy, adding that her talent might be hereditary, as she was the granddaughter of the famous sculptor Mikhail Kozlovsky on her mother's side.[70] His request had some effect, as in 1848 the Academy recommended that the governing body grant her some form of assistance.[71] There is no record of what help, if any, was offered, but the fact that Lazareva-Stanishcheva was the first woman to be made an Artist of History Painting confirms that the Academy held her work in high regard.

A further milestone was reached in 1854 when Sophia Sukhovo-Kobylina (1825–1867) won a first-class gold medal, becoming the first woman to win the Academy's highest award.[72] The artist broke away from her usual practise of landscape painting to commemorate this momentous event in *Sophia Vasilevna Sukhovo-Kobylina Receiving a First-class Gold Medal in the Academy of Arts for her Landscape Works Painted from Life* (1854). The medal carried with it the right to study abroad as an Academy pensioner, but Sukhovo-Kobylina went abroad at her own expense,

for reasons that are not clear: perhaps because she came from a noble family, because she was a woman, or because she was not a full-time student of the Academy.[73] (The third supposition is supported by precedent, as Alexander Ivanov had also been ineligible for a studentship, having been admitted to the Academy unofficially because his father was a professor of painting there.) Sukhovo-Kobylina established a successful studio in Rome that became a focal point for both Russian and foreign artists, and her achievement in winning a first-class gold medal served as an example for women artists for years to come.[74] By the end of the 1850s, women were even being elected Academicians. Natalia Makukhina, the wife of a captain-lieutenant, was made an Academician of Portrait Painting in 1857 for her portraits of Prince G.P. Volkonsky and members of the imperial family, and in 1858 the same rank was awarded to the Baltic German Julie Hagen-Schwartz.[75] Hagen-Schwartz, who had studied both in Munich and with her father, a painter and engraver, went on to paint more than five hundred portraits in Europe between 1872 and 1898, but the whereabouts of only a few of these are now known.[76] Indeed, none of these artists achieved any widespread or long-standing renown. The only woman artist who did establish a lasting reputation in the middle of the nineteenth century was a foreigner, the Scottish portraitist Christina Robertson, which suggests that Russian artists were still viewed by at least some imperial and aristocratic patrons as inferior to their Western European counterparts.[77] But the fact that over twenty-five women painters won academic medals or titles in the 1850s demonstrates the progress that the Academy had made in nourishing their art.[78]

It is not clear exactly why, in the middle of the nineteenth century, the Academy was prepared to recognize more women artists, and to award them greater distinctions. There had been changes to the Academy's statutes in 1840 that may have included a greater accommodation of women artists than in previous years, but there is no specific record of this.[79] Nor are there sufficient extant works by women artists of this and earlier periods to assess whether their rising profile was thanks to a higher quality in their art. After the Emancipation of Serfdom, in 1861, more women in general were seeking work, as impoverished members of the Russian gentry were no longer able to support unmarried female relatives, and they also hired governesses less frequently, reducing the opportunities available in one of the traditional occupations open to women.[80] But it is difficult to ascertain whether women were applying to the Academy in greater numbers, as the Academy archives include far more documents relating to its successful applicants than it does to those whom it rejected.

The greater recognition of women artists from the 1850s may, however, have been linked to the Academy's first woman president, Grand Duchess Maria Nikolaevna, who was elected in 1852. The eldest and favorite daughter of Nicholas I, Maria Nikolaevna had long been a keen promoter of the arts, and, as was common among her class, painted watercolors, which she would occasionally give away to friends.[81] In 1839 she had married Maximilian, Duke of Leuchtenberg, who had inherited the impressive Leuchtenberg art collection. Together, Maximilian and his wife had expanded this collection until it was one of the richest private collections in Russia at the time.[82] The imperial couple was closely involved with the Academy, with Maximilian serving as president from 1843 to 1852, and Maria Nikolaevna elected an honorary lover of the arts in 1845.[83] In Christina Robertson's portrait of Maria Nikolaevna of 1841 (opposite), the twenty-two-year-old grand duchess is shown turning away momentarily from her music, a look of distant concentration on her face. Robertson may have been sensitive to the aims and aspirations of this particular sitter, thanks to the grand duchess's budding interest in the arts.

When Maximilian died, in 1852, Maria Nikolaevna assumed the presidencies both of the Academy and of the Society for the Encouragement of the Arts. She took these responsibilities seriously, taking pains to keep the Academy informed of her movements, and delegating her duties where necessary if she was going away.[84] The grand duchess's involvement, which one scholar has termed "meddlesome,"[85] was not always welcome, and at times the Academy Council did not adopt her proposals. In March 1853, for example, it turned down her recommendation that a certain architect named Simon be made an Academician without submitting the requisite program of work. But the grand duchess also made constructive suggestions that were adopted, and frequently intervened on the Academy's behalf. In 1856 she proposed a new class in icon painting, for which Alexander II, her brother, agreed an annual subsidy of 4000 rubles from the State Treasury to buy books, Byzantine icons, and copies of icons to serve as teaching aids. In 1869 Maria Nikolaevna herself began to donate 1000 rubles a year to reward the best works at the annual exhibitions, persuading Count Tolstoi to give 1500 rubles a year for the same cause, and in 1871 the tsar agreed to give the Academy a further 10,000 rubles a year.[86] The grand duchess made generous donations to the Academy museum and library, and left a number of paintings, and 5000 rubles to buy works of art in her name when she died. During her presidency the Academy also implemented important new statutes, in 1859. These introduced major changes in staffing and administration, a weekly life-drawing class, and a broader

Christina Robertson,
*Portrait of Grand Duchess
Maria Nikolaevna*, 1841,
detail (see p. 153)

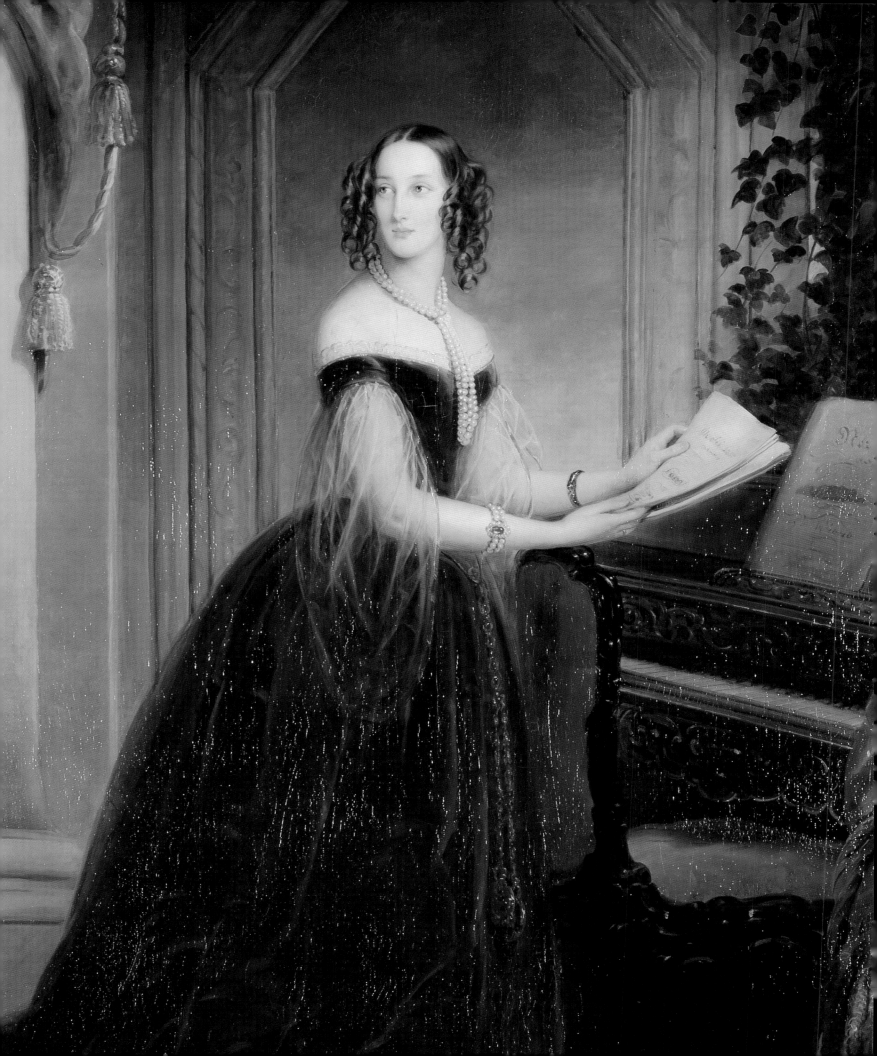

education program, which now included subjects such as aesthetics and archaeology for all students, and physics and chemistry for those studying architecture.[87]

By far the most significant change in this context, however, was the Academy's eventual recognition of the need to provide an official education for women artists. More than a century after it had received its first statutes (in 1764), and twenty-one years into the tenure of its first female president, the Academy finally admitted women as full-time students in 1873.[88] This development was congruent with much broader changes in Russian society, where a campaign for women's secondary and higher education had been gathering momentum since the atmosphere of reform that followed the Crimean War. The campaigners had achieved their first successes in the late 1850s, when Alexander II had approved a plan for secondary schools for girls (whose curriculum included drawing), and women had begun to audit university courses.[89] Following setbacks in the 1860s,[90] there were further advances from 1869 to 1876, the years immediately prior to and following the admission of women to the Academy. These included advanced secondary courses to prepare women for university, which started in St. Petersburg and Moscow in 1869; a series of evening lectures on academic subjects, which opened to both sexes in St. Petersburg in 1870; and Alexander II's final authorization of women's higher courses in April 1876.[91] The Moscow School of Painting, Sculpture, and Architecture began to admit more women students as auditors and full-time students at the same time.[92]

The Academy of Art's first full-time women students were initially admitted to the same practical and academic classes as the men, where, as their numbers were small, "they did not present any particular encumbrance to either the [male] students or to those charged with supervising them."[93] But by 1876, with twenty-four women now enrolled, the decision was taken to segregate them. According to the Council, classes had become over-crowded, and supervision almost impossible, "with such a large number of members of the female sex circulating among the [male] students in all corners of the Academy."[94] The Council therefore proposed a series of separate classes for women, including daily drawing classes of plaster-casts from 11 am to 1 pm, and life-drawing classes, but of heads only, at the same time. For this provision each student would pay 50 rubles, of which 25 was for their professors and 25 to cover other expenses, such as the cost of the models. While women could still obtain an official training in the arts, these reforms meant that they no longer had access to the range of artistic education that was available to men.

These changes to the treatment of women artists were made in 1876, the very year in which Maria Nikolaevna died. Perhaps it was only after her death that the Academy felt free to impose restrictions again on its female students. In 1884 further limitations were introduced when, in view of the fact that the number of women studying in the Academy had now grown to fifty-two, a Council meeting agreed to restrict their number to twenty-five full-time students and twenty-five auditors per year (as had apparently been stipulated by the president eight years previously).[98] Women artists therefore continued to face constraints that were not presented to their male counterparts. These cutbacks reflected stringent limitations that were imposed on higher education establishments for both men and women following the assassination of Alexander II in 1881. Convinced that the universities were a crucible of political radicalism, the government replaced the university statute with a far more restrictive charter, in 1884, stripping the universities of their autonomy. In 1886 the government also closed admissions to the women's higher courses, its suspicion of women's higher education fueled by the fact that the assassination had been coordinated by a woman (Sophia Perovskaia, who became the first woman to be hanged in Russia for a political crime). In time, the courses ceased as their existing students graduated.[96]

Despite the limitations imposed on their education, in the last three decades of the nineteenth century many Russian women managed to establish themselves as recognized fine artists. Many trained successfully at the Academy, which awarded medals and titles to more than eighty women painters from 1880 to 1914.[97] Others, most notably Marie Bashkirtseff, attempted to forge reputations for themselves abroad.[98] Several women set up long-lasting and thriving art schools. In 1868 Maria Ivanova-Raevskaia established an art school in Kharkov, Ukraine, for which she was made an honorary free associate of the Academy in 1872.[99] Elizaveta Zvantseva also set up a private art school in St. Petersburg whose teachers included Valentin Serov and Konstantin Korovin, two of the most famous artists of Russia's Silver Age.[100] By the centennial anniversary of the death of Catherine the Great, in 1896, the work of these and other women artists as both pedagogues and practitioners was marked by its professionalism and dedication. No longer dismissed as amateur dilettantes or simply tolerated by an artistic establishment that paid lip-service to their achievements, they made a full and active contribution to Russian cultural life.

"Brilliant Proof of the Creative Abilities of Women": Marie-Anne Collot in Russia

IRINA G. ETOEVA

FOR MORE THAN TWO HUNDRED YEARS, a striking sculpture of a powerful horse rearing on a granite pedestal has dominated Senate Square in the heart of St. Petersburg (fig. 20). Known as The Bronze Horseman, the sculpture was conceived as a monument to Peter I (reigned 1682–1725), the founder of St. Petersburg, who made it his mission to transform Russia into a modern European state. The sculpture was immortalized by Russia's most famous poet, Alexander Pushkin, in his epic poem *The Bronze Horseman* (1833), from which the monument derives its name.

Catherine the Great commissioned the monument from the renowned French sculptor Etienne-Maurice Falconet, whom she invited to Russia for the project. Falconet's response to the commission went far beyond contemporary conceptions of the nature of an equestrian statue. Free of traditional bombastic allegory, his monument embodies Peter's role and significance for Russia. As the sculptor wrote in response to a program for the sculpture suggested by his friend the philosopher Denis Diderot: "My monument shall be simple. Peter the Great himself is both subject and attribute: it remains only to demonstrate this."[1] Seated on a fiery horse, Peter is the picture of majesty and composure as he reaches out to the city of his creation, his proud head crowned with a laurel wreath, and his face reflecting the vision and determination for which he was famed. Yet the head of the sculpture was not the work of Falconet but that of his student, twenty-year-old Marie-Anne Collot (1748–1821), who came with him from France to Russia and played a major role in creating the monument. It was in St. Petersburg, where Collot stayed for twelve years, that the young Frenchwoman realized her artistic potential. Her most significant works remain there to this day.

Even by today's standards, Marie-Anne Collot's meteoric rise as a successful woman sculptor would be deemed unusual. Little is known about her early years, but

Fig. 20 Etienne-Maurice Falconet and Marie-Anne Collot, Monument to Peter the Great (The Bronze Horseman), 1766–78, unveiled 1782, Senate Square, St. Petersburg

77

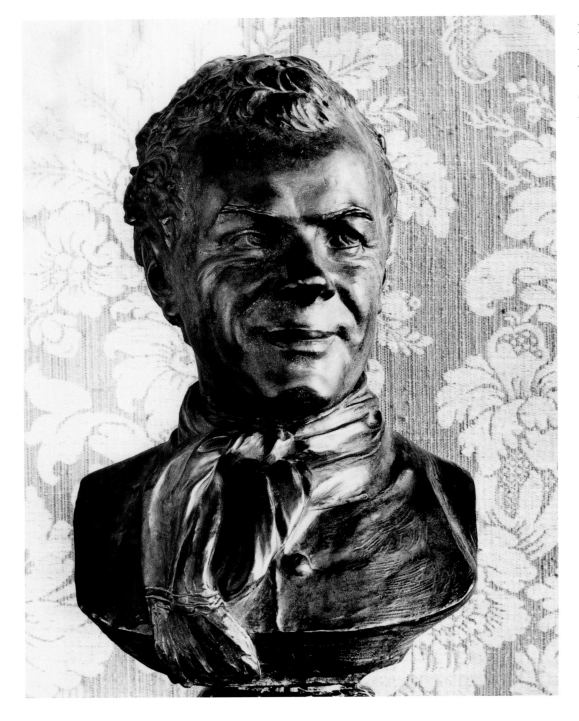

Fig. 21 Marie-Anne Collot,
*Portrait of the Sculptor
Etienne-Maurice Falconet*,
1768, plaster, height 25⅜ in.
(65 cm), Musée des Beaux-
Arts, Nancy

she did not come from an artistic family, as was the case with many contemporary women artists including Anna Dorothea Therbusch-Lisiewska, Angelica Kauffman, and Elisabeth Vigée-Lebrun. Rather, Diderot's letters to Falconet reveal that she came from a humble background (as did Falconet, who was the son of a cabinetmaker). Deprived of her family at an early age (her father abandoned his family when she was

a minor), she began to earn a living as an artist's model out of financial necessity. This work, which was of low social status, was to cause problems when she later became a professional artist and sought the approval of the French artistic establishment.

In 1763, aged fifteen, Collot entered the studio of Falconet (fig. 21), and found herself an alternative family in the circle of artists, writers, and connoisseurs that surrounded him. These included Diderot, Baron von Grimm, Mme Geoffrin, and the Russian Prince Dmitry Golitsyn, who acted as one of Catherine the Great's agents in the purchase of works of art and facilitated the empress's acquaintance with numerous French intellectuals. One of the first women known to sculpt prior to 1800, Collot was something of a novelty, as during her lifetime there were no women artists—at least in Paris, the center of the contemporary art world—who made a career for themselves in an area as physically demanding as sculpture.

Within two years, Collot had made a reputation within her artistic circle for portraiture. Diderot so admired Collot's work that in his review of the sculpture at the Salon of 1765 he attempted to sway public opinion in her favor, writing that "if there are women who paint heads, then why should there not be one who sculpts a bust?"[2] Grimm, for his part, praised her portrait of the famous actor Préville in the role of Molière's Sganarelle, as well as those that she had sculpted of Diderot and Golitsyn. As Grimm noted, Collot was "a quite rare and perhaps unique phenomenon."[3] Some women, especially the wives or daughters of artists, engaged in painting or printmaking and occasionally exhibited their work at the Paris Salons. But there is no mention at the Salons of women who exhibited sculpture, which was essentially perceived as a masculine endeavor. Collot was therefore alone in her artistic ambitions, as Falconet would later emphasize in a letter to Catherine the Great: "without wishing here to vaunt her talent, Your Majesty knows that it is unique and that she is the sole representative of her sex who is devoted to the hard craft of working in marble, and working it successfully."[4] Rightly proud of his protégée, Falconet was to promote her reputation and work in this way for many years.

In 1766, after much deliberation, Collot agreed to accompany Falconet to Russia. She came highly recommended. Diderot told General Ivan Betskoi, who was in charge of the Imperial Academy of Arts under Catherine the Great, that the young sculptor possessed faultless taste and outstanding talent. Prince Golitsyn, for his part, wrote to the minister of foreign affairs, Count Panin: "she is like a prodigy in her talent and her behavior; the vast number of portraits which I have seen her make here are perfect and she cannot fail to be useful in our country."[5] In drafting Falconet's

contract with Golitsyn, Diderot included Collot's conditions of work, indicating that she already had a certain artistic independence from Falconet. The young sculptor must have had great expectations that St. Petersburg would offer an environment in which she could flourish as an artist.

On Collot's arrival in the Russian capital, her hopes were soon realized. On 23 December 1767 she was accepted into the Imperial Academy of Arts, which enabled her to display her works in the Academy's galleries. She also soon established her reputation, and an impressive clientele, with a series of portraits that she produced for the court and for the cream of St. Petersburg society. Collot's two portrait busts of the Empress Catherine, in particular, guaranteed the artist's success. The first, dated 1768, follows the traditional form of the state portrait and was produced from existing images, as was often the case for imperial portraits. Indeed, neither Falconet nor Collot had met Catherine by this stage, as the empress was enjoying an extended stay in Moscow (a circumstance that led to the extensive correspondence between Catherine and Falconet that is a particularly useful source of information about Collot's work). Collot's second portrait of the empress (fig. 22), however, was sculpted from life in 1769 after Catherine's return from Moscow, and skillfully captures the appearance of the forty-year-old empress. Collot selected a form similar to an ancient bust, but chose to model Catherine as a priestess to the goddess of reason, rather than as a Roman empress. This was bound to appeal to Catherine, who was well read in philosophy and corresponded regularly with Diderot and Voltaire. It is possible that Collot's approach stemmed from the numerous trips that she and Falconet made at the time to Catherine's summer residence at Tsarskoe Selo, near St. Petersburg. While Catherine conversed with Falconet, who was himself interested in philosophy, Collot might have been able to model Catherine in clay, or at least to make a careful study of the empress. She thus managed to capture the empress's intelligence and her well-known interest in philosophical debate. Of the vast number of images of Catherine, this was the first sculpted portrait to be executed from life, and was praised for being much more lifelike than other images of the empress. When Collot presented it to Catherine, the empress admired it, and rewarded the sculptor with a gold snuffbox and 500 rubles.[6]

Collot's busts of the empress cemented her reputation and status, and secured her a regular salary from the imperial court. In 1767, when Catherine had returned from her trip to Moscow, she had signed an instruction to her office "To pay to the young French lady Collot currently in our service since the start of this year 1767 for as long

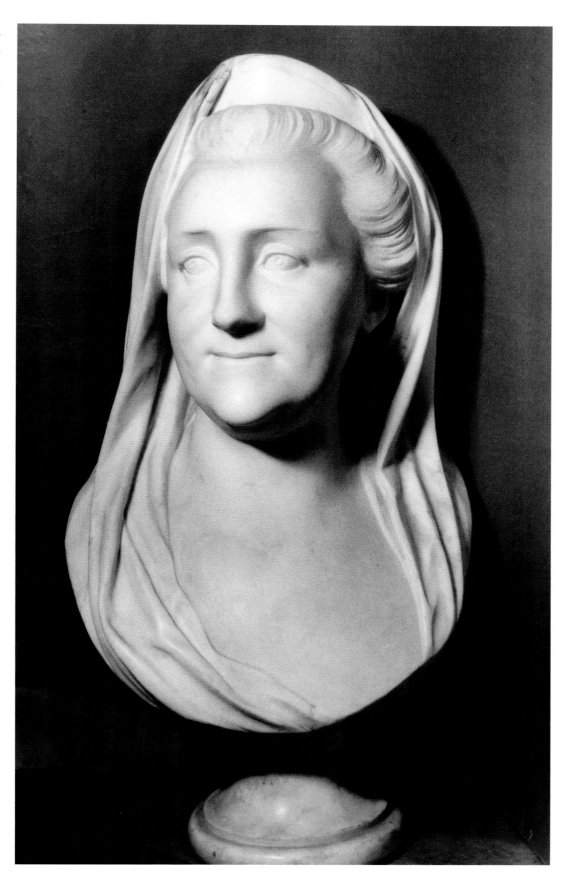

Fig. 22 Marie-Anne Collot,
Portrait of Catherine the Great,
1769, marble, height 24 in.
(61 cm) (see also p. 201)

as she shall be in service 300 rubles per annum." On 22 August 1768 came a further order to add "to the previously assigned 300 rubles" another 700 rubles, bringing Collot's annual salary to 1000 rubles.[7] This second order came after Collot's participation at the annual exhibition at the Imperial Academy of Arts. According to Stählin:

> In June there was the usual eight-day holiday at the Academy of Arts when the latest works by Academicians were publicly exhibited. Among them in the sculpture section appeared a very well caught head of Her Majesty in plaster, the work of Mademoiselle Collot, and also most expressive heads of her teacher Monsieur Falconet, and of the Colonel of Artillery Melissino and his wife.[8]

The last two portraits of the colonel and his wife are no longer extant, but that of Falconet (see p. 207) is still one of the most renowned sculptures in the Hermitage collection.

Collot knew the complexities of Falconet's character better than anyone: she had often witnessed his creative process and worked as his assistant, and was both valued and respected by the sculptor. Her portrait of him clearly conveys the depth of this personal and professional relationship, and demonstrates the extent to which Collot was able to combine her professional skill with psychological insight into the character of her mentor and friend. It captures in particular both Falconet's brilliance and his humanity, a quality that Diderot had alluded to in his Salon review of 1769. Writing about one of the works on display, Diderot had enthused: "I like it when the heart does that which talent alone could not."[9] When Collot had completed the bust, Catherine honored it, and the Frenchwoman's other works, by placing them in the Hermitage Gallery, despite the fact that the Hermitage was not intended for the display of works of sculpture at the time.

Catherine, whose opinion of artists fluctuated wildly, was consistent in her respectful treatment of Collot, even after the empress's relationship with Falconet had deteriorated, and she had lost all interest in carrying on a correspondence with him. She demonstrated her affection for Collot early on, and repeatedly mentioned the Frenchwoman in her letters, which are unfailingly positive in their assessment of her talent. Thus in a letter to Falconet of 17 September 1769, she praised Collot for working hard and acquitting herself so well. Writing of her desire to obtain several more medallions by Collot, the empress added: "in all this, good Monsieur, I consult you and you shall tell me your opinion without worrying Mad. Collot inconveniently by suggesting to her too many things at once."[10] Catherine even sought to pamper

the young sculptor, expressing her intention of giving her a trinket as a present. When she failed to make good her promise, she wrote: "I think that Mlle Collot is very cross with me because the trinket I promised her has not yet arrived, but I shall keep my word to her." This subject developed over the course of several letters, with Falconet replying to Catherine "I indeed think that Mlle Collot is cross with Your Majesty" as she had quit her work "jumping for joy" at the prospect of the trinket from the empress.[11] These letters suggest an occasional, and unusual, absence of ceremony in the relationship between the sculptor and the empress, who manifested an unwavering admiration for her young employee's work.

It is possible that this relationship of mutual respect between the empress and the artist provided the fuel to complete the monument of Peter the Great. Collot had assisted Falconet from the start with his projected public monument: in Falconet's own words, her advice helped him overcome "a chasm of stupidities."[12] When Falconet was unable to produce a satisfactory model for Peter's head (both Catherine and Ivan Betskoi, who was in charge of the project, rejected numerous designs), Collot took over this aspect of the work (fig. 23). Her ability to work at lightning speed gave rise to the legend that the sketch for Peter's head was sculpted in a single night. In fact, Falconet's correspondence with the empress reveals that Collot worked on the head for more than a year, from 1772 to 1773, producing both a small sketch that captured her essential idea, and a large model the size of the finished monument. In order to make her head sufficiently lifelike, Collot used the death mask of Peter the Great. The result vividly caught the character of the tempestuous ruler, who holds his horse back from the craggy outcrop as he surveys the land that he had transformed.

Falconet was one of the first to praise the finished work. Despite the empress's increasing coldness toward him, he also took pains to inform her of Collot's success in Paris during the trip she made home in 1775–76. "It is to your patronage, your kind encouragement," he wrote, "that she owes the eulogies which people are showering on her in the country where they had wanted to believe that I produced her works. They saw her modeling and they were convinced [that the work was Collot's own]. Our best artists and connoisseurs have said and written of her the most flattering things."[13] Thus Falconet continued to help cultivate the relationship between his favorite pupil and Catherine the Great.

On her return to Russia from Paris in 1776, Collot married Falconet's son Pierre-Etienne, a mediocre painter who had studied in England under Joshua Reynolds and had come to St. Petersburg in 1773. Through his father's contacts, he

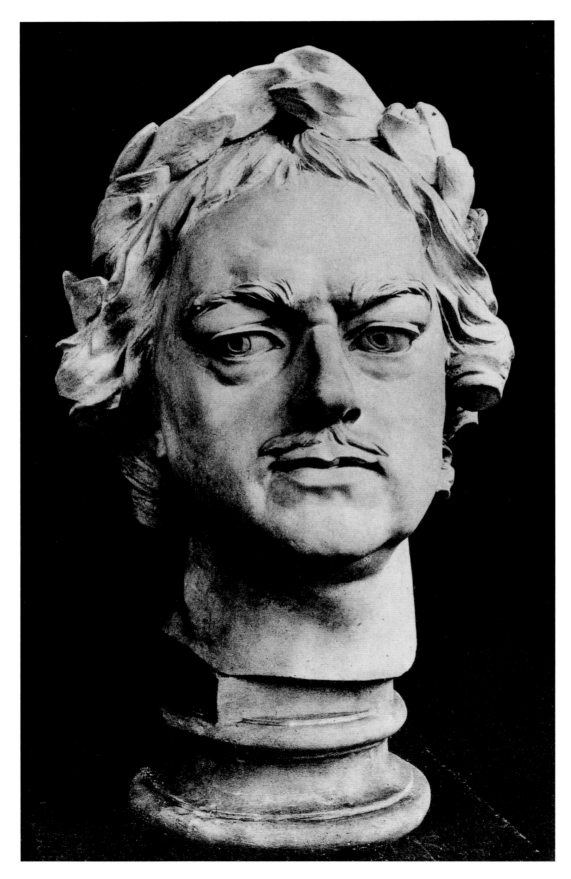

Fig. 23 Marie-Anne Collot,
Model of Peter the Great's
head for the statue The
Bronze Horseman by Etienne-
Maurice Falconet, 1770s,
plaster, $36\frac{5}{8} \times 22\frac{7}{16} \times 23\frac{5}{8}$ in.
(93 × 57 × 60 cm),
State Russian Museum,
St. Petersburg

was commissioned to paint portraits of the empress and other members of the imperial family. His best work from this time, however, is a portrait he produced of his wife (Musée des Beaux-Arts, Nancy). The State Russian Museum in St. Petersburg also owns a pencil drawing by him of Collot, which was clearly a sketch for an engraving (see p. 198). Unfortunately the marriage brought Collot little happiness, and many believed that it had been conducted simply to please Pierre's father.

In 1778, after the birth of her daughter, Marie-Anne Collot Falconet left St. Petersburg for good. She took with her the models for her sculpture, hoping that they would impress members of the French Académie, but she was to produce little work in France. An unhappy family life, the demands of motherhood, and caring for her father-in-law, who was paralysed in 1783, made it impossible for her to work on her art. She remained loyal to her teacher, looking after him until his death on 24 January 1791. Just six months later, her husband also died. Collot Falconet managed to escape the terrors of the French Revolution, and purchased the Château of Marimont, near Nancy in Lorraine, from the duc de Richelieu (who had emigrated to Russia). There, she spent the next thirty years of her life, keeping her existing sculptures and a collection of works of art, but no longer practicing as an artist. She died on 23 February 1821 at the age of seventy-three. Her daughter, Marie-Lucie, Baroness Jankowitz, who was the last member of the Falconet family, maintained her mother's collection. Not long before her own death, the baroness carried out her grandfather's wishes and returned to Russia all his correspondence with the Empress Catherine, as well as a number of gifts that he had received from her.

If Collot Falconet never made an impact in her native country, her reputation remained strong in Russia even after her death. The leading nineteenth-century art critic Vladimir Stasov, for example, devoted an essay to three of the great French sculptors who had worked in Russia, in which he included Collot alongside Houdon and Falconet. "Yes," enthused Stasov, "in Collot's creation there was great superiority, to employ Falconet's expression; here was manifest brilliant proof of the creative abilities of women in art, on an equal with the most talented and powerful male artists. Everything here is energetic and courageous, and of course no one not already aware of the fact would have guessed that this magnificent head of the great Russian Tsar, full of power and expression, had been modeled by a young girl."[14] As a critic, Stasov was much more concerned with promoting native Russian art than he was with drawing attention to the work of foreigners. His high praise for Collot's work is, therefore, particularly compelling testimony of the legacy of her sculpture.

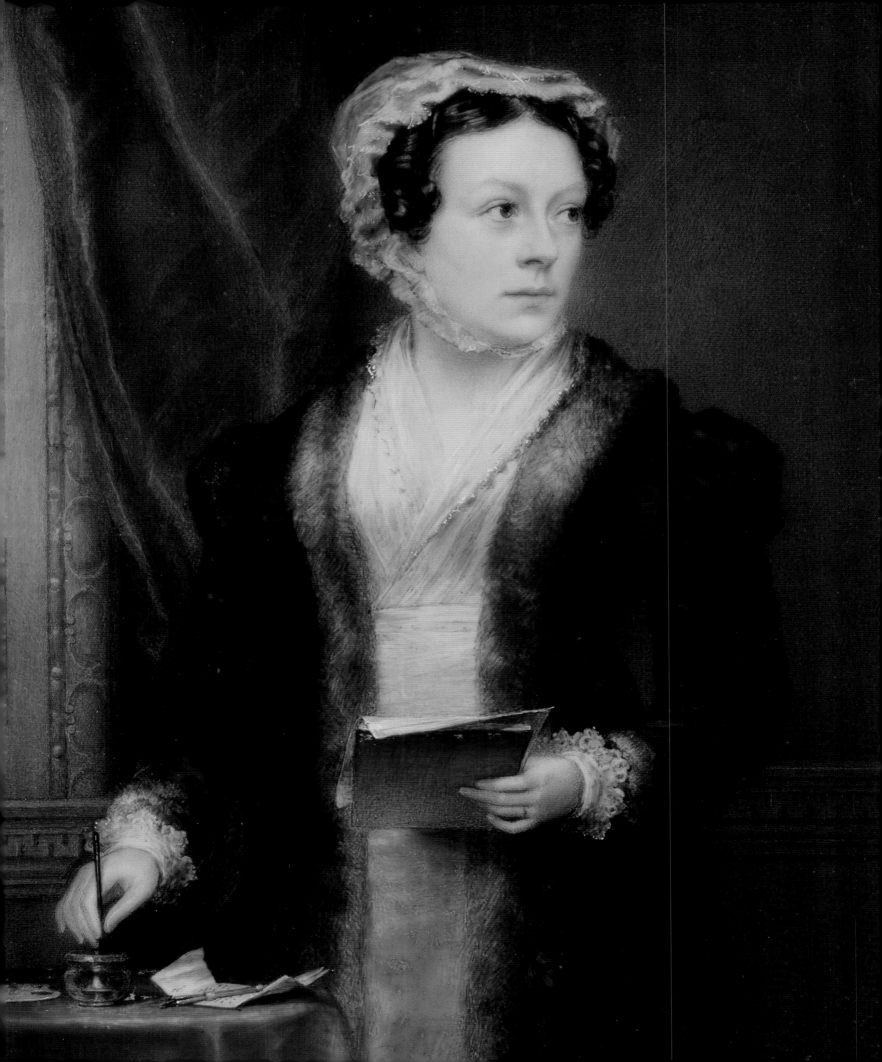

Bridging Two Empires: Christina Robertson and the Court of St. Petersburg

ELIZAVETA P. RENNE

OULD THE SCOTTISH ARTIST CHRISTINA ROBERTSON (née Sanders) ever have imagined, as she set sail from the shores of Great Britain, what stunning success awaited her in the northern capital of the Russian Empire? There can be no doubt that she was confident of her abilities; she made her appearance in Russia at the very height of her popularity and talent, with two decades of intensive work and success in London behind her. What could have prompted the flourishing artist, and mother of a large family, to set off for St. Petersburg? Was it curiosity and a passion for travel, or dissatisfaction with her home life? Profitable commissions? Or perhaps a need to assert herself and to extend the geographical borders of her fame? The little extant information about her life cannot provide a clear answer to this question. But her biography can be reconstructed from a few surviving documents: her account book, invoices, letters, exhibition reviews, and brief mentions in memoirs; and Robertson's works themselves provide particularly good clues to the artist's life and career as a foreigner in St. Petersburg.

Robertson, who was born in Fife, Scotland, settled in London after her marriage, in 1822, to the artist James Robertson. From 1823 she was an active participant in the annual Royal Academy exhibitions in both London and Edinburgh, despite giving birth to eight children, four of whom died in infancy.[1] From 1824 Robertson also exhibited with the Society of British Artists, and from 1833 with the British Institution. On 13 March 1829 she was elected an honorary member of the Scottish Academy (the first woman to merit this distinction) in "consideration of her eminent talents in Miniature Painting and in the hope that her best exertions will be directed to advance the honour and interests of the Society, the progress of Art and the dignity of its Professors."[2]

The press lavished attention on Robertson's work, and frequently singled out the artist among a great number of other exhibitors. In an essay on the annual exhibition in 1833 at the Royal Academy in London, *The Spectator* stated:

Christina Robertson,
Self-portrait, c. 1822, detail
(see p. 146)

We ought not to pass over the admirable full-length portrait of the Honourable Mrs. Pelham … without complementing the fair artist, Mrs. J. Robertson, on her success. This is the best and most pleasing whole-length female portrait in the Exhibition: which is some praise—though we never saw little justice done to beauty and grace in any of the annual displays of the Royal Academy.[3]

The following year *The Athenaeum* noted another of the artist's successes: "Mrs. Robertson has a full-length of Lady Rolle, which will not suffer by being compared with the full-length done by one or more of the Lords of the Creation."[4] In the 1830s, London's exhibitions often comprised several hundred works by hundreds of artists, few of whom were mentioned in the pages of periodicals. Yet in those reviews addressing oil portraits, Robertson's works were considered worthy each time of lengthy panegyrics.

Engravings were made after both of the portraits cited above, which furthered the artist's popularity. An engraving by W.H. Mote from the portrait of the Hon. Mrs. Pelham (Lady Worsley) appeared in *The Court Magazine* in 1834, and in *Heath's Book of Beauty* for 1840. Other engravings of Robertson's work also appeared in a spread of illustrated publications in the 1830s and 1840s, such as *John Burke's Portrait Gallery of Distinguished Females*, *Heath's Book of Beauty*, *La Belle Assemblée*, and *The Court Magazine*, which helped to reinforce the reputation of the Scottish artist in Britain and abroad. The prints after her works were published along with images of society's beauties by the most popular contemporary painters, and the numerous ladies' journals in which they appeared often made their way to Russia. There, they familiarized the Russian public with the latest fashions in art as well as dress, and helped prepare the ground for Robertson's enthusiastic reception when she traveled to Russia in 1839. The journals were even read by members of the imperial family: several volumes of *Heath's Book of Beauty* that originally belonged to Empress Alexandra Fedorovna can be found in the Hermitage library.

Among the volumes of *Heath's Book of Beauty* in the Hermitage library that bear the empress's initials is that for 1840, in which Robertson's portrait of Lady Worsley appears near an image of Countess Helene Zavadovsky (Elena Zavadovskaia), one of the great St. Petersburg beauties. The image—W. H. Egleton's engraving after Alfred Chalon's portrait of the countess from 1838—was accompanied by the following text:

Who talks of southern beauty?—Lo! The North,
Answering, in triumph, sends its daughter forth,

To show those sunnier climes their boast in vain;
Wakening hoar Winter in his cave of snow,
To rob his treasures for that marble brow,—
And shame the olive hues of Italy and Spain!

Shortly before this portrait was painted, in 1837, Countess Zavadovskaia had also sat for Robertson. The artist recorded this in her account book along with other commissions for Russian clients, including "Prince Wittengshtein [Wittgenstein] as a price for a drawing of Princess – 21£ / Countess Zavadovsky drawing herself and son – 21£ / Countess Patoski drawing – 21£ / The above painted and paid in Paris."[5] Robertson may have met these members of the Russian aristocracy in London before painting them in Paris. The first mention of them in her account book attests to the Anglomania that had taken root in Russia, and that helped guarantee the artist's success at the Russian court.

Any one of the members of St. Petersburg society who sat for the artist in Paris might have recommended Robertson to the Russian court. The first of the three clients mentioned in 1837 was probably Leonilla Bariatinskaia, the wife of Prince Ludwig Wittgenstein (son of a fieldmarshal-general of the Russian army who had made his name in the war against Napoleon). Robertson developed particularly strong links with the Bariatinskys, and during the first two years of her stay in Russia produced at least six portraits of members of their extensive family. A depiction of Leonilla's sister Maria Kochubei, née Bariatinskaia (fig. 24), which matches the description of a work that the artist exhibited at the Imperial Academy of Arts in St. Petersburg in 1839, may be the earliest of her works from her Russian period. Robertson also depicted Leonilla's other sister, Olga. The portraits of Olga and Maria, which are still extant in Russian collections, appear in a watercolor by F.W. Kloss of 1841 that depicts the salon in the Wittgensteins' house in Berlin (Robertson often produced copies of her own works at the request of her clients—sometimes several copies—in which she occasionally altered the dimensions or small details).[6]

The first public display of works by the British artist in the Russian capital, in 1839, whipped up a storm of enthusiasm. The art critic P.P. Kamensky, breathless with admiration, wrote:

The best portrait of all those exhibited at the Academy, however, is a portrait of a woman in a white satin dress playing the organ. This might confidently be placed alongside Rembrandt, and it would lose little from such an ambitious

Fig. 24 Christina Robertson, *Portrait of Princess Maria Ivanovna Kochubei (née Bariatinskaia)*, 1839 (?), oil on canvas, 26⅜ × 21¹/₁₆ in. (67 × 53.5 cm), State Tretiakov Gallery, Moscow

comparison. What a bold, powerful brush! How simple and natural everything is! What superb coloring! And who would have thought? All this is the work of a weak woman's hand! Or, more correctly, only a woman could paint this: a man would not be capable of so much feeling. If there were no organ each would have guessed [that the instrument was there] from the movement of the whole figure, from the face, from the musical thoughts that overflow in her soul. It is immediately clear that Mrs. Robertson is an Englishwoman, that she was brought up in the tradition of sublime portrait painting, that she studied mastery of the brush in the land of Reynolds and Lawrence.[7]

Kamensky's review echoes the response of a British critic writing in *The Art Union* about the Royal Academy exhibition in London in 1839, to which the energetic artist had dispatched works before her departure for Russia:

One of the best pictures in the gallery is this picture by Mrs. Robertson—an artist of the highest talent, who is always graceful and effective in arranging a picture; and whose power of execution is of a "masterly" order. The term "masterly" will cease to be used as denoting the highest merit, if many women paint with as much thought, skill and vigour as Mrs. Robertson.[8]

So, bereft of language to describe this woman painter, both critics felt compelled to transverse gender boundaries to fit her work into a male-dominated history of art.

Robertson's popularity in St. Petersburg was not surprising, as a taste for British portraiture deriving from the tradition of Reynolds and Lawrence, as well as for all things British, was already pronounced in Russia. Since the foundation of St. Petersburg, in 1703, the city had been notable for its English-oriented tastes. By the beginning of the nineteenth century, a large area of it by the mouth of the River Neva had been settled by the British. The British colony, comprising sailors and merchants, gardeners and businessmen, and influential owners of large factories and shops, thrived. Many British names—a good number of them Scottish—feature in the history of the city. Famous doctors and admirals, architects and artists, came to spend a short time in Russia and remained for the rest of their lives. Their presence was reflected in the toponymy of the city: English Avenue, English Quay, Bairdov Bridge (after Charles Baird, the owner of an iron foundry and shipping company), and Golodai Island (a Russian transcription of the name Halliday, the owner of a factory on one of the islands) still exist today. Revitalized trading contacts after the

end of the Napoleonic Wars brought new Anglo-Russian links to life. Passengers on British ships arriving at Kronstadt, the island where customs inspections were held, were taken to St. Petersburg on board a steamer "at Mr. Baird's Wharf,"[9] and would have been struck by the considerable English presence they encountered. As the diplomat and journalist Pavel Svinin wrote of Kronstadt in 1820:

> One cannot but stop as one sees to either side the curious signs, such as: Joseph Williams, or Osip Vasiliev, and hears the sounds of the English tongue emerging from the mouths of bearded compatriots, trading in onions, carrots or cabbage. The stall on the site of the Russian merchant Kurychanov, who is called Johnson by the foreigners, is built along the lines of English shops. The Russian Johnson speaks perfect English and is as cunning and welcoming as the best stall-holder in Westminster.[10]

Robert Harrison, who visited in the late 1840s (during the time of Christina Robertson's second stay in Russia), left an excellent record of the British presence in St. Petersburg:

> The liveliest part of the town is the neighbourhood of the Mole, or mercantile harbour where you seem to meet none but Englishmen, and to hear only our native language, a very delightful change to one who has been long among a strange people. English inscriptions over shop doors abound, 'Grogs', and 'Porter sold here', being of frequent occurrence. The English Vice-Consul is one of the most important personages in the place, and the English church one of the handsomest edifices.[11]

Another British traveler, Captain Colvill Frankland, observed that "among the Russian noblesse, I find the greatest desire on their part to show me how much they value the good opinion of my country, and how much they strive to equal us in their progress towards perfection in the arts and sciences. They mostly speak English, and love English customs and literature, and admire our national character."[12] By the late 1820s and 1830s an entire generation of Russians had been brought up on English literature (with a particular passion for Walter Scott, Lord Byron, and Thomas Moore). England was perceived as a land of progress, where the political system and stable economy made possible the development of the sciences, the arts, and technology. All Russians who wished for liberal reform looked to England. Russian nobles, who had taken up the fashion for English gardens in the late eighteenth century, now also showed an interest in introducing British agricultural methods and land irrigation.

Many noble homes also employed English governesses "to give the child habits of tidiness, and to teach it the English pronunciation, a result not always successfully achieved, especially where the bonne happens to be, as not unfrequently is the case, an Irish or Scotch woman."[13] The presence of an English governess or nanny in a noble family became so common that it featured in Alexander Pushkin's short story *Mistress into Maid* as a characteristic aspect of modern life.[14] Until the age of seven, Emperor Nicholas I (fig. 25) was raised by an English nanny whom his imposing grandmother, Catherine the Great, had selected for him. Her name was Jane Lyon, although she was known in Russia as Evgenia Vasilevna, and the young Nicholas called her "the lion nanny." It is possible not only that Miss Lyon was the first to acquaint the grand duke with the letters of the Russian alphabet, but also that she instilled in him an interest in, and respect for, her own language and literature, and for the history of her people and her land. He remained fond of her and attentive to her family throughout his life, providing material support first to her daughter Evgenia Burtseva (née Vecheslova) and then to her granddaughter Zinaida. When Jane Lyon left the service of the imperial family, she was given a one-time payment of 2000 silver rubles and an annual pension of 600 rubles; her daughter and granddaughter received one-time payments as well.[15]

Nicholas's journey to Britain in 1816, where he made the acquaintance of the 6th Duke of Devonshire, visited castles and country houses, and met Walter Scott in Edinburgh, put the finishing touches to the formation of the future emperor's tastes. His impressions were influenced by the prevailing fashion for the medieval era as well as the exoticism of the Orient and the Crusades, a trend that spread across the whole of Europe. Nicholas's tastes were clearly manifested in his patronage of the Scottish architect Adam Menelaws, who executed much work for the tsar in the 1820s, in the area around St. Petersburg. Nicholas's taste also influenced his patronage of British entrepreneurs, engineers, doctors, and factory owners, and his interest in the British artists George Dawe and William Allan. The imperial family even preferred to make purchases through the English shop Nichols and Plinke: a mass of documents relating to this prototype of the modern department store survives in the archives of the ministry of the imperial court.

Following the family tradition set by Catherine II and experienced by Nicholas, English nannies were regularly imported to care for other royal children, and were well rewarded for their work. The English nanny Eugenia Christie was employed to care for the heir to the throne, Grand Duke Alexander, and his sisters Grand Duchesses Maria and Olga; when she left to get married, in 1830, the emperor ordered that Christie be

Fig. 25 R.J. Lane after Christina Robertson, *Nicholas I, Emperor of Russia*, lithographed by J. Graf, 1840, The Royal Collection © 2002, Her Majesty Queen Elizabeth II

given a single payment of 2000 rubles and that she receive henceforth "an annual pension of 900 rubles a year until her death."[16] A maid to Grand Duke Constantine, the Englishwoman Helen Forman, daughter of a watchmaker, was paid a salary of 300 rubles and a food allowance of 1095 rubles per annum.[17] The value placed on English nannies was noted by Georgiana, Baroness Bloomfield, during a stay at the royal palace of Peterhof in 1845: the Baroness "saw the Czarewitch's children, a nice boy of about two years old and his sisters. They were attended by English nurses. These are greatly preferred in Russia and are generally bribed by the Russians to enter their service."[18]

The large sums paid to English women in the service of the Russian court can be compared with prices paid for the works of Christina Robertson, which confirm the considerable status she enjoyed in Russia. In 1840 Robertson received 4285 rubles and 72 kopecks for a full-length portrait of the emperor and empress.[19] A letter written to Prince P.M. Volkonsky, minister of the imperial court, provides a glimpse into Robertson's capability in managing her career:

> I have not at all altered the price of the portraits. That of His Majesty the Emperor (that which is the same size as that of Her Majesty the Empress in the Rotunda [fig. 26]) is 2000 silver rubles and the small one is the same price, 2285, as the original of Her Majesty the Empress for the Horseguards and which is much larger than the other. I beg you to understand that I take not a penny more from His Majesty the Emperor than I take from the rest of the world here, and also in England, and that I always take the same price for the small as for the large, and the same price for copies as for the original—as I have already explained carefully with regard to this subject to Madame Baranoff, when the question arose last spring of painting smaller versions of Grand Duchess Maria and the Duke and the child for Her Majesty the Empress. Thus, Prince, it did not enter my head to say all that to the Emperor when he did me the honour of commissioning the small painting; the reason why the smaller paintings are more expensive is that they are very difficult to make and do much to spoil the eyes.[20]

The emperor was not put off by the artist's frankness. Rather, the elegant art of Christina Robertson was very much in accord with the tastes of the ruling family, and he was prepared to pay dearly for portraits he commissioned from the Scottish artist. He intended to hang them in the interiors of the Winter Palace, newly renovated after a devastating fire in 1837.

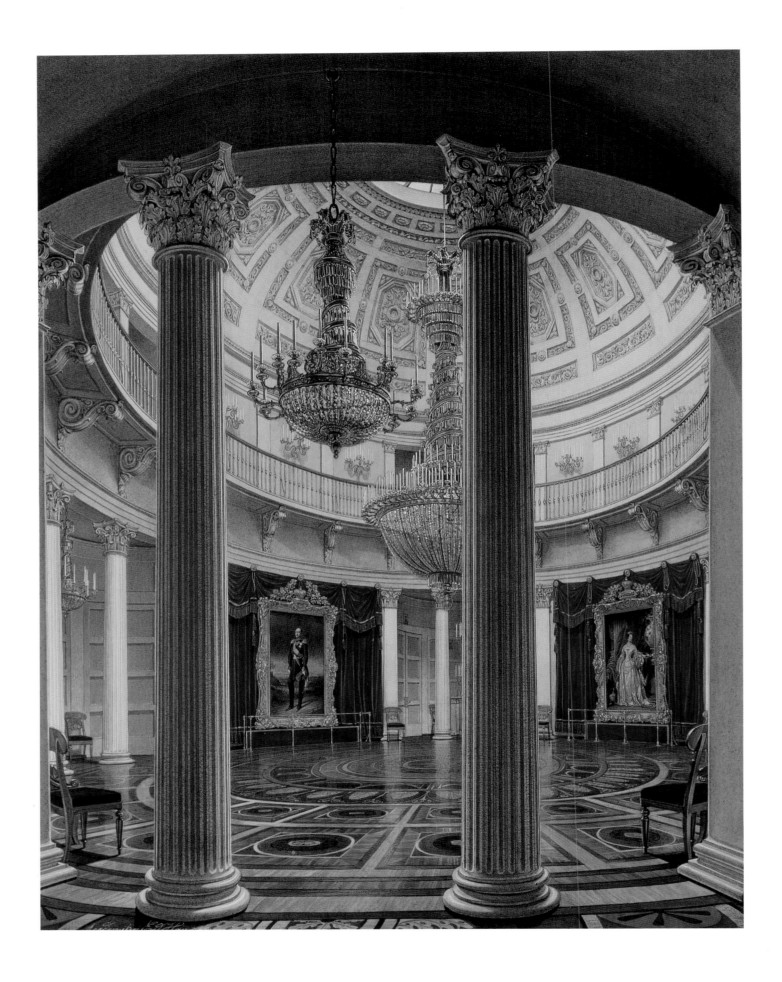

In addition to imperial portraits, the artist accepted many other commissions, particularly in 1840–41, when she painted numerous portraits of members of those aristocratic families that were close to the court and connected with Britain. Prince Ivan Bariatinsky, the father of Robertson's sitters Leonilla, Olga, and Maria, had in the early nineteenth century served as secretary at the Russian embassy in London, where he may have met his first wife, the daughter of Lord Sherborne. His son-in-law Vladimir Orlov-Davydov graduated from Edinburgh University and was well acquainted with Walter Scott, while his son, Alexander Bariatinsky, paid a number of visits of several months to Britain in the 1830s, mixing with aristocratic society. Christina Robertson also painted members of the family of Prince Boris Yusupov, who, as his father before him, had made several visits to England and assembled a fine art collection that included works by Joshua Reynolds, Benjamin West, and Daniel Gardner, artists whose works were rarely found on Russian soil at the time.

In 1839 a new almanac appeared in St. Petersburg called *Utrenniaia Zaria* (*Morning Dawn*), in which poetry and prose by contemporary writers were accompanied by engravings after portraits of society beauties, similar to the English *Book of Beauty*. In 1841 this included an engraving after Robertson's portrait of Princess Elena Beloselskaia-Belozerskaia (fig. 27). Prior to the discovery of this engraving, the portrait (current location unknown) had been known only from the words of Lady Eastlake (Elizabeth Rigby), who visited St. Petersburg in 1841 and wrote: "Princess Belozelsky, whose beauty I have before alluded to, is now sitting to Mrs. Robinson [*sic*], our English artist, who is earning golden opinions in the high circles for the beauty and grace of her portraits. This lady is also engaged upon a full-length of the Empress."[21] The error in writing the surname probably arose from its similarity to that of the engraver H. Robinson. Curiously, both H. Robinson and his fellow engraver W. H. Mote worked at the same time on *Heath's Book of Beauty* and *Utrenniaia Zaria*, which reproduced their engravings after works by Russian and foreign artists living in St. Petersburg.

During the 1830s and 1840s periodicals reflected the revitalized artistic contacts between St. Petersburg and London. Russian newspapers and journals increasingly included information about British artists and exhibitions, and reviews of new English-language literary works. Meanwhile, news about Russia appeared regularly in Britain. The celebrated engraver Thomas Wright, who spent many years in Russia in the 1820s and 1830s and was acquainted with many Russian artists, sought in 1841 to induce his colleague, the engraver Nikolai Utkin, to collaborate on the London publication *The*

Fig. 27 H. Robinson after Christina Robertson, *Portrait of Princess Elena Beloselskaia-Belozerskaia*, engraving reproduced from the almanac *Utrenniaia Zaria*, 1841

OPPOSITE Fig. 26 Eduard Hau, *The Rotunda of the Winter Palace*, 1862, watercolor on paper, 16⁵⁄₁₆ × 12¹³⁄₁₆ in. (41.5 × 32.6 cm), State Hermitage Museum, St. Petersburg. Christina Robertson's portraits of Nicholas I and his wife are visible on the far walls.

Art Union. This publication issued news from many European countries, but as Wright explained: "it lacks information about the fine arts in Russia and since I am much interested in their progress I would much like to announce in this journal works already complete and those in progress by the Professor Academicians and other celebrated artists in Russia."[22] That the author of notes in subsequent issues of *The Art Union* revealed himself to be very well informed regarding the state of artistic life in St. Petersburg suggests that Wright must have succeeded in persuading Utkin to help.

Utkin was a skilled engraver, professor at the Imperial Academy of Arts, and Curator of the Department of Prints at the Hermitage, and often acted as an intermediary between his European colleagues and the Russian Academy.[23] He corresponded with them, organized exchanges of works, and had a collection of approximately eighty-seven prints of the English school with personal inscriptions from the authors. It was he who facilitated the election of Christina Robertson as honorary free associate of the Imperial Academy in 1841, after she had exhibited her full-length portraits of the empress and her three daughters there (see pp. 151, 153, 155, 157). Robertson thanked Utkin profusely for the warmth of her reception during her first trip to St. Petersburg,[24] and also turned to him for assistance in selecting material when painting a number of portraits during her second stay.

Robertson's second visit to Russia, from 1847 to 1854, began just as successfully as the first. Nicholas I acquired her painting *The Meeting of Amy Robsart and the Earl of Leicester*, which had been exhibited in the spring of 1847 at the British Institution, and had merited a magnificent review in *The Art Union*.[25] This painting, which reproduces in great detail the scene as described in Sir Walter Scott's novel *Kenilworth*, was placed in the imperial family's private summer residence near Peterhof, known as the Cottage. In 1826 Menelaws had designed the neo-Gothic interiors at the Cottage in keeping with the owners' taste, and indeed with the nature of Robertson's painting. Although the painting disappeared during the Soviet period, it is known from a copy on porcelain (fig. 28) that the Grand Duchess Maria Nikolaevna commissioned, and kept in her home, the Mariinsky Palace in St. Petersburg. In Eduard Hau's watercolor of the interior of the Mariinsky Palace (fig. 29), Robertson's painting is shown standing on an easel.

In 1849 Christina Robertson was once again working on a commission for the emperor—two portraits of his daughters-in-law, Maria Aleksandrovna, wife of the heir to the throne (see p. 159), and Alexandra Iosifovna (current location unknown). Nicholas ordered that the artist be given a room in the Hermitage to complete this

Fig. 28 Ilia Artemiev after Christina Robertson, *The Meeting of Amy Robsart and the Earl of Leicester*, 1852, polychrome overglaze painting on porcelain, 51 3/16 × 37 3/8 in. (130 × 95 cm), State Hermitage Museum, St. Petersburg

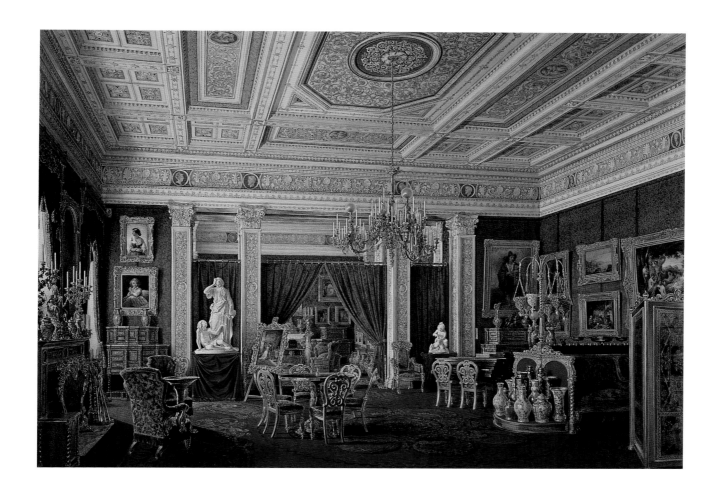

Fig. 29 Eduard Hau *Sitting Room in the Mariinsky Palace*, watercolor, 13³⁄₁₆ × 18¹¹⁄₁₆ in. (33.5 × 47.5 cm), State Hermitage Museum, St. Petersburg

work, that she be served a cold breakfast at 12 noon, and that for lunch she be given bouillon (the artist refused a full luncheon).[26] At the same time, the tsar asked the artist to make copies of these portraits and of the three images of his daughters produced during the first visit, to be hung in the Romanov Gallery of the Winter Palace (this gallery was decorated with portraits of all the members of the Romanov dynasty). But circumstances took an unexpected turn when, in February 1850, the artist received a letter from the minister of the imperial court stating:

> The Emperor has received the Portrait of Her Imperial Highness Madame the Grand Duchess Alexandra Iosifovna which you have just produced and I regret to have to inform you that His Imperial Majesty was not satisfied with it, not finding any resemblance, and has ordered me to reject it. Nor has His Majesty judged entirely satisfactory your Portrait of Her Imperial Highness Madame the Tsarevna Grand Duchess Maria Aleksandrovna and has ordered me to ask you to retouch it. At the same time, His Majesty the Emperor has not deigned to wish for copies from these two portraits.[27]

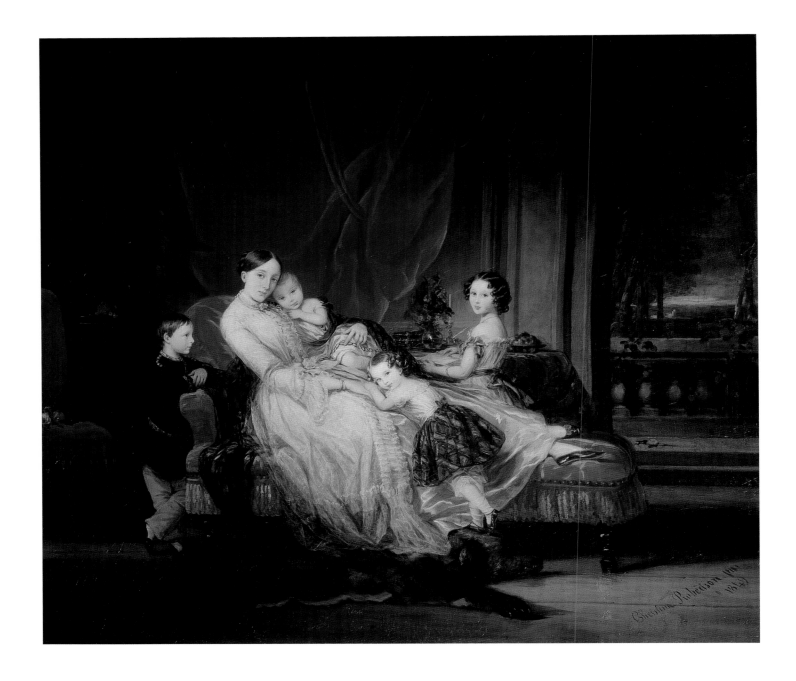

The surviving portrait of Grand Duchess Maria Aleksandrovna indeed bears traces of reworking in the sitter's face. A comparison with other images of the grand duchess by Robertson also demonstrates not only differences in the brushwork (usually quite recognizable), and the use of different paints, but even a radically new vision of the sitter. The grand duchess's face now has more in common with a portrait by Franz Xavier Winterhalter, painted in Brückinau in 1857, than with Robertson's works of 1849–50. The amazing likeness of two paintings produced eight years apart can be explained either by the artists having taken the same

Fig. 30 Christina Robertson, *Grand Duchess Maria Nikolaevna with her Children*, 1849, oil on canvas, 35¹³⁄₁₆ × 41⅛ in. (91 × 104.5 cm), State Russian Museum, St. Petersburg

daguerreotype as a model, or by the painting in the Romanov Gallery having been corrected after the artist's death to resemble Winterhalter's model.

Despite the emperor's unexpectedly cool reception of these portraits, Robertson continued to receive commissions from members of the imperial family. In 1849 she produced a portrait of Nicholas I's eldest daughter, Maria Nikolaevna, Duchess of Leuchtenberg, with her children (fig. 30), and in 1850 she painted several portraits of Maria Aleksandrovna. The same year, she painted the empress and Maria Nikolaevna (State Hermitage Museum), Maria Aleksandrovna's eldest daughter (Pavlovsk Palace Museum), and several watercolors of Maria Aleksandrovna and three of her sons. In 1852 she painted a portrait of Empress Alexandra Fedorovna standing on a balcony, a version of an earlier painting produced during Robertson's first trip to Russia (Pavlovsk Palace Museum). As during her first visit, Robertson also continued to receive commissions from the wealthiest Russians, including the Sheremetev, Shuvalov, Yusupov, Bobrinsky, and Stroganov families. In 1850 she produced one of her most compelling paintings, *Children with a Parrot* (see p. 163).

But Robertson was already suffering setbacks in her career, as is evident in a letter to Grand Duchess Maria Nikolaevna of 9 December 1852. In her letter Robertson requests assistance in receiving 4800 rubles for portraits she had painted in 1849, complaining of poor health and expressing a desire to return to her family in England, not having visited her native land for five years.[28] Her wish was not to be fulfilled; she died two years later in St. Petersburg at the age of fifty-eight. Her death seemed to symbolize the end of friendly artistic interchange between Russia and Britain, just as broader relations were severed by the outbreak of the Crimean War (1854–56), marking a tragic page in the history of Anglo-Russian relations.

During the last two years of her life, the artist—probably owing to the poor health she cited in her letter—produced almost no works. Certainly there are no surviving paintings dating from this period. If she had lived longer, she would have found it difficult to compete with the spread of photography, and the growing fame of Winterhalter's society portraits at the courts of Europe. Christina Robertson, the Scottish artist who enjoyed a successful career in both London and Paris, nonetheless achieved her greatest fame in Russia, where her main clients were Emperor Nicholas I and his circle. Her elegant, ethereal art, so flattering to her sitters, was perfectly fitted to its time. These works convey across the ages the air of a distant era, dominated by the character of Nicholas and the distinctive tastes he promulgated at the imperial court.

Sofonisba ANGUISSOLA

c. 1535 Cremona – 1625 Palermo

The most talented of six artist sisters from a noble Cremona family, Sofonisba Anguissola studied under Bernadino Campi (1522–*c.* 1590), a painter who excelled in fresco painting and portraiture, as well as under Bernardino Gatti (*c.* 1495–1576), who had studied Correggio's work in Parma. Known above all as a painter of portraits, Anguissola also produced works on religious and mythological subjects. Self-portraits, of which twelve are still extant, occupied a major place in the artist's work. Giorgio Vasari, who visited the Anguissola family in 1566, praised the work of the sisters but particularly homed in on Sofonisba, noting her knowledge of design and color, and her excellence in drawing from nature and copying (Vasari 1880, V, pp. 80–81).

Vasari was not the only artist to admire Anguissola's talent. At the behest of her father, Michelangelo critiqued one of her drawings. Her talent so impressed him that he asked her for another drawing. In 1560 the Queen of Spain invited Anguissola to Madrid to become an official court painter. Anguissola accepted the position and remained there for twenty years. In Spain she became one of the court ladies to Queen Elizabeth de Valois, painting portraits of the king, queen, and members of the Spanish nobility.

Around 1571 Anguissola married Fabrizio de Mocada, brother of the Vice-King of Sicily, Francesco II, and moved with her husband to Palermo. After Fabrizio's death in 1584 she married the Genoese courtier Orazio Lomellino, and settled in Genoa. Anguissola died in Palermo in 1625. Shortly before her death, Anthony Van Dyck visited the artist and made a sketch of her in his *Italian Album.* [TK]

Portrait of a Woman

A young woman with red hair is depicted half-length in profile, holding in her hands a vase of flowers. Despite the relatively small size of this canvas, and the simplicity of the composition, this is undoubtedly an official portrait. The hairstyle, jewelry, and elaborate costume draw one's attention even more than the woman's face, and these features—the extremely luxurious attire and the abundance of jewelry—confirm her high social status. The sleeves of her satin dress are finished with colored braids; the green velvet cloak is embroidered with gold threads; in her ears are pearl earrings; and around her neck is a pearl necklace fastened with a gold and sapphire fastening. The artist has painted the details with a tactile sense of each object, leaving us in no doubt that one fabric is silk, the other velvet. We can see each stitch in the gold embroidery.

The three flowers in the finely executed vase have commonly been used as symbols: the rose indicates love, as does the red carnation, which was thought to signify marriage (see Levi d'Ancona 1977, pp. 80–81).

The portrait arrived at the Hermitage as the work of Titian. Bruni (1861) and Waagen (1864) attributed it to Angelo Bronzino, an opinion supported by Bode (1882), Harck (1896), and Schulze (1911). Lasareff (1923) suggested that the painting was by Bronzino's pupil Alessandro Allori, in which he was joined by MacComb (1928). Liphart (1912) first named Bronzino as the author of the painting but later (in an unpublished catalogue) Scipione Pulzone. H. Voss suggested the current attribution in a personal communication. [TK]

Oil on canvas, 26¹⁵/₁₆ × 20¹¹/₁₆ in. (68.5 × 52.5 cm)
Inv. no. GE 36
PROVENANCE Acquired in 1829 from the collection of the duchesse de Saint-Leu; formerly in the collection of Empress Josephine, Malmaison, near Paris
EXHIBITIONS Leningrad 1938, issue III, no. 8; Göteborg 1968, no. 1; Leningrad 1972, no. 312; Moscow 1972, p. 33; Nara 1990, no. 5
BIBLIOGRAPHY Livret 1838, p. 37; Bruni 1861, p. 129; Waagen 1864, p. 68; Bode 1882, installment 16, p. 5; Harck 1896, p. 417; Schulze 1911, p. 26; Lasareff 1923, p. 249; MacComb 1928, p. 279; Kustodieva 1994, no. 20

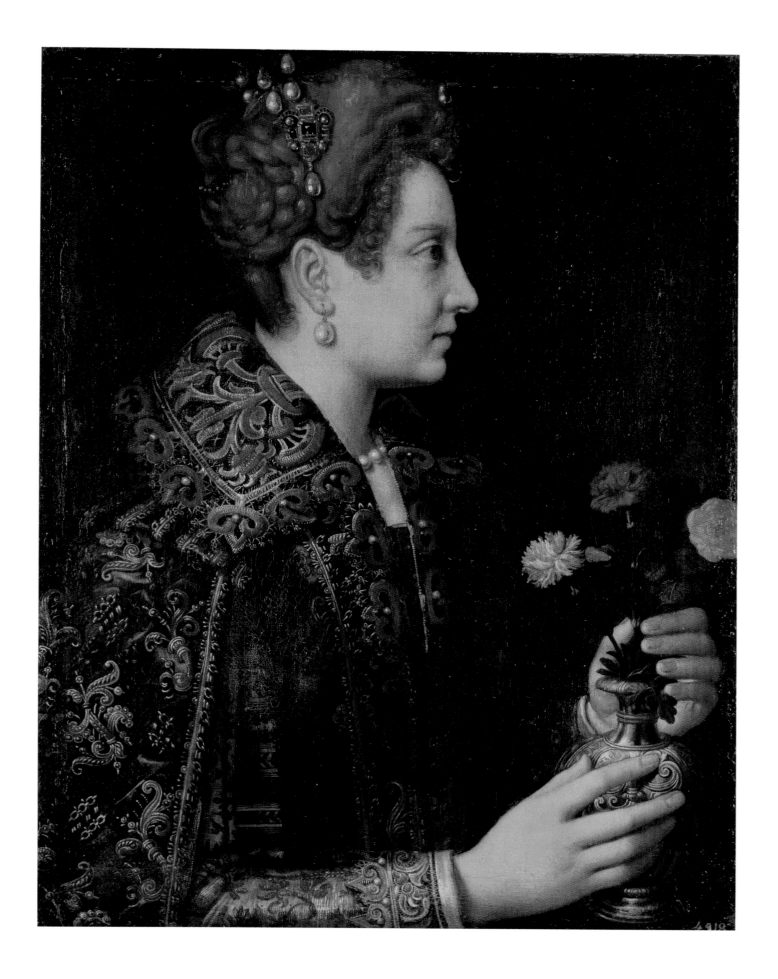

Lavinia FONTANA

1552 Bologna – 1614 Rome

Born in the major art center of Bologna in 1552, Lavinia Fontana studied under her father, Prospero Fontana, who passed on his interest in naturalism and attention to meticulous detail. Her work also reflected the influence of the Emilian painter Antonio Allegri Correggio, whose own monumental style derived from many sources, including Michelangelo and Raphael. Primarily a painter of portraits, Fontana also produced works on religious and mythological themes. She spent the first part of her life in her native city developing a career as a portraitist of Bolognese noblewomen. She also painted portraits of important officials associated with the university of Bologna. At the age of twenty-five Fontana married Gian Paolo Zappi, a fellow painter from a noble family, who acted as his wife's assistant. They had eleven children together, although only three outlived their mother.

Fontana's fame spread south to Rome, where she received an important commission to paint the *Virgin Appearing to St. Hyacinth* for Cardinal Ascoli's chapel in the church of Santa Sabina, which further augmented her reputation. In 1604 Fontana moved permanently to Rome, where she became a portraitist at the court of Pope Paul V and received many honors. [TK]

Venus Feeding Cupid

Venus Feeding Cupid can be placed among Lavinia Fontana's late works. The facial type, hairstyle, and form of the arms with dimpled elbows are similar to the artist's *Minerva's Toilet* (Borghese Gallery, Rome) from 1613. In *Venus Feeding Cupid* Fontana shows the goddess of love gracefully dropped to her knees, with Cupid standing before her and nursing at her breast. Venus's figure displays a smooth contour, the short transparent robe subtly revealing the beautiful forms of her body. The painter also introduces a number of decorative details: flowers in the folds of the silk cloak beneath Venus's feet, and flowers scattered on the grass. At the goddess's shoulder is a precious fibula, and her braids are interwoven with ribbons.

It was possibly the graceful elongation of the figures and composition that led some to see Parmigianino as the author of this work. Count Antonio Litta in his handwritten note (Hermitage Archives, fund 1, *opis'* V, *delo* 7, f. 3) gave this attribution, for example, when confirming his sale of four paintings to the imperial museum in the Hermitage, among them *Venus Feeding Cupid*. Shortly afterwards D.V. Grigorovich recorded the new acquisitions from the Litta collection, giving Lavinia Fontana as the author of *Venus Feeding Cupid*. Gustav Waagen, the great nineteenth-century German connoisseur and cataloguer of collections who visited St. Petersburg in the early 1860s, may have suggested this attribution to him.

In 1928 a work similar to *Venus Feeding Cupid*, thought to be by Dosso Dossi, was in the possession of antiquarians J. & S. Goldschmidt in Berlin (reproduced in the journal *Der Cicerone*, 1, 1928). Pigler (1974, II, p. 249) notes that an identical version was formerly at Belvoir Castle in England and was listed as the work of Parmigianino (reproduced in *The Connoisseur*, VI, 1903, p. 133). Pigler also notes that an old copy of *Venus Feeding Cupid* was in a private collection in Milan. [TK]

Oil on canvas, 24¹³⁄₁₆ × 18½ in. (63 × 47 cm)
Inv. no. GE 2345
PROVENANCE Acquired in 1865 from the collection of Count A. Litta, Milan
BIBLIOGRAPHY Grigorovich 1865, p. 61; Venturi 1933, p. 694; Galli 1940, p. 125; Cantaro 1960, p. 259; Fortunati Pierantonio 1986, II, p. 759; Kustodieva 1994, no. 79

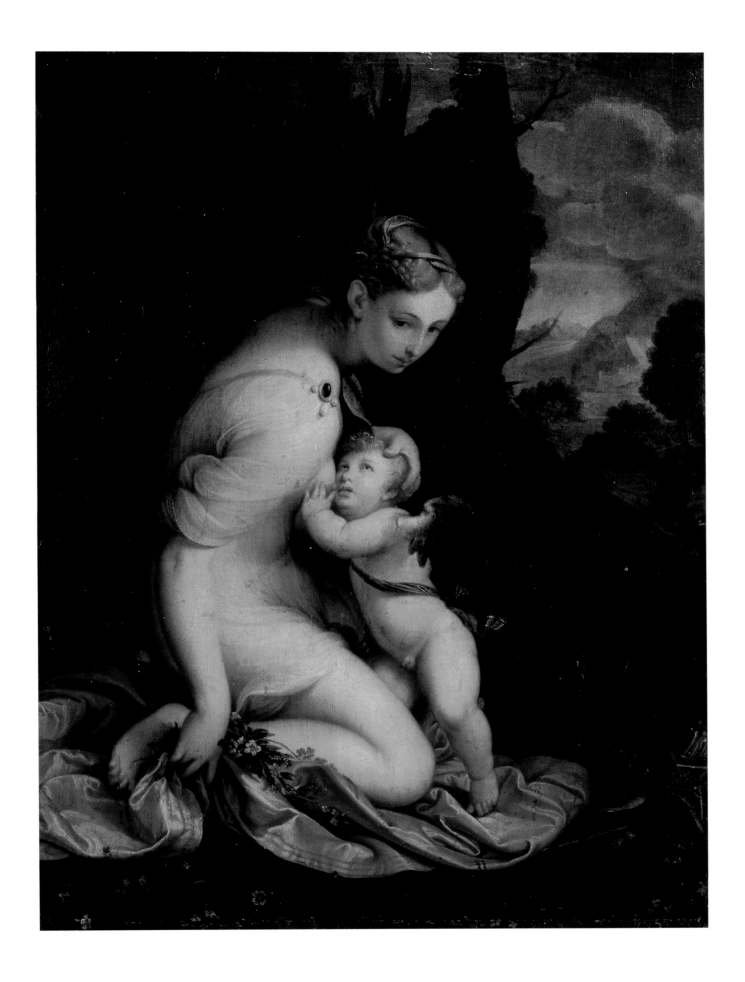

Carolina Friederika FRIEDRICH

1749 Friedrichstadt, near Dresden – 1815 Dresden

Carolina Friederika Friedrich was born on 4 March 1749 in Friedrichstadt, near Dresden. Her father, David Friedrich, was a local artist and owner of a tapestry manufactory, who taught her to draw and paint with watercolors, while she learned to work in oils from her eldest brother, Alexander. The second brother, Johann Christian Jakob, studied at the Academy of Painting in Dresden and was schooled in botany, drawing many of the flowers and plants in the rich botanical gardens belonging to the Elector of Pillniz for the latter's cabinet of curiosities. In 1774 the elector appointed Carolina Friedrich a pensioner of the Dresden Academy, and she was a regular participant in their exhibitions, a privilege rarely granted to a woman. Her works enjoyed great popularity, and some contemporaries even compared them with paintings by the famous Dutch still-life master Jan van Huysum. In the floral still lifes that became her primary subject, Carolina Friedrich looked not only to her own skill and imagination but also directly to nature itself, making a careful study of each plant. She created a vast number of paintings and drawings comprised of various combinations of arranged flowers and fruits, although many of these have not survived. [MG]

Fruit and Flowers

A melon, grapes, plums, and a lemon lie on the corner of a table directly before the viewer's eyes. Great care and attention has been given to arranging the composition so that both the selection of fruits and their placement seem to be a matter of pure chance and appear most natural, as if someone had just brought them back from the market and scattered them straight from the basket on to the kitchen table. The artist uses light to emphasize the mass of each object. She stresses the contrast between the damp sheen of the grapes and the matt, velvety bloom of the plums that slightly hang over the table and, together with the curly vine tendrils, interrupt the surface of the canvas. Friedrich draws attention to the lacy pattern on the skin of the melon and the toothed edges of the vine's leaf, and stresses the difference between the shining flesh and the thick, dense skin of the sliced lemon.

Behind all these artistic devices lies an intense study of nature, and the desire to achieve a likeness to the original that was typical of the work of Friedrich. Her teachers were the seventeenth-century Dutch masters, whose still lifes adorned the art collections and interiors of houses in Dresden. Although her paintings create a sense of mass, she was not sufficiently skilled in the creation of a sense of light and air, but this does nothing to reduce the painting's decorative effect. The beetle creeping across the table and the fly seated on a plum were probably not intended here to be perceived as symbols of evil, as in seventeenth-century Dutch still-life paintings, but were rather mere imitations of the style of the latter, an attempt to breathe a sense of life and animation into the stillness of the arrangement. [MG]

1788, oil on canvas, 15¾ × 21¼ in. (40 × 54 cm)
Signed and dated bottom left: *C.F. Friedrich 1788*
Inv. no. GE 6301
PROVENANCE Acquired in 1925; formerly in the collection of P.P. Durnovo, St. Petersburg
BIBLIOGRAPHY Nikulin 1987, p. 248, no. 195

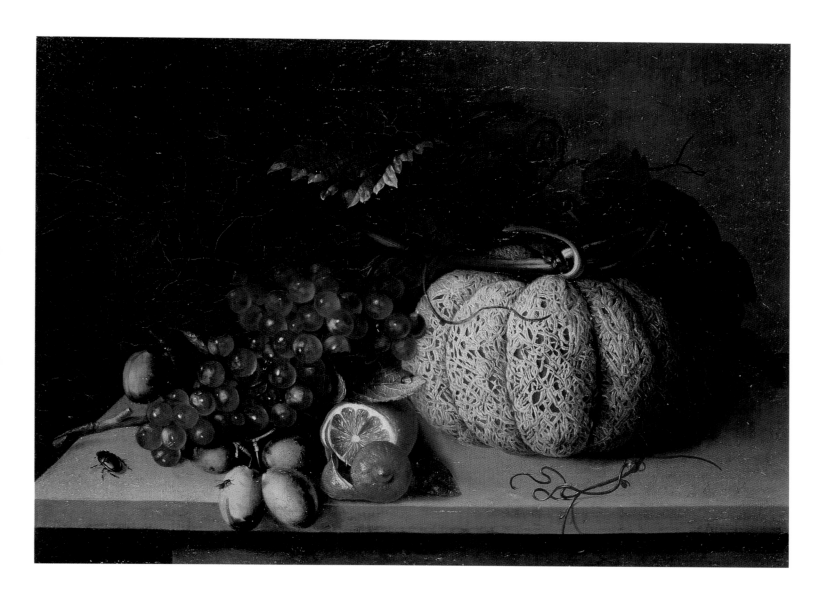

Marguérite GÉRARD

1761 Grasse – 1837 Paris

Born in the Provençal town of Grasse, Marguérite Gérard was a sister-in-law of Jean-Honoré Fragonard (1732–1806), who helped shape her interest in art after she had moved to Paris to live with her sister's family. Gérard produced a number of works jointly with Fragonard, but by the mid-1780s she had established her own style, which departed from Fragonard's Rococo and instead emphasized tight, polished brushstrokes and painstakingly rendered details. The artist gained fame as the author of genre scenes and as a portraitist, producing mainly small scenes of family life that are visibly influenced by seventeenth-century Dutch painting. A miniaturist and book illustrator, in 1796 and 1798 Gérard illustrated Choderlos de Laclos's *Les Liaisons dangéreuses* and *Les Amours du Chevalier de Faublas* by Jean-Baptiste Louvet de Couvray. Gérard, who never married and chose not to join the Academy, achieved great success in her career, winning three medals for her work, and exhibiting regularly at the Salons when they opened to women in the 1790s. [AB]

The Present

This picture displays the influence of seventeenth-century Dutch painting, notably the work of Gerard Terborch (1617–1681) such as *Lady at her Toilet* (c. 1660; Detroit Institute of Arts). Gérard largely repeated Terborch's composition, altering a number of details. For example, in Gérard's work the page brings the young lady not only a love letter but also a basket of flowers and game. Gérard creates a "picture within a picture": in the upper right corner is an oval pastoral scene in the spirit of Fragonard. Some contemporary scholars, notably Cuzin, feel that Gérard and Fragonard jointly created the painting in the Hermitage, noting the delicacy of the drawing and the particularly soft coloring, while Wells-Robertson stresses that *The Present* was the work of Marguérite Gérard alone.

Wells-Robertson cites important information for the dating (1785–87) and provenance of the Hermitage painting, which went to auction in Paris in 1795 (when it was attributed to Fragonard). *The Present* was listed in the possession of Count Nikolai Sheremetev in 1809, when an inventory was compiled of the contents of the Sheremetev family palace, the Fountain House, in St. Petersburg.

Nikolai Petrovich Sheremetev, appointed *Hofmarschall* (lord chamberlain) of the imperial court at the end of 1796 by Emperor Paul I, was a celebrated Russian collector who owned other works by Gérard: *The Music Lesson* (now Ostankino Palace Museum, Moscow) and *The Kiss* (formerly Hermitage, sold by the Soviet state via Antikvariat in 1932). Today, the Hermitage has a whole series of paintings by French artists, contemporaries of Gérard, from the collection of Count Sheremetev. From the Fountain House, for example, came *A l'entrée* (*By the Entrance*) by Louis-Léopold Boilly (1761–1845); *Le Passage à gué d'un ruisseau* (*Ford Crossing a Stream*) and *Paysage aux hommes et bêtes* (*Landscape with Figures and Animals*) by Jean-Louis Demarne (1752–1829); and *Port de mer* (*Sea Port*) and *Paysage avec personnages* (*Landscape with Figures*) by Nicolas Antoine Taunay (1755–1830).

Although Sheremetev visited Western Europe, spending four years there in the early 1770s, *The Present* was probably purchased on the St. Petersburg market, where foreign dealers often sold paintings. [AB]

1785–87, oil on canvas, 21⅝ × 17¹¹⁄₁₆ in. (55 × 45 cm)
Inv. no. GE 6649
PROVENANCE Acquired in 1931 from the Museum of Everyday Life of the Leningrad Regional Department of Public Education; formerly, before 1795, private collection (Villiers sale, Paris, 2 December 1795, no. 7); by 1809 in the collection of the Counts Sheremetev, St. Petersburg
EXHIBITIONS Leningrad 1969, p. 18; Paris 1974–75; Sverdlovsk 1990, no. 12
BIBLIOGRAPHY Wildenstein 1960, no. 543 (as lost); Wells-Robertson 1978, p. 757, no. 19; Berezina 1983, no. 193; Cuzin 1988, p. 339, no. 413; Rakina 1995, p. 27; Babin 2001, pp. 98–99, note 61

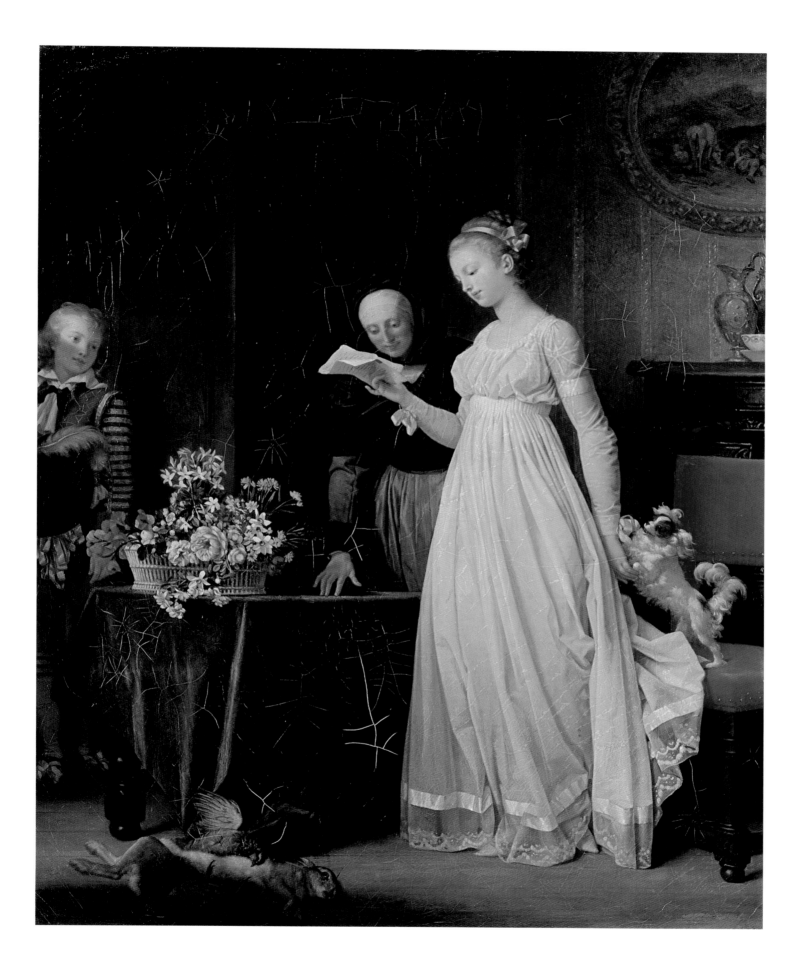

Marguérite GÉRARD

First Steps (L'Elan de la nature)

The style of this painting suggests that Gérard produced it early in her career, around 1788. Soon after it was completed the artist's brother, Henri Gérard, created a print after the painting under the title *L'Elan de la nature*, or "the beginning of life" (there is no documentary evidence for a date for the print, but scholars usually place it at 1788). Some scholars feel that *L'Elan de la nature* was in fact the author's own original title for the work, and was not created merely for the print. This title not only allows us to differentiate between the Hermitage work and an earlier canvas by the same artist on a similar subject, based on a drawing by Fragonard (*Le Premier Pas de l'enfance*, c. 1783; Fogg Art Museum, Harvard), but more enthusiastically conveys the spirit of the subject-matter. If *Le Premier Pas de l'enfance* represents Marguérite Gérard's first steps in art—her work of the early 1780s still looks to the art of Fragonard—the Hermitage painting is her first independent work. *L'Elan de la nature* departs from the Rococo style of her teacher and looks toward Neo-classicism.

L'Elan de la nature, with its multi-figure composition built along symmetrical principles, fits into the new Neo-classical mood in French art, and into that line of development that originates from Joseph-Marie Vien, the teacher of Jacques-Louis David (1748–1825). In composition and subject the painting reveals not so much homage to Fragonard as a dependence on Vien and his canvas *The Cupid Seller* (Musée national du château Fontainebleau), which caused a sensation at the Salon of 1763 and introduced into France the fashion for everything "*à la grecque.*" For example, Gérard's painting features the figure of the mother and child found in Vien's work (which itself was mainly based on an ancient fresco, *The Seller of Cupids*, discovered at Stabiae, on the Neapolitan coast). In the lively spirit of the frescoes of Pompeii, Gérard's painting takes on a vivacious and contemporary character, and provides us with one of the most expressive and sensitive images of maternal love in painting of the 1780s. [AB]

c. 1788, oil on canvas, 17 15/16 × 21 5/8 in. (45.5 × 55 cm)

Signed bottom left: *Mte Gerard*

Inv. no. GE 6321

PROVENANCE Transferred in 1925 from the Yusupov Palace Museum; formerly, sold 13 March 1815 at an auction of paintings from the collection of M. Fauchet, Paris (no. 9); before 1827 entered the collection of Prince Nikolai Yusupov

EXHIBITIONS St. Petersburg 1912, no. 261; Warsaw 1973, no. 12; Hokkaido 1987, no. 2; Moscow–St. Petersburg 2001–02, no. 76.

BIBLIOGRAPHY Cat. 1839, no. 272; Prakhov 1906, p. 203, table 123; Iaremich 1912, p. 50; Monod 1912, pp. 195–96; Doin 1912, pp. 237, 443; Yusupov Gallery 1920, no. 73; Ernst 1924, pp. 188–89; Izergina 1969, p. 20; Berezina 1972, p. 60, fig. p. 61; Wells-Robertson 1974, p. 438, no. 71; Wells-Robertson 1978, pp. 771–72, no. 25; Berezina 1983, no. 192; Berezina 1987, no. 47; Cuzin 1988, pp. 221–22, 340; Savinskaia 1994, p. 206; Savinskaia 1999, p. 84; Babin 2001, p. 88, no. 76

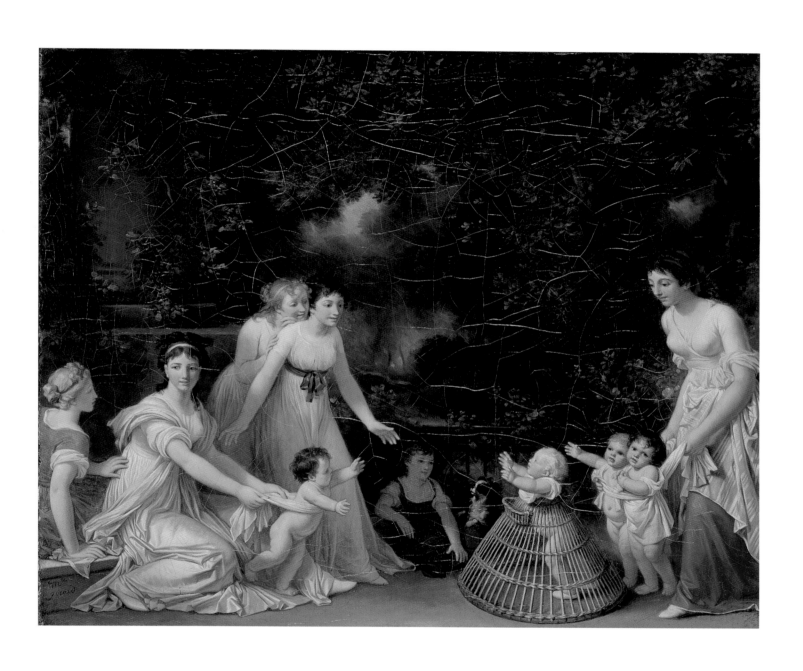

Marie GOMION

Active first half of 19th century

Little is known about the portraitist Marie Gomion. Between 1810 and 1821 she lived in St. Petersburg, where an auction was held of her paintings in 1818. Gomion's portrait of the famous Russian actress Ekaterina Semenova as Joan of Arc enjoyed some popularity in Russia, and was engraved by P.A. Aleksandrov (an example of the print is in the Museum of Alexander S. Pushkin in Moscow).

Portrait of Prince Boris Kurakin

Son of Procurator-General Alexei Borisovich Kurakin and godson of Catherine II, Boris Alekseevich Kurakin (1783–1850) became court chamberlain in 1804. In 1810 Kurakin journeyed to Paris to congratulate Napoleon on his marriage to Marie-Louise as part of an envoy on behalf of Russian Emperor Alexander I (the sitter's uncle, Prince Alexander Borisovich Kurakin, was at this time the Russian envoy in Paris). On his return to Russia he spent eleven years associated with the Collegium of Foreign Affairs and later with the Ministry of Finance. In 1822 he was appointed senator with the rank of privy counselor. He retired in 1833. The sitter remained unidentified until 1950, when V.N. Berezina (1983) noted the likeness to a portrait of Boris Kurakin by an unknown artist reproduced in *Russkie portrety XVIII–XIX stoletii* (*Russian Portraits of the 18th and 19th Centuries*). Confirmation of the sitter's identity was found in the painting's origin in the Kurakin collection.

Gomion worked primarily in St. Petersburg, painting Russian sitters, and took certain features from both the French and the Russian schools of painting. She is linked with the French school in the compositional scheme of the portrait (the half-length image, the three-quarter turn of the head), technique, and style, derived from the works of pupils and followers of Jacques-Louis David. *Portrait of Prince Boris Kurakin* displays similarities to portraits of Enlightenment figures that David's pupils produced in 1790 and which are now in the Hermitage (such as *Portrait of Voltaire* and *Portrait of Turgo* by Claude Gautherot [1769–1825]). Unusually for this kind of portrait, however, the sitter is shown with a specifically Russian fur coat (with fur both inside and out) thrown over the dress suit, and set against an ideal landscape background. While French artists preferred to paint portraits of similar format and dimensions, their sitters were usually presented against a neutral background or in a barely indicated interior. Possibly Gomion depicted winter clothing to emphasize the sitter's Russian nationality, and perhaps to stress that people were always—in her perception—cold in Russia. [AB]

1821, oil on canvas, 26⅜ × 22¹⁄₁₆ in. (67 × 56 cm)
Signed and dated just below middle left: *Marie Gomion. 1821*
Inv. no. GE 7518
PROVENANCE Transferred in 1931 from the All-Russian Antikvariat Society; formerly in the collection of A.A. Kurakin, St. Petersburg; from 1924 in the State Museums Fund
BIBLIOGRAPHY Berezina 1983, no. 209

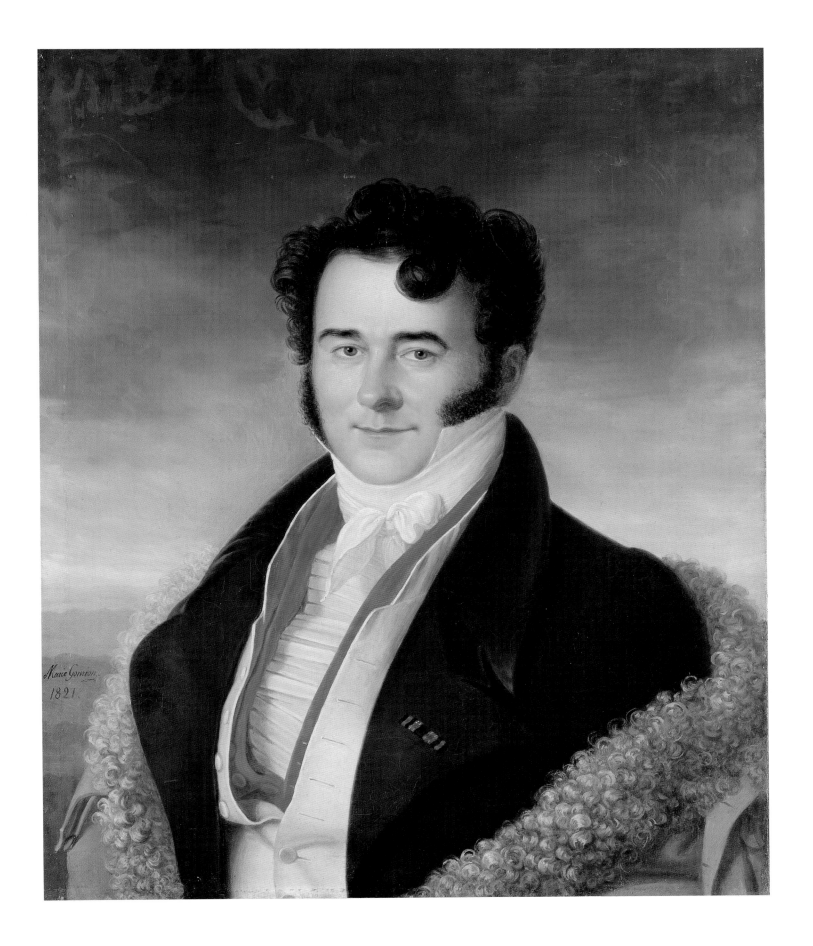

Catharina van HEMESSEN

1528 Antwerp – after 1587 Antwerp

The daughter and pupil of Jan van Hemessen, Catharina van Hemessen developed an international reputation during her lifetime for her painting and royal patronage. She painted large-scale portraits primarily of women, as well as works on religious themes, and may have worked with her father on large commissions. Lodovico Guicciardini mentions Catharina van Hemessen in his famous description of The Netherlands, *Descrittione di tutti i Paesi Bassi, altrimenti detti Germania Inferiore,* first published in Antwerp in 1567. Guicciardini writes that she married the musician Chrétien de Morien and that Queen Mary of Hungary (Regent of The Netherlands and sister of Emperor Charles V) invited them to Spain. When the queen moved to Brussels, Van Hemessen became a lady-in-waiting at her court. It is not known if this position precluded further activities as a painter.

Self-portrait

The darkened background and illuminated foreground reflect the influence of sixteenth-century Italian painting on Netherlandish painters. By using such lighting, Van Hemessen dramatically draws attention to herself: her signature "I Catharina van Hemessen painted myself in 1548 at age 20" suggests her sense of professionalism, even from an early age. This self-portrait illustrates a device employed by painters in The Netherlands in the sixteenth century: the painting on which the artist is working stands on an easel already in its frame. Van Hemessen employs a maulstick to steady her hand and the palette displays the various paints she used for the composition.

Catharina van Hemessen captured her own appearance on a number of occasions. A similar self-portrait from the same year as the Hermitage example (1548) is in the Öffentlich Kunstsammlung in Basel, Switzerland, and comes from the collection of the Russian artist A. Somov, St. Petersburg. On another occasion the artist transposed her features on to a woman playing a virginal, although it is possible that the sitter was in fact the painter's elder sister Christina (signed and dated 1548; Wallraf-Richartz-Museum, Cologne). [NN]

1548, oil on canvas glued on to plastic, 13 × 10⁷⁄₁₆ in. (33 × 26.5 cm)
Signed top left on the background: *Ego Catharina de Hemessen me pinxit 1548. Etatis suae 20*
Inv. no. GE 10062
PROVENANCE Acquired in 1969 via the Hermitage Purchasing Commission
EXHIBITIONS Antwerp–Arnhem 1999, no. 6
BIBLIOGRAPHY Nikulin 1989, no. 53; Gaze 1997, pp. 661–64

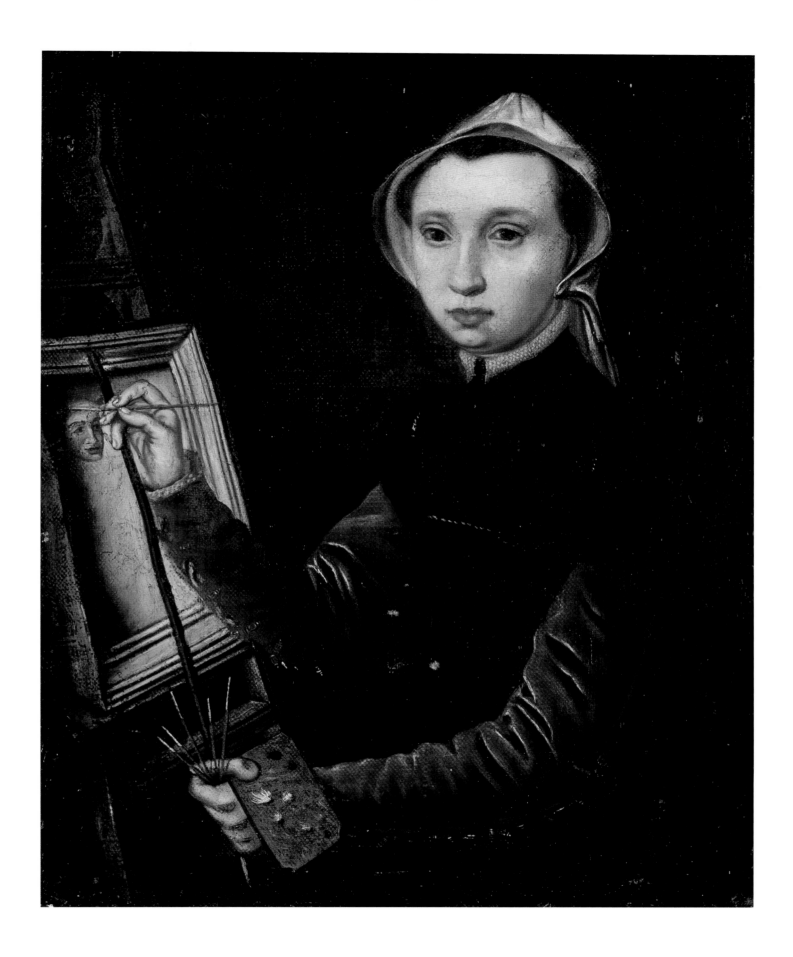

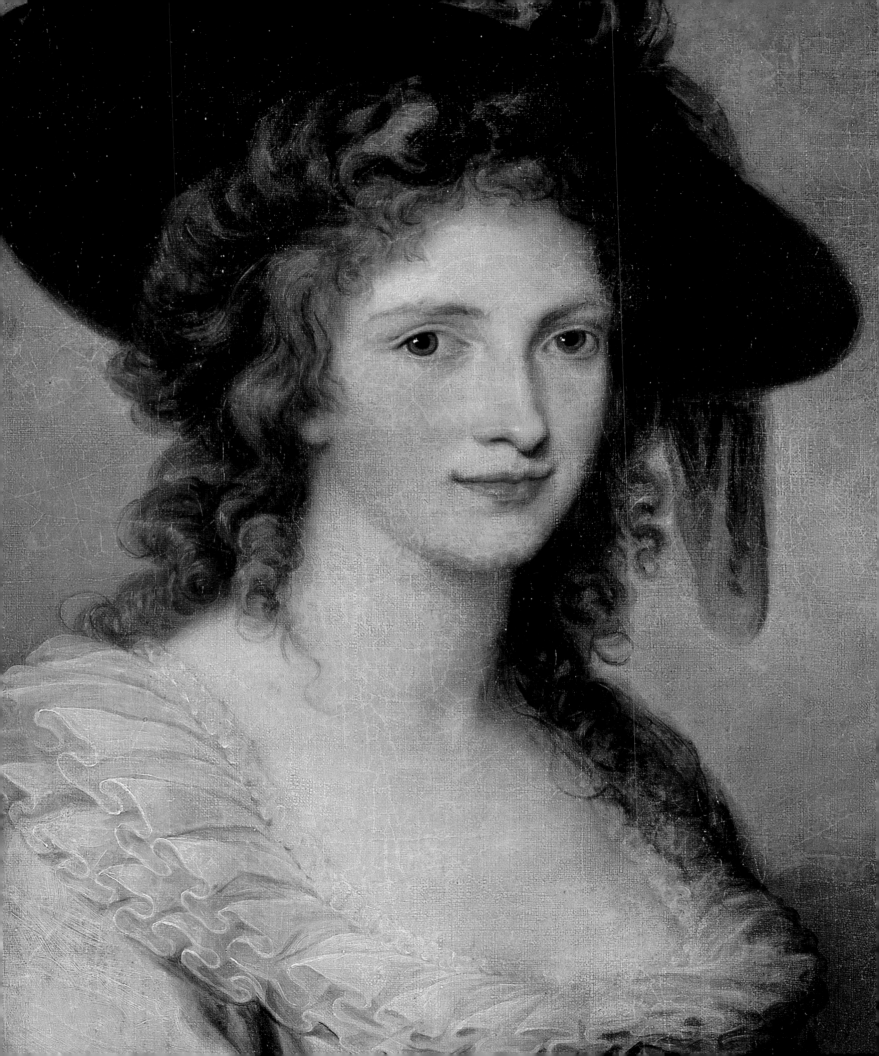

Angelica KAUFFMAN

1741 Chur, Switzerland – 1807 Rome

Women artists working within the family studio were not rare in the eighteenth century, but instances of those who successfully broke away from the confines of the family, even leaving their native land to earn their living independently and gain fame throughout Europe, can be counted on the fingers of one hand. One such artist was Angelica Kauffman.

Born on 30 October 1741 at Chur in the Swiss canton of Graubünden, she proved at an early age to be gifted in many different spheres. Her *Self-portrait*, painted when she was thirty years old (Tiroler Landesmuseum Ferdinandeum, Innsbruck), shows the artist singing and holding sheet music in her hand. Her great skill in both music and painting meant that she did not immediately make her choice between them. She also possessed an outstanding memory and as a child could already speak four languages, which was to be of great assistance later in life, both in communicating with numerous clients from different countries and in making friends and business associations.

Kauffman studied under her father, the muralist Johann Joseph Kauffman, and during the early 1760s helped him carry out commissions for frescoes, traveling around the Bodensee and finding patrons at the courts of the Swiss and German aristocracy. It was at this time that she received her first portrait commissions. Both father and daughter worked at the court of Milan from 1754 to 1757, and a second trip to Italy in 1758 was totally devoted to her artistic education. In Florence the young artist made the acquaintance of Benjamin West, with whose early work we find many parallels in her paintings. Her circle of friends and acquaintances included the painters Gavin Hamilton, Giovanni Battista Piranesi, and Pompeo Batoni, as well as the archaeologist and theoretician of Neo-classicism Johann Joachim Winckelmann, all of whom Kauffman portrayed. Success in Italy brought the young artist an honorary membership of two academies—the Accademia Clementina in Bologna and the Accademia del Disegno in Florence.

In 1762 the artist moved to Rome, where she became a member of the Accademia di San Luca, and in July 1764 her career took a great leap forward when she completed her *Portrait of Winckelmann* (Kunsthaus, Zurich), which was widely admired. Kauffman's most productive artistic period began in 1766. Through her English acquaintances she moved to London and successfully took up history painting, taking as her sources the *Tableaux tirés de l'Illiade et de l'Odyssée d'Homère et de l'Enéide de Virgile* by the archaeologist, writer, and collector the comte de Caylus, as well as the works of Winckelmann. Her canvases unite Roman and Venetian influences, and convey a sense of poetry, grace, and elegance.

Queen Charlotte, wife of George III, commissioned her portrait from Kauffman, and in London Kauffman met Joshua Reynolds, with whom she was to become one of the founding members of the Royal Academy in 1768. European fame was now hers; her works were engraved and published in large numbers both by the artist herself and by other printmakers.

In 1781 (after a first, unsuccessful, marriage in 1767), Kauffman married the Venetian *vedute* painter Antonio Zucchi and moved to Venice, where she became an honorary member of the Accademia di Venezia. Her studio was visited by Grand Duke Pavel Petrovich (later Russian Emperor Paul I) and his wife, who bought from her three history paintings. That same year Kauffman moved to Rome. She settled in a palazzo that had formerly belonged to Anton Raphael Mengs, and her studio became the most famous in the city. Her husband relieved her of the management of her affairs and he began to keep her commission book, while her hospitable salon was the gathering place for celebrated poets, artists, and scholars. She was a friend of Johann Wolfgang Goethe (who mentioned her in his *Italienischen Reise*), the Polish King Stanislaus II August Poniatowski, and the Russians Prince Nikolai Yusupov and Princess Ekaterina Bariatinskaia (née Princess of Holstein-Beck). Her career continued to flourish and unlike many women artists she enjoyed great fame and wealth during her lifetime.

Angelica Kauffman died on 5 November 1807. Rome had not seen such a rich funeral since the death of Raphael: the coffin was borne by her colleagues from the Accademia, and her last great canvases were carried behind the procession. [MG]

Self-portrait, 1780–87, detail (see p. 127)

Angelica KAUFFMAN
The Monk of Calais

Kauffman's painting derives from an episode from Laurence Sterne's *A Sentimental Journey through France and Italy* (part 1, chapter 2), published in 1768, which became a cult novel while Kauffman was in England. The painting shows Parson Yorick, hero of *A Sentimental Journey*, meeting a French monk, Father Lorenzo, and exchanging snuffboxes with him. Present at this exchange is a young woman traveling from Brussels to Amiens. To the left, through the arch, we can see the port of Calais. Here, as in the episode with *The Insane Maria* (see p. 121), the artist keeps close to the original text in describing the heroes:

> It was one of those heads which Guido has often painted—mild, pale, penetrating, free from all commonplace ideas of fat contented ignorance looking downwards upon the earth: it look'd forwards; but look'd, as if it look'd at something beyond this world … it was a thin, spare form, something above the common size, if it lost not the distinction by a bend forward in the figure—but it was the attitude of Entreaty.

Nikolai Nikulin (1987) points out that the face of Parson Yorick bears a likeness to Sterne himself (see Joshua Reynolds: *Portrait of Laurence Sterne*, 1760; National Portrait Gallery, London). J.M. Delattre engraved this work in 1781 under the guidance of F. Bartolozzi. [MG]

c. 1766–1781, oil on canvas, 25 13/16 × 25 13/16 in. (65.5 × 65.5 cm) (circular, set into a square)
Inscription bottom left: *The Snuff-Box. Calais*
Inv. no. GE 1340 (pair to inv. no. GE 1339)
PROVENANCE Acquired before 1797
BIBLIOGRAPHY Waagen 1864, p. 265; Clément de Ris 1879, p. 352; Williamson 1904, p. 15; Nikulin 1987, p. 277, no. 222

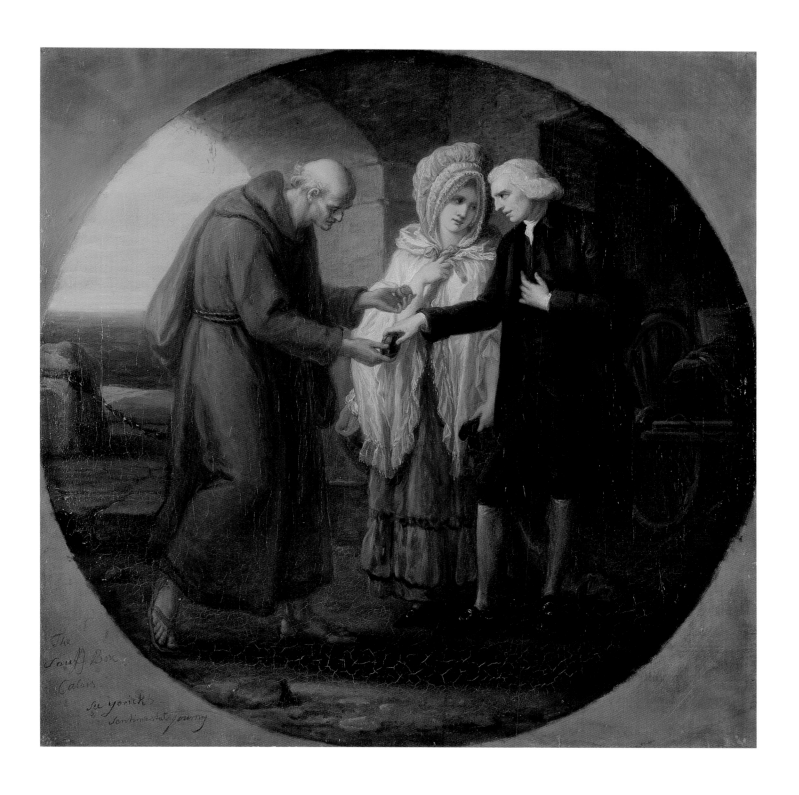

Angelica KAUFFMAN

The Insane Maria

As with *The Monk of Calais* (see p. 119), this painting derives from an episode in *A Sentimental Journey through France and Italy* by Laurence Sterne, a cult novel from the "age of sentiment" published in 1768, while Kauffman was in England. Maria, already known to the public from Sterne's previous book, *The Life and Opinions of Tristram Shandy*, lost her ability to reason after an unhappy love affair. She wandered around the environs of Moulines, where her aged mother sat waiting for her at home. Parson Yorick visited the poor mad girl, of whom he had heard from his friend Tristram Shandy. The Hermitage painting illustrates the moment in Yorick's narrative when Maria shows him Tristram's handkerchief:

She was dress'd in white, and much as my friend described her, except that her hair hung loose, which before was twisted within a silk net. She had, superadded likewise to her jacket, a pale green ribband, which fell across her shoulder to the waist; at the end of which hung her pipe. Her goat had been as faithless as her lover: and she had got a little dog in lieu of him.

In all details, Angelica Kauffman remained close to the original text.

The artist's first work on the subject of the insane Maria had been exhibited at the Royal Academy in London in 1777 (now The Burghley House Collection, Stamford, Lincolnshire). It was hugely successful and much copied. Kauffman herself painted three more versions of it. The Hermitage canvas may have been specifically commissioned by Russian Empress Catherine II (Nikulin 1987; Düsseldorf– Munich–Chur 1999). Although Bettina Baumgärtel suggests that Kauffman painted this last, fifth painting during the second wave of interest in Sterne's work in the late 1780s (Düsseldorf– Munich–Chur 1999), the engravings made after it, by W. W. Biland in 1779, and by J. M. Delattre under the guidance of F. Bartolozzi in 1782, indicate an earlier dating. The painting should therefore be placed at *c.* 1777–79. [MG]

c. 1777–79, oil on canvas, 25 ¹³⁄₁₆ × 25 ¹³⁄₁₆ in. (65.5 × 65.5 cm)
(circular, set into a square)
Inv. no. GE 1339 (pair to inv. no. GE 1340)
PROVENANCE Acquired before 1797
EXHIBITIONS Bregenz–Vienna 1968–69, p. 72, no. 65; Vaduz 1992, p. 266, no. 39
BIBLIOGRAPHY Waagen 1864, p. 265; Clément de Ris 1879, p. 352; Williamson 1904, p. 15; Manners, Williamson 1924, pp. 45, 182; Nikulin 1987, p. 276, no. 221; Düsseldorf–Munich–Chur 1999, p. 416

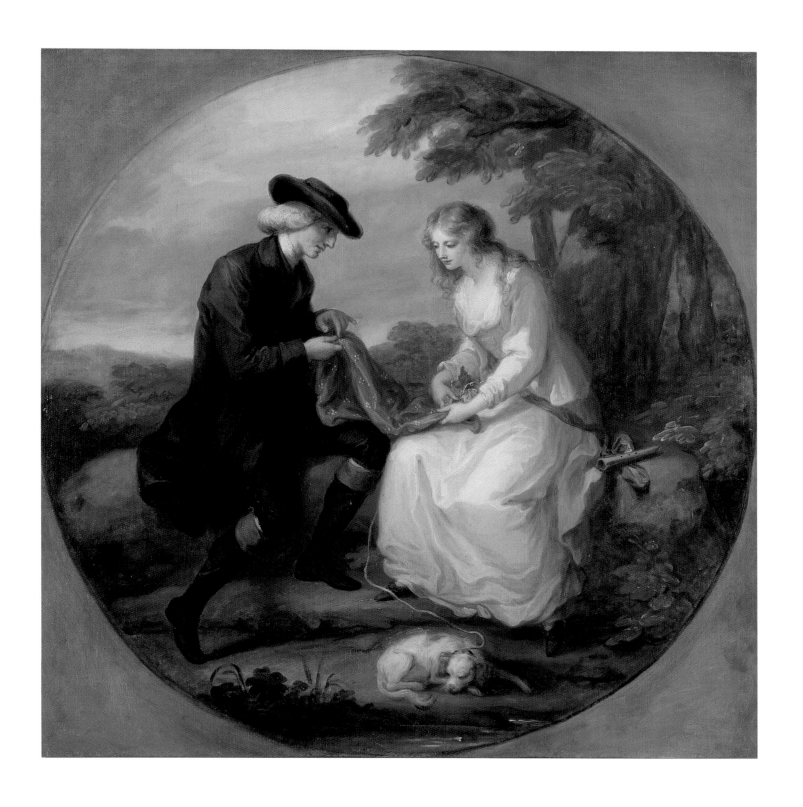

Angelica KAUFFMAN

Abelard Saying Farewell to Heloïse

The French medieval theologian and scholastic philosopher Pierre Abelard (1079–1142) began teaching in Paris in 1113, where he fell in love with Heloïse (1101–1164), niece of Fulbert, a canon at Notre Dame Cathedral. Fulbert found the lovers together, after which Abelard abducted the girl and secretly married her. Unable to bear society's judgment, in 1119 Heloïse went into a convent at Argenteuil, while her uncle accused Abelard of abandoning Heloïse and ordered that he be caught and castrated. Abelard hid within the monastery of St. Denis and there wrote the history of his unhappy love, *Historia calamitatum mearum*, to which he appended his correspondence with his beloved. In 1817 the remains of Abelard and Heloïse were reburied together at Père-Lachaise Cemetery in Paris in recognition of the admiration their story had aroused in generations of sentimental lovers. In 1761 Jean-Jacques Rousseau published the story as a novel in epistolary form, *La Nouvelle Héloïse*. Alexander Pope's *Eloisa to Abelard* published in London in 1717 provided the motifs for Kauffman's work.

The painting in the Hermitage is one of a series of four that Kauffman produced showing events in the story of Abelard and Heloïse. Bettina Baumgärtel lists the following paintings and related prints by G.I. Skorodumov, dating from 1778 to 1780: *Abelard Leading Hymenaeus to Heloïse* (The Burghley House Collection, Stamford, Lincolnshire); *The Death of Heloïse* (Moravska Galerie Brno, Brno); *Abelard and Heloïse Caught by Fulbert* (location unknown; see Düsseldorf–Munich–Chur 1999, p. 418). There is also a copy of the Hermitage painting in a private collection in Russia (Düsseldorf–Munich–Chur 1999, p. 418). [MG]

c. 1779, oil on canvas, 25 $^{13}/_{16}$ × 25 $^{13}/_{16}$ in. (65.5 × 65.5 cm)
(circular, set into a square)
Signed below: *Angelica K. pinx*
Inv. no. GE 1338
PROVENANCE Acquired before 1797
EXHIBITIONS Bregenz–Vienna 1968–69, p. 72, no. 66; Düsseldorf–Munich–Chur 1999, p. 418, no. 257
BIBLIOGRAPHY Cat. 1797, no. 942; Waagen 1864, p. 265; Clément de Ris 1879, p. 352; Williamson 1904, p. 15; Christoffel 1966, III, p. 548; Nikulin 1987, p. 275, no. 220

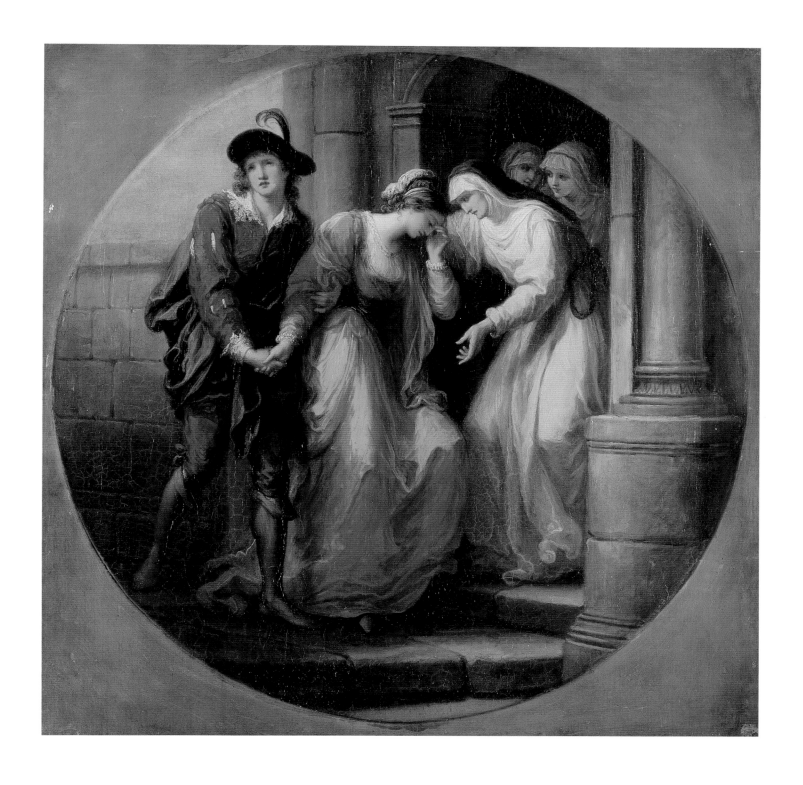

Angelica KAUFFMAN

Hector Summoning Paris to Battle

Kauffman used as the source for this work Homer's *Iliad*: VI. 325–31. We see a background of late Roman architecture, in which powerful fluted columns are surrounded by a curved wall with niches, and a large arched opening is visible slightly right of center. Nikolai Nikulin (1987) suggests that this is the Scaean Gate, leading out of the city of Troy to the field of battle. Thus the figures are Hector, dressed in full armor with a spear and helmet, pointing to remind Paris of the latter's obligation to fight. Paris's weapons lie scattered at his feet as he rests in a chair on a soft carpet, with the beautiful Helen seeking to restrain him by placing her hand on his shoulder. To the right stand three of Helen's serving women, engaged in various crafts. All the figures are arranged in a frieze-like composition.

Despite the classicizing aims of this history painting, the artist has not achieved here such clarity of drawing and use of local color as is seen in her works of the 1780s and 1790s. This painting exhibits Rococo elements, in its soft coloring, fragmentary use of light and shade, and the similarities between the women's robes and contemporary attire.

There is a version of the Hermitage painting and a copy made in 1793, both in private collections (Vaduz 1992, p. 265, no. 36). Bettina Baumgärtel also mentions a copy (Kunsthandel Lepke, Berlin, 19 November 1932, acquired for a private collection; Vaduz 1992, p. 380). It was engraved in 1782 by G.I. Skorodumov under the title *Ulysses Reveals Achilles Dressed as a Woman in the Home of Lycomedes*. [MG]

1775, oil on canvas, 53 15/16 × 70 1/16 in. (137 × 178 cm)
Signed and dated middle left: *Angelica Kauffman pinx. Anno 1775*
Inv. no. GE 6472
PROVENANCE Acquired before 1797; kept during the nineteenth century at Gatchina Palace, near St. Petersburg; returned to the Hermitage in 1926
EXHIBITIONS Leningrad 1986, p. 18, no. 23; Frankfurt-am-Main 1991, pp. 130–31, no. 30; Vaduz 1992, p. 265, no. 36; Düsseldorf–Munich–Chur 1999, p. 379, no. 224
BIBLIOGRAPHY Cat. 1797, no. 2894; Nikulin 1987, p. 274, no. 219

Angelica KAUFFMAN

Self-portrait

Although traditionally thought to be a self-portrait, this painting differs strongly from the artist's other self-portraits in its distinct prettiness and charm, in the freshness of the skin, the soft blush on the cheeks, and the clarity of the sitter's chestnut eyes. Bettina Baumgärtel notes that Kauffman's *Memorandum of Paintings* does not include such a commission from Nikolai Yusupov (Düsseldorf–Munich–Chur 1999, p. 301, no. 3), but this suggests it might indeed be a self-portrait, not produced specifically as a commission but acquired later by the Russian prince.

Compared to her other self-portraits, the eyebrows are somewhat straighter, while the lines of the nose and chin have been perfected. This is the artist as she might wish to see herself, with her innermost character, her soul, expressed in the ennobled features of her face. A similarity exists between this idealized image and her *Self-portrait as Drawing Inspired by the Muse of Poetry* of 1782. Such associations, taken with Kauffman's portrait of Goethe of 1787 (Goethe National-Museum, Weimar)—idealized in the same spirit as the *Self-portrait* in the Hermitage—allow us to suggest that the Hermitage painting may have been produced around that date. Sandner (Vaduz 1992, p. 256, no. 9) noted the clearly English features of the Hermitage work, but nonetheless thought that it had been produced while the artist was in Italy, some time between 1780 and 1785, on the basis of stylistic similarities with *Portrait of Frau von Bauer* (1786; Staatsgalerie Stuttgart; Bregenz–Vienna 1968–69, p. 57, no. 29, fig. 17). Sandner (Vaduz 1992) also noted stylistic similarities between the *Self-portrait* and *Portrait of Lady Betty Foster* of 1785 and *Portrait of Almeria Carpenter* of 1787. Baumgärtel (Düsseldorf–Munich–Chur 1999) sees the Hermitage work and the *Portrait of Frau von Bauer* as quotations from Rubens's *Portrait of Susanna Fourment* (National Gallery, London). [MG]

1780–87, oil on canvas, 30⅛ × 24¹³⁄₁₆ in. (76.5 × 63 cm) (oval, set into a rectangle [not shown])

Inv. no. GE 7261

PROVENANCE Acquired in 1925; until 1801 in the collection of Prince Nikolai Yusupov

EXHIBITIONS Bregenz–Vienna 1968–69, p. 48, no. 5; Leningrad 1986, p. 18, no. 22; Vaduz 1992, p. 256, no. 9; Florence 1998, p. 89, no. 76; Düsseldorf–Munich–Chur 1999, p. 301, no. 163 [*Bildnis einer Dame (sog. Selbstbildnis)*]

BIBLIOGRAPHY Nikulin 1987, p. 278, no. 223

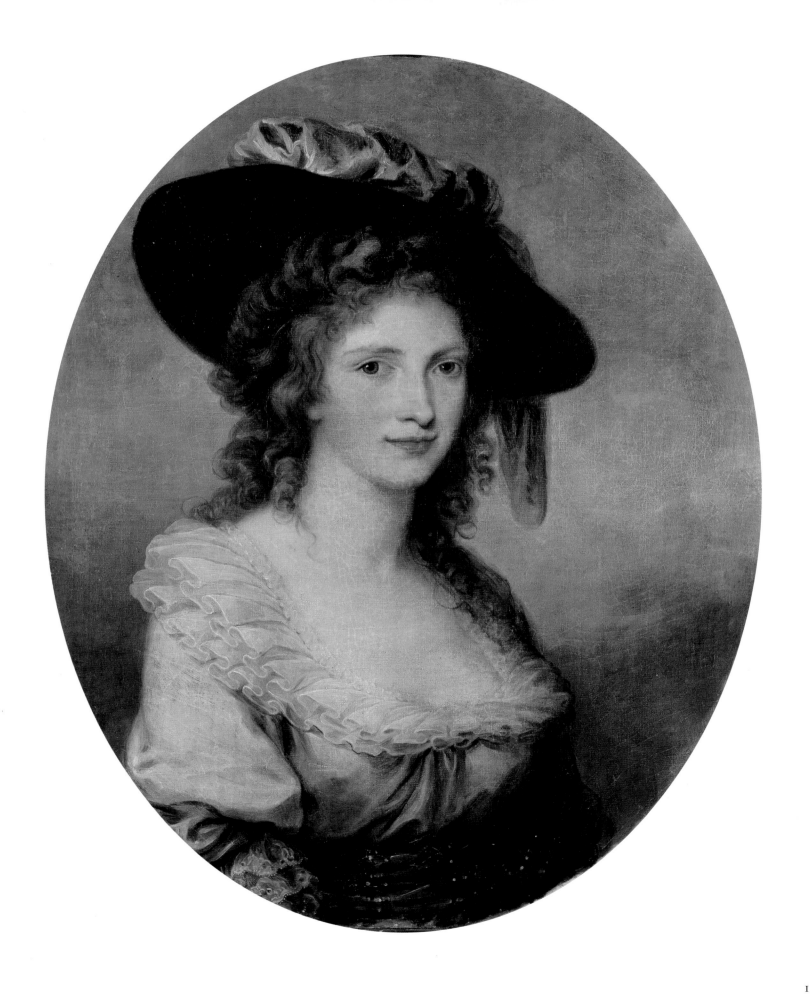

Angelica KAUFFMAN

Portrait of Karl Leberecht (?)

Born in Meiningen, Germany, Karl Leberecht (1755–1827) worked from 1779 at the St. Petersburg Mint as a medalist and engraver. Between 1783 and 1785 he studied in Rome on a grant from the Imperial Academy of Arts, of which he became a full member in 1794. In his *Description of the Russian Imperial Capital City of St. Petersburg* (1794), Johann Gottlieb Georgi (died 1802), professor of mineralogy at the Imperial Academy of Sciences, described the scene in the Old Hermitage:

> In a special secondary room with its windows looking out into the courtyard the court medalist Leberecht and the chemist König practice the making from a compound of copies from gems in the Cabinet, often in the presence of and by instruction of Her Imperial Majesty [Catherine the Great]. Abutting onto this room König has a furnace for the making of the compounds and Leberecht all the equipment for carving in stone. (Georgi 1996, p. 340)

Leberecht's activities were of great significance at the court of St. Petersburg, for Catherine was particularly passionate about her collection of engraved gems and was a specialist in them. In 1799 Leberecht took Russian citizenship and was appointed chief medalist at the St. Petersburg Mint. Leberecht also taught Empress Maria Fedorovna, wife of Catherine's son Paul I, in her amateur but skilled attempts at carving in steel and precious stones. He was an honorary member of both Berlin and Stockholm Academies of Art.

The identification of the sitter is traditional, but some doubt arises from the absence of any particular likeness to other portraits of Leberecht. The objects in the sitter's hands, however, leave no doubt that the sitter was indeed an engraver and medalist by profession: in his right hand is a chisel, and in his left an almost finished work, a carved profile on an oval piece of stone. The date and the signature suggest that this painting may have been produced during Leberecht's stay in Rome.

The portrait is in brown tones, with the brightly lit face, shirt, and hands of the sitter set off against the background. Soft light and shade are also used to emphasize the texture of the fur and fabrics, the folds and creases of the clothing. The canvas recalls Kauffman's works of the early 1790s, such as *Portrait of Johann Gottfried Herder* (1791; Goethe-Museum, Frankfurt), who closely resembles Leberecht. [MG]

1785, oil on canvas, 29 15/16 × 25 3/16 in. (76 × 64 cm)
Signed and dated left on the ground: *Angelica Kauffman. Pinx. Rom 1785*
Inv. no. GE 8364
PROVENANCE Acquired in 1939
EXHIBITIONS Bregenz–Vienna 1968–69, pp. 56, 57, no. 27
BIBLIOGRAPHY Nikulin 1987, p. 284, no. 229

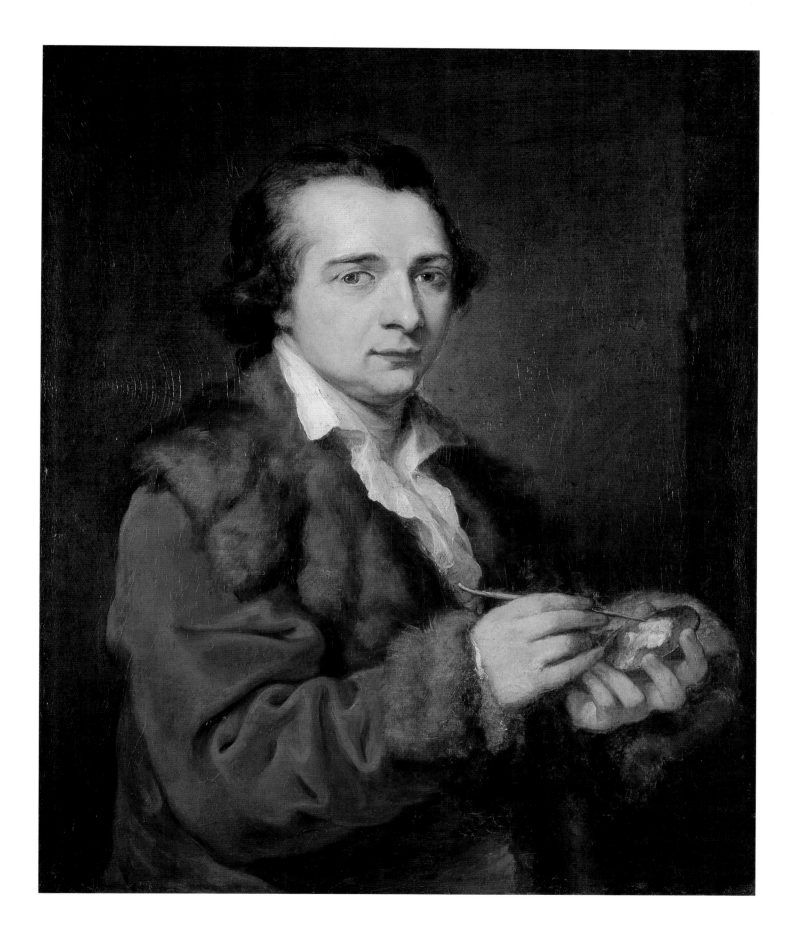

Angelica KAUFFMAN

Portrait of Lady-in-Waiting Anna Protasova with her Nieces

Anna Stepanovna Protasova (1745–1826) was the daughter of the Russian senator Stepan Protasov, and, through the maternal line, niece of Catherine the Great's favorite guardsman and lover, Count Grigory Orlov. Catherine was particularly fond of Protasova, who was one of Catherine's Ladies of the Bedchamber from her early youth. The sovereign created for Protasova a notable position at the court, where she soon gained the title of lady-in-waiting of the Order of St. Catherine. Protasova wears on her left a miniature portrait of Catherine II studded with diamonds, confirmation of her title of lady-in-waiting.

At the coronation of Paul I, Protasova was awarded the Order of St. Catherine Second Class, and at the coronation of Paul's son Alexander I she received the title of countess (Rostopchina 1989, p. 432). That same year, in 1801, the title of countess was also given to three of the five nieces shown with her in this painting: Varvara, Vera, and Anna. All five nieces were the daughters of Anna Stepanovna's brother, Lieutenant-General Petr Protasov, and they lived with their aunt in the Winter Palace. Thanks to her encouragement and connections, all the girls received an excellent education and four were able to marry well. Alexandra Petrovna (1774–1842) married the diplomat Prince A.A. Golitsyn in 1791; Varvara Petrovna (born 1788) died young

and single; Ekaterina Petrovna (1776–1859), an ardent Catholic, married in 1794 Count F.V. Rostopchin, president of the Collegium of Foreign Affairs and from 1812 governor of Moscow; Vera Petrovna (1780–1814) became the first wife of Lieutenant-General I.V. Vasilchikov, hero of the Napoleonic War of 1812; and Anna Petrovna (1784–1869) married Count V.V. Tolstoi.

In her *Memorandum of Paintings*, Angelica Kauffman mentions a commission from Prince Nikolai Borisovich Yusupov (Manners, Williamson 1924, pp. 141–74) who sent six half-length images to the artist to help her in painting the group portrait. Nikolai Nikulin (1987) related this entry to the Hermitage portrait, which can thus be dated to 1788. [MG]

1788, oil on canvas, 48⁷⁄₁₆ × 62⅝ in. (123 × 159 cm)
Inv. no. GE 5769
PROVENANCE Acquired before 1797; in 1870 in the collection of Prince S.I. Vasilchikov, Moscow
EXHIBITIONS St. Petersburg 1870, p. 125, no. 443; St. Petersburg 1905, issue IV, p. 24, no. 781; Leningrad 1986, p. 18, no. 24; Düsseldorf–Munich–Chur 1999, p. 301, no. 163
BIBLIOGRAPHY Rovinsky 1886–89, II, pp. 1832–34; Rovinsky 1895, I, p. 134, no. 31; List of Portraits 1904, p. 142, no. 2; Russian Portraits 1905–09, V, table 8; Morozov 1913, III, p. 978, table CCCLX; Manners, Williamson 1924, pp. 73, 154; Nikulin 1987, p. 279, no. 224

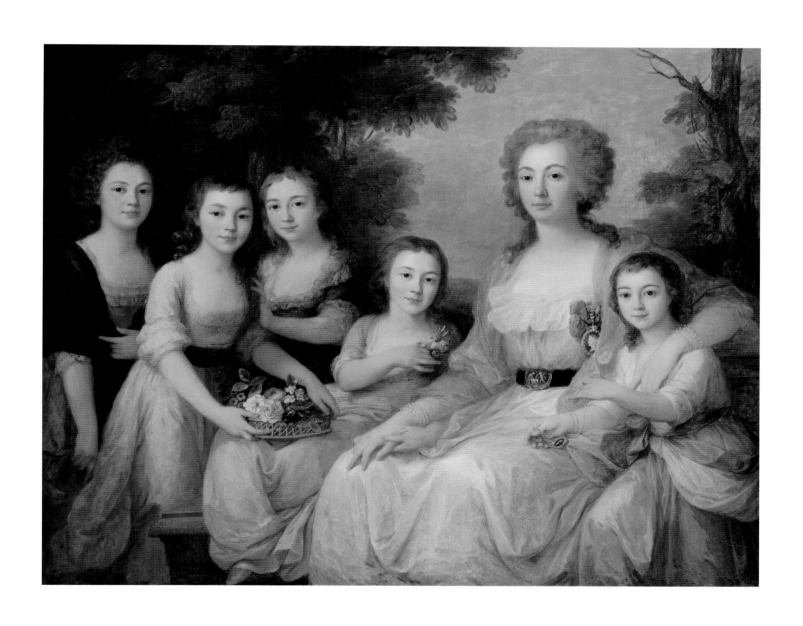

Angelica KAUFFMAN

Virgil Reading the Aeneid to Octavia and Augustus

An entry in Kauffman's *Memorandum of Paintings* (Manners, Williamson 1924, pp. 141–74) explains the content of this painting:

> Rome. Aug. 1788. For His Majesty the King of Poland, finished a picture on canvas … with figures … representing Augustus, Octavia and Virgil. Virgil is reading the sixth book of his Aeneid, wherein he speaks of Marcellus to Augustus and Octavia falls down in a faint, Augustus is trying to assist her as likewise two women who have rushed to help the Princess—the Poet remains motionless and amazed at the effect which his writing had on Octavia's soul.

The action takes place against a background of Roman architecture. The Capitoline Hill and the Temple of Jupiter are visible through the arch in the background. In the center of the composition is Octavia, toward whom the gazes and movements of all the remaining figures are directed. Augustus has leapt from his throne and runs to her aid, while one serving woman kneels and holds her and another supports her mistress's head, looking angrily at Virgil, who stands to the right. The poet holds in his hands a scroll of paper bearing words from the *Aeneid*: "*Tu Marcellus eris …*" The remaining sheets are visible tucked into his robes. He is somewhat distanced from the other figures and merely observes this moment of high drama. Here the artist has produced a far more mature expression of Winckelmann's classicizing ideas than in her earlier historical paintings, such as *Venus Persuading Helen to Accept the Love of Paris* (see p. 135) or *Hector Summoning Paris to Battle* (see p. 125) of 1775. In *Virgil Reading the Aeneid* she has achieved great simplicity of line and arrangement of color, rejecting excessive fragmentation in the molding of fabrics with light and shade. The work demonstrates clarity of form and equilibrium of composition.

Kauffman produced a copy of this painting in 1790 for a Mr. Matthews of London (recorded in her *Memorandum of Paintings*), but its present location is unknown. There is an engraving by Kauffman showing a three-figure version of the painting, an engraving by F. Bartolozzi after a replica (Vorarlberger Landesmuseum, Bregenz), and a drawing by Johann Jacob Fink (1821–1846) from an unknown version (Vorarlberger Landesmuseum, Bregenz); see Düsseldorf–Munich–Chur 1999, pp. 388, 389, figs. 165–67. [MG]

1788, oil on canvas, 48⁷⁄₁₆ × 62⅝ in. (123 × 159 cm)
Signed and dated bottom left: *Angelica Kauffman pinx. Rome 1788*
Inv. no. GE 4177
PROVENANCE Acquired in 1902 from the palace in Lazenki (Warsaw)
EXHIBITIONS Düsseldorf–Munich–Chur 1999, pp. 388–89, no. 251
BIBLIOGRAPHY Gerard 1893, pp. 374, 377 (incorrectly described as having been commissioned by Prince Yusupov); Manners, Williamson 1924, pp. 154, 155; Nikulin 1987, p. 280, no. 225

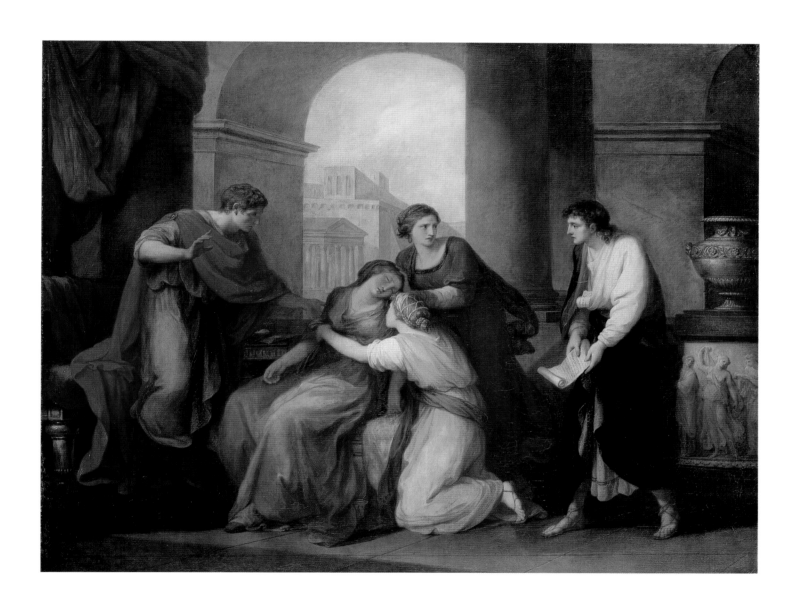

Angelica KAUFFMAN

Venus Persuading Helen to Accept the Love of Paris

In 1773 Angelica Kauffman first attempted this subject-matter which was popular in eighteenth-century painting, the source being Homer's *Iliad*: III. 390–94. Venus promised Paris the most beautiful woman on earth if he were to declare her the most beautiful of the goddesses in a competition with Hera and Athena. Here the goddess fulfils her promise, convincing the indecisive Helen with speeches and her bewitching gaze, while the impatient Cupid hurries Paris, who has stopped, frozen in admiration. The composition derives from ancient art. A detailed study of its iconographic sources was undertaken by L.R. Eddy (1976), who considers the painting to be a free repetition of reliefs with just such a scene of "persuasion" (Hellenistic relief *Aphrodite Persuading Helen to Love Alexander*, first century BC, Museo Nazionale, Naples; copy of the first, first century BC, Belvedere Gallery, Vatican; relief on the Jenkins Vase brought in 1776 from Italy as part of the Smith Collection to Marbury Hall, Cheshire). In Eddy's opinion, Kauffman borrowed the figure of a winged Cupid with his bow, pulling Paris by his cloak, from the Pompeiian wall fresco *Bacchus/Dionysus Discovering the Sleeping Ariadne*, from the first century AD, published in *Le antichità di Ercolano*, Rome, 1767–92, and in *Antiquités d'Herculanum*, Paris, 1770. As another example of the artist's use of the same sources, Bettina Baumgärtel cites a print by Thomas Burke after Angelica Kauffman, *Self-portrait as Drawing Inspired by the Muse of Poetry* (1782; Düsseldorf–Munich–Chur 1999, p. 242, no. 112). Baumgärtel first linked the Hermitage painting with a drawing of the same title by Kauffman of *c.* 1790, the composition of which, with the exception of a few minor details, is preserved in the canvas (British Museum, London; see Düsseldorf–Munich–Chur 1999, p. 357, no. 199).

In her *Memorandum of Paintings*, under commissions received in Rome in April 1790, Kauffman recorded:

For his Excellency Prince Youssoupoff of Russia, a picture 6 spans and 9 inches by 4 spans 8, with figures about 3 spans representing Venus persuading Helen to love Paris who has been sent to Helen by Cupid, 100 roman Zecchini Mr. Thomas Jenkins paid above sum on 8th May, 1790,— picture sent off on 10th July.

The Hermitage canvas can be seen as a pendant to a painting of the same dimensions that Kauffman listed in her *Memorandum of Paintings* for Naples, October 1785, as a commission from Prince Nikolai Yusupov, showing the dying Ovid on the Pontian shore (lost). In the catalogue from 1839 of the Yusupov collection, these items were listed next to each other (nos. 58, 59). [MG]

1790, oil on canvas, 40³⁄₁₆ × 50³⁄₁₆ in. (102 × 127.5 cm)
Signed and dated in the center, on the column plinth: *Angelica Kauffman pinx.
1790*
Inv. no. GE 5350
PROVENANCE Acquired in 1925; from 1790 in the collection of Prince Nikolai Yusupov
EXHIBITIONS Moscow 1982, no. 48; Leningrad 1986, no. 25; Vaduz 1992, pp. 147, 270, no. 53; Düsseldorf–Munich–Chur 1999, p. 358, no. 198
BIBLIOGRAPHY Manners, Williamson 1924, p. 171; Eddy 1976, pp. 569–73; Nikulin 1987, p. 281, no. 226

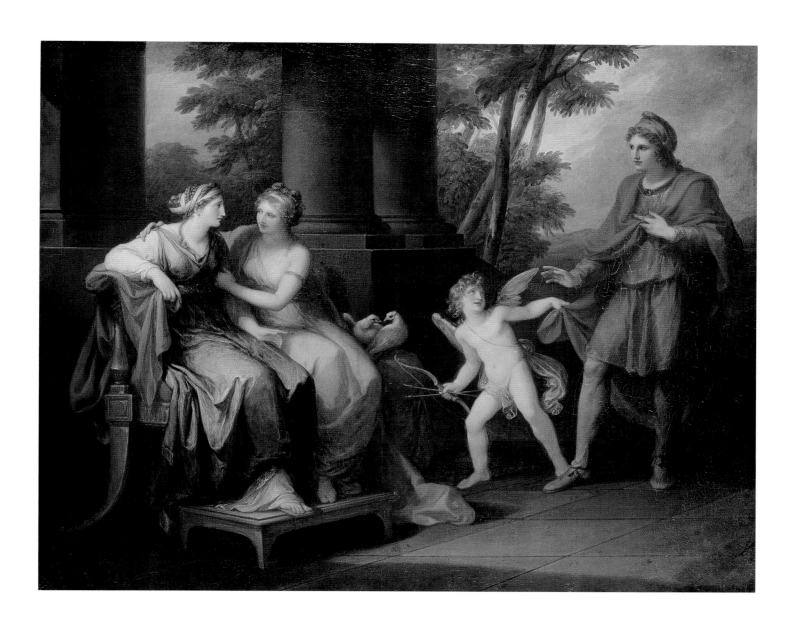

Eugénie Tripier LEFRANC (née Le Brun)

1805 Paris – 1872 Paris (?)

Eugénie Tripier Lefranc was the niece and a pupil of Marie Louise Elisabeth Vigée-Lebrun. She owned several paintings by Vigée-Lebrun, among them her *Self-portrait with Daughter* of 1786, which she donated to the Louvre in 1843, after her aunt's death and in accordance with her wishes. Tripier Lefranc also studied under Jean-Baptist Regnault (1755–1829).

Until 1824 she signed herself "Mlle Le Brun" but from 1831, after her marriage, she signed herself "Mme Tripier Le Franc née E. Le Brun." She produced mainly portraits, exhibiting her works at the Salons between 1819 and 1842.

Self-portrait (?)

This work entered the Hermitage as a portrait of Mlle de Rivière, although no documentation has ever arisen that supports this identification. At the same time, the painting bears compositional and stylistic similarities to Vigée-Lebrun's portrait from 1831 that probably depicts her niece Mme de Rivière (see p. 195). The faces of the sitters in both Tripier Lefranc's self-portrait and the portrait of Mme de Rivière reveal great similarities, which might be explained by the possible familial relationship; the two paintings may depict Vigée-Lebrun's favorite nieces. Not only are the paintings almost identical in dimensions, but the sitters' poses are also mirror reflections of each other. Tripier Lefranc appears to have modeled the figure of herself on the construction of Vigée-Lebrun's portrait from three years earlier. Vigée-Lebrun warmly praised the talent of Tripier Lefranc, and her description of her niece provides a basis for calling Tripier Lefranc's work a self-portrait. [AB]

1834, oil on canvas, 31½ × 25 13/16 in. (80 × 65.5 cm)
Signed and dated bottom left: *Mme Tripier Le Franc née E. Le Brun 1834*
Inv. no. GE 8275
PROVENANCE Acquired in 1937 via the Leningrad State Purchasing Commission
BIBLIOGRAPHY Berezina 1983, no. 415; Berezina 1987, no. 67

Marie-Victoire LEMOINE

1754 Paris – 1820 Paris

Marie-Victoire Lemoine was a follower of Marie Louise Elisabeth Vigée-Lebrun. She studied under François-Guillaume Menageot (1744–1816), who played an important role in the return of the "*grande manière*" in French painting in the last quarter of the eighteenth century. Lemoine's connections with Menageot would have served her well in establishing a career, as he was a member of and a professor of painting at the Académie des Beaux-Arts. She worked in Paris, exhibiting her first portraits (*Portrait de la princesse Lambale*, *Portrait présumé de Mademoiselle de Chartres et de sa compagne anglaise*, *Paméla*) in 1779 and 1785 at the Salon de la Correspondance. She then took part in six exhibitions at the Salons between 1796 and 1814. Lemoine painted in oils and also produced miniatures. In addition to portraits she painted genre scenes, with compositions that usually comprised just one or two figures. Two of her sisters (Marie-Elisabeth and Marie-Denise) were also painters.

Woman and Cupid

The inscription was only discovered in 1948, prior to which the painting was attributed to an unknown French artist of the late eighteenth century. The date on the canvas was correctly deciphered (as 1790 rather than 1792) in 1999.

J. Baillio (1996) has linked Lemoine's *Woman and Cupid* to the poetry of Anacreon, the ancient Greek poet known for his songs praising love and wine. Baillio has noted that the artist borrowed from the works of Vigée-Lebrun and drew a parallel with Jean-Honoré Fragonard's *Le Chiffre d'amour* (The Wallace Collection, London). In Lemoine's painting the Cupid recalls a figure in Vigée-Lebrun's *Portrait of Young Prince Henryk Lubomirski as Cupid of Glory* (1788; Staatliche Museen Preussicher Kulturbesitz, Gemäldegalerie, Berlin).

Notable for both the clarity of its landscape and the pyramidal arrangement of two figures in the foreground, Lemoine's *Woman and Cupid* opens itself to a variety of interpretations. A woman taking an arrow from Cupid's quiver, for example, is one of the emblems for voluptuousness. The woman prepares to write down with the arrow tip on the bark of the tree some words that Cupid is about to speak, a motif that shares similarities with the subject "The Poet's Inspiration," or "Cupid and the Muse," in which Sappho is presented as the "ninth Muse." Nor can we exclude a subject more traditional in late eighteenth-century painting, "Venus and Cupid," in which Cupid hesitates to pronounce the name of Psyche for fear of Venus's revenge on his beloved. Cupid's gesture with his right hand may indicate "Silence!" deriving from the iconography of "*Cupid sub rosa*," suggested by the rose bush at the left of the composition. [AB]

1790, oil on canvas, 36⁷⁄₁₆ × 28¾ in. (92.5 × 73 cm)
Signed and dated bottom left: *M. Vic^re/ Le moine/ 1790*
Inv. no. GE 5159
PROVENANCE Acquired in 1920 via the State Museums Fund; until 1917 in a private collection in St. Petersburg
BIBLIOGRAPHY Berezina 1983, no. 284; Baillio 1996, pp. 131–32, fig. 8, no. 25; Oppenheimer 1996, fig. 13, pp. 173–74, 179, notes 61, 62; Jeffares 1999, pp. 68–69, fig. 5

Marie Françoise Constance
MAYER-LAMARTINIÈRE

1775 Paris – 1821 Paris

Until 1801 Marie Françoise Constance Mayer-Lamartinière worked under the guidance of Jean-Baptiste Greuze (1725–1805), producing sentimental scenes with a soft handling of the paint similar to that of Greuze. She also executed miniatures and portraits, the most famous of which features herself in an interior with her father, exhibited at the Salon of 1801. That year she began taking lessons from Jacques-Louis David, and the following year entered the studio of Pierre-Paul Prud'hon (1758–1823), where she became his favorite pupil. From then on the majority of the artist's works were after sketches by Prud'hon, who frequently corrected and finished works she had begun. Among the most important paintings that Constance Mayer and Prud'hon jointly produced are *Innocence Prefers Love to Wealth*, in the Hermitage, and a work in the Louvre, *The Dream of Happiness* (exhibited at the Salon of 1819). Mayer exhibited at the Salon between 1796 and 1822 (her works being exhibited posthumously in 1822). [AB]

Pierre-Paul PRUD'HON
and
Marie Françoise Constance
MAYER-LAMARTINIÈRE

Innocence Prefers Love to Wealth or *Scorn for Wealth*

Like Count Sheremetev (see p. 108), Prince Nikolai Borisovich Yusupov acquired the works of Marguérite Gérard, Louis-Léopold Boilly (1761–1845), and Jean-Louis Demarne, but the Yusupov collection of French painting was much more complete, including leading names such as Jacques-Louis David, Pierre-Narcisse Guérin (1774–1833), Jean-Baptiste Greuze, and Prud'hon.

While we find no direct mention of contacts between Count Sheremetev and contemporary French artists, Prince Yusupov either met in Paris, or corresponded with, all the above artists. Such contacts resulted in numerous commissions for French artists, although neither Marguérite Gérard's *First Steps* nor *Innocence* *Prefers Love to Wealth* or *Scorn for Wealth* was a commission, having been purchased by the prince long after they were executed.

Nikolai Yusupov was a leading figure of the Enlightenment in Russia and had a taste for the sentimental subjects so widespread in painting, acquiring works by Greuze, Jean-Honoré Fragonard, and Gérard. Yusupov also purchased a number of works by teachers and their pupils, including works by Gérard and a canvas by Fragonard, *Le Baiser gagné* (State Hermitage Museum).

The Yusupov collection included a number of paired works (for example by Guérin) and unusual "diptychs," such as Constance Mayer's *Archangel Gabriel* and *Head of the Virgin from an Annunciation* (1811) by Prud'hon (both Pushkin Museum of

Fine Arts, Moscow). In the Hermitage painting *Innocence Prefers Love to Wealth*, the love of the mythological characters echoes the love between Prud'hon and his pupil.

This painting bears the signature of Constance Mayer alone, but the artist produced it with Prud'hon. This is the very earliest example of what would become a long-term collaboration between teacher and pupil. Mayer executed the painting after sketches by Prud'hon, who worked extremely slowly. On occasion, therefore, as in this case, he entrusted Mayer with the execution of the final embodiment of his drawings. Prud'hon always insisted that Mayer alone created *Innocence Prefers Love to Wealth*, allowing his pupil to exhibit the painting at the Salon of 1804 as her own work and offering it as such to Prince Nikolai Yusupov. But the hand of Prud'hon can be felt both in the overall structure of the composition and in the finished painterly resolution. Prud'hon's underdrawing was already beginning to show through the paint layer when restoration of the painting in 1970 uncovered a number of corrections in his hand. The most significant reworkings can be seen in the figure of Cupid, whose form acquired a more Classical finish. The figure is also essentially a reverse repetition of Prud'hon's Cupid in a painting he produced ten years earlier, *The Union of Love and Friendship* (1793; Institute of Arts, Minneapolis).

The main heroes, Cupid and Innocence, are largely the work of Constance Mayer. To the left is a very "Prud'honian" figure, the personification of Hymenaeus or Pleasure. This putto demonstrates Prud'hon's great interest in the work of Correggio. The powerful figure of Wealth (Luxury), derived from the iconography of Juno with the Peacock, also reveals the master's brush. He too must have been largely responsible for the back-ground, which is similar to other landscape backgrounds in works by him. In this composition the building to the right, which is sometimes seen as a generalized view of one of the palaces in the park at Malmaison, may have been the work of Prud'hon rather than that of his pupil. Although this painting reflects the close intermingling of the two painters' hands, Constance Mayer became so familiar with Prud'hon's technique that she produced copies of his work for such patrons as Nikolai Yusupov.

The idea for the painting and the first sketch on the subject of "Love Seduces Innocence" came to Prud'hon much earlier than the studies for this painting, which he executed in 1803–04. Yet the Hermitage painting of 1804 was the first finished painting on the subject. [AB]

1804, oil on canvas, 95 $^{11}/_{16}$ × 76 ⅜ in. (243 × 194 cm)
Signed and dated bottom left: *Constce-Mayer pinxit 1804*
Inv. No. GE 5673
PROVENANCE Transferred 1925 from the Yusupov Palace Museum, Leningrad; purchased 1811 by Prince Nikolai Yusupov from Constance Mayer, Paris; kept at the Yusupovs' Arkhangelskoe Estate, near Moscow; transferred 1837 to the Yusupov Palace, St. Petersburg
EXHIBITIONS Moscow–St. Petersburg 2001–02, pp. 92–93, no. 95 (exhibited St. Petersburg only).
BIBLIOGRAPHY Breton 1808, p. 83; Cat. 1839, no. 189; Goncourt 1876, pp. 310–12; Duplesis 1876; Guellette 1879, p. 488; Prakhov 1907, p. 11, table 8; Iaremich 1912, p. 48; Ernst 1924, p. 238; Guiffrey 1924, pp. 25–28, nos. 67–69, 736; Réau 1929, no. 229; Jeudwine 1956, p. 69; Izergina 1969, p. 13; Berezina 1972, pp. 26, 27, 29; Chicago 1976, no. 19; Kostenevitch 1977, nos. 7–8; Berezina 1987, p. 11, nos. 20, 21; Savinskaia 1994, pp. 209, 218; Levis-Godechot 1997, pp. 70, 104–105, 280–81, pls. 127–28; Laveissière 1997–98, pp. 180–81, fig. 120b ("*Le Mépris des richesses*"); Savinskaia 1999, p. 78; Babin 2001, pp. 92–93, no. 96

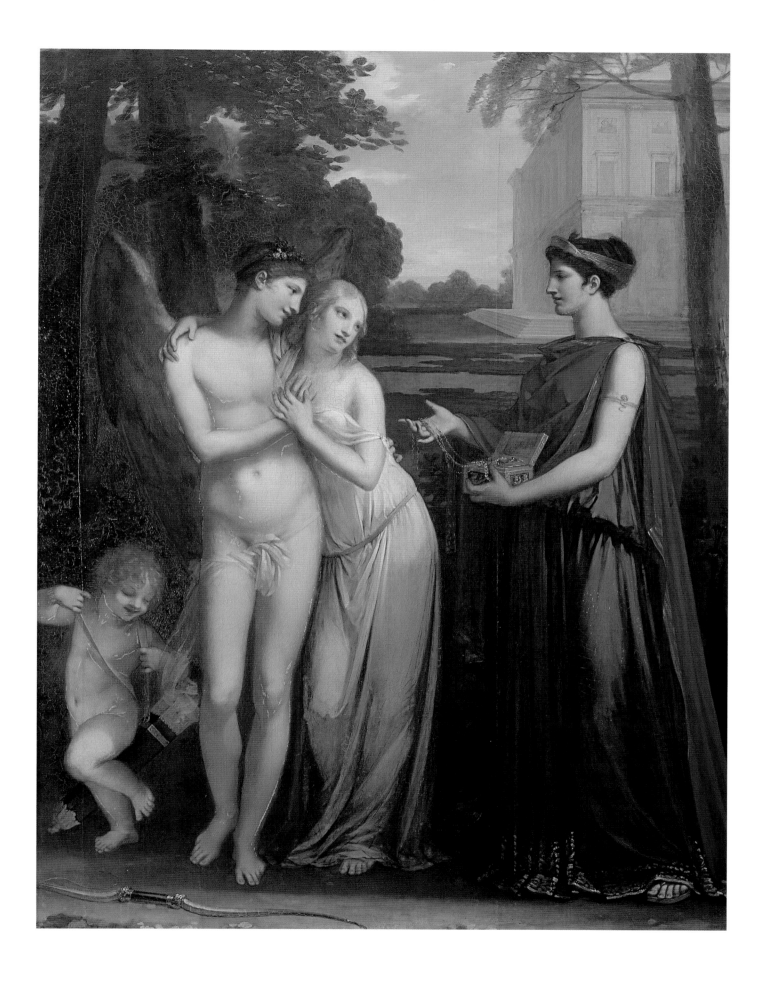

Adèle RICHÉ

1791 Paris – 1878 Fontainebleau

Very little is known about the painter Adèle Riché, who studied the art of still life under Gerard van Spaendonck (1745–1822) and Jan Frans van Dael (1764–1840). At the Salons of 1819, 1824, 1831, and 1833 she exhibited watercolors of flowers and fruits. The artist also worked in oils, and painted portraits as well as still lifes.

Portrait of Natalie Obrenovic, Queen of Serbia

Natalie, Queen of Serbia (1859–after 1905), née Kesko, married in 1875 the Prince of Serbia, Milan Obrenovic, who ruled from 1869 to 1889, taking the title of King of Serbia in 1882. After her divorce from Milan in 1888, she left Serbia, returning only in 1893, once her son Alexander had ascended the throne. In 1898 she left Serbia forever, disapproving of her son's choice of bride and his marriage. She adopted the Catholic faith in 1902, and spent the last years of her life in Paris.

This portrait would seem to have been produced between 1875, when Natalie married Milan (she wears a gold crown), and 1878, the year of the artist's death. It is possible that the artist saw her sitter as an exotic beauty, which places the painting within the orientalist trend in French art from the last third of the nineteenth century. This is manifested in the exotic attire of the sitter and in the skillful creation of the textures of the various fabrics, for which the artist made full use of a multilayered painting technique. [AB]

1875–78, oil on canvas, 26¹⁵⁄₁₆ × 21⅝ in. (68.5 × 55 cm)
Signed to right just below the middle, on the ground: *A. Riché*
Inv. no. GE 10070
PROVENANCE Presented to the Hermitage in 1969 by P.I. Kharzina, Leningrad
BIBLIOGRAPHY Berezina 1983, no. 347

Christina ROBERTSON

1796 Kinghorn, Fife, Scotland – 1854 St. Petersburg

Christina Robertson, neé Sanders, was one of the leading Scottish painters of the first half of the nineteenth century. Following the example of her uncle, George Sanders, a renowned miniaturist from whom she received her first artistic training, Christina soon moved from the small town of Kinghorn in Fife, where she was born, first to Edinburgh and then to London. It is likely that Sanders not only taught and shared his London studio with her, but also acquainted her with potential clients. She soon gained popularity for her elegant and finely painted miniature portraits on ivory, usually of relatively large size and rectangular format.

The earliest known examples of the artist's work are a *Portrait of The Hon. Clementina Elizabeth Drummond-Burrell and Her Sister* (1819; Grimsthorpe and Drummond Castle Trust, UK), and a *Self-portrait* (Victoria and Albert Museum, London) dating from around 1822, approximately the time of her marriage. We know almost nothing of her married life apart from the fact that her husband, James Robertson, was also an artist, and that they had eight children, of whom only four reached adulthood.

From 1823 Christina Robertson was a regular participant in Academy exhibitions in both London and Edinburgh, being elected an honorary member of the Royal Scottish Academy in 1829 (the first woman to merit such a distinction). Prints were made from her miniature portraits of Charlotte Florentia, 3rd Duchess of Northumberland; Lady Worsley; the Rt. Hon. Jane Elizabeth, Viscountess Barrington; Lady Marjoribanks; the Rt. Hon. Louisa, Viscountess Stormont; and others. These appeared in the pages of fashionable journals and publications, such as John Burke's *Portrait Gallery of Distinguished Females* (1833), *La Belle Assemblée,* and *Heath's Book of Beauty*, and increased Robertson's popularity as a fashionable artist.

From the mid-1830s Robertson traveled several times to Paris, where she painted portraits of famous members of the European aristocracy, politicians, and members of the nouveau riche, such as the comtesse de Noailles and the eminent statesman and historian Adolphe Thiers. It was in Paris that she received her first commissions from Russian clients—Princess Wittgenstein, Countess Zavadovskaia, and Countess Patoski—St. Petersburg society beauties who were related to German and Polish families, and close to the Russian imperial court.

It is possible that it was the contacts she made in Paris that encouraged the artist to set off intrepidly for Russia, where she spent the years 1839 to 1841. Here her art immediately found a market, and those who posed for her included members of Russia's highest-ranking families—the Orlov-Davydovs, the Bariatinskys, the Yusupovs, and the Kurakins. But her main patrons and clients were members of the imperial house. Documents record payments to the artist for three portraits of Nicholas I (location unknown), portraits of the heir to the throne, Crown Prince Alexander (location unknown), of Empress Alexandra Fedorovna (State Hermitage Museum), and three of her daughters, Maria, Olga, and Alexandra (all State Hermitage Museum). These last four works were exhibited at the Academy of Arts in St. Petersburg, after which Christina Robertson was given the title of honorary free associate (1841).

Robertson's primary body of work produced during this period comprises full-length state portraits painted in oil on large canvases. She continued to use this painting technique when she returned to England in December 1841. In the late 1840s Robertson returned to Russia, and once again worked for the Russian court, but Nicholas I was dissatisfied with the portraits he had commissioned from her of his two daughters-in-law, Grand Duchesses Maria Aleksandrovna and Alexandra Iosifovna, and refused to pay for them. Nonetheless, many of her paintings and watercolors dated between 1849 and 1852 survive in Russian collections. The artist died in 1854 in St. Petersburg and was buried in the Volkovo Cemetery. [ER]

Self-portrait, c. 1822, watercolor on ivory,
7 × 5¹⁄₁₆ in. (17.8 × 12.8 cm) (9¹⁄₁₆ × 7³⁄₁₆ × 1³⁄₁₆ in./23 × 18.3 × 3 cm with frame),
Victoria and Albert Museum, London, © V&A Picture Library

Christina ROBERTSON

Portrait of Grand Duchesses Olga Nikolaevna and Alexandra Nikolaevna

One of Christina Robertson's first paintings in Russia, this work depicts the two youngest daughters of Emperor Nicholas I (reigned 1825–55). Seated at the desk, pencil in hand, is Grand Duchess Olga (1822–1892), who in 1846 married Karl Friedrich Alexander, Prince of Württemberg; at the clavichord is Grand Duchess Alexandra (1825–1844), who married Friedrich Georg Adolph, Prince of Hesse and Kassel, in 1843. The two girls received an outstanding education under the guidance of the celebrated Romantic poet and royal tutor Vasily Zhukovsky. Both Olga and Alexandra were renowned for their beauty, and Count Mikhail Buturlin wrote: "The two littlest Grand Duchesses, Olga and Alexandra Nikolaevna, were of such amazing beauty that, in my opinion, they had no rivals in the aristocratic world at that time. Grand Duchess Olga Nikolaevna's stately figure did not prevent her from being extremely graceful" (Buturlin 1901, p. 436). The Dutch General Friedrich Gagern, who accompanied the young heir to the title of Prince of Orange on a journey to Russia in 1839, wrote in his diary: "the Grand Duchess, Olga Nikolaevna, beloved of all the Russians; it is indeed impossible to imagine a more lovely face, which would express such a degree of gentleness, kindness, and tolerance. She is very slim, her face translucent, and her eyes have that unusual sparkle which poets and lovers describe as heavenly, but which inspires doctors with concern. The very youngest grand duchess, Alexandra, is 13 years old, and still has something of the child in her; she is very lively and mischievous, and is promising to be the most beautiful of all the sisters" (Gagern 1991, p. 668). [ER]

1840, oil on canvas, 14⅜ × 11⅝ in. (36.5 × 29.5 cm)
Signed and dated bottom right: *C. Robertson pinx 1840*
Inv. no. GE 9574
PROVENANCE Transferred in 1929 from the Winter Palace
EXHIBITIONS London 1841, no. 435; Edinburgh 1996, pp. 17, 26, no. 2; Moscow 1997, no. 150
BIBLIOGRAPHY Krol 1969, p. 98; Bird 1977, pp. 32–33; Dukelskaya, Renne 1990, no. 75; Renne 1995, p. 43

Christina ROBERTSON

Portrait of Empress Alexandra Fedorovna

Alexandra Fedorovna (1798–1860), born Princess Frederika Louisa Charlotte Wilhelmina, was the daughter of Friedrich Wilhelm III of Prussia. She married Grand Duke Nikolai Pavlovich (from 1825 Emperor Nicholas I) in 1817, adopting the Russian Orthodox faith and taking a Russian name.

Christina Robertson painted this portrait in 1840–41, soon after her arrival in Russia. During this period she worked on large, full-length portraits of Nicholas I (location unknown) and the empress's three daughters, Maria, Olga, and Alexandra (see pp. 153, 155, 157). The portraits were commissioned to decorate the interiors of the Winter Palace, which were restored after a devastating fire in 1837. In the autumn of 1841, portraits of Alexandra Fedorovna and her daughters were exhibited in the Imperial Academy of Arts. So successful were these paintings that Christina Robertson was elected an honorary free associate of the Academy and began to enjoy great popularity among the Russian nobility. One contemporary, M.D. Buturlin, recalled:

> The fashionable British artist painted in turn the whole imperial family in full length and received for that in the region of a hundred thousand silver rubles. Of the Empress Alexandra Fedorovna, who was then of course fully forty years old, the flattering brush of the British woman made a twenty-year-old beauty; but it was very difficult for her to flatter the Grand Duchesses … here nature herself could compete with the artistic ideal. (Buturlin 1901)

Alexandra Fedorovna is shown at a difficult period in her life. She had suffered greatly from the inevitable parting from her grown children, a parting that threatened to disrupt the comfortable atmosphere of the family circle, of which she felt herself to be the center. She felt that the best and happiest part of her life was now in the past. Baron A. Th. von Grimm wrote that she appears:

> still indeed, in all her loveliness and the charm of her womanly nature, but her sorrowful mood was shown by a white rose that she held in her hand, the leaves of which were beginning to fall. This portrait does not emulate, either in design or color, those master-works displayed in the Romanov Gallery of the great Catherine and Maria Fedorovna; it is not flattering, and still less idealized, and yet it shows Alexandra in that calm, happy mood in which she was so often seen by the public in latter years. In Mrs. Robertson's portrait, the Imperial Majesty is fully attained, and traces of many and great experiences in life are manifest in it. (Grimm 1870)

After it was exhibited at the Academy of Arts, the portrait was placed in the Rotunda of the Winter Palace, where it remained until the October Revolution of 1917. It can be seen in a watercolor by Eduard Hau, *The Rotunda of the Winter Palace* (1862; State Hermitage Museum; fig 26), and in photographs dating from the late nineteenth and early twentieth centuries.

During her years in Russia, Christina Robertson painted the empress in both oil and watercolor (see p. 165) on several occasions. The fact that this type of portrait immediately found favor among contemporary Russian artists, who repeatedly used it as a prototype, testifies to the great influence her art had on her Russian peers. [ER]

1840–41, oil on canvas, 103 15/16 × 63 13/16 in. (264 × 162 cm)
Inv. no. GE 4443
PROVENANCE Transferred in 1918 from the Rotunda in the Winter Palace
EXHIBITIONS St. Petersburg 1841; St. Petersburg 1905, issue V, p. 35, no. 1294
BIBLIOGRAPHY Grimm 1870, p. 195; Buturlin 1901, p. 451; Uspensky 1913, p. 185; Dukelskaya, Renne 1990, no. 79; Renne 2000, p. 36

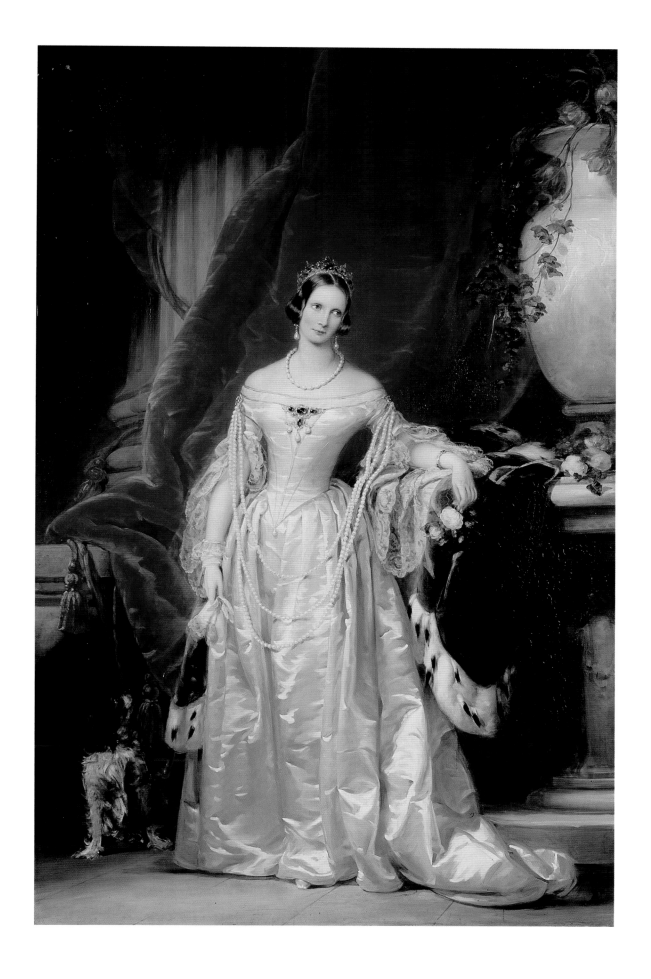

Christina ROBERTSON

Portrait of Grand Duchess Maria Nikolaevna

Maria Nikolaevna (1819–1876), the eldest daughter of Nicholas I, was most like her father in looks and character; she also exerted the greatest influence over him. In 1839 she married Maximilian, Duke of Leuchtenberg (1817–1852). During the last years of her father's reign, she began to play a personal role in the management of institutions of female education. She directed the Patriotic Institute which educated the daughters of officers who had fallen in battle or been made invalids in war. After the death of her husband, Maria Nikolaevna replaced him as president of the Academy of Arts and of the Society for the Encouragement of the Arts. She later married Count G.A. Stroganov.

Documents indicate that this is one of several portraits Christina Robertson produced of the grand duchess. In the spring of 1840 the artist painted *"la Grand Duchesse Marie et le Duc et l'enfant en petit pour S.M. L'Impératrice"* (location unknown). In 1849 Robertson painted a portrait of the duchess surrounded by her four children (State Russian Museum, St. Petersburg; fig. 30), and there are also watercolor portraits of Maria Nikolaevna by Robertson (see p. 169). This ceremonial portrait is very different from such intimate works. Maria Nikolaevna is shown full-length, in a dark-blue velvet dress, by an open clavichord on which stands the music for Bellini's popular opera *Norma*. The portrait was commissioned to hang in the Romanov Gallery of the Winter Palace, together with portraits of the sitter's sisters Olga and Alexandra (see pp. 155, 157). [ER]

1841, oil on canvas, 98⅟₁₆ × 59⁷⁄₁₆ in. (249 × 151 cm)
Signed and dated below: *1841 Christina Robertson*
Inv. no. GE 4784
PROVENANCE Transferred in 1918 from the Romanov Gallery of the Winter Palace
EXHIBITIONS St. Petersburg 1841
BIBLIOGRAPHY Grimm 1870, p. 195; Buturlin 1901, p. 451; Krol 1969, pp. 100–101; Dukelskaya, Renne 1990, no. 78; Renne 2000, p. 36

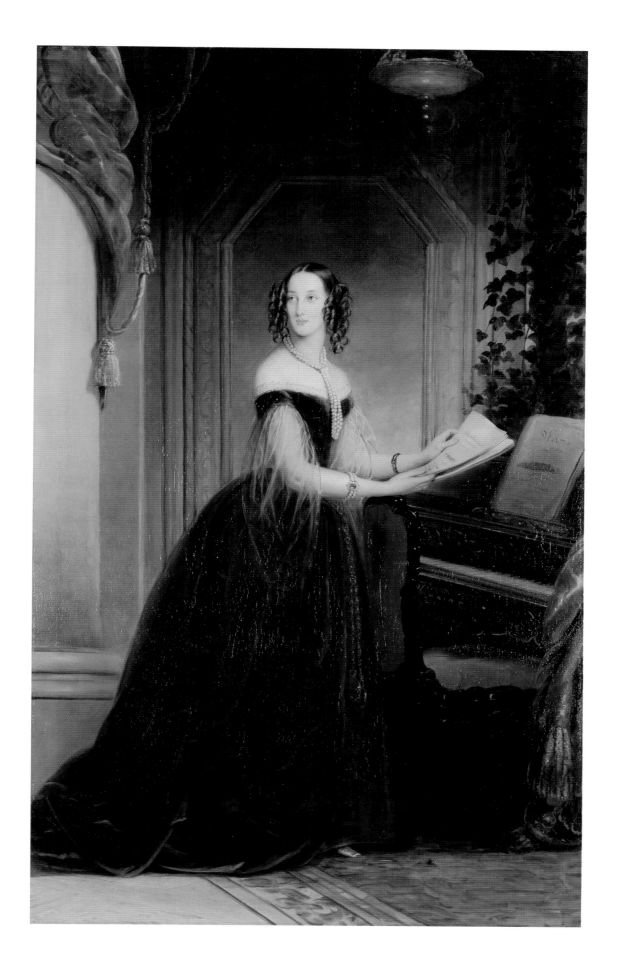

Christina ROBERTSON

Portrait of Grand Duchess Olga Nikolaevna

In this painting, Christina Robertson partly repeated the pose she so successfully used in the small portrait of Alexandra and Olga produced in 1840 (see p. 149). A report dated 13 March 1841 for the minister of the imperial court stated that:

> the commissioned carved gilded frames for the portraits of Their Imperial Highnesses Grand Duchess Maria Nikolaevna and Grand Duchess Olga Nikolaevna in full length, painted by Mme Robertson, are already complete and presented to the Hermitage, where they have temporarily been placed in the Raphael Gallery. (Russian State Historical Archive, fund 472, *opis'* 17, 1823–50)

For the two portraits together the artist received 3285 silver rubles (Russian State Historical Archive, *ibid.*).

In the autumn of that same year, Robertson showed this portrait at the Imperial Academy of Arts along with three other works by her (see pp. 151, 153, 157). A larger, slightly different copy of the portrait with the signature *Christina Robertson*—which may be an author's repetition of 1849—can be found in the Great Peterhof Palace. There the movement of the grand duchess as she ascends the stairs is more successfully conveyed than in the Hermitage painting. In increasing the scale of the canvas, the artist also altered the architectural background. For instance, the grand duchess's right hand resting on the rail lacks the bouquet of roses, while the velvet drapery and the vase are painted differently. [ER]

1841, oil on canvas, 98⅟₁₆ × 59⁷⁄₁₆ in. (249 × 151 cm)
Signed and dated to right on the balustrade: *1841 Christina Robertson*
Inv. no. GE 4593
PROVENANCE Transferred in 1918 from the Romanov Gallery of the Winter Palace
EXHIBITIONS St. Petersburg 1841

BIBLIOGRAPHY Grimm 1870, p. 195; Buturlin 1901, p. 451; List of Portraits 1905, p. 252, no. 134; Wrangel 1912, p. 32; Krol 1969, p. 100; Dukelskaya, Renne 1990, no. 77; Renne 2000, p. 36

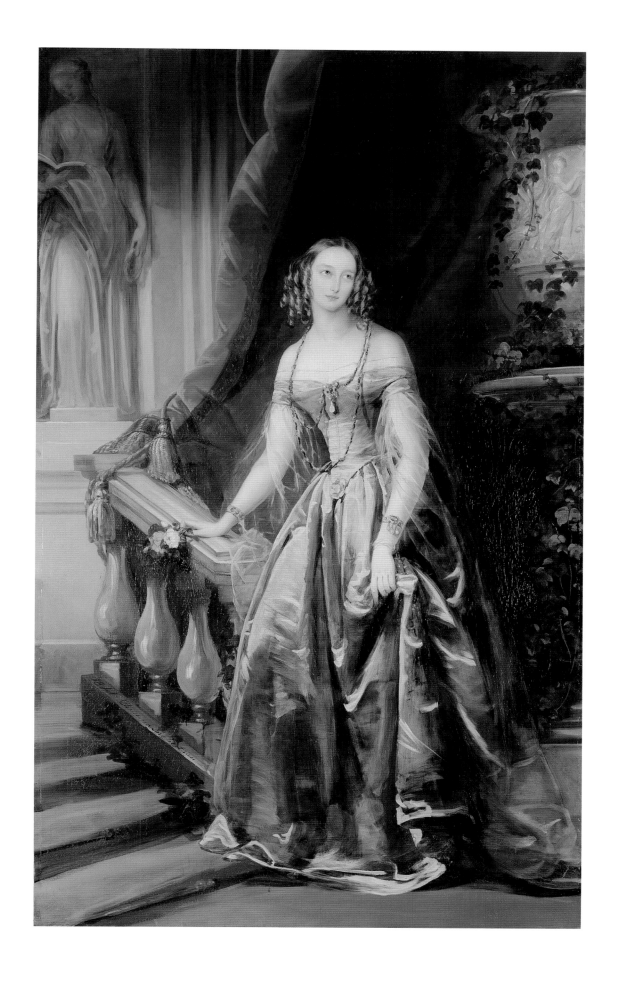

Christina ROBERTSON

Portrait of Grand Duchess Alexandra Nikolaevna

The youngest daughter of Russian Emperor Nicholas I and his wife Alexandra Fedorovna, Alexandra Nikolaevna (nicknamed Adini in the family circle) was just fifteen years old when she posed for Christina Robertson in the summer of 1840 at the imperial summer residence, the Great Peterhof Palace. Of all the children, she was most like her mother, and even more like her grandmother, the Prussian Queen Louisa. Contemporaries praised untiringly her unworldly character, her angelic kindness, her meekness and gentleness. Her sister Olga described her as "happy as a lark, radiating only joy around her" (Würtenberg 1955, p. 137).

Robertson showed her with a bouquet of cornflowers, fully in keeping with the lack of artifice that made her so loved. To her left on the balustrade lie an open album and a pencil. For Alexandra, drawing and particularly music were not merely part of acquiring the accomplishments of a noble young lady: she was a talented singer and took lessons from the renowned singer Henrietta Sontag. But tuberculosis put an end first to her lessons and then to her brief life: she died just a few years after the portrait was completed, at the age of twenty.

In February 1841 Christina Robertson received the sum of 1572 silver rubles for this portrait (Russian State Historical Archive, fund 468, *opis'* 1, 1841, *delo* 39-62, f. 63). After the portrait was exhibited in the autumn of 1841 at the Imperial Academy of Arts, it was placed together with portraits of Nicholas's two eldest daughters in the Romanov Gallery in the Winter Palace. [ER]

1840, oil on canvas, 98 1/16 × 59 7/16 in. (249 × 151 cm)
Signed and dated to right on the balustrade: *Christina Robertson pinxit 1840*
Inv. no. GE 1351
PROVENANCE Transferred in 1918 from the Romanov Gallery of the Winter Palace
EXHIBITIONS St. Petersburg 1841; St. Petersburg 1902, p. 106; St. Petersburg 1905, issue V, p. 36, no. 1300
BIBLIOGRAPHY Grimm 1870, p. 195; Buturlin 1901, p. 451; List of Portraits 1905, p. 252, no. 135; Wrangel 1912, p. 32; Krol 1969, p. 100; Dukelskaya, Renne 1990, no. 76; Renne 2000, p. 36

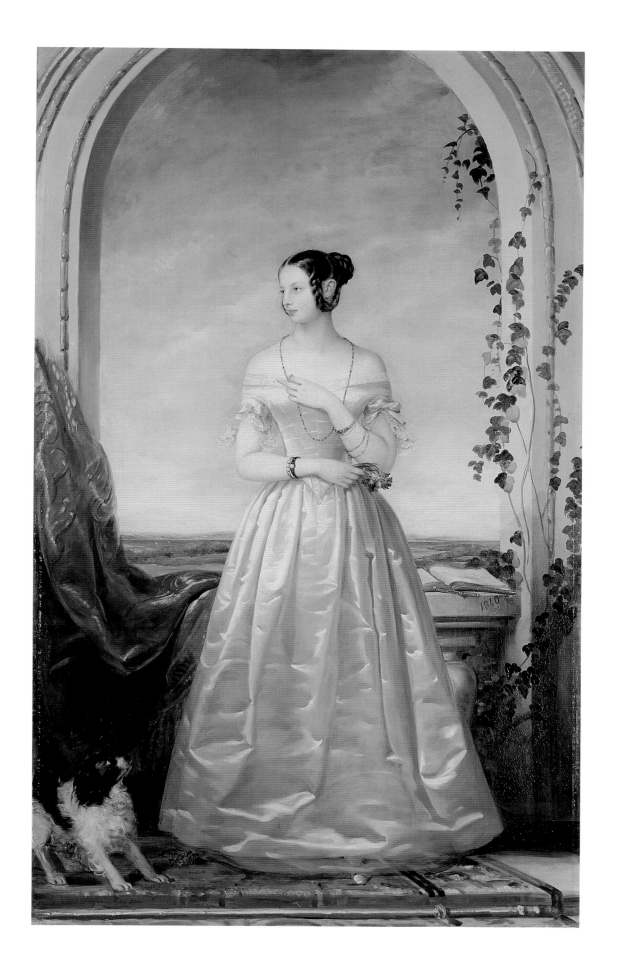

Christina ROBERTSON

Portrait of Grand Duchess Maria Aleksandrovna

Maria Aleksandrovna (1824–1880), born Maximiliana-Wilhelmina-Augusta-Sofia-Maria, daughter of Ludwig II, Grand Duke of Hesse-Darmstadt, married the heir to the Russian throne, Grand Duke Alexander Nikolaevich (from 1855 Emperor Alexander II) in 1841, adopting the Russian Orthodox faith and taking a Russian name. She devoted the whole of her life to charitable concerns and the education of women. On her initiative, diocesan schools opened to girls, and public schools were set up for girls from all social classes. Her greatest achievement in the world of charitable organizations was the establishment of the Russian Red Cross.

This portrait is not dated, but the cut of the dress and the hairstyle suggest a dating of the late 1840s. The following is reported among the records of the Chancellery of the Ministry of the Imperial Court: "1—in January 1849 portraits full-length of Their Imperial Highnesses the Crown Princess and Grand Duchess Alexandra Iosifovna for 3000 silver rubles for both. 2—in April copies from the two portraits mentioned for 750 silver rubles each" (Russian State Historical Archive, fund 472, *opis'* 17, 1823–50, *delo* 2/934). The large sum of 1500 rubles for each portrait and 750 for each copy suggests that these must have been full-length works. This painting may be one of those mentioned in the document, or a copy made especially for Yusupov. [ER]

c. late 1840s, oil on canvas, 98 1/16 × 61 13/16 in. (249 × 157 cm)
Signed bottom left: *Christina Robertson pinx*
Inv. no. GE 5254
PROVENANCE Transferred in 1925 from the Yusupov Palace Museum, Leningrad, via the State Museums Fund; formerly in the collection of Prince Felix Yusupov
BIBLIOGRAPHY Krol 1969, p. 102; Cat. 1920, p. 8, no. 101; Dukelskaya, Renne 1990, no. 84

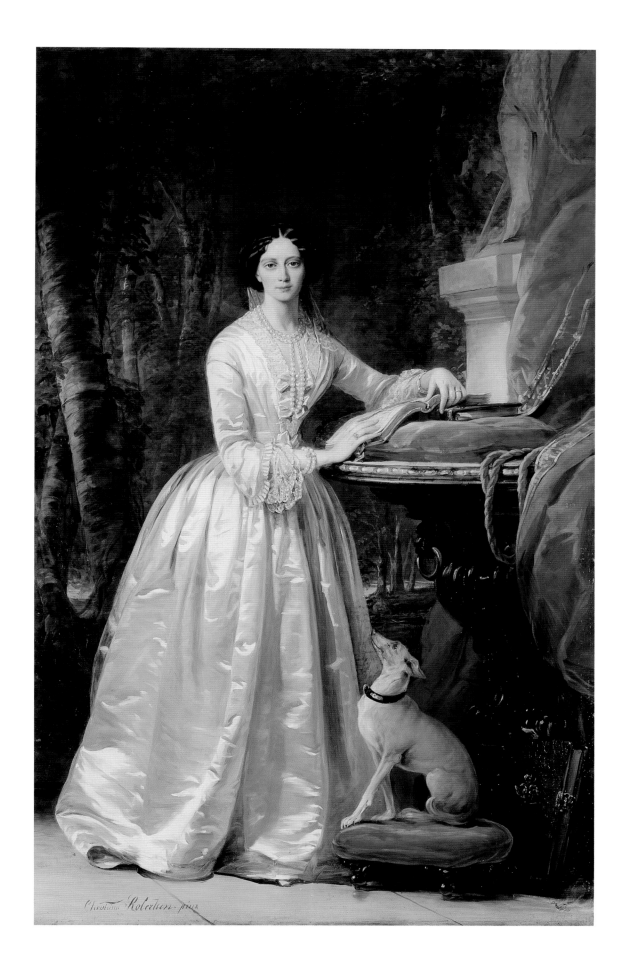

Christina ROBERTSON
Portrait of Princess Zinaida Yusupova

Princess Zinaida Ivanovna Yusupova (1809/10–1893), daughter of the chamberlain Ivan Dmitrievich Naryshkin, was a lady-in-waiting at court and a leading St. Petersburg beauty. In 1827 she married the wealthiest man in Russia, Prince Boris Nikolaevich Yusupov, whose first wife had died in 1820. Widowed in 1849, Zinaida Yusupova married again in 1861, this time to the comte de Chauveau et marquis de Serre.

In Russia, Christina Robertson's leading clients outside the royal family were the Yusupovs, along with members of several other leading aristocratic families—the Bariatinskys, Shuvalovs, and Sheremetevs. She painted numerous portraits of members of the Yusupov family, including Zinaida's husband Boris, her mother-in-law Tatiana Vasilevna, and her son Nikolai. Zinaida Yusupova posed for the artist on several occasions.

In the earliest portrait, the princess sits at a table with a rose in her right hand, with her head turned at the same angle, and with the same expression on her face as in this painting. This work is now in the museum of the Yusupovs' former estate near Moscow, Arkhangelskoe. The portrait type found favor, and Robertson developed it in other works: the turn of the sitter's head, as well as the depiction of her shoulders and face, is repeated in a large state portrait (Pushkin Museum of Fine Arts, Moscow), from which the artist made several copies. At Arkhangelskoe there are also two other portraits, probably from a later date, in which the princess seems older and fuller in figure. [ER]

1840–41, oil on canvas, 37⅝ × 24⅝ in. (95.5 × 62.5 cm)
Inv. no. GE 7419
PROVENANCE Transferred in 1925 from the Yusupov Palace Museum, Leningrad; formerly in the collection of Prince Felix Yusupov
EXHIBITIONS Edinburgh 1996, p. 48, no. 3
BIBLIOGRAPHY Krol 1969, p. 101; Dukelskaya, Renne 1990, no. 82

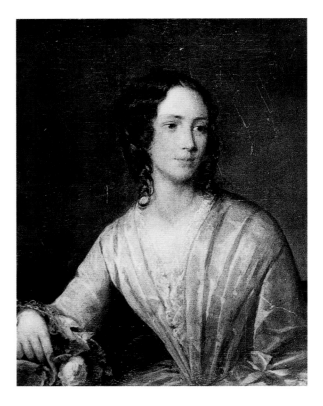

Christina Robertson, *Portrait of Princess Zinaida Yusupova*, c. 1840, oil on canvas, 30⅛ × 25 in. (76.5 × 63.5 cm), Arkhangelskoe Palace Museum, Moscow

Christina ROBERTSON

Children with a Parrot

So far the identity of the children in this highly naturalistic portrait has proven impossible to establish. The riddle is complicated by a lack of information regarding both the picture's provenance and the biography of the artist herself. It is nonetheless clear that the sitters—posed on a marble staircase with a large decorative vase, in the shadow of tall trees, perhaps somewhere in the family park or estate—are from the highest ranks of society. The boy wears the uniform of the Corps de Pages, one of Russia's most privileged educational establishments; and the large talking macaw perched on the girl's hand is an extremely rare and expensive bird. The spacious landscape that unfolds to the right is typical of central Russia, with its squat, white stone church, and tent-roofed bell-tower, and suggests either that the sitters came from that region or that the family had an estate there. [ER]

1850, oil on canvas, 44⅛ × 39⁹⁄₁₆ in. (112 × 104 cm)
Signed and dated top left along the edge of the vase: *C. Robertson pinxit 1850*
Inv. no. GE 8330
PROVENANCE Acquired in 1938 through the State Purchasing Commission
EXHIBITIONS Moscow 1956, p. 33 (incorrectly dated 1836); Edinburgh 1996, p. 37, no. 15; Moscow 1997, no. 158

BIBLIOGRAPHY Krol 1940, p. 13; Krol 1969, p. 101; Bird 1977, p. 33; Dukelskaya, Renne 1990, no. 86; Renne 1995, p. 45

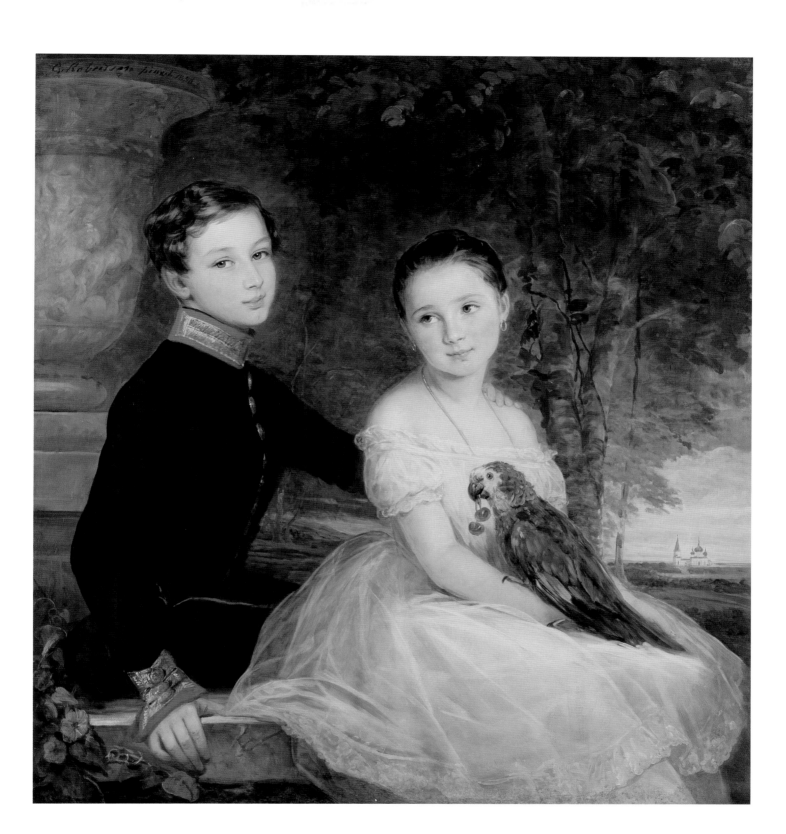

Christina ROBERTSON

Portrait of Empress Alexandra Fedorovna

Alexandra Fedorovna posed on numerous occasions for Christina Robertson (see p. 151). The Pushkin Museum of Fine Arts, Moscow, owns one such portrait from 1851, and the same year Robertson produced another watercolor portrait of the empress that is also in the collection of the Hermitage. The empress's image graced not only paintings and watercolors, but engravings and weavings as well.

On entering the collection of the Hermitage's Department of Drawings, this portrait was attributed to an unknown artist. T. Kamenskaia (Leningrad 1937) attributed it to Robertson. The sitter's age and hairstyle, and the soft delicate manner, suggest a tentative date of 1840–41, the year that the British artist was working on oil portraits of Grand Duchesses Olga, Alexandra, and Maria, the daughters of Nicholas I and Alexandra Fedorovna. [AK-G]

1840–41, watercolor and white highlights, with traces of a pencil sketch on Bristol card, 9¹⁵⁄₁₆ × 7¹¹⁄₁₆ in. (25.3 × 19.6 cm)
Inv. no. OR 26599
PROVENANCE Transferred to the Hermitage in 1927; formerly in the Library of Alexander II in the Winter Palace
EXHIBITIONS Leningrad 1937, no. 175

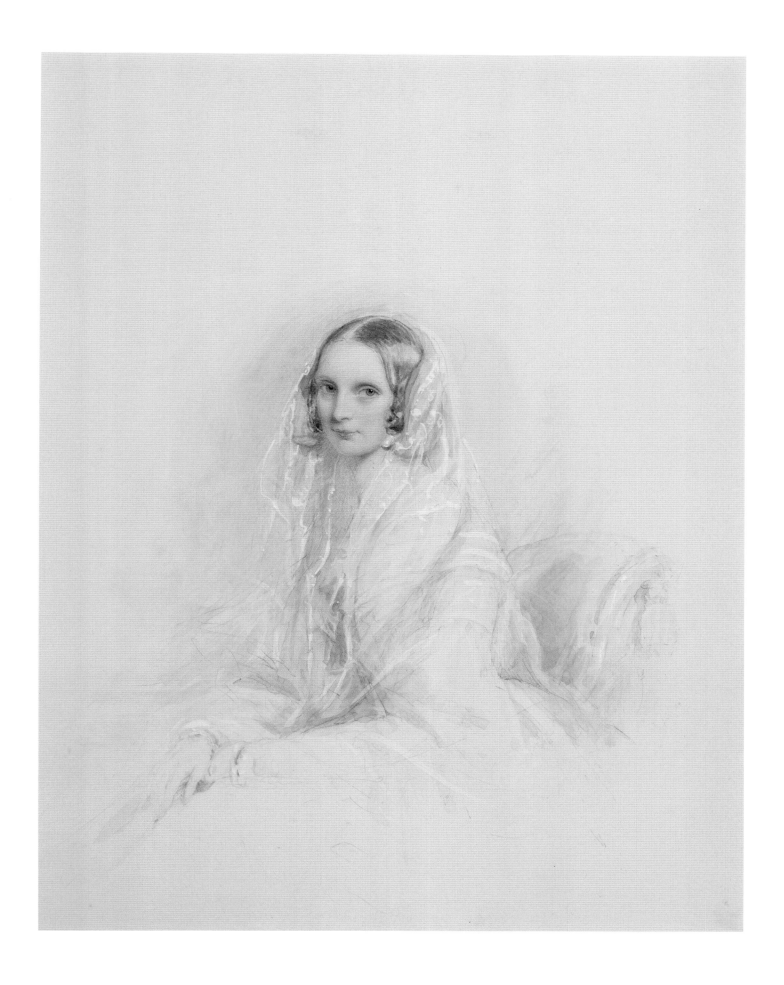

Christina ROBERTSON

Portrait of Grand Duchess Maria Aleksandrovna

Robertson executed a number of variations in watercolor of this portrait of Grand Duchess Maria Aleksandrovna. One of the most similar watercolors to this work was formerly in the collection of Countess Elena Adlerberg, and was shown at the exhibition of portraits in 1905 in the Tauride Palace (the palace in St. Petersburg that originally belonged to Count Grigory Potemkin of Tauria). Although its present location is unknown, it is reproduced in Wrangel (1912). It differs from the Hermitage composition only in the dog's absence, the sitter's dress, and the various items on the table that replace the bouquet of flowers.

The Peterhof Palace Museum recently acquired from the Paris collector V.V. Tsarenkov another variant on the portrait—in the same technique but on a slightly larger sheet—signed and dated 1851. That watercolor is clearly linked with an oval half-length portrait also in the collection of the Hermitage. [AK-G]

1850, watercolor, pencil, and white highlights on fine white card, 13 7/16 × 9 11/16 in. (34.2 × 24.6 cm) (upper edge rounded)
Signed and dated bottom left: *C.Robertson pin. 1850*
Inv. no. OR 26603
PROVENANCE Transferred to the Hermitage in 1927; formerly in the Library of Alexander II in the Winter Palace
EXHIBITIONS Moscow 1997, no. 198

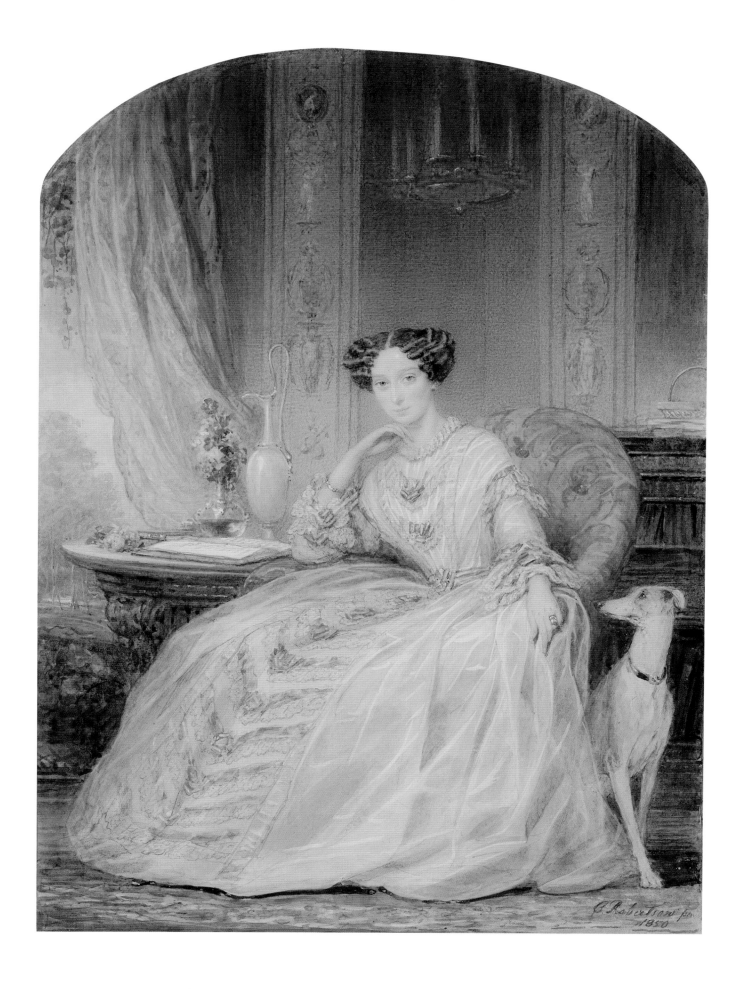

Christina ROBERTSON

Portrait of Grand Duchess Maria Nikolaevna

In the late 1840s and the early 1850s, Christina Robertson painted several watercolors of members of the Tsar's family. She depicted them sitting in cosy armchairs in their private rooms, surrounded by their favorite possessions in a relaxed and intimate setting. Here the picture on the wall, fanciful porcelain clock, candlestick, vases, and Japanese fan all help to convey the taste of the grand duchess, and the domestic atmosphere of her private life.

There is a watercolor very similar to this in composition, showing Maria Nikolaevna from the same angle and with the same tilt of the head, in the Pushkin Museum of Fine Arts in Moscow. There is also a similarity between the Hermitage watercolor and a painting in the Russian Museum in St. Petersburg, where the Grand Duchess is shown with her children (fig. 30). [ER]

1851, watercolor, gouache, white highlights, and pencil on fine white card,
13 7/16 × 10 3/8 in. (34.2 × 26.4 cm) (upper edge rounded)
Signed and dated bottom left: *C. Robertson pin. 1851*
Inv. no. OR 18966
PROVENANCE Transferred to the Hermitage in 1927; formerly in the Library of Alexander II in the Winter Palace

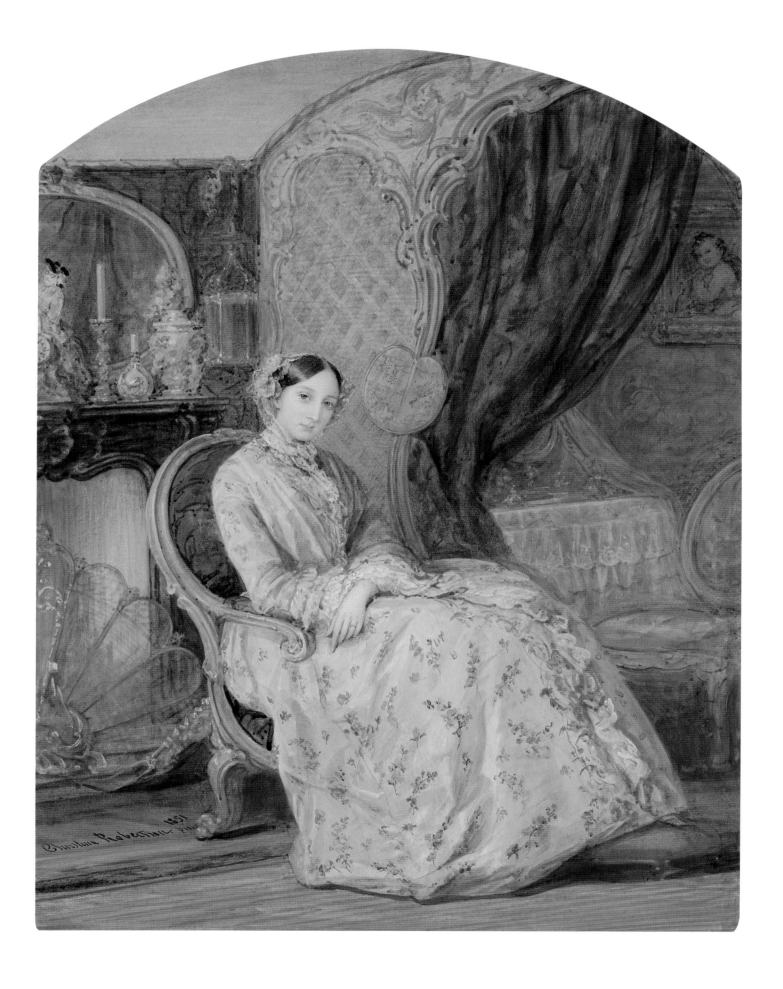

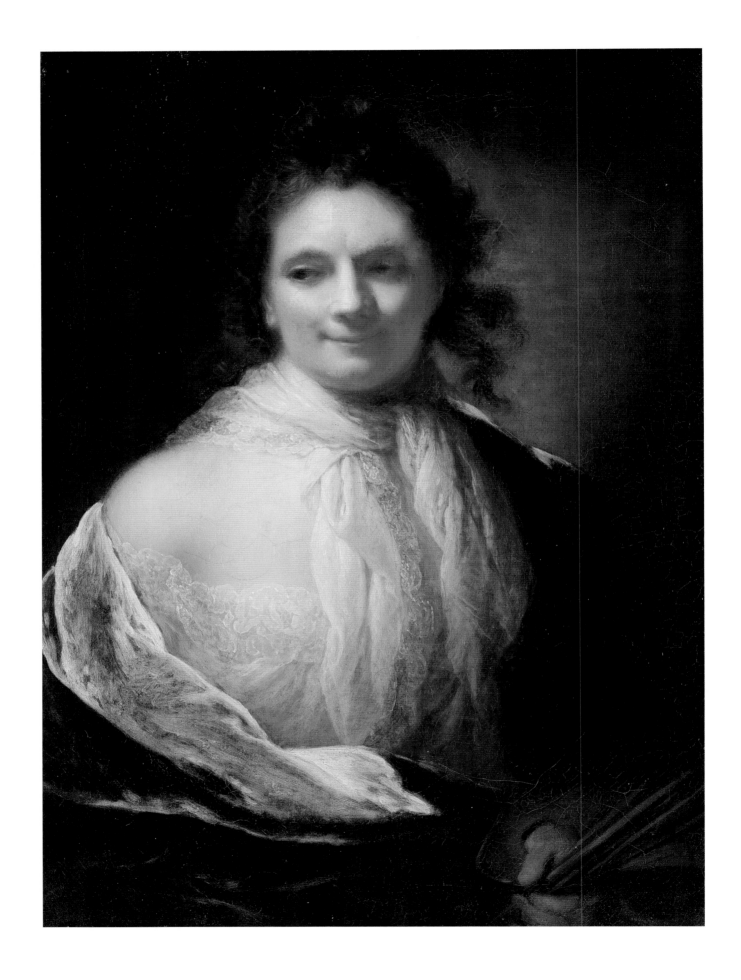

Anna Dorothea THERBUSCH-LISIEWSKA

1721 Berlin – 1782 Berlin

Anna Dorothea Lisiewska was born on 23 July 1721, the seventh child in a family of artists. Her father, the Polish-born portrait painter Georg von Lisiewski, taught his craft to four of his children: his daughters Anna Rosina, Anna Dorothea, and Julia, and his son Christian Friedrich Reinhold. Under her father's guidance, Anna Dorothea began to study the works of Antoine Pesne, the French portrait painter at the court of Berlin. She also copied paintings by Lancret and Watteau.

In 1742 Anna Dorothea married, at her parents' insistence, the amateur artist Ernst Friedrich Therbusch, owner of the White Dove Hotel on Holy Spirit Street in Berlin. Marriage and children (and most persuasively her mother-in-law, who thought that a wife should devote all her time to home and family) prevented Anna Dorothea from continuing with her painting. Over the next ten years she produced only a few canvases, painted in stolen hours. These included her first self-portraits. After the death of her mother-in-law she devoted herself entirely to her beloved art.

Therbusch-Lisiewska's painting style became softer and more individualized. She executed many portraits in which she did not idealize the sitters, instead producing truthful depictions of their wrinkles, double chins, and poor posture, and she achieved great skill in conveying the texture of fabrics. Her works became well known; her clients included members of both the aristocracy and the bourgeoisie, as well as representatives of the arts and sciences.

In 1761 pride and a sense of adventure prompted Anna Dorothea to undertake a trip to Stuttgart, where she was called to the court of Duke Karl Eugen von Württemberg. Here she gained a taste of a new life, of a vibrant artistic world dominated from 1760 by the Italian Giacomo Casanova. She found favor at the court in Stuttgart, and was given many portrait commissions, as well as a commission to produce eighteen decorative panels to hang above doors in the Mirrored Gallery of the palace of the duke. In her *Self-portrait* of 1761 (Staatsgalerie Stuttgart), the forty-year-old woman clearly defined herself as an artist. Brush and palette in hand, dressed somewhat freely, with her right shoulder revealed and hair tumbling down, she wears a mysterious half-smile.

In 1762 Therbusch-Lisiewska was elected an honorary member of the Stuttgart Academy, and was accepted into the Institute of Free Arts in Poland. Owing to her steadily increasing popularity, the artist was soon invited to work for the Elector of Pfalz, Carl Theodor, whose state portrait she painted at Mannheim in 1763 (Reiss-Museum, Mannheim). She became court artist for a brief period, but in 1764 returned to Berlin, where she produced numerous commissions. Eighteen months later her unfailing quest for European recognition led her to leave her native land once more as she set out to win over the artistic Mecca of Europe: Paris. She brought with her *Night Scene "Drinker"* (*Nachtstück "Trinker"*), which she used as her exhibition work in an attempt to be admitted into the Académie Royale de Peinture et de Sculpture (this is probably the painting now in the Pushkin Museum of Fine Arts, Moscow). The Academy, however, did not accept that the painting was all her own work, declaring that "such daring strokes, such beautiful tones, and such marvellous coloring were, in the opinion of these doubters, qualities which revealed the hand of a man" (Meusel 1779–97, p. 267).

Therbusch-Lisiewska was able to restore her reputation only by taking legal action, which she won. Her success led to acceptance as a member of the Académie Royale, and she was at last able to show her paintings at the Paris Salon. She was fortunate to enjoy the friendship and assistance of the philosopher, art critic, and *Encyclopédiste* Denis Diderot, who may have been ruthless in pointing out the deficiencies in her paintings but was a constant source of aid and support. Therbusch-Lisiewska was the only woman who permitted herself to paint the nude male figure: even Diderot posed for her.

In Paris Therbusch-Lisiewska came into contact with members of the Russian court through a client and admirer of her work, the Russian envoy Prince Golitsyn. Owing to Golitsyn's influence, on her return to Berlin the artist received a commission from Catherine II to paint portraits of members of the Prussian royal family for the gallery in her Chesma Palace (see pp. 173, 175). It was probably also thanks to Golitsyn that the Russian empress acquired Therbusch-Lisiewska's *Jupiter and Antiope*,

Self-portrait, 1761, oil on canvas,
26 × 19¼ in. (66 × 48.9 cm), Staatsgalerie Stuttgart

criticized in its time by Diderot, branded by Münich (the author of the manuscript catalogue of paintings in the Hermitage started in 1773) as a "mannered and disagreeable canvas," and mocked by Catherine II herself in a conversation with the sculptor Etienne-Maurice Falconet as a "very bad" painting (Trofimoff 1916, p. 99).

In 1768, weighed down by debts, full of resentment and disappointment that her dreams of success had not come true, but still unbowed, Therbusch-Lisiewska set off for Brussels and from there moved on to The Netherlands, where she studied Dutch painting. It was at this time that she painted a portrait of the celebrated German landscape painter Jakob Philipp Hackert (Kunstakademie Wien, Gemäldegalerie, Vienna) and *Artemisia Lamenting the Death of Mausolus* (destroyed), for which she was admitted as an external member of the Vienna Academy of Arts. As if to compensate for her earlier disappointments in Paris, the Marquis d'Argenson, the French Minister of State, begged her to return to France as he would entrust the portrait of his family to no other painter (Meusel 1779–97, p. 271). But the artist preferred to return to her homeland, where she once more began work for the Prussian court in Berlin, creating highly successful portraits of Friedrich II (Frederick the Great), one of which, a half-length, was presented by the monarch to Voltaire.

After the death of her husband in 1772, Therbusch-Lisiewska worked with her brother Christian in a studio on Unter-den-Linden, Berlin, producing many collaborative portraits. In these, Christian painted the faces while his sister was responsible for the backgrounds and dress. Therbusch-Lisiewska devoted the last years of her life to religious paintings. She died of consumption in Berlin on 9 November 1782.

Therbusch-Lisiewska's tomb bears the following descriptive epitaph, composed by her pupil Christian Samuel Gohl:

Wer Du auch seyst,	(Whoe'er thou art,
Merke auf Dies Denkmal	Take heed of this monument
Einer Frau	To a woman
Die viel Männer übertraf	Who surpassed many men) [MG]

Portrait of Prince August Ferdinand of Prussia

This portrait depicts August Ferdinand (1730–1813), younger son of King Friedrich Wilhelm I of Prussia and brother of Friedrich II. At the tender age of five, in a military parade in Berlin, he was attached to the Kronprinz Infantry Regiment, and in 1740 Friedrich II gave him command of a newly refounded infantry regiment. In 1756 August Ferdinand became a major-general, and later a lieutenant-general. He became a full general only in 1787, for he was in poor health and was able to take part in military campaigns only in 1756–58.

This is a typical state portrait, with all the obligatory accessories: the column, balustrade, drapery, and landscape in the background. The prince wears the velvet mantle of the master of the Ioannites of Brandenburg with an embroidered Maltese cross. The same type of cross is also seen on the large book that the sitter holds in his right hand. Across his shoulder is the sash and star of the Prussian Order of the Black Eagle. The hilt of his sword is just visible under the edge of the mantle.

This canvas formed part of a series of eight portraits of members of the Hohenzollerns, the Prussian royal family. One of these is now in the Neues Palais, Potsdam, near Berlin, and the other seven are in the Hermitage. The Russian court commissioned the whole series in 1773 for the Chesma Palace, the construction of which was concluded by Yury Velten in 1777. Fifty-six portraits of reigning monarchs of Europe, with their consorts and heirs, could be found at the Chesma Palace. Prince Dmitry Golitsyn acted as intermediary in the commission, meeting with the artist in Paris.

Therbusch-Lisiewska produced this commission collaboratively with her brother, Christian Friedrich Reinhold Lisiewski, who was court artist at Anhalt-Dessau. Seeking to imitate the style of portraits by the famous Swiss pastel artist Jean-Etienne Liotard (1702–1789), he painted the faces with thick strokes, using flesh-colored pastels. His sister was responsible for the background and dress. [MG]

1773, oil on canvas, 103 15/16 × 54 5/16 in. (246 × 138 cm)
Inscribed on the back, on the stretcher: *Augustus Verdinandus Princeps Borussiae*
Inv. no. GE 4436
PROVENANCE Transferred in 1920 from the English Palace at Peterhof, near St. Petersburg; until 1830, Chesma Palace, St. Petersburg
BIBLIOGRAPHY *Der Teutscher Merkur* 1776, p. 274; Nicolai 1786, p. 157; Cat. 1971, pp. 11, 14, note 16; Nikulin 1987, pp. 381–82, no. 317; Wöhle 2000, p. 191

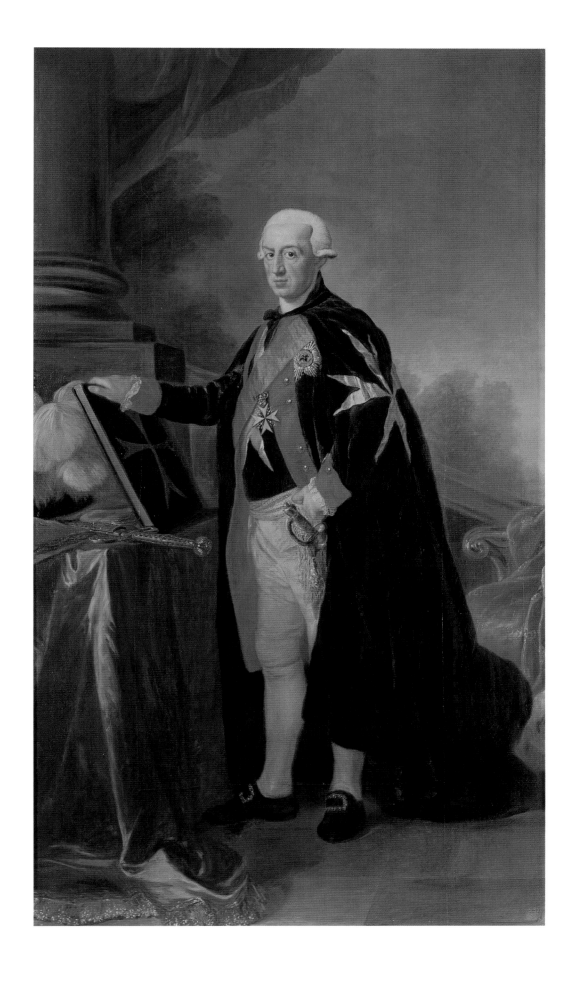

Anna Dorothea THERBUSCH-LISIEWSKA
Portrait of Princess Anna Elisabetha Luisa Ferdinanda of Prussia

Therbusch-Lisiewska produced this portrait of Anna Elisabetha Luisa, née Markgräfin von Brandenburg-Schwedt (1738–1820), collaboratively with her brother, Christian Friedrich Reinhold Lisiewski. Married to Prince August Ferdinand of Prussia in 1755, the princess is shown here in ceremonial dress with an ermine mantle, wearing the Maltese cross on her breast. A marble balustrade adorned with an imitation ancient vase stands out against a landscape background. The artists render the portrait in a painterly fashion, focussing on the texture of the different fabrics and jewelry. The sitter's coquettish mood recalls Rococo works by Boucher and Watteau. The coloring is bright if not garish, the brushstrokes loose, coarse, and hastily applied. Therbusch-Lisiewska, in somewhat straitened circumstances after the death of her husband, was in a hurry to complete so large a commission as quickly as possible. Nonetheless, despite these undesirable circumstances, the artists have successfully brought out the princess's grace: in her head as it turns, in her hand that holds a light veil, and in the movement of the figure as it descends the staircase.

As with the *Portrait of Prince August Ferdinand of Prussia* (see p. 173), this work was produced for the portrait gallery of contemporary monarchs at the Chesma Palace. [MG]

1773, oil on canvas, 98¹⁄₁₆ × 55½ in. (249 × 141 cm)
Inscribed on the back, on the stretcher: *Anna Elisabetha Luisa Ferdinandi principis Borussiae uxor.*
Inv. no. GE 4437
PROVENANCE Transferred in 1920 from the English Palace at Peterhof, near St. Petersburg; until 1830, Chesma Palace, St. Petersburg
BIBLIOGRAPHY *Der Teutscher Merkur* 1776, p. 274; Nicolai 1786, p. 157; Cat. 1971, pp. 11, 14, note 16; Nikulin 1987, p. 380, no. 316; Woehle 2000, p. 191.

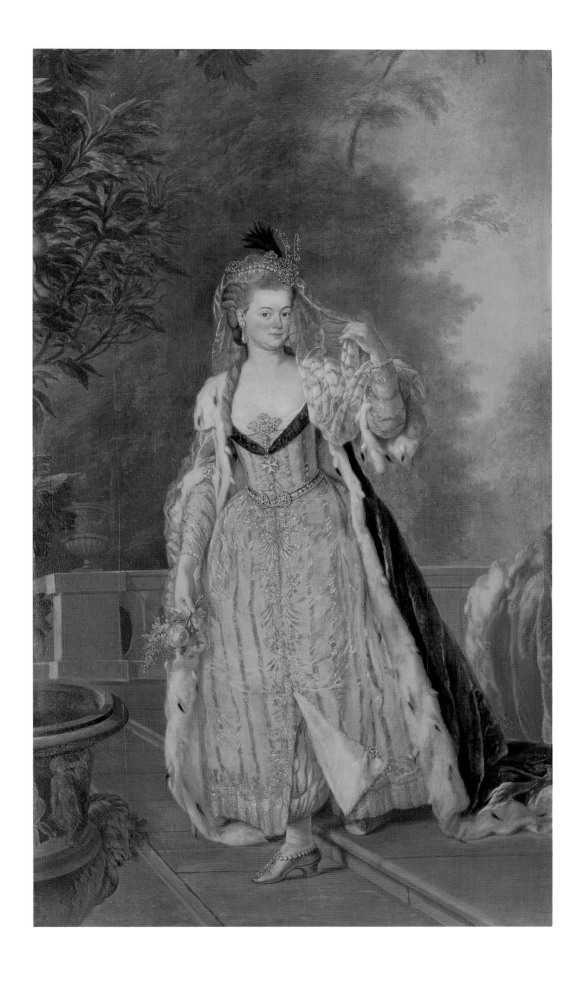

Anna Dorothea THERBUSCH-LISIEWSKA

Bacchante

Anna Dorothea Therbusch-Lisiewska gained fame primarily for her portraits; she depicted mythological subjects only in response to the tastes and desires of her clients, first at the court of Mannheim, and after 1779 as court artist to Friedrich II in Berlin.

The Hermitage canvas demonstrates the artist's rejection of her usual Rococo style in favor of academic Neo-classicism, which influenced her greatly while she was in Stuttgart. Therbusch-Lisiewska's *Bacchante* seems rough in comparison with the polished mythological paintings of her famous younger contemporary, Angelica Kauffman. Still, in keeping with the subject of the painting, Therbusch-Lisiewska uses line and color differently to imbue the bacchante with sensuous energy and bright expressiveness. The curling locks of thick, red hair have stuck to the damp and sweaty skin on the bacchante's shoulders and breast; the right hand beats a tambourine decorated with flowers; the full lips are obstinately compressed; and the large and somewhat slanted eyes throw an inviting look over her shoulder. The artist has drawn on seventeenth-century Dutch painting in the image's earthiness and in her desire to come as close as possible to nature in conveying details.

Because their styles, themes, and dimensions are similar, it is likely that *Dionysus (Bacchus)* (see p. 179) and *Bacchante* should be seen as companion paintings, although *Dionysus*, unlike *Bacchante*, was not included in the 1773 manuscript catalogue of paintings in the Hermitage that Münich compiled. [MG]

c. 1765–69, oil on canvas, 27⅜ × 20⁹⁄₁₆ in. (69.5 × 52.2 cm)
Inv. no. GE 8357 (pair to inv. no. GE 8356)
PROVENANCE Acquired in 1939 via the Leningrad State Purchasing Commission; from 1766 kept in the Winter Palace; from 1798 at Bip Fortress, in the grounds of Pavlovsk Palace, near St. Petersburg
EXHIBITIONS Frankfurt-am-Main 1991, pp. 94, 122–24, no. 26, fig. p. 124
BIBLIOGRAPHY Cat. 1773, no. 1387; Trofimoff 1916, p. 107; Nikulin 1987, p. 386, no. 321

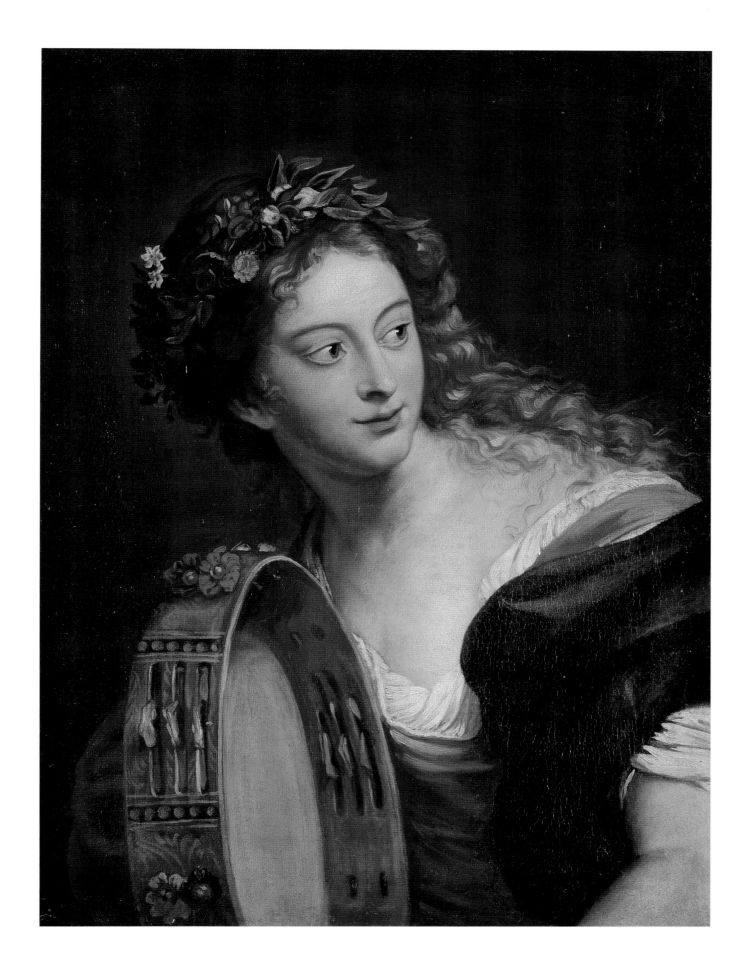

Anna Dorothea THERBUSCH-LISIEWSKA

Dionysus (Bacchus)

The myth of Dionysus (Bacchus), god of fertility and wine, patron of all the forces of growth on the earth, became a favorite subject in Western European art, finding full expression especially in Renaissance Italy. The mythological god was usually depicted as a naked youth, or as a youth attired in a short tunic, crowned with a vine and holding in his hands a chalice or a vine leaf.

The subject in this work, with its darkly tanned skin, the uneven and coarse facial features, the large pointed ears, and the goat skin and pipes in his hand, looks less like Dionysus than one of the figures from Dionysus' suite, which included wild bacchantes, the goat-legged Pan, patron of forests and meadows, and satyrs. It is therefore probable that we should see the subject as a satyr, his blood warmed by wine and the wild dancing of the bacchantes. He has his fingers pressed over the holes in the pipes, and the sound still seems to linger: his lips, not yet closed, are breaking into a slightly tipsy grin, while his eyes catch an inviting look from a young bacchante with a tambourine who turns toward him (see p. 177, companion to this canvas).

In both paintings the artist has successfully managed to convey individual character and energy, as well as a lively interaction between the two Dionysian characters. [MG]

c. 1765–69, oil on canvas, 27⅜ × 20⅞ in. (69.5 × 53 cm)
Inv. no. GE 8356 (pair to inv. no. GE 8357)
PROVENANCE Acquired in 1939 via the Leningrad State Purchasing Commission
EXHIBITIONS Frankfurt-am-Main 1991, p. 123, no. 27, fig. p. 125
BIBLIOGRAPHY Nikulin 1987, p. 385, no. 320

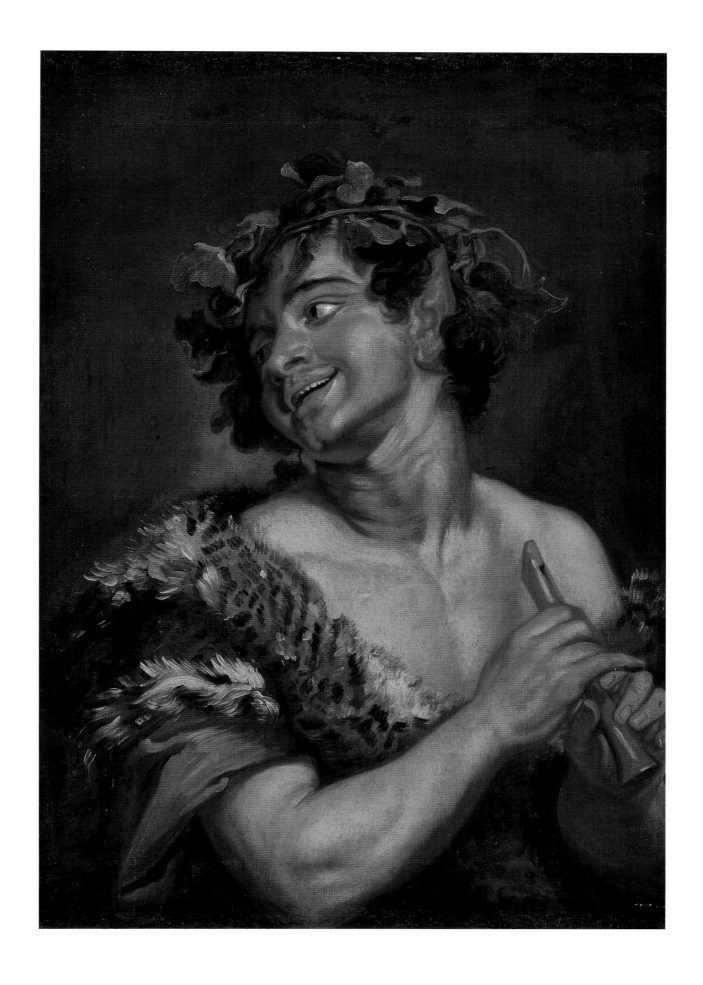

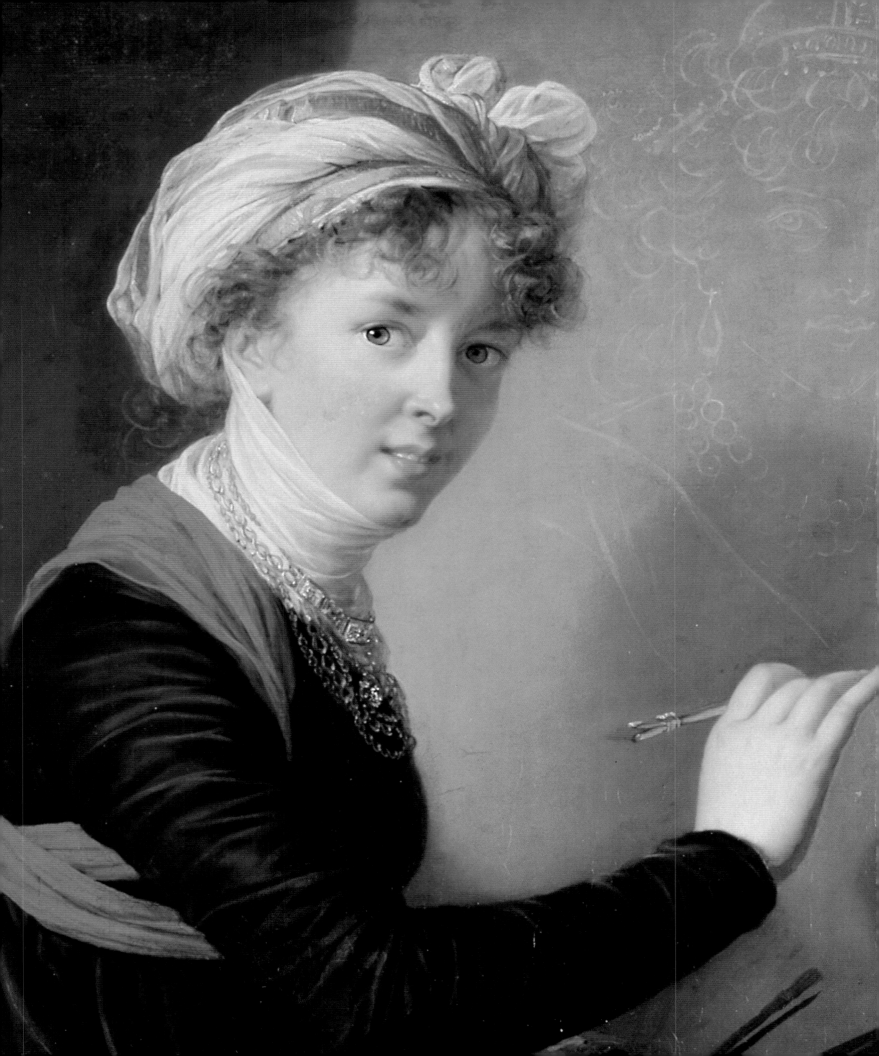

Marie Louise Elisabeth VIGÉE-LEBRUN

1755 Paris – 1842 Paris

Marie Louise Elisabeth Vigée-Lebrun was the daughter of the French portraitist and pastel painter Louis Vigée, from whom she received her first lessons. After her father's death, in 1768, she continued her training under the painters Gabriel Briard and Gabriel-François Doyen, while the renowned painter of seascapes Claude-Joseph Vernet drew the young artist's attention to Italian and Flemish masters, and to the lessons to be learned from nature itself. Vigée learned from the gallery of works by Rubens in the Palais de Luxembourg, and various private collections (including that of the duc d'Orléans in the Palais Royal), copying motifs from paintings by Rubens, Rembrandt, Van Dyck, and Greuze.

Vigée began to paint independently at the age of fifteen or sixteen, and soon gained her first commissions from powerful clients. Although these early works give no sense of the artist's individual personality, we can already feel the effect of Greuze's style. The young artist's compelling character and beauty drew much attention, and she was often invited to society dinners, where she was able to extend her circle of clients. These were mainly society ladies, but she also produced pictures of some of the gentlemen who were charmed by her. "Many admirers of my face," she recalled, "had me paint theirs, in the hope of coming to please me." It was therefore necessary that she worked in the presence of her mother.

From 1774 Vigée publicly exhibited her works and gained important foreign clients, among them Ivan Shuvalov (founder of the Imperial Academy of Arts in St. Petersburg), Prince Nassau, and Princess Potocka from Austria and Poland. In 1776 she married Pierre Lebrun, a painter and art dealer, with whom she had a daughter and whom she divorced in 1794. In 1776 she also began to work for the royal court. She was invited in 1779 to Versailles to work on a full-length state portrait of Marie-Antoinette. She became the queen's favorite portrait painter, forming a close association with her, and was honored with a commission to paint the royal children. Marie-Antoinette's favor brought her a degree of success unprecedented for a woman painter in France, and, in 1783, the Académie Royale recognized her talent and made her a member.

On the eve of the French Revolution, changes took place in Vigée-Lebrun's painting style, primarily influenced by Jacques-Louis David's portraits. In 1789 her intimacy with the French court forced her to leave her native land, together with her daughter, to escape the Revolution. She spent the early years as an émigré in Florence, Rome, and Naples (1790–92), and then in Vienna (1792–95). She was accompanied by unfailing success in all the European aristocratic salons and portrayed representatives of many of Europe's ruling houses, including those of the Two Sicilies, and of the Tuscan and Neapolitan kingdoms. Her stay in Vienna brought her acquaintances who would determine her future in exile: the prince de Ligne (who had accompanied Catherine II of Russia on her journey to the Crimea), the Russian ambassador Count Razumovsky, and others unanimously declared that in Russia she would find ardent admirers and further increase her success.

Thus it was at the height of her fame, in the summer of 1795, that Vigée-Lebrun arrived in St. Petersburg. She felt at home in the French atmosphere of St. Petersburg's salons, and her stay had a major effect on the development of late eighteenth-century Russian portraiture. With the exception of Catherine II, who often took up an artist who was fashionable but then changed her mind about him or her, the imperial family received the artist favorably, and Vigée-Lebrun portrayed many members of the imperial house, as well as of the aristocracy in St. Petersburg and Moscow. In her *Souvenirs de Mme Louise-Elisabeth Vigée-Lebrun*, published in 1835–37, she listed forty-eight portraits in Russia; in fact, there were considerably more that she did not record. Unfortunately Vigée-Lebrun's health deteriorated in the harsh northern climate, and in 1801, shortly after she was accepted into the St. Petersburg Academy of Arts, she left Russia for France, via Berlin. With the exception of brief sojourns in England and Switzerland, she was not to leave France again. She painted the new Parisian society that had appeared around Emperor Napoleon, and in 1809 settled in her favorite area, at Louveciennes. At the age of sixty-eight she wrote that painting was her passion and would end only with her life. With the passing of the years the artist gave ever more time to the writing of her *Souvenirs*, in which she positioned herself firmly within the pantheon of great painters. On 29 May 1842, Vigée-Lebrun died in Paris at the age of eighty-seven. She was buried, in accordance with her will, in the cemetery at Louveciennes. Her tomb bears a brush and palette. [ED]

Self-portrait, 1800, detail (see p. 189)

Marie Louise Elisabeth VIGÉE-LEBRUN

Baroness Anna Stroganova with her Son

Anna Sergeevna Stroganova (1765–1824), née Trubetskaia, was the daughter of Prince Sergei Trubetskoi and sister of Duchess Ekaterina Samoilova, one of the great beauties of the reign of Catherine the Great. Vigée-Lebrun also painted a full-length portrait of Ekaterina Samoilova with two of her children (State Hermitage Museum). Anna Sergeevna was a maid-of-honor to Catherine II. In 1791 she married Baron Grigory Aleksandrovich Stroganov (1770–1857), and went on to have five sons and a daughter. Until 1795 Stroganov remained in military service; he then retired with the rank of captain, moving on to the world of diplomacy, for which he traveled on various missions to Madrid, Stockholm, Constantinople, and London.

For many years the painting was thought to be a companion to the portrait of Grigory Stroganov painted a few years earlier, in 1793, in Vienna (State Hermitage Museum). It is recorded that Vigée-Lebrun did produce such a pair of portraits, but the location of these two works is unknown. In her memoirs Vigée-Lebrun mentions that she continued her acquaintance with the baroness in St. Petersburg. Undoubtedly, this portrait of Anna Sergeevna with her son should be placed in the Petersburg period of Vigée-Lebrun's career (1795–1801), for the baroness's first child was born in 1794. It has not proved possible to identify which of the four elder sons is shown with his mother, as they were born in quick succession one after the other between 1794

and 1797, the fifth being born later, in 1801. The child may be the eldest son, Count Sergei Stroganov (1794–1882), who would go on to be a general, an archaeologist, a patron, and a passionate art collector, passing on that passion to his sons Pavel and Grigory.

This portrait of Anna Stroganova and her son was originally a very small composition, showing only the sitters' heads and shoulders. Clearly visible are the seams where additions were made around the first square version. The new work—which increases the size of the canvas threefold—was unquestionably by Vigée-Lebrun. Either the artist changed her mind or the client herself wished for a larger portrait, the latter being more likely, because the format of the finished version is closer to the Vienna portrait of Grigory Stroganov (36¼ × 26 in./92 × 66 cm). [ED]

c. 1795–1801, oil on canvas, 35⅝ × 28¾ in. (90.5 × 73 cm)
Inv. no. GE 7585
PROVENANCE Acquired in 1931; in the nineteenth century in the collection of the Counts Stroganov, St. Petersburg
EXHIBITIONS St. Petersburg 1905, no. 249 (?); Leningrad 1956, p. 14; Mie–Osaka–Hiroshima–Toyama 1992, no. 226; Portland–Fort Worth 2000, no. 144; Paris 2002
BIBLIOGRAPHY *Souvenirs* 1835, II, pp. 210, 219, 289; III, p. 346; Dussieux 1856, no. 909; Nolhac 1912, p. 197; Réau 1924, p. 296; Réau 1929, no. 197; Nicolenco 1967, pp. 96, 103–104; Nemilova 1973, pp. 124–31; Nemilova 1982, no. 85; Nemilova 1985, no. 318

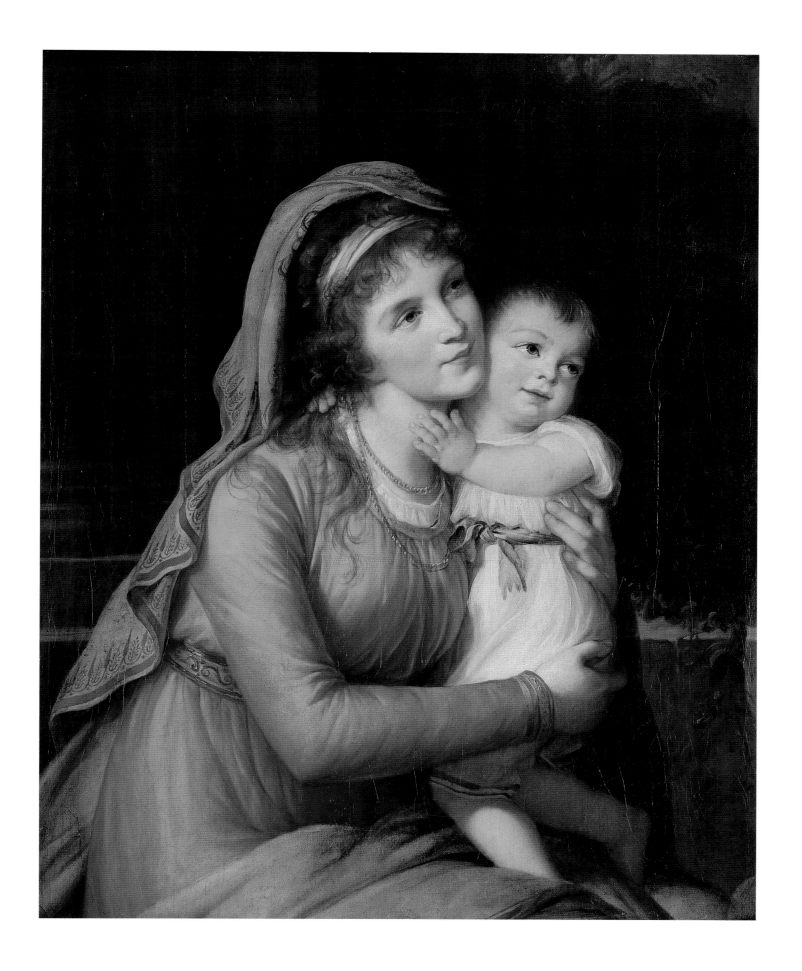

Marie Louise Elisabeth VIGÉE-LEBRUN

The Daughters of Paul I, Grand Duchesses Alexandra Pavlovna and Elena Pavlovna

Alexandra Pavlovna (1783–1801), the eldest daughter of Russian Emperor Paul I and Empress Maria Fedorovna, is shown together with her sister Elena, the second daughter of Paul and his wife. Elena holds a medallion showing Catherine II, the grandmother of both girls. In the autumn of 1795 Vigée-Lebrun received her first important imperial commission: Count Alexander Stroganov officially conveyed to the artist Catherine II's wish for a portrait of her granddaughters Alexandra and Elena, for which Vigée-Lebrun would be paid the large sum of 3000 rubles. The artist was enthusiastic about her sitters' beauty and originality, and described both girls in detail in her memoirs. She thought they must be thirteen or fourteen years old: "Their complexions were so fine and delicate that one could have believed they lived on ambrosia." At the same time their "heavenly faces" bore very different expressions: the eldest, Alexandra, had a Grecian profile and was very much like her eldest brother, the future Emperor Alexander I. But the face of the younger girl, Elena, was much more refined.

Vigée-Lebrun recorded in detail her work on the portrait: "I grouped them together, holding and looking at a portrait of the Empress; the costume was a little Greek but very modest." She also wrote that the empress was displeased with the costumes, and hurried to replace the tunics with more modest, long-sleeved dresses of the kind ordinarily worn by girls. "I in no way spoiled the ensemble of my picture, except in that the pretty arms to which I had given of my best could no longer be seen," she declared. Vigée-Lebrun then states in her memoirs that after Paul I came to the throne he asked why she had altered his daughters' attire, and their conversation revealed that Catherine II's lover, Platon Zubov, had invented the rumors of Catherine's dissatisfaction. However, a letter exists from Catherine herself, addressed to her friend and connoisseur of the arts Baron von Grimm in Paris, in which she expresses great displeasure with the painting altogether: "Madame Le Brun captures the two figures on a divan, twists the neck of the younger, giving both of them the air of two pug dogs warming themselves in the sun, or if you wish, of two nasty little Savoyards with hair dressed like bacchantes, with grapes, and dressed in large tunics in red and lilac. In this portrait-painting we find neither resemblance, nor taste, nor nobility."

X-ray studies of the painting do not reveal any changes. Vigée-Lebrun must have painted it anew, somewhat altering the story in her memoirs—suggesting that only minor changes were made to the costumes—in order to present herself in a more favorable light. In all likelihood she was forced to make considerably more serious alterations to the composition overall. It was thought that there was formerly an author's repetition of this work in the Romanov Gallery of the Winter Palace, but I. Nemilova established that this was a copy by the celebrated Russian artist Vladimir Borovikovsky (1757–1825), who himself portrayed the grand duchesses on several occasions (these portraits are now in the Hermitage and in the State Russian Museum, St. Petersburg). [ED]

1796, oil on canvas, 39⁵⁄₁₆ × 39⁵⁄₁₆ in. (99 × 99 cm)
Signed and dated right on the background: *L.E.V. Le Brun 1796*
Inv. no. GE 7747
PROVENANCE Transferred in 1934 from Gatchina Palace Museum, near Leningrad
EXHIBITIONS St. Petersburg 1905, no. 260; Belgrade 1968–69; Paris 1986–87, no. 311; Nara 1990, no. 37; Ekaterinburg 1995, p. 74, no. 139; Stockholm 1998–99, no. 109

BIBLIOGRAPHY *Souvenirs* 1835, II, pp. 294–95; III, pp. 345–46; Dussieux 1856, no. 909; SbRIO 1878, pp. 655, 661–62, 665; Nolhac 1908, pp. 113, 162; Wrangel 1911, pp. 23–24, 76, note 121; Nolhac 1912, p. 198; Uspensky 1913, p. 129; Réau 1924, pp. 296–97; Thieme, Becker 1940, p. 346; Nicolenco 1967, pp. 95, 112, no. 38; Nemilova 1973, pp. 174–83; Nemilova 1975, p. 438; Nemilova 1982, no. 86; Nemilova 1985, no. 319

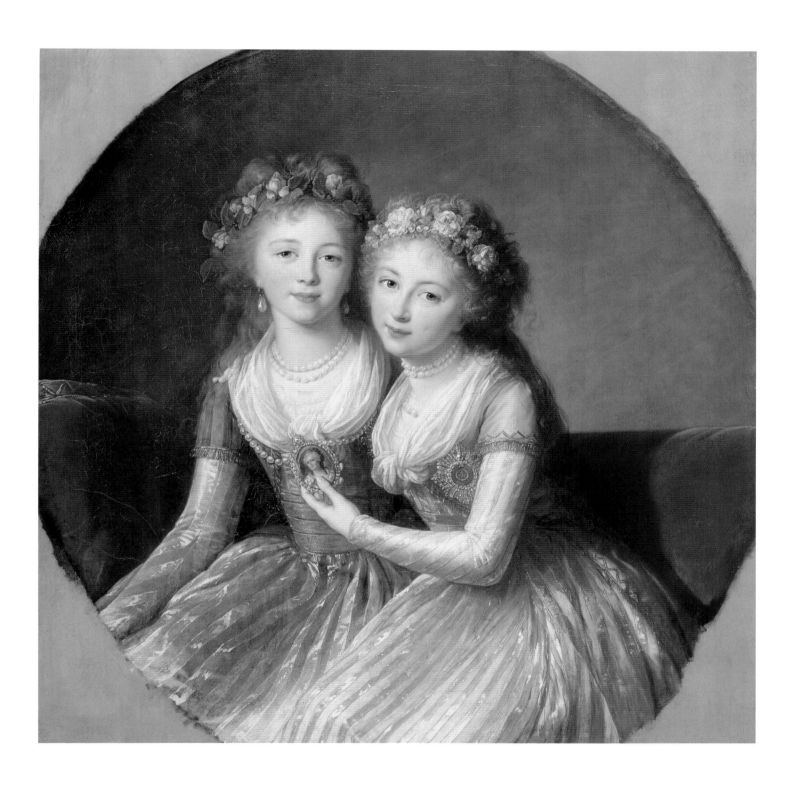

Marie Louise Elisabeth VIGÉE-LEBRUN

Prince Alexander Kurakin

Known as the "diamond prince" for his ostentatious display of wealth, Alexander Borisovich Kurakin (1752–1818) was the son of Boris Kurakin, *Hofmeister* (steward) of the imperial household. He was educated with the heir to the throne, Grand Duke Pavel Petrovich (later Emperor Paul I), with whom he remained friends throughout his life. In the late 1770s he became high procurator to the Senate, and was elected marshal of the St. Petersburg nobility, accompanying the grand duke on his foreign travels, including a journey to Berlin. After the death of her husband Peter, Catherine II took advantage of an opportunity to send Kurakin from the court to Saratov province. When Paul I came to the throne in 1796, however, he brought Kurakin back to St. Petersburg and generously rewarded him: he was appointed a privy counselor, a member of the emperor's Council, and vice-chancellor of the Russian Empire, and later received all the Russian orders, including the very highest, the Order of St. Andrew. He later fell briefly out of favor and was forced to move to Moscow, but the new emperor, Alexander I, brought him back to the capital once more and made him president of the Collegium of Foreign Affairs. Kurakin spent the rest of his life in the diplomatic service. In 1806 he was envoy to Vienna; in 1807 he was involved in concluding the Peace of Tilsit, and from 1809 to 1812 he served as the Russian ambassador in Paris.

Kurakin was vain and sybaritic, surrounding himself with his own "court." One contemporary, F.F. Wigel, recalled:

From youth Prince Kurakin was most handsome and nature had given him a strong, even athletic build. But luxury and love of voluptuousness weakened his bodily and spiritual energy, and his epicurism was visible in all his movements; while his radiant kindness was for years most captivating and respected, in the new reign, with its new ideas, it gave reason to compare him with a peacock.

This description is exceedingly fitting with regard to the Hermitage portrait of Kurakin, painted by Vigée-Lebrun in 1797, when the sitter was at the peak of his court career. Here we see the man who admired and was admired by women, already revealing a tendency toward portliness, a man utterly satisfied by life. Vigée-Lebrun mentions two versions of the portrait in her memoirs (the second is now at Pavlovsk Palace Museum, near St. Petersburg). When she visited Moscow some time later, Alexander Kurakin invited her to dinner and gave her an unforgettable reception in his luxurious Moscow palace. The artist described admiringly the rich decor of the house, and herself found its scandalously famous owner a delightful man, who treated his equals with great civility and his inferiors without arrogance. [ED]

1797, oil on canvas, 37³⁄₁₆ × 29¹⁵⁄₁₆ in. (96 × 76 cm)
Signed and dated right on the background: *L.E. Vigée Le Brun à Pétersbourg 1797*
Inv. no. GE 5664
PROVENANCE Acquired in 1923 from the collection of E.P. and M.S. Oliv, Petrograd; formerly in the collection of Count F.A. Kurakin, Moscow; after 1905 collection of E.P. and M.S. Oliv, St. Petersburg
EXHIBITIONS St. Petersburg 1905, no. 241; Irkutsk–Novosibirsk 1986, no. 6; Karlsruhe 1996, no. 29
BIBLIOGRAPHY *Souvenirs* 1835, III, pp. 66–67, 348; Dussieux 1856, no. 909; Nolhac 1908, p. 161; Wrangel 1911, pp. 22, 76, note 108; Réau 1929, no. 176; Nicolenco 1967, p. 114, nos. 50, 50a; Nemilova 1982, no. 88; Nemilova 1985, no. 321

Marie Louise Elisabeth VIGÉE-LEBRUN
Self-portrait

A year before she left Russia, Vigée-Lebrun was made an honorary free associate of the Imperial Academy of Arts in St. Petersburg. In her memoirs she described in detail the ceremony of 16 June 1800, in which the president of the Academy, Count Alexander Stroganov, received her personally, which was one of the dearest recollections she brought back from her travels. For the reception ceremony at the Academy, the artist ordered herself the required uniform—a riding-habit composed of a small violet jacket, yellow skirt, and black hat with a feather. Arriving at the appointed time, she passed through a long gallery with tribunes filled with spectators; in the distance, at a table, sat Count Stroganov. At a sign from him she came forward, and the count made a brief speech before giving her, in the name of Emperor Paul I, a diploma awarding her the status of member of the Academy of Arts. The thunder of applause took a long time to die down, bringing tears to her eyes and remaining in her memory forever. "I immediately made a self-portrait for the Academy in St. Petersburg; there I showed myself painting and with my palette in my hand," she wrote in her memoirs. For more than a hundred years the self-portrait that she presented to the Academy hung with the collection of portraits in the Council Chamber.

Vigée-Lebrun retained fond memories of the land in which she had sought refuge, and particularly of the Imperial Academy of Arts, which had recognized her skills. In 1843, under the conditions of her will, payment was made of "100 francs annually for the stamping of a gold medal to be awarded to a pupil in the painting class of the Academy."

In this self-portrait Vigée-Lebrun showed herself working on a portrait of the Empress Maria Fedorovna, wife of Paul I, wearing the so-called "lesser imperial set," a small crown scattered with diamonds. The portrait in the picture is a half-length version (until the mid-1990s in the collection of V.S. Popov, Moscow) of a large full-length state portrait of Maria Fedorovna that Vigée-Lebrun painted in 1799 (State Hermitage Museum).

According to Nolhac (1908), Vigée-Lebrun later told friends that she considered this the best of all her self-portraits. [ED]

1800, oil on canvas, 30⅞ × 26¾ in. (78.5 × 68 cm)
Signed and dated bottom left: *Vigée Le Brun à Pétersbourg 1800*
Inv. no. GE 7586
PROVENANCE Transferred in 1922 from the Academy of Arts, Petrograd
EXHIBITIONS St. Petersburg 1870, no. 729; St. Petersburg 1905, no. 256; Leningrad 1956, p. 14; Bordeaux 1965, no. 38; Paris 1965–66, no. 38; Dresden 1967–68; Leningrad 1972, no. 319; Melbourne–Sydney 1979–80, no. 45; Paris 1986–87, no. 313; Leningrad–Moscow 1987, no. 378; London 1988, no. 16; Karlsruhe 1996, no. 30; Portland–Fort Worth 2000, no. 142; Paris 2002
BIBLIOGRAPHY *Souvenirs* 1835, II, p. 472; III, pp. 38–39, 348; Dussieux 1856, no. 909; Nolhac 1908, p. 162; Réau 1924, p. 299; Réau 1929, no. 180; Nemilova 1982, no. 93; Nemilova 1985, no. 326

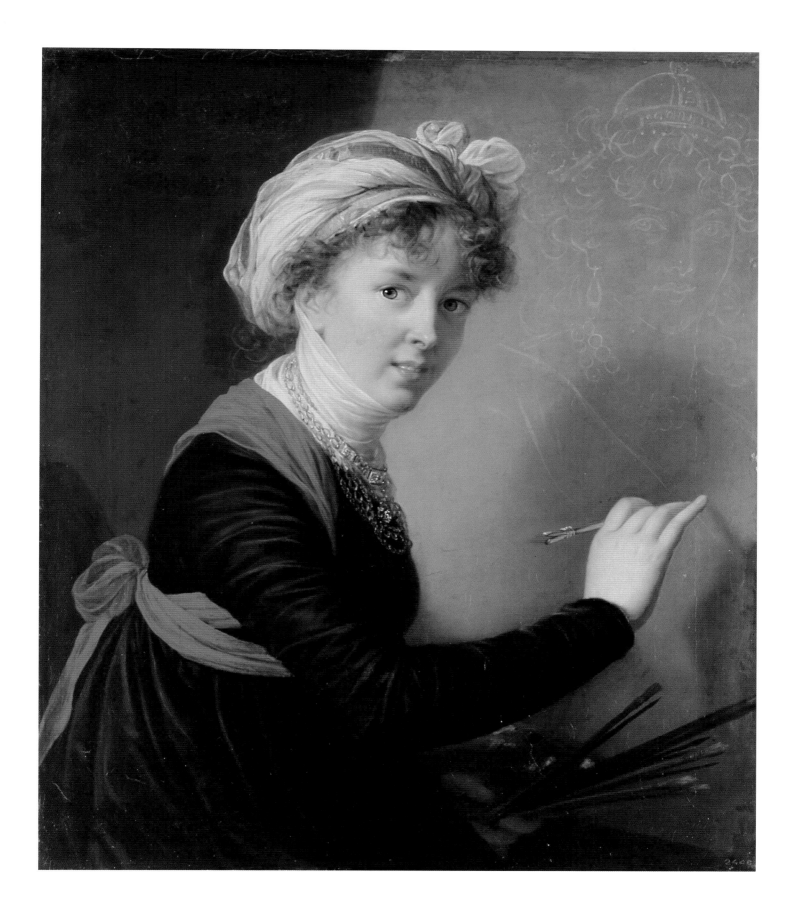

189

Marie Louise Elisabeth VIGÉE-LEBRUN

Grand Duchess Elizaveta Alekseevna

Princess Louisa Maria Augusta (1779–1826), third daughter of Carl Ludwig, Markgraf of Baden, became Grand Duchess Elizaveta Alekseevna when, in 1793, she married the heir to the Russian throne, Grand Duke Alexander, the future Alexander I. They had two daughters, who died in infancy. According to contemporaries, her kindness and sympathy brought her general love and affection, but she played no significant role in the reign of Alexander I, not even at court, as the energetic Dowager Empress Maria Fedorovna overshadowed her. The beauty of Elizaveta Alekseevna drew many famous artists from the moment she appeared at the Russian court. Jean Laurent Mosnier (1803, 1806), Franz von Kügelgen, Vladimir Borovikovsky (between 1797 and 1800), Gabriel de Saint-Aubin (1810), and George Dawe all painted her.

Vigée-Lebrun first saw Grand Duchess Elizaveta Alekseevna in 1795, at Tsarskoe Selo (site of one of the royal summer residences near St. Petersburg). She described her in her memoirs:

> Her features were fine and regular and her face a perfect oval. Her pretty complexion was not animated but of a paleness totally in harmony with the expression on her face, which was of an angelic sweetness. Her ash-blond hair floated around her neck and on her forehead. She was dressed in a white tunic fastened by a girdle knotted casually around a waist as fine and supple as that of a nymph. I cried: ''Tis Psyche!'

Vigée-Lebrun asserts that immediately after completing the portrait of Grand Duchesses Alexandra and Elena (see p. 185), she received a commission from Catherine II for a state portrait of Elizaveta Alekseevna (State Hermitage Museum). "I have already said what a ravishing person this princess was; I would have preferred not to show so select a figure in vulgar costume," the artist wrote vengefully in her memoirs (*Souvenirs* 1835, II, p. 298), recalling her previous faux pas regarding the attire of the young girls.

Vigée-Lebrun was nonetheless able to capture her first impression of the sitter a little later, in this more intimate composition, painted in 1798 as a commission from Elizaveta Alekseevna herself as a gift for her mother, Amalia, Markgräfin of Baden. "I painted her with a transparent violet shawl, leaning on a cushion." It remained in the Winter Palace, and Vigée-Lebrun produced another version for Amalia; some scholars have suggested that the other version is that now in the Musée Fabre at Montpellier.

Vigée-Lebrun was extremely fond of the grand duchess, and this affection seems to have been mutual: she relates a touching story of how, one morning as the grand duchess was posing for her, the artist became faint. The grand duchess wept, and herself ran to fetch a glass of water. These friendly relations, and her personal interest in the sitter, led Vigée-Lebrun to depict Elizaveta Alekseevna repeatedly, either working anew or repeating compositions that the grand duchess liked. Another version of this painting, but with a landscape background, is now in a private collection in Paris. Two similar compositions in pastel exist in French collections, while the artist brought a third drawing back to Dresden.

The composition of this portrait was one of the artist's favorites: somewhat earlier she had painted similar portraits of Ekaterina Vasilevna Skavronskaia and the Duchess Litta. The painting became famous thanks to an engraving by I.S. Klauber executed the same year, which served as the model for numerous engraved copies, some of which reveal changes in the sitter's pose, costume, or hairstyle. [ED]

1798, oil on canvas, 31½ × 25¹³⁄₁₆ in. (80 × 65.5 cm)
Inv. no. GE 7615
PROVENANCE Transferred in 1918 from the Winter Palace
EXHIBITIONS Ibaraki–Mie–Tokyo 1994, no. 49; Wilmington–Mobile 1998–99, no. 9
BIBLIOGRAPHY *Souvenirs* 1835, II, p. 300; Dussieux 1856, no. 909; Nolhac 1908, pp. 113–14; Wrangel 1911, pp. 25, 76, note 124; Nolhac 1912, p. 199; Réau 1924, p. 298; Nicolenco 1967, pp. 98, 109–10, nos. 32a, 32b, 32d, 32e; Nemilova 1975, p. 440; Nemilova 1982, no. 90; Nemilova 1985, no. 323

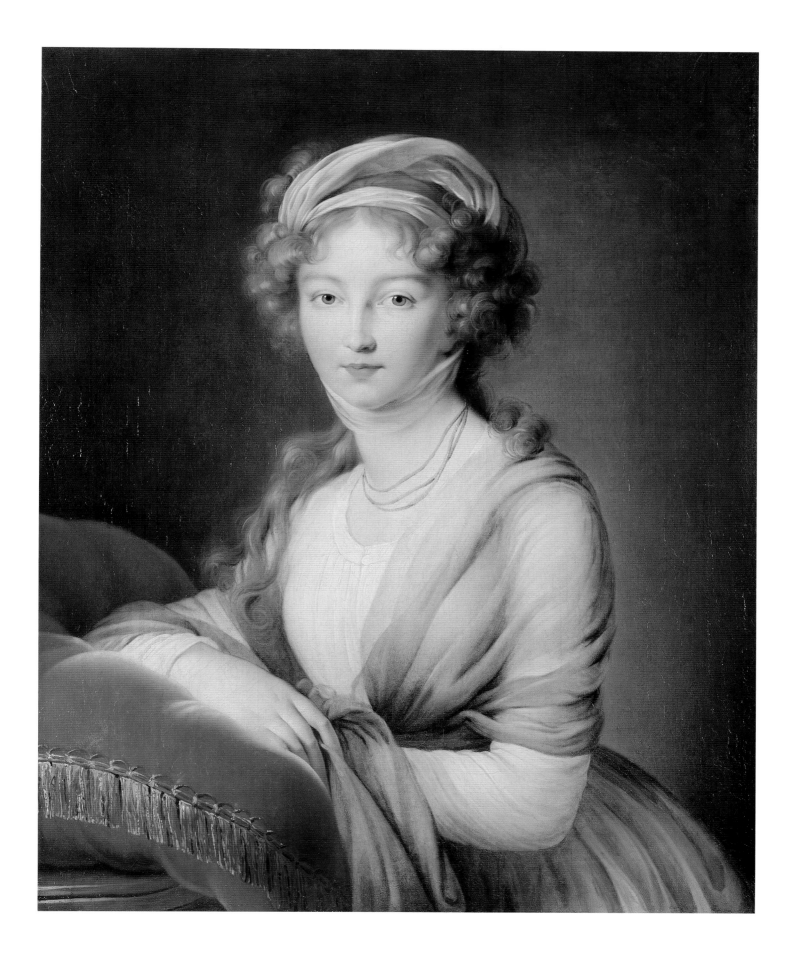

Marie Louise Elisabeth VIGÉE-LEBRUN

Anne Pitt as Hebe

Anne Pitt (1772–1864), daughter of the politician and great supporter of the arts Thomas Pitt, Lord Camelford, married the renowned statesman William Wyndham, Baron Grenville in 1792. Grenville had been granted the peerage in 1790 and entered the House of Lords, of which he soon became Lord Chancellor. He was foreign secretary from 1791 to 1801 and played an important role in the government of his cousin William Pitt the Younger.

Immediately upon her arrival in Rome, in 1792, Vigée-Lebrun undertook her own self-portrait "for the gallery of Florence." She adds: "then I painted Miss Pitt, the daughter of Lord Camelford." As in the majority of her commissions, the artist waxed enthusiastic about the charm of her sitter and described the composition in detail: "I showed her as Hebe on clouds, holding in her hand a cup from which an eagle is about to drink." The eagle in this allegorical portrait was painted from nature, for Vigée-Lebrun notes: "I thought I would be devoured by him." The bird was borrowed for the sittings from the Cardinal de Bernis, and caused a great deal of trouble and inconvenience. "The accursed animal, which was used to being always in the open air, chained in the courtyard, was so furious at finding itself in my chamber that it wished to swoop upon me and I swear that I was most frightened." All ended well, however, and the portrait, signed and dated 1792, was later taken to England, where it still hangs in a private collection (Nolhac 1908).

The painting in the Hermitage is Vigée-Lebrun's copy of the portrait executed in Rome. Until recently nothing was known about when the painting was made and how it was acquired for the collection of the Counts Vorontsov. The following inscription on the stretcher—perhaps written by the painting's later owners—gives the origin of the portrait as the Vorontsov collection: "Anne (Pitt) Baroness Grenville/ This picture was presented by her/ to Count Woronzow." Thus the subject of the portrait would seem to have commissioned the version herself as a gift. The Vorontsov in question was probably Semen Vorontsov, brother of Ekaterina Vorontsova-Dashkova (famous as a one-time friend, supporter, and lady-in-waiting to Catherine II), who arrived in England in 1785 and spent the remaining forty-six years of his life there. For many years, until 1806, he was Russian ambassador in London. His daughter Catherine married Lord Pembroke, and in 1801 his son Mikhail returned to Russia. Vorontsov enjoyed long and close relations with Lord and Lady Grenville from the early 1790s.

A study of the reverse of the painting has produced convincing evidence that Vigée-Lebrun painted this version of Anne Grenville's portrait around 1802–05, during the artist's stay in England and approximately ten to twelve years after the original painting was produced in Rome. The Hermitage painting is on very fine, typical English canvas, on the back of which is a stamp with the name of the London firm that supplied it: "[T] Brown/ High Holborn/linen." The same name and address are carved on the side of the stretcher, suggesting that Brown probably supplied the canvas already on its stretcher. [ED]

c. 1802–05, oil on canvas, 55⅛ × 39³⁄₁₆ in. (140 × 99.5 cm)
Inv. no. GE 4749
PROVENANCE Transferred in 1920 from the collection of Count I.I. Vorontsov-Dashkov, Petrograd; probably presented in the early nineteenth century to Count Semen Vorontsov in London; collection of the Counts Vorontsov-Dashkov, St. Petersburg
BIBLIOGRAPHY *Souvenirs* 1935, II, pp. 38–39; Nolhac 1908, p. 94; Nemilova 1982, no. 94; Nemilova 1985, no. 327

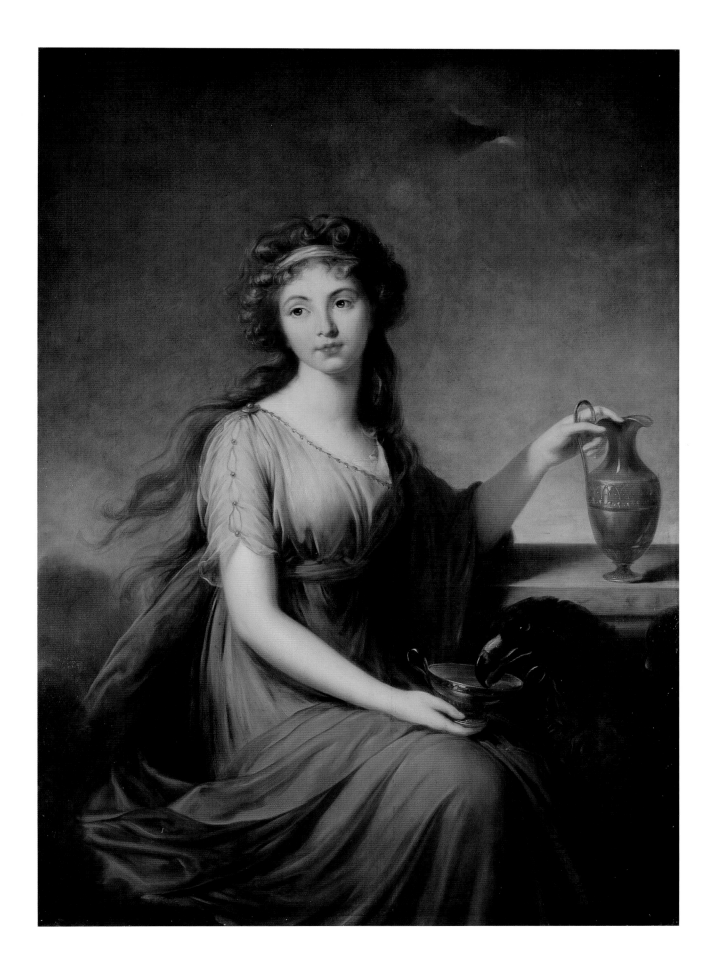

Marie Louise Elisabeth VIGÉE-LEBRUN

Portrait of Madame de Rivière (?)

The name of the sitter in this portrait remains the subject of scholarly controversy. Catalogues of the Hermitage collections have listed the work both as a portrait of an unknown woman and as a portrait of Léontine de Rivière, despite a lack of biographical information about the latter. In the list of her works that Vigée-Lebrun compiled (*Souvenirs* 1835–37, III, p. 352) the artist mentions two portraits of women with the surname "Rivière," but without a first name to aid further identification: "*Mlle de Rivière*" and "*Madame de Rivière, ma nièce, avec les deux mains.*" This latter reference may perhaps be identified with the portrait in the Hermitage, although the arms are shown only to the elbow. While we know nothing of "Mlle de Rivière," Vigée-Lebrun described her niece "Madame de Rivière" in some detail in her memoirs. The artist's two nieces, Eugénie Le Brun (later Tripier Lefranc) and Mme de Rivière, were closer to Vigée-Lebrun than anyone else during the artist's final years.

This portrait reveals compositional and typological similarities to a portrait by Tripier Lefranc from 1834 (see p. 137). By the 1830s Vigée-Lebrun was working less intensively than in earlier decades and rarely produced portraits. Although the artist painted *Portrait of Madame de Rivière* during this later period—the last decade of her life—it is stylistically close to works of a quarter of a century earlier, such as *Portrait of the Actress Giuseppina Grassini as Zaïra* (c. 1805; Musée des Beaux-Arts, Rouen). The portraits in St. Petersburg and Rouen are both of a markedly theatrical nature, manifested in the artificial poses and in the stylized costumes (particularly in the orientalizing form and the ornament of the large buckles worn by both women). [AB]

1831, oil on canvas, 31½ × 25⁹⁄₁₆ in. (80 × 65 cm)
Signed and dated bottom right: *L.E. Vigée-Le Brun 1831*
Inv. no. GE 7793
PROVENANCE Acquired in 1936 from M.K. Glazunov (as *Portrait of Léontine de Rivière*)
EXHIBITIONS Leningrad 1938, issue IV, no. 288; Moscow 1955, p. 26; Leningrad 1956, p. 13
BIBLIOGRAPHY *Souvenirs* 1835–37, III, p. 352; Izergina 1969, pp. 17–19; Nemilova 1982, no. 96 ("*Portrait of a Woman*"); Berezina 1983, no. 442 ("*Portrait de Léontine de Rivière*"); Nemilova 1985, no. 329 ("*Portrait of a Woman*")

Marie Louise Elisabeth VIGÉE-LEBRUN

The Genius of Emperor Alexander I

The *Portrait of Young Prince Henryk Lubomirski as Cupid of Glory* by Vigée-Lebrun (Staatliche Museen Preussischer Kulturbesitz, Gemäldegalerie Berlin) confirms the identity of the sitter for this work. The composition of the Hermitage painting is a sufficiently close variation, albeit in reverse, and the facial features in the portraits are identical. Princess Elzbieta Izabella Lubomirska, aunt of young Henryk Lubomirski, commissioned the Berlin portrait from Vigée-Lebrun in 1789. Vigée-Lebrun exhibited the painting at the Salon in Paris that year under the title *Young Prince Lubomirski as Cupid Holding a Wreath of Myrtle and Laurel*. Because the two versions are of similar size, and the composition in the Hermitage was originally also on panel, it is possible that this painting was commissioned for the portrait gallery of the Lubomirskis but remained in the artist's possession.

One of the earliest catalogues of paintings in the Imperial Hermitage (Livret 1838) describes this composition as "portrait of young Prince Lubomirski, reworked into an allegorical subject on the occasion of the entrance into Paris of the Emperor Alexander of immortal memory, presented to His Imperial Majesty by the artist." Alexander I (reigned 1801–25) switched allegiances regularly during the Napoleonic period, and eventually turned against Napoleon. When French forces marched into Russia, taking Moscow in 1812, the Russian Marshal Kutuzov advised Alexander that instead of trying to face Napoleon, the Russians should retreat, and let the Russian winter finish off the invading troops. With the onset of winter, Napoleon's decimated army withdrew and the Russian army chased what was left of it back to France, making a triumphant entry into Paris in 1814.

Over a number of years, between 1789 and 1792, the artist painted several portraits of Henryk Lubomirski, first in Paris and then in Vienna. The painting in the Hermitage can be dated to about 1789–92. The half-erased date of 1816 indicates that Vigée-Lebrun subsequently reworked the painting. [ED]

c. 1789–92, oil on canvas (transferred from panel in 1893), 42 $^{11}/_{16}$ × 33 ¼ in. (110 × 84.5 cm)
Signed bottom right: *L.E th Vigée Le Brun*; below a poorly preserved and apparently renewed date: *1816* (?)
On the shield the inscription: *ALEXANDRE LE MAGNANIME PARIS 31 MARS 1814*
Inv. no. GE 1149

PROVENANCE Probably painted between 1789 and 1792; finished later and presented to Alexander I; in the nineteenth century kept at Gatchina Palace, near St. Petersburg

BIBLIOGRAPHY *Souvenirs* 1835, I, p. 335; Livret 1838, p. 165, no. 2; Dussieux 1856, no. 961; Somov 1908/1916, no. 1807; Wrangel 1911, pp. 20–21; Réau 1924, p. 300; Mycielski, Wasylewski 1928, pp. 21–28, 59; Réau 1929, no. 181; Rzewuska 1939, pp. 596–97; Nemilova 1973, pp. 279–306; Bock 1978, pp. 83–92; Ruszkiewicz 1979, p. 27, no. 1; Nemilova 1982, no. 95; Nemilova 1985, no. 328

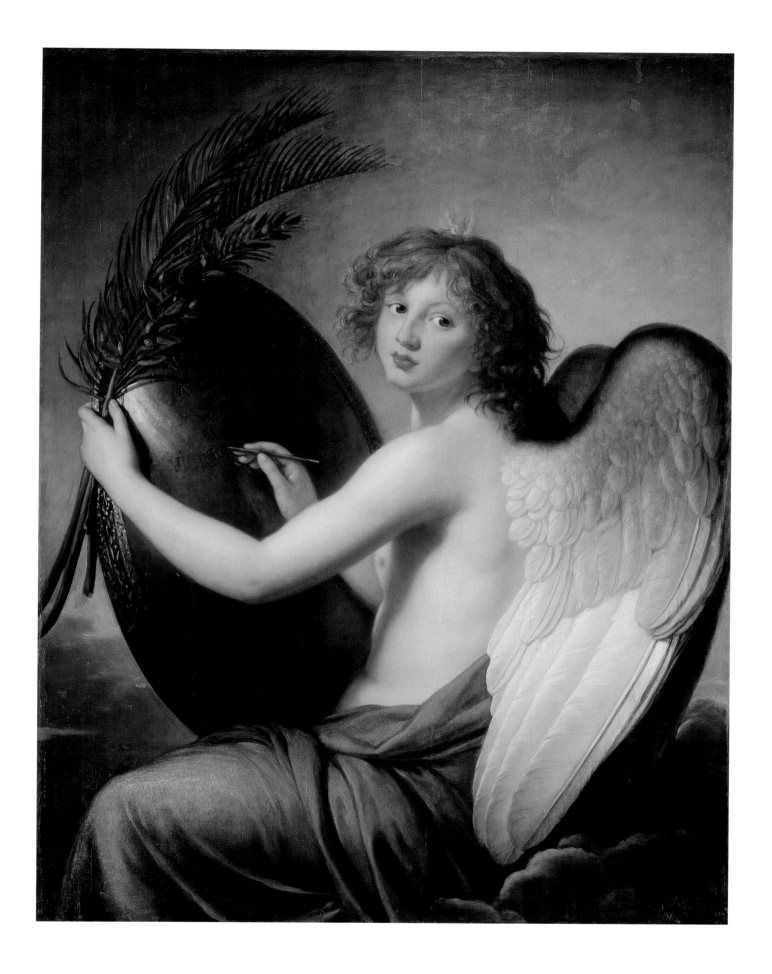

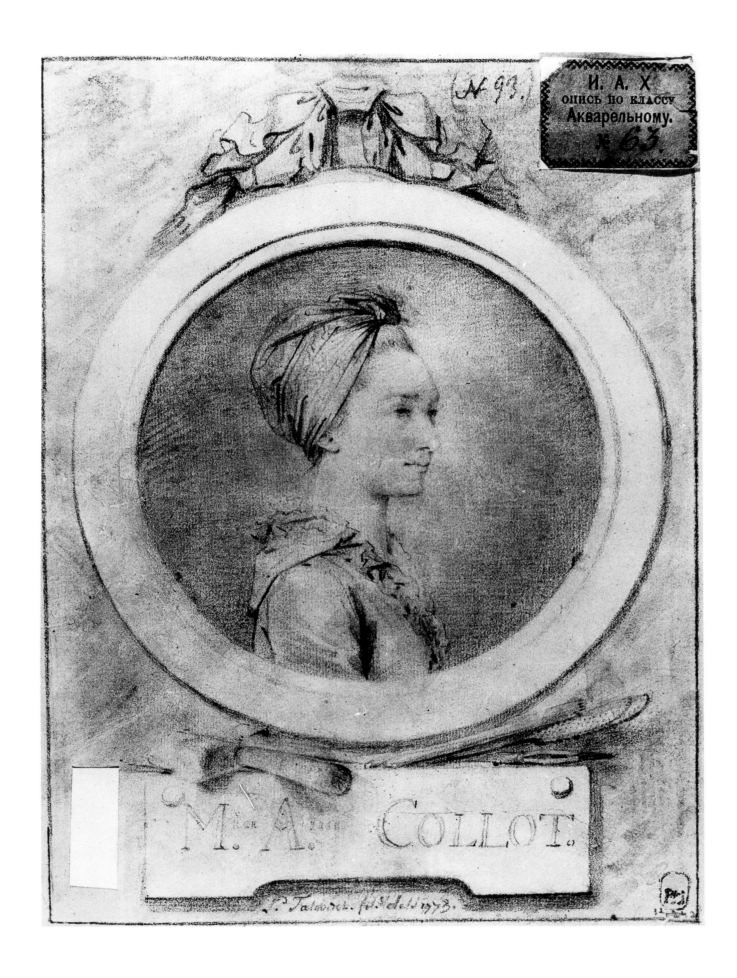

198

Marie-Anne COLLOT

1748 Paris – 1821 Nancy

Marie-Anne Collot's background was not artistic: her father abandoned his family and she lost her mother early in life, thus being forced out into the world to earn money to take care of her grandmother and her younger brother. She was still very young when she began to work as an artist's model, and eventually went on to become a professional artist herself.

Collot began to study drawing under the sculptor Jean-Baptiste Lemoyne, who taught Etienne-Maurice Falconet, and she joined Falconet's studio aged fifteen. When she was just seventeen years old she produced her first works, which brought her renown as a portrait sculptor. Among her clients were the well-known *salonnière* Mme Geoffrin, and Prince Dmitry Golitsyn, the Russian envoy in Paris, who was renowned for his fine taste. Surviving early works—among them a bust of Denis Diderot (1766; Musée National de Céramique, Sèvres) and a *Portrait of an Unknown Man* (1765; Louvre, Paris)—already bear the features of her individual style, which is marked by clarity and simplicity of form. She also developed great skill in selecting those of the sitter's features that slightly ennobled his or her appearance, while not detracting from the unique aspects of the individual's personality.

When Falconet was invited to Russia on the recommendation of Prince Golitsyn to work on The Bronze Horseman—the monumental equestrian sculpture of Peter the Great that stands at the heart of St. Petersburg—the young Marie was one of three assistants permitted him under the terms of the contract. There was a deep emotional bond between pupil and teacher, and despite initial hesitation Collot took the decision to leave her native land and to accompany Falconet on his trip to distant Russia. In this she succumbed to the persuasive arguments of Diderot, who saw her as an ideal companion—both artistic and personal—for his friend Falconet, and of Prince Golitsyn, who described her talent as nothing short of miraculous.

Falconet and Collot were well received in St. Petersburg and given everything they required, including a fully equipped house and a large studio. The Imperial Academy of Arts made Falconet an honorary free associate. Collot followed in his wake, becoming a member of the Academy in 1767, which made it possible for her to show her works at Academy exhibitions.

Collot's work enjoyed its greatest success in the early 1770s, when she produced her most important piece—a monumental head of Peter the Great for Falconet's equestrian portrait. Marie was given this task when it became clear that Falconet was having great difficulties with the portrait of Peter.

In 1775, after the first cast of the sculpture had been made, Collot returned to Paris, spending a year in Jean-Antoine Houdon's studio and enjoying some success. She returned to St. Petersburg, where she married Falconet's son, a portraitist. In 1778 Collot departed forever from St. Petersburg—the city where she had enjoyed the most fruitful years of her life—and essentially ended her career upon her return to Paris. [IE]

Pierre-Etienne Falconet, *Portrait of Marie-Anne Collot*, 1773, lead pencil on parchment paper, 7⅜ × 5½ in. (18.8 × 14 cm), State Russian Museum, St. Petersburg

Marie-Anne COLLOT

Portrait of Catherine II

This bust was Collot's second portrait of Catherine the Great. The empress took great interest in Collot and Falconet during the first years of their stay in Russia. From the letters that the empress and Falconet regularly exchanged, we know that the plaster model for the bust had already been completed by June 1768. On 28 June, Falconet replied to a request from Catherine for advice regarding a gift to Voltaire: "A marble head of Your Majesty made by Mlle Collot (that with the veil, for instance) will most certainly be a present worthy of both the Empress and the philosopher-poet" (*Correspondance* 1876, p. 45). In her reply, the empress expressed her satisfaction with this suggestion: "request Mad. Collot to take a block of stone and make of it my appearance" (*Correspondance* 1876, p. 49). She permitted Collot to defer work on other commissions so that she could complete the portrait before the River Neva and the Gulf of Finland froze, shutting down commercial traffic on the waterway. On 10 October 1769 Falconet informed her that the work was complete.

Falconet had good reason for suggesting such a bust as a gift for Voltaire. In its treatment of the empress's appearance it was somewhat unusual. Unlike Collot's first portrait of Catherine the Great from 1768, with its ceremonial, official attributes, which she created after existing images, this portrait was sculpted from life. Without the least idealization, the young artist presents the features of the forty-year-old empress: the open, rounded forehead that descends smoothly into the severe line of the nose; the attentive, keen gaze from the wide-open eyes; the characteristic mouth with its thin upper lip, the lower lip slightly projecting, and the slight smile playing upon it; the heavy, willful chin; and the overall elongated oval of her face. Full of energy, this face was so impressive in its own right that it had no need of adornment. [IE]

1769, marble, height 24 in. (61 cm)
Signed and dated on the back: *Maria Anna Collot f bat anno 1769*
Inv. no. N.sk. 1391
PROVENANCE Transferred in 1923 from the State Museums Fund; formerly in the Chernyshov collection, St. Petersburg
EXHIBITIONS Genoa, 2001–02
BIBLIOGRAPHY Stählin 1990, p. 183; *Correspondance* 1876, pp. 45, 49, 83, 85, 91, 92; Etoeva 1999, p. 40; Etoeva 2000, p. 37; Etoeva (forthcoming)

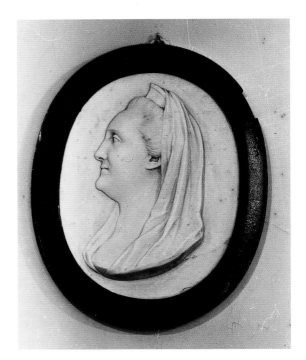

Marie-Anne Collot,
Portrait of Catherine II in Bas-relief, 1769, marble, height 22⅞ in. (57 cm), Gatchina Palace Museum, St. Petersburg

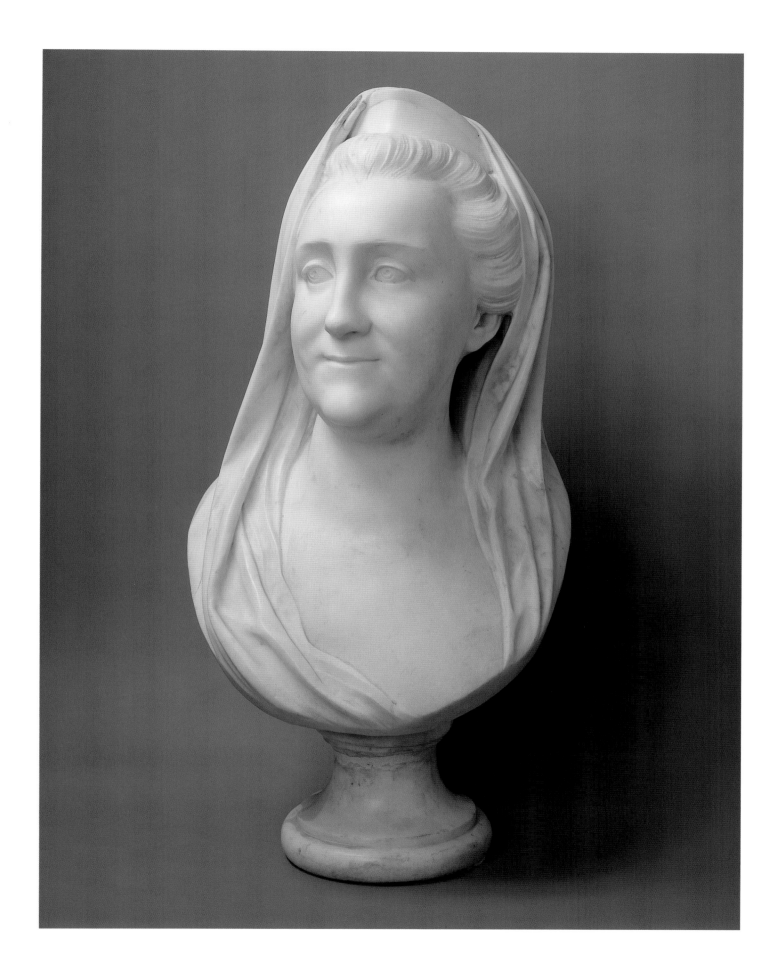

Marie-Anne COLLOT

Portrait of Miss Cathcart, Daughter of the English Ambassador to St. Petersburg, Lord Charles Cathcart

Lord Charles Henry Cathcart, ambassador of Great Britain to the court of Russia (1768–72), made the acquaintance of Etienne-Maurice Falconet immediately on his arrival in St. Petersburg. Allegedly one of the "most artistically educated connoisseurs of horses" (Backmeister 1786, p. 43), Cathcart offered advice of great benefit to the sculptor during his work on the figure of the horse for the equestrian monument to Peter the Great.

The model for this bust of Lord Cathcart's daughter (signed and dated 1768; Louvre, Paris; see below) was one of the first works Collot produced in St. Petersburg, and brought her immediate recognition. By 1769 Collot had modeled in plaster the heads of various individuals, among them a portrait "of the eldest and most beautiful daughter of the Ambassador of Great Britain, aged 15 years" (Stählin 1990, p. 183). Scholars have been unable to agree on which of the three elder daughters of Lord Cathcart sat for this bust: Jane, Mary, or Louisa. Michael Levey notes that the age of the young woman best accords with the age of the eldest daughter, Jane, born on 20 May 1754. She must have been approximately fourteen years old in 1768 when Collot produced the model for the bust, while her sisters would have been only thirteen and fifteen. Levey also points out that, in a letter of 8 February 1768, Lady Cathcart wrote that her eldest daughter was "liked at the Russian court, particularly by the Empress" (cited in Levey 1965, p. 633). [IE]

1772, marble, height 23 13/16 in. (60.5 cm)
Signed and dated on the back: *par Maria Anna Collot 1772*
State Russian Museum, St. Petersburg, Inv. no. N.sk. 1372
PROVENANCE Transferred to the State Russian Museum in 1927 from the State Museums Fund; on permanent display in the Hermitage since 1939
BIBLIOGRAPHY Réau 1922, pp. 518–19; Opperman 1965; Levey 1965; Russian Museum 1988, p. 83; Stählin 1990, p. 183

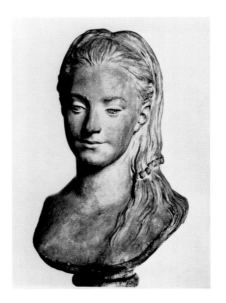

Marie-Anne Collot, *Portrait of Miss Cathcart*, 1768, plaster, height 23 5/8 in. (60 cm), Musée du Louvre, Paris

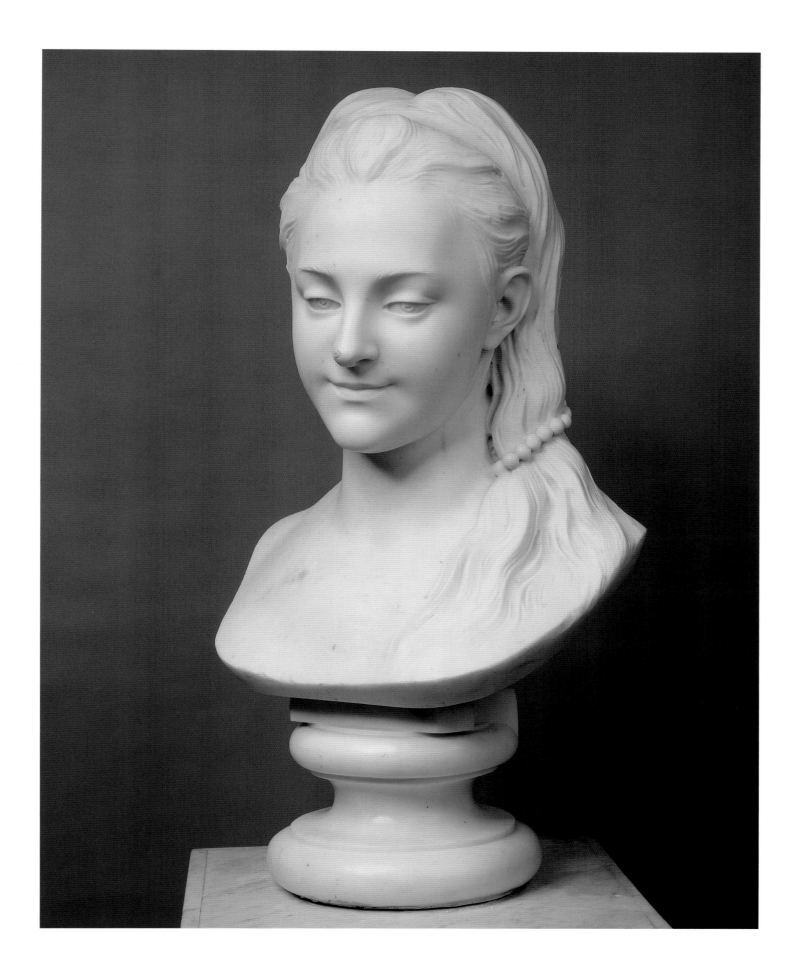

Marie-Anne COLLOT

Portrait of Denis Diderot

Denis Diderot (1713–1784) was Collot's friend and advisor from the very start of her career. She made a terracotta bust of him in Paris in 1766 (Musée National de Céramique, Sèvres), and this was among those works that brought her fame as a portraitist.

Catherine the Great's attention to Falconet had been largely determined by her interest in Diderot, for she saw the sculptor above all as someone who was close in spirit to the philosopher. In a letter to Mme Geoffrin, expressing her joy that she had gained, thanks to Diderot, not only an outstanding master but also an interesting man, she described Falconet as "the friend of Diderot's soul."

Awaiting Diderot's arrival with impatience—he had regarded a journey to Russia with some trepidation for years—Catherine commissioned a marble bust of him. Collot began work on it, judging by Catherine's correspondence with Falconet, no later than October 1770, and had completed it by 7 January 1773 (although she backdated her signature to 1772).

During the reign of Catherine II the bust was kept in the Hermitage and then in the Tauride Palace, from where in 1852 it was transferred to the newly opened New Hermitage, and placed in the main library with other busts of historical figures and philosophers of the ancient world. [IE]

1772, marble, height 22⁷⁄₁₆ in. (57 cm)
Signed and dated on the back: *par MA Collot 1772*
Inv. no. N.sk. 2
PROVENANCE Transferred to the New Hermitage from the Tauride Palace 23 May 1852
EXHIBITIONS London 2000–01, no. 18
BIBLIOGRAPHY *Correspondance* 1876, pp. 125, 173, 184, 281; Diderot, *Salons* 1957–67, II, p. 17; Réau 1922, p. 440; Matsulevich 1940, pp. 62–65; Kossareva 1975, p. 447; Kaganovich 1982, p. 24; Becker 1998, p. 79

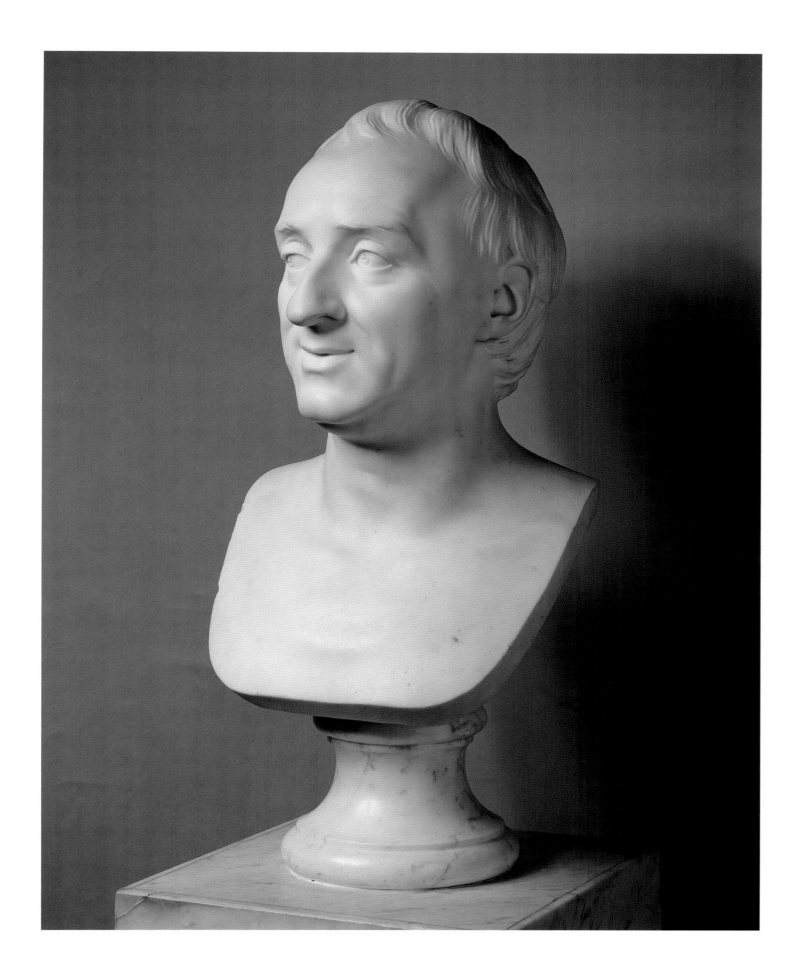

Marie-Anne COLLOT

Portrait of Etienne-Maurice Falconet

This portrait of Etienne-Maurice Falconet (1716–1791), famed in Russia for his magnificent Bronze Horseman, is one of the finest works Collot produced. Her affection for Falconet was clearly the inspiration behind her work, and it gave her a profound understanding of the man himself, enabling her to capture his image in marble with great skill.

Falconet appears in all the complexity of his contradictory nature, so superbly described by Diderot:

> Here is a man who has genius and who has all sorts of qualities both compatible and incompatible with genius. He has finesse, taste, spirit, graciousness, and grace in full measure; he is rustic and polished; affable and brusque, tender and hard; he kneads clay and carves marble, he reads and meditates; he is gentle and caustic, serious and pleasing; he is a philosopher, he believes nothing, and knows perfectly well why … . (*Salon of 1765*; Diderot, *Salons* 1957–67, II, p. 214)

Collot depicts his "Socratian" features (as he termed them)—the high forehead, the untidy locks of hair, the slightly snub nose, the large mouth, and even the wrinkles around the keen, satirical eyes. Falconet's face seems to radiate vital life force. Such an impression of dynamism is achieved by the very placing of the head, and is reinforced by details such as the carelessly tied cravat, one end of which descends to the pedestal, cutting across the line of the lower edge. The virtuoso working of the marble on the mass of hair, which reveals extensive use of the drill, creates a sharp effect of light and shade, contrasted with the finely worked facial features, their surface carefully polished.

Although Collot produced nearly all her other works at incredible speed, she spent a long time on this piece. The work was divided into two stages. She worked on the marble in May 1768. The portrait was delivered to the empress, but later, in April 1773, Falconet requested that it be returned so that Collot could work on it some more. [IE]

1773, marble, height 17¹¹⁄₁₆ in. (45 cm), pedestal 4⁵⁄₁₆ in. (11 cm)
Signed and dated on the back: *STEPH…FALCONET/ F bat PETROPOLI/ MARIA ANNA/ COLLOT. ANNO/ 1773*
Inv. no. N.sk. 6
PROVENANCE Acquired by Catherine II in 1773; transferred to the New Hermitage before 1859
EXHIBITIONS St. Petersburg 1905, no. 2218; Leningrad 1938, no. 232; Leningrad 1966 (no number); Leningrad 1972, no. 493; Paris 1986–87, no. 395; Leningrad–Moscow 1987, no. 435
BIBLIOGRAPHY *Correspondance* 1876, pp. 23, 26, 31, 39, 183, 251; Hildebrandt 1908, p. 54; Grabar [1914], p. 91; Réau 1922, p. 434; Réau 1924, p. 133; Matsulevich 1940, pp. 68–69; Zaretskaia, Kossareva 1965, p. 13; Kossareva 1975, p. 448; Zaretskaia, Kossareva 1975, p. 117; Kaganovich 1982, p. 23; Stählin 1990, p. 184

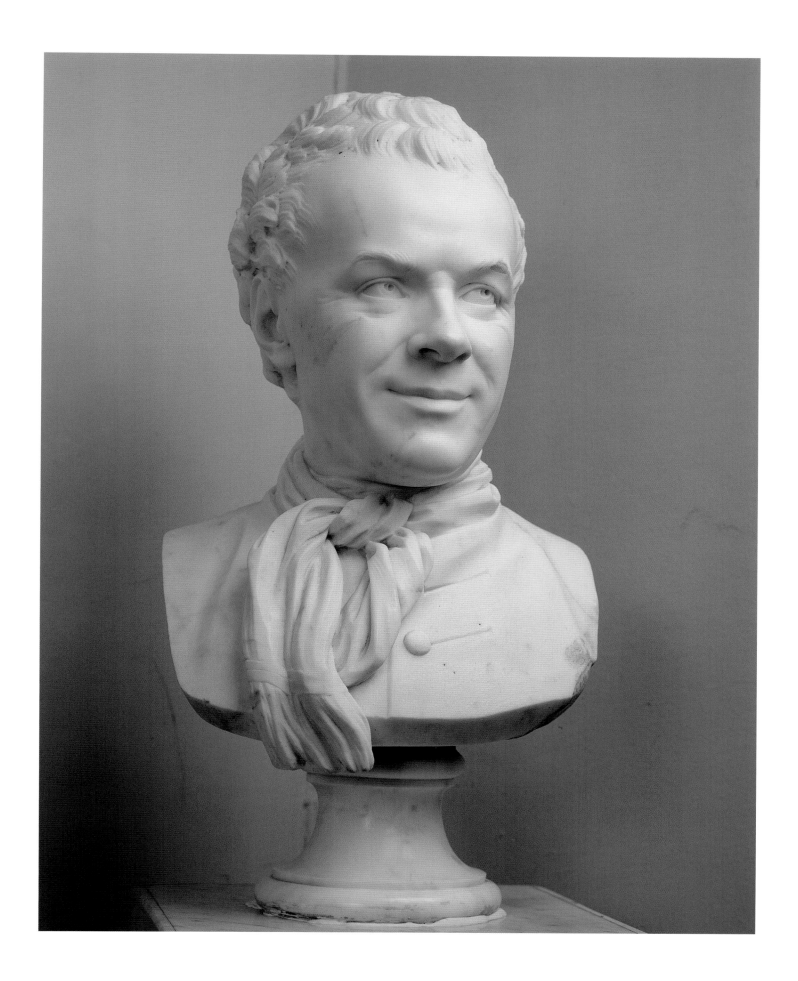

Marie-Anne COLLOT
Portrait of Henri IV

Images of Henri IV (1553–1610), King of France, were extremely popular with monarchs around the world. Catherine II herself possessed engraved images, but very much wished to obtain good busts of both Henri and his First Minister, the duc de Sully, writing to Falconet in a letter of 16 May 1768: "I am dying to see them." The empress wrote in the playful tone, full of coquetry, that is characteristic of this first period of her correspondence with the sculptor.

Falconet's reply reveals that he and Collot reacted immediately to the empress's request. Collot had at this time produced only two private commissions, in addition to busts of the empress that she had made on her own initiative, so this was essentially her first commission from the empress, possibly prompted by Falconet himself.

The extensive correspondence between Catherine and Falconet reveals many details regarding the creation of these busts, and gives us some idea of Collot's methods. When she was not working from nature, as with these portraits of historical figures, she made use of images and casts. The first stage, the production of a plaster model, did not take her long, and she captured her first creative conception within a few days.

During Catherine's reign the bust was kept in the Hermitage, and then in the Tauride Palace, from where it was transferred in 1852 to the newly opened New Hermitage, and placed in the main library along with the busts of Sully and Diderot, and other historical figures and philosophers of the ancient world. [IE]

c. 1768, marble, height 21¼ in. (54 cm), pedestal 4¾ in. (12 cm)
Inv. no. N.sk. 4
PROVENANCE Transferred to the New Hermitage from the Tauride Palace 23 May 1852
BIBLIOGRAPHY *Correspondance* 1876, pp. XIX, 37, 39, 40–42, 73; Réau 1922, p. 436; Matsulevich 1940, p. 66

P. Audouin after F. Pourbus, *Portrait of Henri IV*, engraving, State Hermitage Museum, St. Petersburg

Marie-Anne COLLOT

Portrait of the Duc de Sully

This bust of Maximilian de Béthune, duc de Sully, Baron Rosny (1560–1651), the renowned French statesman, First Minister to Henri IV, and maréchal de France, forms a pair to that of Henri IV (see p. 209). Catherine II commissioned both busts in May 1768, and the models were produced in May–June of that year. As with the portrait of Henri, Collot followed existing images, and on 9 July 1768 Falconet turned to the empress with a request: "If to all your bounties Your Majesty might add that of ordering that a print of Sully be sent, Mlle Collot shall make a study of it while she awaits the marble, since that which she thought good proved not to be so at all" (*Correspondance* 1876, p. 50).

During Catherine's reign, the bust was kept in the Hermitage and then in the Tauride Palace, from where it was transferred in 1852 to the newly opened New Hermitage, and placed in the main library along with the busts of Henri IV and other historical figures and philosophers of the ancient world. [IE]

c. 1768, marble, height 19⁵⁄₁₆ in. (49 cm), pedestal 4¾ in. (12 cm)
Inv. no. N.sk. 5
PROVENANCE Transferred to the New Hermitage from the Tauride Palace 23 May 1852
BIBLIOGRAPHY *Correspondance* 1876, pp. XIX, 37, 50, 51; Réau 1922, p. 436; Matsulevich 1940, p. 66

Marsenau after F. Pourbus, *Portrait of the Duc de Sully*, 1763, engraving, State Hermitage Museum, St. Petersburg

Endnotes

Foreword

1. W. Bruce Lincoln, *Sunlight at Midnight: St. Petersburg and the Rise of Modern Russia*, New York 2000, pp. 81–82.

Women and the Arts at the Russian Court from the Sixteenth to the Eighteenth Century

1. Historians continue to argue about the most appropriate translated terms for the country that today we know as Russia. Russian historians often use the adjective "Old Russian" (*drevnerusskii*) to refer to Russian culture up to the end of the seventeenth century, and "Muscovite" (*moskovskii*) for the political entity that was consolidated in the fifteenth century with Moscow as its capital (Muscovite ideology, rulers, and so on). The terms "pre-Petrine" and "post-Petrine" define Russian history before and after the pivotal reign of Peter I (1682–1725), which also determines the chronological limits of the term "imperial": Peter adopted the title "emperor" in 1721. British travelers in pre-Petrine Russia generally called the country Muscovy and the people Muscovites.
2. See E. Levin, *Sex and Society in the World of the Orthodox Slavs, 900–1700*, Ithaca NY 1989; J. Hubbs, *Mother Russia: the Feminine Myth in Russian Culture*, Bloomington IN 1988.
3. B.N. Floria, "Nekotorye dannye o nachale svetskogo portreta v Rossii," *Arkhiv russkoi istorii*, I, 1992, p. 139.
4. See N. Pushkareva, *Women in Russian History*, ed. and trans. E. Levin, Armonk NY 1997, pp. 100–101.
5. See, for example, J.D. Grossman, "On the Patriarchalization of the Feminine Image in Old Russian Literature and Art," *California Slavic Studies*, 11, 1980, pp. 33–70.
6. *Relation d'un voyage en Moscovie, écrite par Augustin baron de Mayerberg*, Paris 1858, pp. 144–45, 148–49. For more on this topic, see N.S. Kollmann, "The Seclusion of Elite Muscovite Women," *Russian History*, X, 1983, pp. 170–87.
7. D. Schlafly, "A Muscovite Boyarynia Faces Peter the Great's Reforms," *Canadian-American Slavic Studies*, XXXI, 1997, p. 255.
8. N. Boskovska, *Die russische Frau im 17. Jahrhundert*, Cologne 1998; I. Thyrêt, *Between God and Tsar: Religious Symbolism and the Royal Women of Muscovite Russia*, De Kalb IL 2001.
9. Thyrêt, p. 48.
10. Pushkareva, p. 100.
11. The icon is in the State Tretiakov Gallery in Moscow. For a detailed analysis, see Thyrêt, pp. 70–78.
12. B. Shifman and G. Walton, eds., *Gifts to the Tsars 1500–1700: Treasures from the Kremlin*, New York 2001, p. 159. The icon is in the Patriarch's Palace in the Moscow Kremlin.
13. Thyrêt, pp. 81–102.
14. L. Hughes, "The Moscow Armoury and Innovations in 17th-Century Muscovite Art," *Canadian-American Slavic Studies*, XIII, 1979, pp. 204–23; "The 17th-century 'Renaissance' in Russia," *History Today*, February 1980, pp. 41–45.
15. For further information on Sophia, see L. Hughes, *Sophia Regent of Russia 1657–1704*, New Haven CT and London 1990; "'Ambitious and Daring above her Sex': Tsarevna Sophia Alekseevna (1657–1704) in Foreigners' Accounts," *Oxford Slavonic Papers*, XXI, 1988, pp. 65–89; "Sophia, 'Autocrat of All the Russias.' Titles, Ritual and Eulogy in the Regency of Sophia Alekseevna (1682–89)," *Canadian Slavonic Papers*, XXVIII, 1986, pp. 266–86.
16. See A. Smith, "The Brilliant Career of Prince Golitsyn," *Harvard Ukrainian Studies*, XIX, 1995, pp. 639–54; R. Hellie, *The Economy and Material Culture of Russia 1600–1725*, Chicago 1999, pp. 571–627.
17. A.M. Panchenko, ed., *Russkaia sillabicheskaia poeziia XVII–XVIII vekov*, Leningrad 1970, p. 201.
18. L. Hughes, "'Moscow Baroque'—a Controversial Style," *Transactions of the Association of Russian-American Scholars in USA*, XV, 1982, pp. 69–93; J. Cracraft, *The Petrine Revolution in Russian Architecture*, Chicago 1990.
19. Hughes, *Sophia*, p. 243.
20. Shifman and Walton, pp. 38, 161.
21. The print illustrates the text: "It is good and seemly when two brothers rule jointly." See Hughes, *Sophia*, pp. 140–41.
22. Hughes, *Sophia*, pp. 142–44; Thyrêt, pp. 138–69.
23. Foy de la Neuville, *A Curious and New Account of Muscovy in the Year 1689*, trans. J. Cutshall, London 1994, p. 47.
24. Hughes, *Sophia*, pp. 245, 259.
25. L. Hughes, *Russia in the Age of Peter the Great*, New Haven CT and London 1998, pp. 18–19.
26. In London in 1698 Peter had a fling with the famous actress Letitia Cross. See A. Cross, "The Old Man from Cambridge, Mrs Cross, and Other Anglo-Petrine Matters of Due Weight and Substance," in L. Hughes, ed., *Peter the Great and the West: New Perspectives*, Basingstoke 2001, pp. 5–9.
27. L. Hughes, "From Caftans into Corsets: The Sartorial Transformation of Women during the Reign of Peter the Great," in P. Barta, ed., *Gender and Sexuality in Russian Civilization*, London 2001, pp. 17–32.
28. F.W. von Bergholz, *Dnevnik kammer-iunkera Berkhgol'tsa, vedennyi im v Rossii v tsarstvovanie Petra Velikogo s 1721–1725 g*, Moscow 1857, p. 101.
29. The painting is now in the State Hermitage Museum. See N.V. Kaliazina and G.N. Komelova, *Russkoe iskusstvo Petrovskoi epokhi*, Leningrad 1990, ill. 118.
30. See R.S. Wortman, *Scenarios of Power: Myth and Ceremony in Russian Monarchy*, I, Princeton NJ 1995, pp. 55–56.
31. K. Egorova, *Leningrad, House of Peter I, Summer Gardens, Palace of Peter I*, Leningrad 1975; S.O. Androsov, "Gli scultori carraresi e la Russia del Settecento," in *I marmi degli Zar: Gli scultori carraresi all'Ermitage e a Petergof*, Milan 1996, pp. 39–67.
32. G. Bolotova, *Letnii sad. Leningrad*, Leningrad 1981 p. 121.
33. A.G. Kaminskaia, "Khudozhniki Georg i Doroteia Gzel' v Peterburge," in N.V. Kaliazina, ed., *Iz istorii petrovskikh kollektsii: sbornik nauchnykh trudov*, St. Petersburg 2000, pp. 84–116.
34. Kaliazina and Komelova, ills. 21–23.
35. See O. Nesterov, "His Majesty's Cabinet and Peter I's Kunstkammer," in O. Impey and A. McGregor, eds., *The Origins of Museums: The Cabinet of Curiosities in 16th–17th-Century Europe*, Oxford 1985, pp. 54–61.
36. Kaminskaia, p. 98; J. Cracraft, *The Petrine Revolution in Russian Imagery*, Chicago 1997, pp. 202–203.
37. G.V. Vilinbakhov, ed., *Petr I i Gollandiia: russko-gollandskie khudozhestvennye i nauchnye sviazi*, St. Petersburg 1996, pp. 58–59.
38. N.V. Kaliazina and I.V. Saverkina, "Zhivopisnoe sobranie A. D. Menshikova," *Russkaia kul'tura pervoi chetverti XVIII veka: Dvorets Menshikova*, St. Petersburg 1992, pp. 54–61.
39. F.C. Weber, *The Present State of Russia*, I [London 1723], reprint, New York 1968, p. 149.
40. M.O. Blamberg, "The Publicists of Peter the Great," unpublished PhD diss., Indiana University 1974, p. 175; F. Saltykov, "Iz'iavleniia pribytochnye gosudarstvu (1714)," in N. Pavlov-Silvansky, *Proekty reform v zapiskakh sovremennikov Petra Velikogo*, St. Petersburg 1897, p. 9.
41. I.A. Shliapkin, "Tsarevna Natal'ia Alekseevna i teatr ee vremeni," *Pamiatniki drevnei pismennosti*, CXXV–II, St. Petersburg 1898; L. Hughes, "Between Two Worlds: Tsarevna Natal'ia Alekseevna and the 'Emancipation' of Petrine Women," in L. Hughes and M. di Salvo, eds., *A Window on Russia: Papers from the Fifth International Conference of the Study Group on Eighteenth-Century Russia*, Rome 1996, pp. 29–36; *Delo o pozhitkakh*

gosudaryni Natalii Alekseevny, Moscow 1914.

42. *Delo o pozhitkakh,* pp. 113–15.

43. For examples of the repertoire, see *P'esy stolichnykh i provintsial'nykh teatrov pervoi poloviny XVIII v.,* Moscow 1975.

44. E.D. Kukushkina, "Tekst i izobrazhenie v konkliuzii Petrovskogo vremeni (na primere portreta tsarevny Natalii Alekseevny)," *XVIII vek,* XV, 1986, pp. 21–36.

45. See L. Hughes, "'The Crown of Maidenly Honour and Virtue': Redefining Femininity in Peter I's Russia," in W. Rosslyn, ed., *Women and Gender in Eighteenth-Century Russia,* London 2002; and P. Roosevelt, *Life on the Russian Country Estate: A Social and Cultural History,* New Haven CT and London 1997, pp. 107–108.

46. C. de Bruyn, *Travels into Muscovy, Persia, and Part of the East Indies; containing an Accurate Description of what is most remarkable in those Countries,* I, London 1737, p. 30.

47. Weber, I, pp. 27, 147–49.

48. F.W. von Bergholz, *Dnevnik kammer-iunkera Berkhgol'tsa, vedennyi im v Rossii v tsarstvovanie Petra Velikogo s 1721–1725 g,* 3rd edn, IV, Moscow 1902–03, p. 43.

49. Wortman, I, p. 81.

50. Thanks to Prof. Gary Marker, State University of New York at Stony Brook, for information on the Order of St. Catherine.

51. On Anna, see E.V. Anisimov, "Anna Ivanovna," *Russian Studies in History,* XXXII, 1994, pp. 8–38.

52. J. Keith, *A Fragment of a Memoir of James Keith written by Himself, 1714–1734,* Edinburgh 1843, p. 54.

53. Denis Fonvizin, quoted in E. Anisimov, *Empress Elizabeth: Her Reign and Her Russia,* ed. and trans. J.T. Alexander, Gulf Breeze FL 1995, p. 186.

54. Cracraft, *Imagery,* p. 246.

55. M.M. Shcherbatov, *On the Corruption of Morals in Russia,* ed. and trans. A. Lentin, Oxford 1969, pp. 145–47.

56. *Karamzin's Memoir on Ancient and Modern Russia,* ed. R. Pipes, New York 1966, p. 123.

57. *Treasures of Catherine the Great,* ed. N. Guseva and C. Phillips, London, Hermitage Rooms at Somerset House, 2000, cat. entry 30, p. 12.

58. On Catherine as collector, see R.P. Gray, *Russian Genre Painting in the Nineteenth Century,* Oxford 2000, pp. 14–19; G. Norman, *The*

Hermitage: The Biography of a Great Museum, London 1997, pp. 21–46.

59. Locations of works cited: Grooth, Eriksen, Roslin, Shibanov: State Hermitage Museum, St. Petersburg; Borovikovsky: State Tretiakov Gallery, Moscow; Levitsky: State Russian Museum, St. Petersburg.

60. M.L. Marrese, *A Woman's Kingdom: Noblewomen and the Control of Property in Russia, 1700–1861,* Ithaca NY 2002, p. 214.

61. See C. Kelly, ed. and trans., *An Anthology of Russian Women's Writing, 1777–1992,* Oxford and New York 1994; C.D. Tomei, ed., *Russian Women Writers,* New York 1999; W. Rosslyn, *Feats of Agreeable Usefulness: Translations by Russian Women 1763–1825,* Fichtenwalde 2000.

62. *The Memoirs of Princess Dashkova,* ed. and trans. K. Fitzlyon, intro. J.M. Gheith, Durham NC and London 1995, p. 140.

63. On Kovaleva, see Pushkareva, pp. 150–53; W. Rosslyn, "Female Employees in the Russian Imperial Theatres (1785–1825)," in Rosslyn, ed., *Women and Gender,* pp. 265–85. On genre painting, see Gray.

64. I. de Madariaga, *Russia in the Age of Catherine the Great,* London 1981, p. 30.

65. I.E. Grabar, ed., *Istoriia russkogo iskusstva,* V, Moscow 1960, p. 368, note 3.

66. *Istoricheskoe opisanie pervostol'nogo v Rossii khrama moskovskogo bol'shogo Uspenskogo sobora, protoiereem Aleksandr[om] Georgievym Levshinim,* Moscow 1783, supplement, pp. 5–6.

A Century of Women Painters, Sculptors, and Patrons from the Time of Catherine the Great

I would like to thank Professor Barbara Alpern Engel of the University of Colorado, Elena Nesterova, Raia Dashkina, and Elena Stolbova of the State Russian Museum, Marta Kryzhanovskaia, Elizaveta Renne, Maria Garlova, and Tatiana Bushmina of the State Hermitage Museum, and Patrick Blakesley for their help with this essay.

1. V.V. Stasov, "Tri frantsuzskikh skul'ptora v Rossii (XVIII stol.)," *Drevniaia i novaia Rossiia,* I–IV, 1877, p. 345.

2. *Sbornik Imperatorskogo russkogo istoricheskogo obshchestva,* XVII, 1771, pp. 27, 128, 175, 236, 245: quoted in Stasov, p. 345.

3. A.I. Somov, "Zhenshchiny khudozhnitsy," *Vestnik iziashchnykh iskusstv,* I, no. 3, 1883, p. 512.

4. N. Moleva and E. Beliutin, *Russkaia khudozhestvennaia shkola pervoi poloviny XIX veka,* Moscow 1963, p. 140.

5. The Smolny Institute, officially called the Imperial Society for the Education of Well-Born Young Women, was founded in 1764.

6. See P. Hunter-Stiebel, ed., *Stroganoff: the Palace and Collections of a Russian Noble Family,* New York 2000, pp. 225–26.

7. For Vigée-Lebrun's account of receiving this award, which she claimed was "one of the sweetest memories I have retained throughout all my travels," see *The Memoirs of Elisabeth Vigée-Le Brun,* trans. S. Evans, London 1989, p. 211.

8. "No-one wore shawls then, but I liked to drape my models with large scarves, interlacing them around the body and through the arms, which was an attempt to imitate the beautiful style of draperies seen in the paintings of Raphael and Dominichino. Examples of this can be seen in several of the portraits I painted whilst in Russia; in particular one of my daughter playing the guitar." *The Memoirs of Elisabeth Vigée-Le Brun,* p. 27.

9. N. Pushkareva, *Women in Russian History,* ed. and trans. E. Levin, Armonk NY 1997, p. 242.

10. S.N. Kondakov, *Iubileinyi spravochnik Imperatorskoi Akademii khudozhestv, 1764–1914,* I, St. Petersburg 1914, p. 88. For other women who endowed prizes at the Academy, see pp. 90–93.

11. For the death in childbirth of Paul's first wife, Natalia Alekseevna, and Paul's reaction to it, see R.E. McGrew, *Paul I of Russia, 1754–1801,* Oxford 1992, pp. 91–95.

12. For Catherine's hope that the journey would help effect a rapprochement between Russia and Austria, see McGrew, pp. 112–14. For the significance of the tour for Paul, see McGrew, pp. 116–42.

13. *Zapiski N.A. Sablukova: Tsareubiistvo 11 marta 1801 goda,* St. Petersburg 1907, p. 12: quoted in A.N. Guzanov, "Khudozhestvennye kollektsii Pavlovskogo dvortsa i puteshestvie grafa i grafini Severnykh," in

I.E. Danilova, ed., *Chastnoe kollektsionirovanie v Rossii,* XXVII, Moscow 1995, p. 65.

14. Following the destruction at Pavlovsk during the Second World War, only one of these, *View of Rome from the park of the Villa Conti in Frascati* (1789), survives.

15. For this commission, and Maria Fedorovna's copies of Kauffman's paintings, see N. Stadnichuk, "Angelika Kaufman i Pavlovsk," in Iu. V. Mudrov, ed., *Pavlovsk, imperatorskii dvorets: stranitsy istorii,* St. Petersburg 1997, pp. 347–53. Paul and Maria also bought a third painting from Kauffman, *The Death of Leonardo da Vinci* (private collection, St. Petersburg).

16. Various sources state that it was Marie-Antoinette who presented the dressing set, but it was officially a gift from the king. For this and the Russians' purchases at the Sèvres manufactory, see P. Ennès, "The Visit of the Comte and Comtesse du Nord to the Sèvres Manufactory," *Apollo,* March 1989, pp. 150–56.

17. Baron von Grimm also mentions the imperial couple visiting the studios of Jean-Antoine Houdon and Jean-Baptiste Greuze, by whom there were several paintings in the Pavlovsk collection that may have been bought or commissioned at this time. Guzanov, "Khudozhestvennye kollektsii Pavlovskogo dvortsa," pp. 71–72.

18. S.V. Mironenko and N.S. Tretiakov, eds., *Imperatritsa Mariia Fedorovna,* St. Petersburg 2000, p. 38.

19. See correspondence cited in Guzanov, "Khudozhestvennye kollektsii Pavlovskogo dvortsa," p. 68 and p. 75, note 21; and S. Massie, *Pavlovsk: the Life of a Russian Palace,* London 1990, pp. 29–34.

20. See A. Guzanov, "Andrei Voronikhin," in Hunter-Stiebel, ed., p. 178. For Voronikhin's work at Pavlovsk, see Guzanov, "Andrei Voronikhin," pp. 177–85; and Massie, pp. 68–76.

21. Stadnichuk, p. 350.

22. Letter from F. Lafermière to Prince S.R. Vorontsov, in *Arkhiv Kn. Vorontsova,* book XXIX, p. 281: quoted in D.F. Kobeko, "Imperatritsa Mariia Fedorovna, kak khudozhnitsa i liubitel'nitsa iskusstv," *Vestnik iziashchnykh iskusstv,* II, no. 6, 1884, p. 402.

23. Cited in Massie, pp. 51–52.

24. A. Odom and L.P. Arend, *A Taste for Splendor: Russian Imperial and European Treasures from the Hillwood Museum*, Alexandria VA 1998, p. 142. For copies made by Wedgwood of this and other cameos by Maria Fedorovna, see G.B. Andreeva, ed., *Nezabyvaemaia Rossiia: russkie i Rossiia glazami britantsev XVII–XIX vek*, Moscow 1997, pp. 78–79.

25. See A. Vasileva, "Velikaia kniaginia Mariia Fedorovna—khudozhnitsa," in Mudrov, ed., p. 336.

26. Lampi worked in Russia from 1792 to 1797.

27. See R. Wortman, "The Russian Empress as Mother," in D.L. Ransel, ed., *The Family in Imperial Russia: New Lines of Historical Research*, Urbana IL and London 1978, pp. 60–63; and R.S. Wortman, *Scenarios of Power: Myth and Ceremony in Russian Monarchy*, I, Princeton NJ 1995, p. 250.

28. McGrew, pp. 95–96. For Maria Fedorovna's role in promoting family loyalty and marital love as part of the public image of the imperial family, see Wortman, *Scenarios of Power*, I, pp. 250–54.

29. In 1828, the year of Maria Fedorovna's death, the government established the Department of the Institutions of Empress Maria to manage the schools and charitable institutions that she had founded or sponsored. See A. Lindenmeyr, *Poverty is Not a Vice: Charity, Society, and the State in Imperial Russia*, Princeton NJ 1996, p. 75.

30. Quoted in B.A. Engel, *Mothers and Daughters: Women of the Intelligentsia in Nineteenth-Century Russia*, Cambridge 1985, p. 24.

31. Kauffman mentioned that she was working on a painting for Catherine in a letter to Yusupov of 5 April 1788: see L. Iu. Savinskaia, "Russkie kollektsionery zapadnoevropeiskoi zhivopisi 1780-kh godov. Vkus i stil'," in Danilova, ed., pp. 59–60. The painting's current location is unknown. For Kauffman's other Russian patrons, see Savinskaia, p. 59.

32. Savinskaia, p. 59. The current location is known for only one of these, *Seated Cupid*, which is in the A.N. Radishchev Art Museum in Saratov.

33. Walker traveled to Russia in 1784, and was appointed an imperial engraver the following year. In 1786 he was made an associate of the Imperial Academy of Arts, where he taught mezzotint engraving, and in 1794 he was appointed an Academician and councilor. See A. Bird, "James Walker: a British Engraver in St. Petersburg," in B. Allen and L. Dukelskaya, eds., *British Art Treasures from Russian Imperial Collections in the Hermitage*, New Haven CT and London 1996, pp. 92–103; and D. Alexander, "James Walker: a British Engraver in Russia," *Print Quarterly*, XII, 1995, pp. 412–14.

34. Until the accession of Alexander II in 1855, women's opportunities for secondary education were very limited. Some of the wealthier noble families employed foreign tutors, while lesser gentry and officials had the option of sending their daughters to élite boarding schools. These included private *pansiony* (based on the French *pensionnat*), and the institutes of the Fourth Department, which managed the charitable and educational institutions set up by Maria Fedorovna. There were twenty-five of these by the mid-nineteenth century. See C. Johanson, *The Women's Struggle for Higher Education in Russia, 1855–1900*, Kingston, Ontario, and Montreal 1987, p. 3. There were 2007 girls attending school in 1802, and 4864 were enrolled in the institutes of the Fourth Department in 1834. See Engel, p. 27.

35. See Kondakov, I, pp. 155–62.

36. Paul I implemented a succession law whereby the throne passed to the eldest son through the male line, which essentially barred women from the Russian throne.

37. P.N. Petrov, *Sbornik materialov dlia istorii Imperatorskoi S-Peterburgskoi Akademii khudozhestv za sto let ee sushchestvovaniia*, I, St. Petersburg 1864, p. 415.

38. Kondakov, II, p. 69.

39. P.N. Petrov, *Sbornik materialov dlia istorii Imperatorskoi S-Peterburgskoi Akademii khudozhestv za sto let ee sushchestvovaniia*, II, St. Petersburg 1865, p. 36.

40. Petrov, II, p. 68.

41. Petrov, I, pp. 351–52.

42. Petrov, II, pp. 68–69, 77.

43. Petrov, II, pp. 150, 159–60.

44. L.A. Markina, "Woman Artists in Russia from the Baroque to the Modern," in *Femme Art: Women Painting in Russia XV–XX Centuries*, Moscow 2002, p. 57.

45. M.P. Botkin, ed., *Aleksandr Andreevich Ivanov: ego zhizn' i perepiska 1806–1858 gg.*, St. Petersburg 1880, p. 138.

46. Botkin, ed., p. 98.

47. The merchant estate in imperial Russia was divided into various guilds (*gil'dy*), membership of which depended on occupation, wealth, and trading rights. For Peter I's division of the merchants into two guilds, and Catherine the Great's later creation of a third guild, see A.F. Rieber, *Merchants and Entrepreneurs in Imperial Russia*, Chapel Hill NC 1982, pp. 3–12. Kurt's marital status is noted at the top of her letter of application to the Academy: Russian State Historical Archive, St. Petersburg (henceforth RGIA), fund 789, *opis'* 14, *delo* 110-K, f. 1.

48. RGIA, fund 789, *opis'* 14, *delo* 110-K, f. 1.

49. RGIA, fund 789, *opis'* 14, *delo* 110-K, ff. 6–8.

50. See M. Fairweather, *Pilgrim Princess: a Life of Princess Zinaida Volkonsky*, London 1999, p. 29.

51. For Zinaida's salon in Moscow, see Fairweather, pp. 194–215.

52. For an early appreciation of the Villa Volkonsky, see O.I. Buslaev, "Rimskaia villa kn. Z.A. Volkonskoi," *Vestnik Evropy*, I, January 1896, pp. 18–32. The young sculptor Samuil Galberg described the informal hospitality and light-hearted entertainment that Russian artists found there in a letter to his brothers of 30 May 1821. S.I. Galberg, "Skul'ptor Samuil Ivanovich Galberg v ego zagranichnykh pis'makh i zapiskakh, 1818–28," *Vestnik iziashchnykh iskusstv*, II, no. 5, 1884, pp. 124–25.

53. Cited in Fairweather, p. 230.

54. Z.A. Volkonskaia, "Proekt Esteticheskogo muzeia pri Imperatorskom Moskovskom universiteta," *Teleskop*, III, 1831, pp. 387–88.

55. Volkonskaia, pp. 396–99.

56. I. Tsvetaev, "Pamiati kniagini Z.A. Volkonskoi," *Moskovskie vedomosti*, LXXXIIII, 1898, p. 4.

57. These included Prince Dmitry Vladimirovich Golitsyn, the Moscow governor general and a member of the family that had been responsible for the first public art museum in Russia. For Volkonskaia's letter to Golitsyn, see Tsvetaev, p. 4. For the Golitsyn museum, see R.P. Gray, "The Golitsyn and Kushelev-Bezborodko Collections and their Role in the Evolution of Public Art Galleries in Russia," *Oxford Slavonic Papers*, NS XXXI, 1998, pp. 51–67.

58. Quoted in N. Belozerskaia, "Kniaginia Zinaida Aleksandrovna Volkonskaia," *Istoricheskii vestnik*, LXVIII, April 1897, pp. 144–45.

59. Prince Nikita Volkonsky wrote in a letter of 2 April 1830 to Stepan Shevyrev, his son's tutor in Rome, that the museum project was "a noble, delightful and grand idea, but you have not specified your means for achieving this aim." It would, he added, cost more than 5000 rubles for the first stage of the project alone. Quoted in Belozerskaia, p. 143.

60. For the Rumiantsev Museum, see R.P. Gray, *Russian Genre Painting in the Nineteenth Century*, Oxford 2000, pp. 38–40.

61. The Pushkin Museum of Fine Arts, the major museum of non-Russian art in Moscow, opened in 1912 with casts of Classical and Renaissance sculpture as well as original works of art. Ivan Tsvetaev, father of the famous poet Marina Tsvetaeva and the guiding light behind the museum, paid tribute to the princess as the originator of the idea in 1898. See Tsvetaev, pp. 3–4.

62. For Venetsianov's school, see T.V. Alekseeva, *Khudozhniki shkoly Venetsianova*, Moscow 1982. For Nadezhin's school, see Moleva and Beliutin, *Russkaia khudozhestvennaia shkola pervoi poloviny XIX veka*, pp. 310–15. Alexandra Venetsianova left a valuable account of her father's activities. See A.A. Venetsianova, "Zapiski," in A.V. Kornilova, ed., *Aleksei Gavrilovich Venetsianov: stat'i, pis'ma, sovremenniki o khudozhnike*, Leningrad 1980, pp. 214–36.

63. Moleva and Beliutin, *Russkaia khudozhestvennaia shkola pervoi poloviny XIX veka*, p. 382.

64. P.N. Petrov, *Sbornik materialov dlia istorii Imperatorskoi S-Peterburgskoi Akademii khudozhestv za sto let ee sushchestvovaniia*, III, St. Petersburg 1866, p. 251.

65. Petrov, III, p. 137. Klevetskaia had been made a Non-class Artist in 1838.

66. Petrov, III, p. 164.

67. Petrov, III, p. 181. For Baltius and Sordet's correspondence with the Academy concerning these awards, see RGIA, fund 789, *opis'* 14, *delo* 140-B, and *delo* 146-S.

68. RGIA, fund 789, *opis'* 14, *delo* 90-Sh, f. 1.

69. Petrov, III, p. 184.

70. RGIA, fund 789, *opis'* 14, *delo* 72-L, ff. 1–2.

71. RGIA, fund 789, *opis'* 14, *delo* 72-L, f. 4.

72. Sukhovo-Kobylina had already won a second-class silver medal in 1849, a first-class silver medal in 1851, and a second-class gold medal in 1853. Petrov, III, pp. 110, 165, 204–205.

73. The fact that Sukhovo-Kobylina traveled at her own expense is documented in *Opisanie obshchago sobraniia Imperatorskoi Akademii khudozhestv, byvshago 17-go marta 1857, i otchet Akademii s 4-go oktiabria 1855 po 17-e marta 1857 goda*, St. Petersburg 1857, pp. 12–13.

74. Ekaterina Yunge wrote in her memoirs that, although she had not heard of the "women's question," or *zhenskii vopros*, at the time, she was delighted that a woman had been honored in this way. E.F. Yunge, *Vospominaniia*, Moscow 1914, p. 57: quoted in *Femme Art*, p. 79. Sukhovo-Kobylina was unusual in inviting foreign artists to her studio, as her compatriots tended to socialize only with other Russians. See the letters of the painter Mikhail Skotti to the sculptor Nikolai Ramazanov, quoted in Markina, pp. 59–60.

75. Petrov, III, p. 280.

76. Markina, p. 59. For one of Hagen-Schwartz's few works in Russia, *Young Italian with a Pistol in his Hand* (State Tretiakov Gallery, Moscow), see *Femme Art*, p. 85.

77. For the arrival of European artists and forms of imagery in Russia in the eighteenth century, see J. Cracraft, *The Petrine Revolution in Russian Imagery*, Chicago 1997. The continuing preference of certain imperial and aristocratic patrons for Western European artists in the nineteenth century applied as much to men as to women. Nicholas I, for example, favored the German artist Franz Krüger. See B.I. Asvarishch, *"Sovershenno modnyi zhivopisets": Frants Kriuger v Peterburge*, St. Petersburg 1997.

78. This figure is taken from the records compiled by Sergei Kondakov in 1914, which are not exhaustive. See Kondakov, I, pp. 306–25, and II, pp. 8–233.

79. For these and other revisions to the Academy's statutes during the reign of Nicholas I, see E.K. Valkenier,

Russian Realist Art, the State and Society: the Peredvizhniki and their Tradition, New York 1989, pp. 4–7.

80. See Johanson, p. 26.

81. For the sketchbook that Maria kept from 1826 to 1830 (private collection, USA), see Z. Belyakova, *Grand Duchess Maria Nikolayevna and her Palace in St. Petersburg*, St. Petersburg 1994, pp. 20–21.

82. The Leuchtenberg collection was initiated by Maximilian's grand-parents, Josephine (later the wife of Napoleon) and her first husband, Viscount Alexandre de Beauharnais. For its history, see Gray, *Russian Genre Painting*, pp. 31–34. In St. Petersburg, the collection was housed in the Mariinsky Palace on St. Isaac's Square, which was commissioned for the imperial couple from the architect Andrei Stakenschneider in 1839.

83. The imperial couple regularly visited the Academy's annual exhibitions, from which they acquired works of art. See Petrov, III, p. 55.

84. See Petrov, III, p. 312.

85. Valkenier, p. 8.

86. Kondakov, I, pp. 44, 47.

87. For the reforms of 1859, see V.G. Lisovsky, *Akademiia khudozhestv: istoriko-iskusstvovedcheskii ocherk*, Leningrad 1982, pp. 105–108.

88. *Sbornik postanovlenii Soveta Imperatorskoi Akademii khudozhestv po khudozhestvennoi i uchebnoi chasti s 1859 po 1890 god*, St. Petersburg 1890, p. 181. The date is wrongly given as 1871 in A. Novitsky, *Istoriia russkogo iskusstva*, II, Moscow 1903, p. 517.

89. For the two different categories of school (known from 1870 as gymnasia and pro-gymnasia), see Engel, pp. 50–51; R. Stites, *The Women's Liberation Movement in Russia: Feminism, Nihilism, and Bolshevism, 1860–1930*, Princeton NJ 1978, pp. 51–52; and Johanson, pp. 29–32. For the first women auditors at university courses, see Johanson, pp. 17–19.

90. In 1861 the government expelled women auditors from universities in a decision ratified in 1863, despite the fact that the universities of St. Petersburg, Kharkov, Kazan, and Kiev had all voted in favor of admitting women students (only Moscow and Dorpat universities dissented). In 1864 the St. Petersburg Medical-Surgical Academy, Russia's most prestigious

medical school, also closed its doors to women students after admitting them for just three years. Finally, in 1869, the government rejected a petition signed by 396 women for university-level courses. See Stites, pp. 53–56; and Johanson, pp. 19–23.

91. For the preparatory courses (known as the Alarchin courses in St. Petersburg and the Lubianka courses in Moscow) and the evening lectures (the so-called Vladimir courses), see Johanson, pp. 38–41, 42–47, 59–76. V.I. Guerrier, a historian at Moscow University, also established the Guerrier courses for women in Moscow in 1872, which offered two and later three years of further education. See Johanson, pp. 48–50; and Stites, pp. 81–82.

92. N. Dmitrieva, *Moskovskoe uchilishche zhivopisi, vaianiia i zodchestva*, Moscow 1951, p. 109.

93. *Sbornik postanovlenii*, p. 181.

94. Minutes of the Academy Council meeting of 27 February 1876: *Sbornik postanovlenii*, pp. 181–82. These minutes record the Council's opinion that the Academy would attract even more female applicants "once they find out that a separate section of women's classes has been established."

95. *Sbornik postanovlenii*, p. 223.

96. See Stites, pp. 168–69; and Johanson, pp. 95–103. The courses in St. Petersburg, known as the Bestuzhev courses, reopened in 1889.

97. Kondakov, II, pp. 8–233.

98. For Bashkirtseff's career, see *Marie Bashkirtseff, 1858–1884: Peintre et Sculpteur, Ecrivain et Témoin de Son Temps*, Nice 1995; and M. Bashkirtseff, *The Journal of Marie Bashkirtseff*, trans. M. Blind, London 1985.

99. For Ivanova-Raevskaia's Academy records, see RGIA, fund 789, *opis'* 14, *delo* 1-I. For her school, see Kondakov, I, pp. 238–42; and N. Moleva and E. Beliutin, *Russkaia khudozhestvennaia shkola vtoroi poloviny XIX-nachala XX veka*, Moscow 1967, pp. 153–54.

100. For the institutions where women could receive an artistic education in the last third of the nineteenth century, see Novitsky, pp. 518–19.

"Brilliant Proof of the Creative Abilities of Women": Marie-Anne Collot in Russia

1. A.L. Kaganovich, *"Mednyi vsadnik." Istoriia sozdaniia monumenta*, Leningrad 1982, p. 42.

2. D. Diderot, *Salons* [1765, 1767], Texte établi et présenté par J. Seznec et J. Adhemar, IV, Oxford 1957–67, p. 212.

3. *Correspondance Littéraire, philosophique et critique par Grimm, Diderot, Raynal, Meister, etc., revue sur les texts originaux*, VII, Paris 1879, p. 107.

4. "Perepiska imperatritsi Ekateriny II s Fal'konetom," in *Sbornik Imperatorskogo russkogo istoricheskogo obshchestva*, XVII, 1876, p. 128–29.

5. "Perepiska imperatritsi Ekateriny II s Fal'konetom," in *Sbornik Imperatorskogo russkogo istoricheskogo obshchestva*, XVII, 1876, p. 374.

6. I. von Stählin, *Zapiski Iakoba Shtelina ob iziashchnykh iskusstvakh v Rossii*, 2 vols., Moscow 1990, I, p. 183.

7. Russian State Historical Archive, St. Petersburg, fund 468, *opis'* 1, *delo* 3882, f. 7.

8. Stählin, I, p. 152.

9. *"J'aime bien que le cœur ait exécuté ce que le talent seul n'aurait su faire."* Diderot, *Salons*, IV, p. 116.

10. "Perepiska imperatritsi Ekateriny II s Fal'konetom," in *Sbornik Imperatorskogo russkogo istoricheskogo obshchestva*, XVII, 1876, p. 65.

11. *"Je crois M-lle Collot bien fachée contre moi de ce que le rossignol que je lui ai promis n'est pas venu encore, mais je lui tiendrai parole."* "Perepiska imperatritsi Ekateriny II s Fal'konetom," p. 41. It is not clear from the correspondence if *"le rossignol"* should be translated as a nightingale or a trinket.

12. V.V. Stasov, "Tri frantsuzskikh skul'ptora v Rossii (XVIII stol.)," *Drevniaia i novaia Rossiia*, I–IV, 1877, p. 345.

13. "Perepiska imperatritsi Ekateriny II s Fal'konetom," p. 243.

14. Stasov, p. 346.

Bridging Two Empires:
Christina Robertson and the
Court of St. Petersburg

1. In March 1823 a daughter was born to Christina and James Robertson, Agnes (1823–1860), who in Russia married Count Ponkin, an officer of the Engineering Troops of the Russian army who was killed at Kronstadt during the Crimean War. Four other children—Christina (17 May – 11 September 1824), James (20 April 1825 – 22 December 1826), Christina (16 March 1828), and William (18 November – 19 December 1829)—died within their first two years. Three more children lived to old age: two sons, John (born 21 May 1826) and William (born 25 November 1830), both died in the early twentieth century in Australia, while Robertson's daughter Mary (born 28 March 1833) married J.M. Stuart of the London Westminster Bank (Hodgson on Christina Robertson in *Notes and Queries*, London, series 10, V, April 1906, p. 304). The children's dates were kindly provided by Mr. Alan Bird.

2. The text of the diploma she received, now in the possession of Ian Robertson (UK), one of Christina Robertson's descendants.

3. *The Spectator*, CCLIV, May 1833, p. 432.

4. *The Athenaeum*, 1834, p. 355.

5. Christina Robertson, Account Book 1822–1842, National Art Library, Victoria and Albert Museum, London, MS.L.1344-1940.

6. This watercolor is reproduced in C. Gere, *Nineteenth Century Interiors. An Album of Watercolours*, London 1992, p. 150.

7. [P.P. Kamensky] "Vystavka russkikh khudozhestvennykh proizvedenii v Sankt-Peterburge i Rime 1839," *Biblioteka dlia chteniia*, XXXVII, section II, 1839, pp. 53–54.

8. *The Art Union*, 1839, p. 101.

9. Baird's first steamer was launched in 1815.

10. P. Svinin, *Dostopamiatnosti Sankt Peterburga i ego okrestnostei*, St. Petersburg 1997, p. 307.

11. R. Harrison, *Notes of a Nine Years' Residence in Russia, from 1844 to 1853 with notice of the tzars Nicholas I and Alexander II*, London 1855, pp. 41–42.

12. C.C. Frankland, *Narrative of a Visit to the Courts of Russia and Sweden, in the years 1830 and 1831*, I, London 1832, p. 163.

13. Harrison, p. 112.

14. See also A.G. Cross, "Early Miss Emmies: British Nannies, Governesses and Companions in Pre-Emancipation Russia," in *New Zealand Slavonic Journal*, 1 (1981), pp. 1–2.

15. Russian State Historical Archive, St. Petersburg (henceforth RGIA), fund 468, *opis'* 1, *delo* 733 (1850), *opis'* 3, *delo* 162 (1850), *delo* 189 (1851), *delo* 466 (1855).

16. RGIA, fund 472, *opis'* 1, *delo* 668.

17. RGIA, fund 472, *opis'* 1, *delo* 169.

18. G. Bloomfield, *Reminiscences of Court and Diplomatic Life*, Leipzig 1883, p. 126.

19. RGIA, fund 472, *opis'* 17, *delo* 10, f. 31.

20. Letter dated 2 December 1840. RGIA, fund 472, *opis'* 17, *delo* 10, f. 3.

21. [Lady Eastlake] *Letters from the Shores of the Baltic*, London 1849, p. 158.

22. Russian State Archive of Literature and Art, Moscow (henceforth RGALI), fund 894, *opis'* 1, *delo* 14.

23. For further information on Utkin, see G.A. Printseva, *Nikolai Ivanovich Utkin, 1780–1863*, Leningrad 1983.

24. RGALI, fund 894, *opis'* 1, *delo* 16.

25. *The Art Union*, IX, 1847, p. 81.

26. This cost the court office 2 rubles 30 kopecks per day. RGALI, fund 472, *opis'* 17, *delo* 10, f. 46.

27. RGIA, fund 472, *opis'* 17, *delo* 10, f. 43.

28. RGIA, fund 472, *opis'* 17, *delo* 10, f. 48.

Selected Bibliography

ESSAYS

T.V. Alekseeva, *Khudozhniki shkoly Venetsianova*, Moscow 1982

B. Allen and L. Dukelskaya, eds., *British Art Treasures from Russian Imperial Collections in the Hermitage*, New Haven CT and London 1996

G.B. Andreeva, ed., *Nezabyvaemaia Rossiia: russkie i Rossiia glazami britantsev XVII–XIX vek*, Moscow 1997

E. Anisimov, *Empress Elizabeth: Her Reign and Her Russia*, ed. and trans. J.T. Alexander, Gulf Breeze FL 1995

P. Barta, ed., *Gender and Sexuality in Russian Civilization*, London 2001

M. Bashkirtseff, *The Journal of Marie Bashkirtseff*, trans. M. Blind, London 1985

Z. Belyakova, *Grand Duchess Maria Nikolayevna and her Palace in St. Petersburg*, St. Petersburg 1994

G. Bloomfield, *Reminiscences of Court and Diplomatic Life*, Leipzig 1883

G. Bolotova, *Letnii sad. Leningrad*, Leningrad 1981

N. Boskovska, *Die russische Frau im 17. Jahrhundert*, Cologne 1998

C. de Bruyn, *Travels into Muscovy, Persia, and Part of the East Indies; containing an Accurate Description of what is most remarkable in those Countries*, 2 vols., London 1737

B.E. Clements, B.A. Engel, and C.D. Worobec, eds., *Russia's Women: Accommodation, Resistance, Transformation*, Berkeley CA 1991

Correspondance Littéraire, philosophique et critique par Grimm, Diderot, Raynal, Meister, etc., revue sur les texts originaux, VII, Paris 1879

J. Cracraft, *The Petrine Revolution in Russian Architecture*, Chicago 1990

— *The Petrine Revolution in Russian Imagery*, Chicago 1997

I.E. Danilova, ed., *Chastnoe kollektsionirovanie v Rossii*, no. XXVII, Moscow 1995

D. Diderot, *Salons*, Texte établi et présenté par J. Seznec et J. Adhemar, 4 vols., Oxford 1957–67

N. Dmitrieva, *Moskovskoe uchilishche zhivopisi, vaianiia i zodchestva*, Moscow 1951

K. Egorova, *Leningrad, House of Peter I, Summer Gardens, Palace of Peter I*, Leningrad 1975

B.A. Engel, *Mothers and Daughters: Women of the Intelligentsia in Nineteenth-Century Russia*, Cambridge 1985

M. Fairweather, *Pilgrim Princess: a Life of Princess Zinaida Volkonsky*, London 1999

Femme Art: Women Painting in Russia XV–XX Centuries, Moscow 2002

C.C. Frankland, *Narrative of a Visit to the Courts of Russia and Sweden, in the years 1830 and 1831*, I, London 1832

C. Gere, *Nineteenth Century Interiors: An Album of Watercolours*, London 1992

H. Goscilo and B. Holmgren, eds., *Russia, Women, Culture*, Bloomington IN 1996

R.P. Gray, *Russian Genre Painting in the Nineteenth Century*, Oxford 2000

N. Guseva and C. Phillips, eds., *Treasures of Catherine the Great*, London, Hermitage Rooms at Somerset House, 2000

R. Harrison, *Notes of a Nine Years' Residence in Russia, from 1844 to 1853 with notice of the tzars Nicholas I and Alexander II*, London 1855

R. Hellie, *The Economy and Material Culture of Russia 1600–1725*, Chicago 1999

J. Hubbs, *Mother Russia: the Feminine Myth in Russian Culture*, Bloomington IN 1988

L. Hughes, *Sophia Regent of Russia 1657–1704*, New Haven CT and London 1990

— *Russia in the Age of Peter the Great*, New Haven CT and London 1998

— ed., *Peter the Great and the West: New Perspectives*, Basingstoke 2001

— and M. di Salvo, eds., *A Window on Russia: Papers from the Fifth International Conference of the Study Group on Eighteenth-Century Russia*, Rome 1996

P. Hunter-Stiebel, ed., *Stroganoff: the Palace and Collections of a Russian Noble Family*, New York 2000

O. Impey and A. McGregor, eds., *The Origins of Museums: The Cabinet of Curiosities in 16th–17th-Century Europe*, Oxford 1985

C. Johanson, *The Women's Struggle for Higher Education in Russia, 1855–1900*, Kingston, Ontario, and Montreal 1987

A.L. Kaganovich, *"Mednyi vsadnik." Istoriia sozdaniia monumenta*, Leningrad 1982

N.V. Kaliazina and G.N. Komelova, *Russkoe iskusstvo Petrovskoi epokhi*, Leningrad 1990

N.V. Kaliazina, ed., *Iz istorii petrovskikh kollektsii: sbornik nauchnykh trudov*, St. Petersburg 2000

Karamzin's Memoir on Ancient and Modern Russia, ed. R. Pipes, New York 1966

C. Kelly, ed. and trans., *An Anthology of Russian Women's Writing, 1777–1992*, Oxford and New York 1994

S.N. Kondakov, *Iubileinyi spravochnik Imperatorskoi Akademii khudozhestv, 1764–1914*, 2 vols., St. Petersburg 1914

[Lady Eastlake] *Letters from the Shores of the Baltic*, London 1849

E. Levin, *Sex and Society in the World of the Orthodox Slavs, 900–1700*, Ithaca NY 1989

A. Lindenmeyr, *Poverty is Not a Vice: Charity, Society, and the State in Imperial Russia*, Princeton NJ 1996

V.G. Lisovsky, *Akademiia khudozhestv: istoriko-iskusstvovedcheskii ocherk*, Leningrad 1982

I. de Madariaga, *Russia in the Age of Catherine the Great*, London 1981

Marie Bashkirtseff, 1858–1884: Peintre et Sculpteur, Ecrivain et Témoin de Son Temps, Nice 1995

I marmi degli Zar: Gli scultori carraresi all'Ermitage e a Petergof, Milan 1996

M.L. Marrese, *A Woman's Kingdom: Noblewomen and the Control of Property in Russia, 1700–1861*, Ithaca NY 2002

R. Marsh, ed., *Women in Russia and Ukraine*, Cambridge 1996

S. Massie, *Pavlovsk: the Life of a Russian Palace*, London 1990

R.E. McGrew, *Paul I of Russia, 1754–1801*, Oxford 1992

The Memoirs of Elisabeth Vigée-Le Brun, trans. S. Evans, London 1989

The Memoirs of Princess Dashkova, ed. and trans. K. Fitzlyon, intro. J.M. Gheith, Durham NC and London 1995

S.V. Mironenko and N.S. Tretiakov, eds., *Imperatritsa Mariia Fedorovna*, St. Petersburg 2000

L. Mochalov and N. Barabanova, *The Female Portrait in Russian Art (12th–Early 20th Centuries)*, Leningrad 1974

N. Moleva and E. Beliutin, *Russkaia khudozhestvennaia shkola pervoi poloviny XIX veka*, Moscow 1963

— *Russkaia khudozhestvennaia shkola vtoroi poloviny XIX–nachala XX veka*, Moscow 1967

Iu. V. Mudrov, ed., *Pavlovsk, imperatorskii dvorets: stranitsy istorii*, St. Petersburg 1997

G. Norman, *The Hermitage: The Biography of a Great Museum*, London 1997

A. Novitsky, *Istoriia russkogo iskusstva*, 2 vols., Moscow 1903

A. Odom and L.P. Arend, *A Taste for Splendor: Russian Imperial and European Treasures from the Hillwood Museum*, Alexandria VA 1998

Opisanie obshchago sobraniia Imperatorskoi Akademii khudozhestv, byvshago 17-go marta 1857, i otchet Akademii s 4-go oktiabria 1855 po 17-e marta 1857 goda, St. Petersburg 1857

A.M. Panchenko, ed., *Russkaia sillabicheskaia poeziia XVII–XVIII vekov*, Leningrad 1970

N. Pavlov-Silvansky, *Proekty reform v zapiskakh sovremennikov Petra Velikogo*, St. Petersburg 1897

P'esy stolichnykh i provintsial'nykh teatrov pervoi poloviny XVIII v., Moscow 1975

P.N. Petrov, *Sbornik materialov dlia istorii Imperatorskoi S-Peterburgskoi Akademii khudozhestv za sto let ee sushchestvovaniia*, 3 vols., St. Petersburg 1864–66

N. Pushkareva, *Women in Russian History*, ed. and trans. E. Levin, Armonk NY 1997

D.L. Ransel, ed., *The Family in Imperial Russia: New Lines of Historical Research*, Urbana IL and London 1978

A.F. Rieber, *Merchants and Entrepreneurs in Imperial Russia*, Chapel Hill NC 1982

P. Roosevelt, *Life on the Russian Country Estate: A Social and Cultural History*, New Haven CT and London 1997

W. Rosslyn, *Feats of Agreeable Usefulness: Translations by Russian Women 1763–1825*, Fichtenwalde 2000

Russkaia kul'tura pervoi chetverti XVIII veka. Dvorets Menshikova, St. Petersburg 1992

D.V. Sarabianov, *Russian Art from Neoclassicism to the Avant-Garde*, London 1990

Sbornik postanovlenii Soveta Imperatorskoi Akademii khudozhestv po khudozhestvennoi i uchebnoi chasti s 1859 po 1890 god, St. Petersburg 1890

M.M. Shcherbatov, *On the Corruption of Morals in Russia*, ed. and trans. A. Lentin, Oxford 1969

B. Shifman and G. Walton, eds., *Gifts to the Tsars 1500–1700: Treasures from the Kremlin*, New York 2001

I. von Stählin, *Zapiski Iakoba Shtelina ob iziashchnykh iskusstvakh v Rossii*, 2 vols., I, Moscow 1990

R. Stites, *The Women's Liberation Movement in Russia: Feminism, Nihilism, and Bolshevism, 1860–1930*, Princeton NJ 1978

P. Svinin, *Dostopamiatnosti Sankt Peterburga i ego okrestnostei*, St. Petersburg 1997

I. Thyrêt, *Between God and Tsar: Religious Symbolism and the Royal Women of Muscovite Russia*, DeKalb IL 2001

C.D. Tomei, ed., *Russian Women Writers*, New York 1999

E.K. Valkenier, *Russian Realist Art, the State and Society: the Peredvizhniki and their Tradition*, New York 1989

G.V. Vilinbakhov, ed., *Petr I i Gollandii: Russko-gollandskie khudozhestvennye i nauchnye sviazi*, St. Petersburg 1996

F.C. Weber, *The Present State of Russia*, 2 vols. [London 1723]; reprint, New York 1968

R.S. Wortman, *Scenarios of Power: Myth and Ceremony in Russian Monarchy*, 2 vols., Princeton NJ 1995 and 2000

PLATES

Manuscript publications

Cat. 1773
[E. Münich] "Catalogue raisonné des tableaux qui se trouvent dans les Galeries, Sallons et Cabinets du Palais Impérial de S. Pétersbourg, commencé en 1773 et continué jusqu'en 1785," MS, I and II, 1773–83; III, 1785: Hermitage Archives, fund 1, *opis'* VI-A, *delo* 85

Cat. 1797
"Katalog kartinam, khraniashchimsia v Imperatorskoi galeree Ermitazha, v Tavricheskom i Mramornom dvortsakh, sochinennyi [...] pri uchastii F.I. Labenskogo" (Catalogue of Paintings Kept in the Imperial Hermitage Gallery, the Tauride and Marble Palaces, compiled ... with the participation of F.I. Labensky), MS, 3 vols., 1797: Hermitage Archives, fund 1, *opis'* VI-A, *delo* 87

Inventory 1859
"Opis' kartinam i plafonam, sostoiashchim v zavedovanii II otdeleniia imperatorskogo Ermitazha" (Inventory of Paintings and Ceilings in the Care of the II Department of the Imperial Hermitage), MS, 1859–1929: Hermitage Archives, fund 1, *opis'* XI-B, *delo* 1

Printed Publications

Babin 2001
A.A. Babin, "Frantsuzskie khudozhniki – sovremenniki N.B. Iusupova" (French Artist Contemporaries of N.B. Yusupov), in Moscow– St. Petersburg 2001–02, pp. 86–105

Backmeister 1786
I. Bakmeister [J. Backmeister], *Istoricheskoe izvestie o izvaiannom konnom izobrazhenii Petra Velikogo* (Historic News About the Sculptural Equestrian Image of Peter the Great), St. Petersburg 1786

Baillio 1996
J. Baillio, "Vie et œuvre de Marie-Victoire Lemoine (1754–1820)," *Gazette des Beaux-Arts*, cxxvii, April 1996, pp. 125–64

Becker 1998
M.-L. Becker, "Marie-Anne Collot (1748–1821), l'art de la terre cuite au féminin," *L'Objet d'art*, 325, June 1998, pp. 73–82

Berezina 1972
V.N. Berezina, *Gosudarstvennyi Ermitazh: frantsuzskaia zhivopis' XIX v: ot Davida do Fantin-Latura* (The State Hermitage: French Painting of the 19th Century: From David to Fantin-Latour), Leningrad 1972

Berezina 1983
— *The Hermitage Catalogue of Western European Painting*, II, *French Painting, Early and Mid-Nineteenth Century*, Moscow and Florence 1983

Berezina 1987
— *Frantsuzskaia zhivopis' XIX v. v sobranii Gosudarstvennogo Ermitazha* (French 19th-century Painting in the Collection of the State Hermitage), Moscow 1987

Bird 1977
A. Bird, "A Painter of Russian Aristocracy," *Country Life*, 6 January 1977, pp. 32–33

Bock 1978
H. Bock, "Eines Bildnis von Prinz Henrich Lubomirski als Genius Ruhms von Vigée-Lebrun," *Niederdeutsche Beiträge zur Kunstgeschichte*, 16, 1978, pp. 83–92

Bode 1882
W. Bode, *Kaiserliche Gemäldegalerie der Ermitage in St. Petersburg*, Berlin 1882

Breton 1808
J. de Breton, *Rapport sur les Beaux-Arts*, Paris 1808

Bruni 1861
F. Bruni, "Kartiny ital'ianskikh shkol," in F. Gilles, *Muzei imperatorskogo Ermitazha: opisanie razlichnykh sobranii, sostavliaiushchikh muzei, s istoricheskim vvedeniem ob Ermitazhe Ekateriny II i o obrazovanii muzeia Novogo Ermitazha* (The Imperial Hermitage Museum: Description of Various Collections Making up the Museum, with a historical introduction on the Hermitage of Catherine II and the formation of the New Hermitage Museum), St Petersburg 1861

Buturlin 1901
"Zapiski grafa M.D. Buturlina" (The Notes of Count M.D. Buturlin), *Russkii arkhiv* (Russian Archive), book 3, 1901, pp. 433–71

Cantaro 1960
M.T. Cantaro, *Lavinia Fontana bolognese*, Milan and Rome 1960

Cat. 1839
Musée du prince Joussoupoff contenant les tableaux, marble, ivoires et porcelaines, qui se trouvent dans son hôtel à St. Petersbourg, St. Petersburg 1839

Cat. 1920
Gosudarstvennyi muzeinyi fond: katalog khudozhestvennykh proizvedenii byvshei Iusupovskoi galerei (State Museums Fund: Catalogue of Artistic Works of the Former Yusupov Gallery) St. Petersburg 1920

Cat. 1971
Anna Dorothea Therbusch. 1721–1782. Ausstellung zum 250. Geburtstag. Katalog, Potsdam, Sanssouci, 1971

Chicago 1976
Selected Works of 18th-Century French Art in the Collections of the Art Institute of Chicago, Chicago 1976

Christoffel 1966
U. Christoffel, "Kauffmann, Angelica," in *Kindlers Malerei Lexicon*, Zurich 1966

Clément de Ris 1879
L. Clément de Ris, "Musées du Nord: Musée Impérial de l'Ermitage à Saint-Pétersbourg," *Gazette des Beaux-Arts*, in five parts; part I, xix, 1879, pp. 178–89

Correspondance 1876
"Perepiska imperatritsy Ekateriny II s Fal'konetom" (The Correspondence of Catherine II with Falconet), *Sbornik Imperatorskogo russkogo istoricheskogo obshchestva* (Anthology of the Imperial Russian Historical Society), xvii, 1876

Cuzin 1988
J.-P. Cuzin, *Fragonard: Life and Work*, New York 1988

Diderot *Salons* 1957–67
D. Diderot, *Salons*, Texte établi et présenté par J. Seznec et J. Adhemar, 4 vols., Oxford 1957–67

Doin 1912
J. Doin, "Marguérite Gérard," *Gazette des Beaux-Arts*, 2, December 1912, pp. 237, 429–52

Dukelskaya, Renne 1990
L.A. Dukelskaya and E.P. Renne, *The Hermitage Catalogue of Western European Painting*, XIII, *British Painting, Sixteenth to Nineteenth Centuries*, Moscow and Florence 1990

Duplesis 1876
G. Duplesis, "La collection de M. Camille Marcille," *Gazette des Beaux-Arts*, XIII, 1876, pp. 428–30

Dussieux 1856
L. Dussieux, *Les artistes français à l'étranger*, 2nd edn, Paris 1856

Eddy 1976
L.R. Eddy, "An Antique model for Kauffmann's 'Venus Persuading,'" *The Art Bulletin*, LVIII, 1976, pp. 569–73

Ernst 1924
S. Ernst, *Iusupovskaia galereia: frantsuzskaia shkola* (The Yusupov Gallery: French School), Leningrad 1924

Etoeva 1999
I.G. Etoeva, "Portrety Ekateriny II raboty M.-A. Kollo" (Portraits of Catherine II by M.-A. Collot), *Ermitazhnye chteniia pamiati V.F. Levinsona-Lessinga* (Hermitage Readings in Memory of V.F. Levinson-Lessing), St. Petersburg 1999, pp. 38–41

Etoeva 2000
— "Portretnyi rel'ef v tvorchestve M.-A. Kollo" (Portrait Reliefs in the Work of M.-A. Collot), *Ermitazhnye chteniia pamiati V.F. Levinsona-Lessinga* (Hermitage Readings in Memory of V.F. Levinson-Lessing), St. Petersburg 2000, pp. 36–40

Etoeva (forthcoming)
— "O nekotorykh skul'pturnykh portretakh M.-A. Kollo,

ispolnennykh v Rossii" (On Several Sculptural Portraits Made by M.-A. Collot in Russia), *Sbornik pamiati Iu. A. Rusakova* (Anthology in Honor of Iu.A. Rusakov) (forthcoming), St. Petersburg

Fortunati Pierantonio 1986
V. Fortunati Pierantonio, *Pittura Bolognese dell'500*, Bologna 1986

Gagern 1991
"Fridrikh Gagern: Dnevnik puteshestviia po Rossii v 1839 gody" (Friedrich Gagern: Diary of a Journey Through Russia in 1839), in *Rossiia pervoi poloviny XIX veka glazami inostrantsev* (Russia in the First Half of the 19th Century Through the Eyes of Foreigners), Leningrad 1991

Galli 1940
R. Galli, *Lavinia Fontana pittrice*, Imola 1940

Gaze 1997
D. Gaze, ed., *Dictionary of Women Artists*, 2 vols., Chicago and London 1997

Georgi 1996
I.G. Georgi, *Opisanie rossiisko-imperatorskogo stolichnogo goroda Sankt-Peterburga i dostopamiatnostei v okrestnostiakh onogo, 1794–1796* (A Description of the Russian Imperial Capital City of St. Petersburg and the Sights in its Environs, 1794–1796), [1794], St. Petersburg 1996
[Note: The German and French editions of this book (*Versuch einer Beschreibung der Rußisch Kaiserl. Residentzstadt St. Petersburg under der Merkwürdigkeiten der Gegend, von Johann Gottlieb Georgi*, Riga 1793; and *Description de la Ville de St. Pétersbourg et de ses environs, traduite de l'allemand de Mr. Georgi*, St. Petersburg 1793) do not include the description of the Hermitage]

Gerard 1893
F. Gerard, *Angelica Kauffmann: A Biography*, London 1893

Goncourt 1876
E. de Goncourt, *Catalogue raisonné de l'œuvre peint, dessiné et gravé de P.P. Prud'hon*, Paris 1876

Grabar [1914]
I. Grabar, *Istoriia russkogo iskusstva* (The History of Russian Art), 6 vols., Moscow 1909–16, V [1914]

Graves 1908
A. Graves, *The British Institution 1806–1867*, London 1908

Grigorovich 1865
D.V. Grigorovich, *Novye priobreteniia Ermitazha: "Madonna s mladentsem" Leonardo da Vinchi, "Sud Apollona*

nad Marsiem" Korredzho* (New Acquisitions by the Hermitage: Leonardo da Vinci's *Virgin and Child*, Correggio's *Apollo's Judgment of Mars*), St. Petersburg 1865

Grimm 1870
A. Th. von. Grimm, *Alexandra Feodorowna Empress of Russia*, trans. Lady Wallace, 2 vols., Edinburgh 1870

Guellette 1879
Ch. Guellette, "Mlle Constance Mayer et Prud'hon," *Gazette des Beaux-Arts*, 1, 1879, pp. 1–49

Guiffrey 1924
J. Guiffrey, *L'œuvre de P.P. Prud'hon*, Paris 1924

Harck 1896
F. Harck, "Notizen über italienische Bilder in Petersburger Sammlungen," *Repertorium für Kunstwissenschaft*, 19, 1896, pp. 413–34

Hildebrandt 1908
E. Hildebrandt, *Leben, Werke und Schriften des Bilhauers E.-M. Falconet*, Strasbourg 1908

Iaremich 1912
S.P. Iaremich, "Klassiki i romantiki na vystavke frantsuzskoi zhivopisi za sto let" (Classics and Romantics at the Exhibition of French Painting over One Hundred Years), *Starye gody* (Bygone Years), 2, 1912, pp. 45–52

Izergina 1969
A.N. Izergina, *Frantsuzskaia zhivopis' v Ermitazhe (pervaia polovina i seredina XIX v.): ocherk-putevoditel'* (French Painting in the Hermitage [First Half and Middle of the 19th Century]: Essay Guide), Leningrad 1969

Jeffares 1999
N. Jeffares, "Jacques-Antoine-Marie Lemoine (1751–1824)," *Gazette des Beaux-Arts*, February 1999, pp. 61–136

Jeudwine 1956
W.R. Jeudwine, "Two Drawings from the Ashmolean Museum, Oxford," *Apollo*, September 1956, pp. 69–70

Kaganovich 1982
A.L. Kaganovich, *"Mednyi vsadnik." Istoriia sozdaniia monumenta* ("The Bronze Horseman." The History Behind the Creation of the Monument), Leningrad 1982

Kossareva 1975
N. Kossareva, "Masterpieces of Eighteenth-Century French Sculpture," *Apollo*, June 1975, pp. 446–48

Kostenevitch 1977
Peinture d'europe occidentale des XIXe–XXe siècles: Musée de l'Ermitage, intro. A. Kostenevitch, Leningrad 1977

Krol 1940
A.E. Krol, "Deti s popugaem Kristiny Roberston" (Christina Robertson's *Children with a Parrot*), *Soobshcheniia Gosudarstvennogo Ermitazha* (Papers of the State Hermitage), 1, 1940

Krol 1969
A.E. Krol, *Gosudarstvennyi Ermitazh: angliiskaia zhivopis', katalog* (State Hermitage: English Painting, Catalogue), Leningrad 1969

Kustodieva 1994
T.K. Kustodieva, *The Hermitage Catalogue of Western European Painting*, I, *Italian Painting, Thirteenth to Sixteenth Centuries*, Moscow and Florence 1994

Lasareff 1923
V. Lasareff, "Zwei neue Madonnen von Bronzino," *Jahrbuch für Kunstwissenschaft*, 1923

Laveissière 1997–98
S. Laveissière, *Pierre Paul Prud'hon*, New York 1998

Levey 1965
Michael Levey, "Marie-Anne Collot and Miss Cathcart," *The Burlington Magazine*, December 1965, p. 633

Levi d'Ancona 1977
M. Levi d'Ancona, *Botticelli's Primavera: A Botanical Interpretation Including Astrology, Alchemy and Medicine*, Florence 1977

Levis-Godechot 1997
N. Levis-Godechot, *La jeunesse de Pierre-Paul Prud'hon (1758–1796): Recherches d'iconographie et de symbolique*, Paris 1997

Liphart 1912
Imperatorskii Ermitazh: katalog kartinnoi galerei (The Imperial Hermitage: Catalogue of the Picture Gallery), I, *Ital'ianskaia i ispanskaia zhivopis'* (Italian and Spanish Painting), with a foreword by E. Liphart [Lipgart], St. Petersburg 1912

List of Portraits 1904
Spisok portretov, otobrannykh dlia istoriko-khudozhestvennoi vystavki 1905 goda general'nym komissarom S.P. Diaghilevym v osmotrennykh im v techenie letnikh mesiatsev 1904 goda 72-kh russkikh imeniiakh (List of Portraits Selected for the Historical-Artistic Exhibition of 1905 by the General Commissar S.P. Diaghilev in the 72 Russian Estates which he

viewed in the summer months of 1904), St. Petersburg 1904

List of Portraits 1905
Spisok portretov, otobrannykh dlia istoriko-khudozhestvennoi vystavki 1905 goda v obshchestvennykh i chastnykh sobraniiakh g. S.-Peterburga (List of Portraits Selected for the Historical-Artistic Exhibition of 1905 from Public and Private Collections in St. Petersburg), St. Petersburg 1905

Livret 1838
Livret de la Galerie Impériale de l'Hermitage de Saint-Pétersbourg: Contenant l'explication des Tableaux qui la composent, avec de courtes notices sur les autres objects d'art ou de curiosité qui y sont exposés, St. Petersburg 1838

MacComb 1928
A. MacComb, *Angelo Bronzino: His Life and Works*, Cambridge 1928

Manners, Williamson 1924
Lady Victoria Manners and G.C. Williamson, *Angelica Kauffmann, R.A. Her Life and Her Works*, London 1924

Matsulevich 1940
J. Matsulevich, *Frantsuzskaia portretnaia skul'ptura XV–XVIII vv. v Ermitazhe* (French Portrait Sculpture of the 15th–18th Centuries in the Hermitage), Leningrad and Moscow 1940

Meusel 1779–97
J.G. Meusel, "Lebensumstände der im Jahr 1782 zu Berlin verstorbenen Madame Therbusch," in *Miscellaneen artistischen Inhalts*, Erfurt 1779–97, III, no. 17, pp. 266–75

Monod 1912
F. Monod, "L'exposition centennale de l'art français à St. Petersbourg," *Gazette des Beaux-Arts*, 1, 1912, pp. 191–98

Morozov 1913
A.V. Morozov, *Katalog moego sobraniia russkikh gravirovannykh i litografirovannykh portretov* (Catalogue of My Collection of Russian Engraved and Lithographed Portraits), 4 vols., Moscow 1912–13

Mycielski, Wasylewski 1928
J. Mycielski and St. Wasylewski, *Portrety Polskie Elizabety Vigée-Lebrun, 1755–1842* (The Polish Portraits of Elizabeth Vigée-Lebrun, 1755–1842), Lvov 1928

Nemilova 1973
I. Nemilova, *Zagadki starykh kartin* (Riddles of Old Paintings), Moscow 1973

Nemilova 1975
I. Nemilova, "Contemporary French

Art in Eighteenth-Century Russia," *Apollo*, June 1975, pp. 428–42

Nemilova 1982
I. Nemilova, *Frantsuzskaia zhivopis' XVIII veka v Ermitazhe: nauchnyi katalog* (French 18th-century Painting in the Hermitage: A Scholarly Catalogue), Leningrad 1982

Nemilova 1985
I. Nemilova, *The Hermitage Catalogue of Western European Painting*, X, *French Painting, Eighteenth Century*, Moscow and Florence 1985

Nicolai 1786
F. Nicolai, *Nachricht von den Baumeistern, Bildhauern, Kupferstechern, Malern, Stich-Katurren und anderen Künstlern, welche vom dreizehnten Jahrhundert bis jetzt in und um Berlin sich aufgehalten haben*, Berlin-Stettin 1786

Nicolenco 1967
L. Nicolenco, "The Russian Portraits of Mme Vigée-Lebrun," *Gazette des Beaux-Arts*, July–August 1967, pp. 91–120

Nikulin 1987
N.N. Nikulin, *The Hermitage Catalogue of Western European Painting*, XIV, *German and Austrian Painting, Fifteenth to Eighteenth Centuries*, Florence 1987

Nikulin 1989
— *The Hermitage Catalogue of Western European Painting*, V, *Netherlandish Painting, Fifteenth and Sixteenth Centuries*, Florence 1989

Nolhac 1908
P. de Nolhac, *Madame Vigée Le Brun, peintre de la Reine Marie-Antoinette, 1755–1842*, Paris 1908

Nolhac 1912
— *Mme Vigée Le Brun, peintre de Marie-Antoinette*, Paris 1912

Oppenheimer 1996
M.A. Oppenheimer, "Nisa Villiers, née Lemoine (1774–1821)," *Gazette des Beaux-Arts*, April 1996, pp. 165–80

Opperman 1965
H.N. Opperman, "Marie-Anne Collot in Russia: Two Portraits," *The Burlington Magazine*, August 1965, pp. 408–15

Pigler 1974
A. Pigler, *Barockthemen: Eine Auswahe von Verzeichnissen zur Ikonographie des 17. und 18. Jahrhunderts*, Budapest 1974

Prakhov 1906
A. Prakhov, "Kartiny frantsuzskoi shkoly: materialy dlia opisaniia

khudozhestvennykh sobranii Iusupovykh" (Paintings of the French School: Material for a Description of the Yusupov Art Collection), *Khudozhestvennye sokrovishcha Rossii* (Art Treasures of Russia), 8–12, 1906, pp. 161–221

Prakhov 1907
A. Prakhov, "Khudozhestvennoe sobranie Iusupovskoi galerei" (The Art Collection of the Yusupov Gallery), *Khudozhestvennye sokrovishcha Rossii* (Art Treasures of Russia), 1, 1907, pp. 3–12

Rakina 1995
V.A. Rakina, "Sheremetevy— sobirateli zapadnoevropeiskoi zhivopisi" (The Sheremetevs as Collectors of Western European Painting), in I.E. Danilova, ed., *Chastnoe kollektsionirovanie v Rossii* (Private Collecting in Russia), no. XXVII, Moscow 1995

Réau 1922
L. Réau, *Falconet*, 2 vols., Paris 1922, II

Réau 1924
— *Histoire de l'expansion de l'art français moderne: Le monde slave et l'Orient*, Paris and Brussels 1924

Réau 1929
— *Catalogue de l'art français dans les musées russes*, Paris 1929

Renne 1995
E. Renne, "A British Portraitist in Imperial Russia: Christina Robertson and the Court of Nicholas I," *Apollo*, September 1995, pp. 43–45

Renne 2000
— "Pridvornyi khudozhnik Kristina Robertson" (The Court Artist Christina Robertson), *Nashe Nasledie* (Our Heritage), 55, 2000, pp. 35–37

Rostopchina 1989
Rasskazy moei babushki: iz vospominanii piati pokolenii, zapisannye i sobrannye ego vnukom D. Blagovo (My Grandmother's Tales: From the Recollections of Five Generations, Recorded and Assembled by her Grandson D. Blagovo), ed. T.I. Ornatskaia, Leningrad 1989

Rovinsky 1886–89
D.A. Rovinsky, *Podrobnyi slovar' russkikh gravirovannykh portretov* (Detailed Dictionary of Russian Engraved Portraits), 4 vols., St. Petersburg 1886–89

Rovinsky 1895
— *Podrobnyi slovar' russkikh graverov XVI–XIX vekov* (Detailed Dictionary of Russian Engravers of the 16th–19th Centuries), 2 vols., St. Petersburg 1895

Russian Museum 1988
Gosudarstvennyi Russkii muzei: skul'ptura, XVIII – nachalo XX veka, katalog (The State Russian Museum: Sculpture, 18th – Early 20th Century, Catalogue), Leningrad 1988

Russian Portraits 1905–09
Russkie portrety XVIII–XIX stoletii (Russian Portraits of the 18th–19th Centuries), 5 vols., St. Petersburg 1905–09

Ruszkiewicz 1979
A. Ruszkiewicz, "Les portraits polonais de Mme Vigée-Lebrun. Nouvelles données pour servir à leur identification et histoire," *Bulletin du Musée National de Varsovie*, XX, no. 1, 1979, pp. 16–42

Rzewuska 1939
R. Rzewuska, *Memoires*, Rome 1939

Savinskaia 1994
L. Iu. Savinskaia, "N.B. Iusupov kak tip russkogo kollektsionera nachala XIX veka" (N.B. Yusupov as a Type of Russian Collector in the Early 19th Century), *Pamiatniki kul'tury, novye otkrytiia, ezhegodnik 1993* (Cultural Monuments, New Discoveries, Annual for 1993), Moscow 1994, pp. 200–18

Savinskaia 1999
L. Savinskaia, "La collection de peintures de Nicolai Borisovitch Youssoupov," in *Hubert Robert et Saint-Pétersbourg*, Valence 1999, pp. 72–78

SbRIO 1876
Sbornik Imperatorskogo russkogo istoricheskogo obshchestva (Anthology of the Imperial Russian Historical Society), XVII, 1876

SbRIO 1878
Sbornik Imperatorskogo russkogo istoricheskogo obshchestva (Anthology of the Imperial Russian Historical Society), XXIII, 1878

Schulze 1911
H. Schulze, *Die Werke Angelo Bronzinos*, Strassburg 1911

Somov 1908/1916
A. Somov, *Imperatorskii Ermitazh: katalog kartinnoi galerei* (The Imperial Hermitage: Catalogue of the Picture Gallery), III, *Angliiskaia i frantsuzskaia zhivopis'* (English and French Painting), St. Petersburg 1908 (also published in French as *Catalogue abrégé de l'Ermitage Impérial*, Petrograd 1916)

Souvenirs 1835
Souvenirs de Madame Louise-Elisabeth Vigée-Lebrun, 3 vols., Paris 1835

Stählin 1990
I. von Stählin, *Zapiski Iakoba Shtelina ob iziashchnykh iskusstvakh v Rossii* (The Notes of Jacob Stählin on the Fine Arts in Russia), 2 vols., Moscow 1990

Der Teutscher Merkur 1776
Der Teutscher Merkur, Weimar 1776, second quarter

Thieme, Becker 1940
U. Thieme and F. Becker, *Allgemeines Lexikon der bildenden Kunstler von der Antike bis zur Gegenwart*, 35 vols., Leipzig 1907–50, XXXIV, 1940

Trofimoff 1916
A. Trofimoff, "Études sur quelques tableaux de Gatchina," *Starye gody* (Bygone Years), June–September 1916, pp. 96–108

Uspensky 1913
A.I. Uspensky, "Imperatorskie dvortsy" (Imperial Palaces), in *Zapiski imperatorskogo moskovskogo arkheologicheskogo instituta imeni imperatora Nikolaia II* (Notes of the Emperor Nicholas II Imperial Moscow Archaeological Institute), XXIII, part 1, Moscow 1913

Vasari 1880
G. Vasari, *Le Vite de' più eccellenti pittori, scultori ed architetti …* [1550; 1568], 9 vols., ed. G. Milanesi, Florence 1878–85, V, 1880

Venturi 1933
A. Venturi, *Storia dell'arte italiana*, 9 vols., Milan 1901–39, IX, 1933

Waagen 1864
G.F. Waagen, *Die Gemäldesammlung in der Kaiserlichen Ermitage zu St. Petersburg nebst Bemerkungen über andere dortige Kunstsammlungen*, Munich 1864

Walch 1977
P.S. Walch, "An Early Neoclassical Sketchbook by Angelica Kauffmann," *The Burlington Magazine*, CXIX, 1977, pp. 98–111

Wells-Robertson 1974
S. Wells-Robertson, "Le premier pas de l'enfance," in Paris 1974–75, pp. 437–39

Wells-Robertson 1978
— "Marguérite Gérard, 1761–1837," PhD diss., II, New York University 1978

Wildenstein 1960
G. Wildenstein, *Fragonard*, London 1960

Williamson 1904
G. Williamson, "The Collection of Pictures in the Hermitage Palace at St. Petersburg," *Connoisseur*, IX, no. 33, May 1904, pp. 9–15

Wöhle 2000
T. Wöhle, "Anna Dorothea

Therbusch," in *Deutsche Frauen der frühen Neuzeit: Dichterinnen, Valerinnen, Väzeninnen*, Darmstadt 2000

Wrangel 1911
N.N. Vrangel [Wrangel], "Inostrantsy v Rossii" (Foreigners in Russia), *Starye Gody* (Bygone Years), July–September 1911, pp. 5–94

Wrangel 1912
— "Inostrantsy 19 veka v Rossii" (Foreigners in 19th-century Russia), *Starye Gody* (Bygone Years), July–September 1912, pp. 5–50

Würtenberg 1955
Traum der Jugend goldner Stern: Aufzeichnungen der Königin Olga von Würtenberg, Pfullingen 1955

Yusupov Gallery 1920
Gosudarstvennyi muzeinyi fond: katalog khudozhestvennykh proizvedenii byvshei Iusupovskoi galerei (State Museums Fund: Catalogue of Works of Art in the Former Yusupov Gallery), Petrograd 1920

Zaretskaia, Kossareva 1965
Z.V. Zaretskaia and N.K. Kossareva, *Frantsuzskaia skul'ptura XVII–XX vv.* (French Sculpture of the 17th–20th Centuries), Leningrad 1965

Zaretskaia, Kossareva 1975
— *La sculpture de l'Europe occidentale à l'Ermitage*, Leningrad 1975

EXHIBITIONS

Note: The first or main venue only is given

London 1841
A. Graves, *The Royal Academy of Arts: A Complete Dictionary of Contributors and Their Works from its Foundation in 1769 to 1904*, 4 vols., London 1970

St. Petersburg 1841
Exhibition at the Imperial Academy of Arts (no catalogue)

St. Petersburg 1870
P.N. Petrov, *Katalog istoricheskoi vystavki portretov lits XVI–XVIII vv. ustroennoi Obshchestvom pooshchreniia khudozhestv* (Catalogue of an Exhibition of Historical Portraits of Figures of the 16th–18th Centuries Organized by the Society for the Encouragement of the Arts), St. Petersburg 1870

St. Petersburg 1902
N.N. Vrangel, *Podrobnyi illiustrirovannyi katalog vystavki russkoi portretnoi zhivopisi za 150 let (1700–1850)* (Detailed Illustrated Catalogue of an Exhibition of Russian Portrait Painting Over the Course of 150 Years [1700–1850]), St. Petersburg 1902

St. Petersburg 1905
S. Diaghilev, *Katalog ... istoriko-khudozhestvennoi vystavki russkikh portretov ... v Tavricheskom dvortse v pol'zu vdov i sirot pavshikh v boiu voinov* (Catalogue ... of a Historical-Artistic Exhibition of Russian Portraits ... in the Tauride Palace for the Benefit of Widows and Orphans of Soldiers Fallen in Battle), 8 issues, St. Petersburg, Tauride Palace, 1905

St. Petersburg 1912
La leçon – Deti uchatsia khodit': Sto let frantsuzskoi zhivopisi, 1812–1912 (The Lesson – Children Learning to Walk: One Hundred Years of French Painting, 1812–1912), St. Petersburg 1912

Leningrad 1937
T.D. Kamenskaia, *Gosudarstvennyi Ermitazh: akvarel' XVI–XIX vekov* (State Hermitage: Watercolors of the 16th–19th Centuries), Leningrad, State Hermitage, 1937

Leningrad 1938
Gosudarstvennyi Ermitazh: vystavka portreta XVIII–XX vekov (State Hermitage: Exhibition of Portraits of the 18th–20th Centuries), 4 issues, Leningrad, State Hermitage, 1938

Moscow 1955
Gosudarstvennyi muzei izobrazitel'nykh iskusstv im. A.S. Pushkina: vystavka frantsuzskogo iskusstva XV–XX vekov (Pushkin Museum of Fine Arts: Exhibition of French Art of the 15th–20th Centuries), Moscow, Pushkin Museum of Fine Arts, 1955

Leningrad 1956
Gosudarstvennyi Ermitazh: vystavka frantsuzskogo iskusstva XII–XX vekov (State Hermitage: Exhibition of French Art of the 12th–20th Centuries), Leningrad, State Hermitage; Moscow 1956

Moscow 1956
Gosudarstvennyi muzei izobrazitel'nykh iskusstv im. A.S. Pushkina: vystavka proizvedenii angliiskogo iskusstva: zhivopis', skul'ptura, risunok, graviura, predmety prikladnogo iskusstva iz muzeev SSSR (Pushkin Museum of Fine Arts: Exhibition of English Works of Art: Painting, Sculpture, Drawings, Prints, Objects of Applied Art from Museums of the USSR), Moscow, Pushkin Museum of Fine Arts, 1956

Bordeaux 1965
Chefs-d'œuvre de la peinture française dans les musées de l'Ermitage et de Moscou, Bordeaux 1965

Paris 1965–66
Chefs-d'œuvre de la peinture française dans les musées de Leningrade et de Moscou, Paris 1965–66

Leningrad 1966
Falconet, Leningrad, State Hermitage (no catalogue)

Dresden 1967–68
Meisterwerke der Eremitage, Leningrad: Französische Maler des 17. und 18. Jahrhunderts, Dresden, Staatliche Kunstsammlungen, 1967

Göteborg 1968
Hundra målningar och teckningar från Eremitaget, Leningrad 1968

Belgrade 1968–69
Narodni muzej u Beogradu: Državni Ermitazh u Leningradu: Dela Zapadnoevropskikh slikara 16.–18. veka iz zbirki Državnog Ermitazha (National Museum in Belgrade: State Hermitage in Leningrad: Works of Western European Art of the 16th–18th Century from the Collection of the State Hermitage), Ljubljana (no catalogue)

Bregenz–Vienna 1968–69
Angelica Kauffmann und ihre Zeitgenossen: Katalog, Bregenz and Vienna 1968

Leningrad 1969
Zapadnoevropeiskoe iskusstvo XV–XIX vekov iz fondov Gosudarstvennogo Ermitazha (Western European Art of the 15th–19th Centuries from the Stores of the State Hermitage) (traveling exhibition), Leningrad 1969

Leningrad 1972
Gosudarstvennyi Ermitazh: iskusstvo portreta: Drevnii Egipet, Antichnost', Vostok, Zapadnaia Evropa (The State Hermitage: The Art of the Portrait: Ancient Egypt, Antiquity, The Orient, Western Europe), Leningrad, State Hermitage, 1972

Moscow 1972
Gosudarstvennyi muzei izobrazitel'nykh iskusstv imeni A.S. Pushkina: portret v evropeiskoi zhivopisi XV-nachala XX veka (Pushkin Museum of Fine Arts: The Portrait in European Painting of the 15th–Early 20th Century), Moscow, Pushkin Museum of Fine Arts, 1972

Warsaw 1973
Malarstwo francuskie XVII-XX w. ze zbirow Ermitazu (French Painting of the 17th–20th Centuries from the Collection of the Hermitage), Warsaw, Museum Narodowe, 1973

Paris 1974–75
De David à Delacroix: La peinture française de 1774 à 1830, Paris, Grand Palais, 1974

Melbourne–Sydney 1979–80
USSR: Old Master Paintings,

Melbourne, National Gallery of Victoria, 1979

Moscow 1982
Antichnost' v evropeiskoi zhivopisi XV – nachala XX veka (Antiquity in European Painting of the 15th to Early 20th Century), Moscow, Pushkin Museum of Fine Arts, 1982

Irkutsk–Novosibirsk 1986
Zapadnoevropeiskaia zhivopis' XVIII veka iz sobraniia Ermitazha (Western European Painting of the 18th Century from the Hermitage Collection), Irkutsk 1986

Leningrad 1986
N.N. Nikulin, *Gosudarstvennyi Ermitazh: nemetskaia i avstriiskaia zhivopis' XVIII veka iz fondov Ermitazha* (The State Hermitage: German and Austrian Painting of the 18th Century from the Stores of the Hermitage), Leningrad, State Hermitage, 1986

Paris 1986–87
La France et la Russie au Siècle des Lumières: Relations culturelles et artistiques de la France et de la Russie au XVIIIe siècle, Paris, Grand Palais, 1986

Hokkaido 1987
Works by Western European Masters of the 19th and 20th Centuries from the Hermitage Collection, Hokkaido, Museum of Contemporary Art, 1987 (in Japanese)

Leningrad–Moscow 1987
Rossiia-Frantsiia: Vek Prosveshcheniia: russko-frantsuzskie kul'turnye sviazi v 18 stoletii (Russia-France: The Age of Enlightenment: Russo-French Cultural Links in the 18th Century), Leningrad, State Hermitage, 1987

London 1988
French Painting from the USSR: Watteau to Matisse, London, National Gallery, 1988

Nara 1990
Master Paintings from the Hermitage Museum, Nara, Nara Prefectural Museum of Art, 1990

Sverdlovsk 1990
40 kartin: zapadnoevropeiskaia zhivopis' XVII–XVIII vekov iz sobraniia Ermitazha (40 Paintings: Western European Painting of the 17th and 18th Centuries from the Hermitage Collection), Sverdlovsk 1990

Frankfurt-am-Main 1991
Von Lucas Cranach bis Caspar David Friedrich: Deutsche Malerei aus der Eremitage, Katalog, München, Schirn Kunsthalle; Frankfurt-am-Main 1991

Shizuoka–Navio–Okayama–Kumamoto
1991
*Genre Painting and Prints from the
Collection of the Hermitage Museum*
(no place of publication given), 1991
(in Japanese)
Mie–Osaka–Hiroshima–Toyama 1992
Court Culture in Russia, Tokyo 1992
(in Japanese)
Vaduz 1992
*Hommage an Angelica Kauffmann,
bearbeitet von Oscar Sandner,
Liechtensteinische Staatliche
Kunstsammlung, Katalog*, Vaduz 1992
Ibaraki–Mie–Tokyo 1994
*French Baroque and Rococo Art from
the State Hermitage Museum*, Ibaraki,
Mito, The Museum of Modern Art,
Tokyo 1994
Ekaterinburg 1995
Ermitazh spasennyi, Ekaterinburg,
Ekaterinburg Museum of Fine Arts;
St. Petersburg 1995

Edinburgh 1996
*Christina Robertson: A Scottish
Portraitist at the Russian Court*,
Edinburgh, City of Edinburgh
Museums and Galleries, 1996
Karlsruhe 1996
*Vom Glück des Lebens: Französische
Kunst des 18. Jahrhunderts aus der
Staatlichen Eremitage St. Petersburg*,
Karlsruhe, Städtische Galerie in
PrinaMaxPalais, 1996
Moscow 1997
G.B. Andreeva, ed., *Nezabyvaemaia
Rossiia: russkie i Rossiia glazami
britantsev XVII–XIX vek*
(Unforgettable Russia: Russians
and Russia Through the Eyes of the
British in the 17th–19th Centuries),
Moscow, State Tretiakov Gallery,
1997
Florence 1998
*Catarina di Russia: L'imperatrice e le
arti*, Florence, Palazzo Strozzi, 1998

Stockholm 1998–99
Catherine the Great and Gustav III,
Stockholm, Nationalmuseum,
Helsingborg 1999
Wilmington–Mobile 1998–99
*Nicholas and Alexandra: The Last
Imperial Family of Tsarist Russia,
From the Hermitage Museum and the
State Archive of the Russian
Federation*, London 1998
Antwerp–Arnhem 1999
*Elck zijn waerom vrouwelijke
Kunstenaars in Belgie en Nederland
1500–1950*, 1999
Düsseldorf–Munich–Chur 1999
*Angelika Kauffmann: Herausgegeben
und bearbeitet von Bettina Baumgärtel,
Katalog*, Ostfildern-Rui 1998
Portland–Fort Worth 2000
*Stroganoff: The Palace and Collections
of a Russian Noble Family*, Oregon,
Portland Art Museum; New York
2000

London 2000–01
Treasures of Catherine the Great,
London, Hermitage Rooms at
Somerset House, 2000
Genoa 2001–02
*Russian 19th–20th Century Painters
in Liguria* (forthcoming)
Moscow–St. Petersburg 2001–02
*Uchenaia prikhot': Kollektsiia
kniazia N.B. Iusupova* (Educated
Fancy: The Collection of Prince
Nikolai B. Yusupov), Moscow and
St. Petersburg 2001
Paris 2002
*The Stroganovs: The Palace and
Collections of a Russian Noble Family*,
Paris, Musée Carnavalet, 2002 (no
catalogue)

Index